A DREAM AND A CHISEL

Women's Diaries and Letters of the South
Carol Bleser, Founding Editor
Melissa Walker and Giselle Roberts, Series Editors

A DREAM AND A CHISEL

LOUISIANA SCULPTOR ANGELA GREGORY IN PARIS ♦ 1925–1928

ANGELA GREGORY AND
NANCY L. PENROSE

THE UNIVERSITY OF SOUTH CAROLINA PRESS

© 2019 Angela Gregory, LLC

Published by the University of South Carolina Press
Columbia, South Carolina 29208

www.sc.edu/uscpress

Manufactured in the United States of America

28 27 26 25 24 23 22 21 20 19
10 9 8 7 6 5 4 3 2 1

Library of Congress Cataloging-in-Publication Data
can be found at http://catalog.loc.gov/.

ISBN 978-1-61117-977-4 (cloth)
ISBN 978-1-61117-978-1 (ebook)

This book was printed on recycled paper with
30 percent postconsumer waste content.

CONTENTS

ILLUSTRATIONS

FOUNDING EDITOR'S PREFACE

The Women's Diaries and Letters of the South includes a number of never-before-published diaries, collections of unpublished correspondence, and a few reprints of published diaries—a wide selection nineteenth- and twentieth-century southern women's informal writings. The series may be the largest series of published works by and on southern women.

The goal of the series is to enable women to speak for themselves, providing readers with a rarely opened window into southern society before, during, and after the American Civil War and into the twentieth century. The significance of these letters and journals lies not only in the personal revelations and the writing talent of these women authors but also in the range and versatility of the documents' contents. Taken together, these publications will tell us much about the heyday and the fall of the Cotton Kingdom, the mature years of the "peculiar institution," the war years, the adjustment of the South to a new social order following the defeat of the Confederacy, and the New South of the twentieth century. Through these writings the reader will also be presented with firsthand accounts of everyday life and social events, courtships, and marriages, family life and travels, religion and education, and the life-and-death matters that made up the ordinary and extraordinary world of the American South.

Carol Bleser

FOREWORD

Angela Gregory's (1903–1990) artistic leanings began in childhood and sculpture became her chosen métier at the tender age of fourteen. She became one of New Orleans's most notable artists and was one of few local sculptors throughout Louisiana's three-hundred-year history to undertake large, publicly commissioned works. Gregory's most notable works include her Governor Henry Watkins Allen statue in Port Allen in West Baton Rouge Parish; her John McDonogh statue in New Orleans; and her monumental sculpture of the city's founder, Jean-Baptiste Le-Moyne, sieur de Bienville. She was the only American admitted to the personal studios of Émile-Antoine Bourdelle (1861–1929) and she became one of few women of her era to be recognized nationally and internationally in a field dominated by men.

Gregory received her first formal art training at the Katherine Brès School from 1914 to 1921, where her mother, Selina Brès Gregory (1870–1953), taught art. Rosalie Urquhart (1854–1922), whom Angela recounts as one of her early teachers, studied at Newcomb, became an Art Craftsman, and taught at the Brès School. Angela's father, William Benjamin Gregory (1871–1945), a Tulane University professor of engineering with vast experience in his field, enjoyed an international reputation. His American and European contacts proved invaluable for his daughter. Throughout her art training, Angela Gregory thrived under the aegis of Newcomb College's faculty. Established in 1886 as Tulane's coordinate college for women, Newcomb had an art faculty that held staunchly to the tenets of the Arts and Crafts movement. Ellsworth Woodward (1861–1939), Henrietta Davidson Bailey (1874–1950), Mary Williams Butler (1863–1937), Mary Given Sheerer (1865–1954), and Gertrude Robert Smith (1869–1962), worked incessantly to provide opportunities for their students.

Like her mother, Angela benefitted from the determination of this same founding faculty dedicated fervently to the fledgling cause of women's education. Selina Brès had her first formal lessons at the age of fourteen in Woodward's first drawing class in 1885, and she had the following artistic firsts to her credit: a member of Newcomb's first pottery decoration class in 1895, Selina sold the first piece of the pottery to gain international recognition; and, she published the first souvenir postcard of the South, a reproduction of her drawing of an African American praline vendor who frequented Newcomb's

campus. In 1921 Selina became a cofounder and charter member of the Arts and Crafts Club of New Orleans and its School of Art. This organization was critical in educating artists, exhibiting works by national and international artists, and holding lectures on art and literature. Nurtured in this ground-breaking environment, Angela's budding determination to become a sculptor was supported fully even before she matriculated at Newcomb College.

Gertrude Roberts Smith, who taught watercolor painting at Newcomb, influenced Gregory's selection for the prestigious Mary L. S. Neill Award in watercolor painting in 1924. The first faculty member recruited by Woodward, Smith was also an organizing force on the Board of Directors for the Arts and Crafts Club, and she invited the young Gregory to assist the German sculptor Albert Rieker (1889–1959). He instructed Gregory in the basics of sculpture, including constructing an armature, applying clay to this essential foundation for modeling a three-dimensional figure in clay, and the process of casting a bas-relief. Rieker achieved national recognition; Gregory later surpassed her teacher's accomplishments.

William Woodward (1859–1939), Ellsworth's older brother and a Tulane University professor of architecture, took the young Gregory seriously enough to teach her sculpture despite the fact this was his first teaching experience in the field of sculpture. The experience led Woodward to produce at least three portrait heads of his mother; although, as competent as they were, these works lacked the power, liveliness, and insightful character of Gregory's sculptures.

Following Gregory's education at Newcomb and the Arts and Crafts Club, extraordinary opportunities continued, including work with New York sculptor Charles Keck (1875–1951), who was known for his monuments and architectural sculptures. Keck had studied at the National Academy of Design and the Art Students League. He was the former praticien, or technical assistant, for renowned American sculptor Augustus Saint-Gaudens (1848–1907), whose women apprentices included Helen Farnsworth Mears (1872–1916), Marie Lawrence (1868–1945), Annetta St. Gaudens (1869–1943), Frances Grimes (1869–1963), and Elsie Ward Hering (1872–1923), who all became successful artists.

Elected into the National Academy of Design as an associate member in 1921, Keck became a full academician in 1928 while Gregory was in Paris. Her professional training in this reputable studio in 1924 was critical preparation for her work at L'Académie de la Grande Chaumière and in Bourdelle's atelier in 1926. These experiences formed Gregory's lifelong attitude toward art, particularly the concept that sculpture should be conceived and executed in a manner that is unified with architecture. Gregory became the first woman to receive a Master of Arts degree from the Tulane School of Architecture in

1940. She worked with architects J. Herndon Thomson (1891–1969), A. Herbert Levy (1897–1969), Nathaniel Cortlandt Curtis (1881–1953), and Marion Dean Ross (1913–1991), all of whom Gregory cited in an undated newspaper clipping as having been "a tremendous influence in my professional and personal life." Her personal papers at Tulane include blueprints that document her collaborative work with architects in designing sculpture that integrated seamlessly with architectural structures, a precept that is exemplified in her Bienville Monument.

In 1925 Gregory began her first year in Paris as a scholarship student at Parsons School of Design, time that included studies in Rome, Florence, Venice, Milan, Mantua, and Genoa. She concluded her Parisian studies with Bourdelle in 1928, when her work was exhibited at the Salon des Tuileries, an artistic debut that she acknowledged gave her credibility as an artist.

The way for Gregory's accomplishments was paved nationally by women sculptors who preceded her; many of them, including Gregory's mother, promoted women's suffrage. Adelaide Johnson's (1859–1955) marble busts of suffrage leaders Lucretia Mott, Elizabeth Cady Stanton, and Susan B. Anthony were exhibited at the 1893 Chicago World's Fair in the Columbian Exposition. Johnson recreated these busts in a single monument for the U.S. Capitol, sculpting her *Memorial to the Pioneers of the Women's Suffrage Movement* from an eight-ton block of Carrara marble. The only monument in the nation's capital to commemorate the suffrage movement, Johnson's marble portraits of these suffragettes were completed in 1921, a year after the Nineteenth Amendment passed Congress and only four years before Gregory traveled to Paris.

Opportunities for women artists were limited in early nineteenth-century America, and a number of women went abroad for their studies and work. Among the talented expatriate women sculptors who for a period of time took up residence in Rome, at that time considered the principal art center, were Emma Stebbins (1815–1882), Anne Whitney (1821–1915), Maria Louisa Lander (1826–1923), Margaret Foley (1827–1877), Harriet Goodhue Hosmer (1830–1908), Florence Freeman (1836–1876), Edmonia Lewis (1844–1907), and Vinnie Ream (1847–1914). Until recently these sculptors were generally absent in studies of the history of American art. These women and Gregory are included in the pages of Charlotte Streifer Rubinstein's *American Women Sculptors*.

During the late nineteenth and early twentieth centuries, artists traveled to Paris to study at the Académie de la Grande Chaumière, the Académie Julian, the Académie Colarossi, and the École des Beaux-Arts. The first three academies accepted women students; but the Grande Chaumière, directed by two women artists, became the preferred school among American artists.

Philadelphia-born Harriet Whitney Frishmuth (1880–1980) studied with François-Auguste-René Rodin (1840–1917) at the École des Beaux-Arts in Berlin,

and at the Art Students League of New York with Danish American sculptor Gutzon Borglum (1867–1941) and Hermon Atkins MacNeil (1866–1947). As a graduating senior, Frishmuth received the Saint-Gaudens Medal for excellence in drawing. She gained expertise working as an assistant to sculptor Karl Bitter (1867–1915), known for his architectural sculpture. Frishmuth became fascinated with dance, particularly ballet, and with Yugoslavian adagio dancer Desha Delteil (1899–1980); Frishmuth produced a series of sensuous nude figures on tiptoe, stretching, bending gracefully, or engaged in joyful activities. Revisiting Paris in 1932, Gregory sculpted *Philomela,* a small figure of a winged female holding her wings as though dancing.

New Orleans painter Helen Maria Turner (1858–1958) introduced Gregory to Frishmuth, which led to a lifelong friendship. Both sculptors departed from their usual artistic style to produce art deco sculpture. Frishmuth's *Speed,* a sleek, streamlined winged figure balanced on a globe, became a well-known hood ornament for exclusive automobiles. The figure was produced as a life-size marble relief on the Telephone Building in Erie, Pennsylvania. Gregory's large art deco pelican, her first public monument, was designed for the Criminal Courts Building in New Orleans. Her brass rail–encircled, bas-relief floor map in the Louisiana State Capitol features a pelican feeding her young, a motif she incorporated from the state flag. Lorado Taft's (1860–1936) large, three-figure monument symbolizing patriotism features an angular stylized pelican running around the base.

A frequent award winner, Frishmuth exhibited her work at prestigious venues, including the Salon in Paris, National Academy of Design, the Pennsylvania Academy of Fine Arts, and the National Association of Women Painters and Sculptors. Elected into the National Academy of Design in 1925, she became a full academician in 1929. Like Gregory, Frishmuth disliked modern art, but where Frishmuth adhered to Rodin's teachings, Gregory preferred Bourdelle's oeuvre and philosophy. In 1947, Gregory was a primary motivating force in the acquisition of Bourdelle's bronze statue of *Hercules the Archer* for the Isaac Delgado Museum of Art (now the New Orleans Museum of Art).

Historically, Gregory is among six notable women sculptors associated with New Orleans, each having highly individualized approaches to their work. Ida Kohlmeyer (1912–1997), who studied at Newcomb and was known primarily as a painter, came to sculpture late in her career. Like Gregory, Kohlmeyer and Lin Emery (born 1928) resided in the city their entire careers and became household names. Emery retained elements of nature in her elegant kinetic aluminum sculptures, commissioned for public places internationally. Clyde Connell (1901–1998) created the majority of her modernist work in Northern Louisiana in the Lake Bistineau region. Her non-objective

works, which often incorporated "found objects," frequently had religious or mythological themes. Lake Charles native Lynda Benglis (born 1941), who also studied at Newcomb before relocating to New York, incorporated political and feminist causes in many works. Although Elizabeth Catlett (1915–2012) chaired the art department at Dillard University in New Orleans from 1940 to 1942, her work relates largely to Mexico. Like Gregory's subjects, Catlett's were also representational. Catlett's work generally focused on the experience of African Americans and often conveyed socio-political implications. Where Catlett, Emery, and Gregory worked in traditional media, Connell and Benglis invented their own media for their abstract sculptures.

Like her mother before her, Gregory drew portraits of African Americans, including household servants. Her sympathetically rendered drawings, some of which were executed in Port Gibson, Mississippi, provide insight into the 1928 *La Belle Augustine,* a bust of a family servant, and the 1938 *Plantation Madonna,* which depicts small children beside a Black Madonna cradling an infant in her arms. Gregory often inscribed the names of the sitters on her sketches. Some drawings are signed by the sitters, a tangible recognition of their dignity and humanity. Gregory received the commission for the Criminal Courts Building on the basis of *La Belle Augustine,* and she considered it a seminal sculpture for her career and her ethnic studies—rare for the times. Likewise, Gregory developed a new technical process for her art panels for the John XXIII Library at St. Mary's Dominican College in uptown New Orleans.

In the early twentieth century, African sculpture and ceremonial masks were popular in Europe, especially in France. Of the five women Pablo Picasso depicted in his 1907 *Les Demoiselles d'Avignon,* one woman appears to be African, while two others wear African masks. New Orleans painter Josephine Crawford (1878–1952), who was in Paris at the same time as Gregory, studied in the atelier of Cubist proponent André Lhote (1885–1962). In *An Artist's Vision: Josephine Crawford,* Louise C. Hoffman described Crawford's visit to a Parisian Salon and her purchase of a catalog at the Musée Rodin. Crawford then noted in her journal, "L'Art Nègre is in vogue." She observed that Lhote owned "choice pieces of Art Nègre which he collected at the Port of Bordeaux before they were the vogue."

After their return from Paris, Crawford and Gregory had a joint exhibition at the Arts and Crafts Club in November 1928. In 1935 Crawford produced *Her First Communion,* a full-length view of an African American girl wearing a white dress and veil and holding a white candle. Gregory, who became state supervisor of the arts program for the Works Progress Administration in 1941, mentored black artists such as Frank Hayden (1934–1988) and she continued to explore the subject of African Americans in her art. Her oil

painting of *Louisiana Farmer,* a full-figure portrayal of an African American man seated on the grass, is nearly singular among her colleagues' artwork of the 1930s.

Gregory began her memoir by introducing three sculptures, one of which she described as "a black man, smiling peacefully, rest[ing] on a pedestal near the dining table." This 1929 sculpture portrayed *Faithful George* (Lewis), Tulane's longtime custodian. With this introduction, Gregory placed Lewis in company with a maquette of Bienville, her most celebrated work. In 1950, the Bienville Monument Commission appointed Gregory to sculpt a monument commemorating the founding of New Orleans, to be the first such sculpture in the city. The project was paid for by public subscription in Canada, France, and the United States, with appropriations from the city, the state, and the French government.

This commission represented the culmination of Gregory's studies in Bourdelle's studio, particularly in the powerful synthesis of sculpture with its architectural substructure. She adhered to Bourdelle's advice that a sculptor always be mindful of the relationship of the whole form and the unity of the structure. Gregory spent three years in Paris enlarging and casting her twenty-six-foot bronze figure of Bienville as the principle figure in a three-figure group. He towers over two other figures—a priest who accompanied him on his journey, and an American Indian—in a spiraling, triangular grouping, with each figure situated on a separate but conjoined stepped-base. The Indian's block-like feather headdress spirals upward, directing viewers' eyes to Bienville, who appears to be pausing momentarily, looking outward. He holds the end of a scroll against his leg, creating a sense of tension and movement and establishing the context for a complex historical narrative. Gregory portrayed the sensitive character of the two supporting individuals—both of whom appear withdrawn into their private thoughts—with downcast eyes similar to the subjects in her *La Belle Augustine, Faithful George,* and *Plantation Madonna.* The seated Indian represents the aboriginal inhabitants of the region; a member of the Bayougoula Nation. His calumet, or peace pipe, symbolizes the tribe's amicable greeting of Bienville, whose fluency in the local dialect aided his diplomatic efforts among the Indians.

The French Recollect (or Recollect priest) Père Anatase Douay wears a long habit with a pointed hood. He stands with eyes downcast, toward his book. A missionary order known for travels and spiritual work in Canada, the Récollets were a French reform branch of the mendicant Order of Friars Minor, known as Franciscans, who are devoted to a life of prayer. Douay serves as a symbolic link for three French figures important to Louisiana history: the Canadian-born Bienville and his older brother Pierre Le Moyne, sieur de Iberville; and French explorer René-Robert Cavelier, sieur de La Salle.

The latter claimed the Mississippi Valley for King Louis XIV in 1682. In 1699, Douay served as guide for Iberville's and Bienville's successful search for the Mississippi River.

Originally, the monument was installed on Loyola Avenue in front of the modernist Union Passenger Terminal, which was designed to consolidate the city's passenger rail operations and five scattered passenger depots. Built between 1947 and 1954, the terminal features one of the country's largest murals painted by Conrad Albrizio (1894–1973) to represent the history of Louisiana through exploration, colonization, conflict, and the modern age. Gregory's monument served as a critical foundation for the two-dimensional historical narrative presented inside the terminal. This interdisciplinary approach recalls Bourdelle's counsel to his students that sculpture was something between painting and architecture. In 1996, the monument was relocated to the Vieux Carré where Bienville first set foot. Located today in Bienville Park, a small, triangular green space at the bustling intersection of Decatur and Conti Streets, the sculpture has taken on greater prominence. Viewers now walk freely around the monument, observing the spiraling direction that culminates in the figure of the city's founding father.

The Bienville monument incorporates the strong tectonic quality Gregory aspired to achieve in her works from her earliest days in Bourdelle's studio. She was honored by the French government for the monument in 1960.

Gregory's three-year study in France served as a foundation for the next six decades of her life, during which she sculpted works for public, government, and financial buildings; religious institutions; and universities. She received commissions from most of the leading architectural firms in New Orleans, as well as numerous private commissions. Her work was exhibited in major international venues including Paris, Baltimore, Houston, Philadelphia, and San Francisco; the Metropolitan Museum in New York; and the National Gallery in Washington, D.C.

In 1982, she was awarded a Chevalier de L'Ordre des Arts et des Lettres for her contributions to the enrichment of the French cultural inheritance. In her home country, Angela Gregory was one of few women recognized as a fellow of the National Sculpture Society, the first among professional organizations for sculptors. Nominated by Harriet Frishmuth, this recognition secures Gregory's ranking among the country's noted sculptors.

Judith H. Bonner
SENIOR CURATOR AND CURATOR OF ART
THE HISTORIC NEW ORLEANS COLLECTION

ACKNOWLEDGMENTS

I am indebted to many people who through the years have contributed to the realization of this story about those inspiring days I spent in Bourdelle's studio in Paris in the 1920s. I cannot name them all, but foremost I am indebted to the late Joseph Campbell who, in May 1928, created for me the basic outline of the book about my years in the "spiritual space" of that studio, as Joe expressed it. Again, several years later, Joe offered to collaborate with me on the writing of the book and, in 1985, expressed his delight in my success at finally realizing this dream from my student days.

I am, of course, deeply indebted to the late Cléopâtre Sevastos Bourdelle (Madame Antoine Bourdelle); Rhodia Dufet-Bourdelle and her late husband Michel Dufet; and Fanny Bunand Sevastos (Mrs. Norris Chipman); all of whom generously shared their thoughts, memories, and photographs with me over a lifetime.

I appreciate the generosity of St. Mary's Dominican College, New Orleans, for having provided support with a Shell Oil grant on two occasions. These grants supported my interviews with Madame Bourdelle and the organization and filing of my letters.

The late Frances Louise Diboll Chesworth and the late Polly LeBeuf gave me immeasurable assistance in organizing the many years of materials. Paule Perret's skill in transcribing and translating French tapes and lectures was invaluable.

Grateful thanks to Nancy Staub; William R. Cullison; Joseph Schenthal, M.D.; Moise W. Dennery; Gregory Ferriss, M.D.; and Thomas and Patricia Crosby. Each of these people, in his or her own way, spurred me on. A very special thanks goes to Pocahontas Wight Edmunds whose path crossed mine at just the right moment in 1925, and to Sadie Hope Sternberg who gave me the "push" that made it all come true.

I thank Nancy Penrose, who made this book a reality, and David Muerdter for his gracious cooperation at all times.

Angela Gregory
NEW ORLEANS, 1989

I AM GRATEFUL TO THE MANY PEOPLE who made this book possible through their interest, support, and encouragement—some for more than thirty years. First, of course, I thank Angela Gregory for putting her trust in me, for the privilege of collaborating with her on the story of her years in Paris, and for the joy of a friendship that is among the most cherished of my life.

Susan Hymel, my colleague in "all things Angela," has provided invaluable support and an unwavering belief in the importance of telling Angela's story. Susan understood the kind of assistance I needed before I even knew, and she helped me to move forward with completing the book. Mark Schenthal, a close friend of Angela's, her artistic protégé, and director of the Gregory Art LLC, has been enthusiastic, encouraging, and cooperative in the final preparations of this book. Madeline Munch, an undergraduate student at Louisiana State University, provided invaluable research assistance by locating and scanning Angela's correspondence held in the Louisiana Research Collection at Tulane University.

Thank you to Susan Tucker, retired archivist of Newcomb College, who suggested in 2014 that I submit the manuscript to Giselle Roberts and Melissa Walker, editors of the Women's Diaries and Letters of the South series at the University of South Carolina Press. Upon their first reading, Giselle and Melissa believed it was important to publish Angela Gregory's story. There have been many magazine and newspaper articles and biographies in exhibition catalogues written about Angela through the years, but this book is the first full-length work about her. Changing as little as possible in the manuscript Angela approved before her death in 1990, Giselle and Melissa graciously and generously guided me to create a book that meets the high academic standards of this press. I am deeply grateful for their phenomenal support and effort. Thank you also to the anonymous readers who reviewed the final manuscript in 2017 and to the staff at the University of South Carolina Press who contributed to the preparation and publication of this book.

Many thanks to Judith H. Bonner, senior curator at the Historic New Orleans Collection. She made a deep and generous investment of time and effort in writing the foreword, which so effectively illuminates Angela's place in American art and her role in Louisiana art history.

To Amélie Simier, director of the Musée Bourdelle in Paris; and to museum staff members Chloë Théault, Stéphane Ferrand, and Annie Barbera: a big "merci beaucoup" for their help with research questions and photograph permissions. Another "merci beaucoup" to Christine Vincent, granddaughter of one of Angela's closest friends, who researched and provided information on several individuals in the book, including some of Angela's French ancestors.

William R. Cullison III established Tulane University's Southeastern Architectural Archive, where the Angela Gregory papers were held initially. Bill was a helpful presence during the years of working on the book with Angela and beyond. Susan Larson generously took the time to read a very early draft of the manuscript, and she provided feedback to Angela and me. Bennet Rhodes of Baton Rouge assisted by photographing some of Angela's sculptures. I also owe much gratitude to many librarians who have assisted me with my research, including several at the University of Washington and Tulane University. To Leon C. Miller, head of the Louisiana Collection at Tulane; Ann E. Smith Case, Tulane's university archivist; Sean Benjamin, public services librarian in Tulane's Louisiana Research Collection; and Kevin Williams, department head of Tulane's Southeastern Architectural Archive, I say thank you for your help and for the curatorial care you provide to Angela's legacy.

Several people readily granted permission for use of materials in the book: Angela's beloved nephew, Gregory Stark Ferris; Rudolph Matas Landry, Jr., grandson of Rudolph Matas; and Robert Walter, executive director and board president of the Joseph Campbell Foundation.

Here in Seattle, big thanks to Robert Zat for creating digital audio versions of all of the cassette recordings I made with Angela as we worked together on the book in the 1980s. His work preserves her voice for posterity.

With immeasurable gratitude for their abundant love, I thank my husband, David Muerdter, and our daughter, Claire Penrose Muerdter. Claire was there from her very beginnings, participating in utero as Angela and I worked on the book. David not only has provisioned, fortified, and inspired me with his constant love and support for nearly four decades, but he has also given generously of his photographer's skills and artist's eye to this and many other projects we have worked on together.

And finally, special thanks to Staci and Trey Sundmaker, the current owners of the Gregory home at 630 Pine Street in New Orleans. They have restored and preserved Angela's studio that was built onto the back of the house in 1928. The Sundmakers generously hosted a reception on October 18, 2015, in their home and the studio to celebrate what would have been Angela Gregory's 112th birthday. About thirty of us gathered to remember Angela and to make a few short presentations about her life and work. Some guests were fortunate enough to have known her personally; others were too young but had come to learn about her and to honor her accomplishments. We all soaked in the atmosphere of that space where her creativity had flourished. It was an extraordinary occasion, and I felt Angela's spirit among us.

Nancy L. Penrose
SEATTLE, 2017

EDITORIAL NOTE

The Angela Gregory Papers held at the Louisiana Research Collection, Tulane University, in New Orleans, Louisiana, contain 462 boxes that include correspondence; journals and diaries; financial records; family papers; professional and legal papers; photographs; newspapers; publications; scrapbooks; and sketchbooks.

When I was co-authoring this book with Angela in the 1980s, some of her papers were already stored in Tulane's Southeastern Architectural Archive and some were still in her studio. Angela selected the letters, journal entries, and diaries used in this book. She chose excerpts that she felt were most pertinent to the story she wished to tell of her years in Paris in the 1920s. Where possible, these excerpts have been identified in the main text, with dates provided. On occasion I have added an endnote instead, mostly to preserve the narrative flow. Also noted are the few occasions when original letters were not located and I relied on audio recordings made by Angela in the 1980s.

When quoting directly from these papers, I have preserved inconsistencies in Angela's writing, including variations in spelling and irregularities in punctuation and capitalization. The layout and paragraphing in these and other original documents has, however, been adjusted to accommodate the narrative structure, and the occasional full stop, comma, or missing letter has been silently added. Times have been standardized, so that 6<u>30</u> appears as 6:<u>30</u>. Where a quote ended in an em dash, I have added a comma or full stop instead.

Angela misspelled some French words. I have transcribed her French just as she wrote it. Usually such errors were minor, and I have not noted them. My English translations, which appear in square brackets [], have been made as if she had written in perfect French. Other clarifications also appear in square brackets. Omissions are marked by a three dot ellipsis [. . .].

I have attempted to identify all of the people and places mentioned in the memoir. Where a reference is not included, I have been unable to make an identification. If an exact date of birth or death could not be established, I have estimated one based on available material and indicated by (circa).

Nancy L. Penrose
SEATTLE, 2017

PROLOGUE

NANCY L. PENROSE

Angela Gregory (1903–1990) was eighty and I was thirty when we first met. It was October 1983. I was working at Tulane University, and I had been sent to conduct an interview about her recent sculpting of a bronze medal for members of the University's Paul Tulane Society.

It was late afternoon on one of those autumn days in New Orleans when the sky is azure and the sunshine is mellow after the heat blasts of summer. I followed the directions to her studio that she had given me over the phone: come in off Pine Street and go alongside the big house, pass through the wrought-iron gate and into the brick patio. I stopped in front of a blue-green wooden door and yanked on the handle that clanged the clapper on a metal bell.

I was a bit nervous about meeting this famous woman sculptor. She had studied in Paris in the 1920s with the great French master Antoine Bourdelle (1861–1929). Her work was in museums and private collections, on buildings and in public spaces throughout Louisiana. There was the monument to Bienville, the French-Canadian founder of New Orleans, outside the city's train station; bas-reliefs on the exterior of the state capitol in Baton Rouge; her head of Aesculapius as the keystone in the arched entrance to Tulane's Hutchinson Memorial Building. Before she turned 30 she had already exhibited in Paris, Washington D.C., San Francisco, and New Orleans; had completed three major architectural sculpture commissions; and had been admitted to the National Sculpture Society. All this in an era when few women had careers and in a field of art dominated by men.

The blue-green door was opened by a small woman with silver-grey hair pulled up into a coif that gently framed her face. She wore a white silk shirt and blue knit pants. Her square glasses had big, plastic frames—that kind of 1980s style just like the ones I was wearing.

The moment I stepped into Angela Gregory's studio I was wrapped in her warmth and charm, put at ease by her informality. With a chuckle she apologized for the disarray, explaining that she had recently held a party to celebrate her eightieth birthday. She told me that her studio, built in 1928 onto the back of the big house where she grew up, was now her home and included a small apartment.

I like to say I went for a one-hour interview with Angela and stayed for four years. That's true, but not original; for, Angela often described how she had gone for a ten-minute interview with Antoine Bourdelle in April 1926 and stayed for two years.

That Angela had gotten to see Bourdelle at all was a miracle. Art critics of the era often described him as France's greatest living sculptor, successor to the great Auguste Rodin who had died in 1917. Plenty of students clamored to study with Bourdelle in his personal studios. His wife, Madame Cléopâtre Sevastos Bourdelle, who had been a sculptor before their marriage, was the one who protected him from entreaties and disruptions. Angela had cracked Madame's resolve when she said she wanted to learn to cut stone, unusual for any woman but particularly for a young, American woman. Madame had relented but she had made Angela promise she would stay only ten minutes. By the end of the short interview with the Master, he had agreed to take her on as a student. Angela Gregory became the only American to study with Bourdelle in his personal studios, and she built lifelong friendships with members of his family, including Madame Bourdelle.

Angela began attending Bourdelle's classes and critiques at l'Académie de la Grande Chaumière in Paris. There the sculptor was a philosopher-artist, sketching aloud for his students the proportions of his decades of art and life. He believed that sculpture spoke of the inner qualities of the artist and that "the only real success comes from the good quality of the spirit, that is to say the realities of the soul." He told his students to think of him as a fellow worker, not as their professor. Such was his personality. Students were inspired by even a devastating criticism. Such was the power of his teaching.[1]

What Angela had learned from Bourdelle in the 1920s was not only the art of sculpting but also the art of living life as an artist. She took notes on his lessons as if she knew they were the fuel that would power the rest of her life, her art. As if she knew they would shape her body of work that spanned seven decades and more than 100 pieces: portrait busts, portraits in bas-relief, seals, plaques, medallions, memorials, monuments, medals, and murals. As if she knew his wisdom would guide her to become the doyenne of Louisiana sculpture.

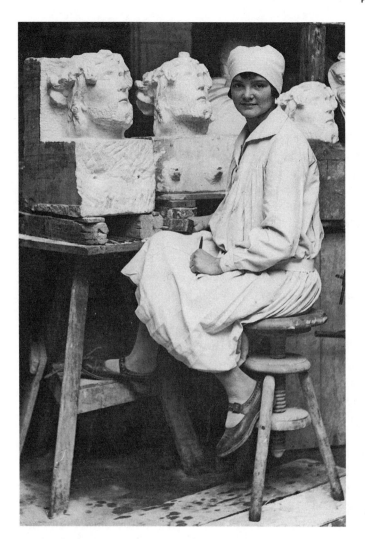

Angela Gregory with the *Beauvais Head of Christ* (1926–28) in Antoine Bourdelle's studio, Paris, France, 1927. Courtesy of Angela Gregory Papers, Louisiana Research Collection, Tulane University.

ANGELA GREGORY: A LIFE ❯

Angela Gregory was born in New Orleans in 1903, the third child of Selina Brès Gregory and William Benjamin Gregory. Selina was a gifted artist who had been a Newcomb potter, part of the Arts and Crafts–era enterprise organized by brothers Ellsworth and William Woodward at the H. Sophie Newcomb Memorial College for Women which had been founded in New Orleans

in 1886 as the coordinate women's college of Tulane University. Angela's father was a hydraulic engineer and a professor at Tulane. The Gregory home at 630 Pine Street had been purchased so that William could walk home for lunch because there was no place on campus to buy a meal. Angela and her older sister and brother, Elizabeth and William, were raised to appreciate the arts. Selina often took the children to Audubon Park to sketch, and there were weekly Sunday evening concerts at home.

Angela often recalled the profound effect of her mother's story about the tap-tap-tapping sound of chisel on stone made by a stonecutter as he carved angels onto the exterior of the Newcomb College chapel in 1895 on the Washington Avenue campus. Selina, who had given up the serious pursuit of her own art for marriage and children, consistently encouraged Angela's ambition to become a sculptor. Indeed, with an artist for a mother and an engineer for a father, Angela Gregory had a childhood for sculpture.

Angela announced her desire to become a sculptor at the age of fourteen while taking summer art classes from William Woodward at Tulane. "I never want to do another thing but clay modelling," she declared in a letter written June 17, 1918, to her father, who was serving overseas in France as a major in the U.S. Army Engineer Reserve Corps during World War I. "I go every day regularly & take clay modeling, & portrait drawing & charcoal. But the clay is the nicest I think. To-day I brought home a cheribs head I made. I have decided to be a sculptor—how do you like that? I made up my mind long ago to be an artist & I think I will like that best of all."

In addition to the summer art classes, Angela had the good fortune to meet Clyde Giltner Chandler, a Texan woman who had studied at the Art Institute in Chicago with the much-lauded American sculptor Lorado Taft. Out of that meeting grew Angela's desire to study with Taft in Chicago rather than to go to college in New Orleans. Her father refused. He supported Angela's wish to become a sculptor but he could not afford to send her to Chicago when she could live at home, attend Newcomb instead, and obtain a degree from the nation's finest art school for women.

Angela balked. She knew she did not need a college degree to become a sculptor. Her mother and sister had attended Newcomb and she regarded the college as "old hat." In addition to that, there were no classes in sculpture. Her father, however, left her no choice. Later in life, Angela came to appreciate the excellent art education she had received at Newcomb; and, there had been modest opportunities to learn the principles of sculpture. Along with several other Newcomb students, Angela took a class at the Arts and Crafts Club (of which her mother had been an organizer and charter member) from sculptor Albert Rieker, where she learned to build an armature and how to handle clay. In the summer of 1924, Angela traveled to New York and studied

in the private studio of sculptor Charles Keck, thanks to an introduction from Calvin W. Rice, one of her father's engineering colleagues.

What were her other influences? In interviews I did with Angela as background for this book, she told me that her mother was not only an artist, but also an activist for women's rights. Angela described Selina as always "being on her tiptoes," staying in touch with what was happening in the city and in the Unitarian church, where the Gregorys were longtime members. While most young girls of her social class might have accompanied their mothers to the country club, Angela recalled being taken along to meetings of the New Orleans Equal Rights Association, whose members supported woman suffrage. Angela later credited those meetings with contributing to her belief that as a woman she could pursue a career and do anything she wanted.

The Gregory family lived a modest albeit comfortable life that included household help. They were respected members of the city's white educated class; Angela's travels and achievements were reported in New Orleans newspapers and in society columns as her artistic talents began to be noticed. Her family's place in New Orleans society and her father's connections within an international community of engineering colleagues helped Angela again and again. People believed in her. They knew of her large talents and her big dreams. They wanted to help her by making a connection, providing a letter of introduction.

Angela's interest in the work of French sculptor Antoine Bourdelle emerged during her sophomore year at Newcomb. She vividly recalled the day in class when Ellsworth Woodward had tossed her an article by Walter Agard titled "Bourdelle: Lover of Stone." Woodward told Angela that if she was determined to pursue sculpture, this was the man with whom she should study.[2]

At that time, Bourdelle's monumental works stood in Buenos Aires, Argentina, Alsace, and Montauban (his hometown in southern France). His bas-reliefs and frescoes decorated the Théâtre des Champs Élysées in Paris and the Opera House in Marseille. His portraits of well-known figures of the period, including Auguste Rodin, Anatole France, and Sir James Frazer, were represented in museums and private collections throughout Europe.

Bourdelle was from the generation of French sculptors in the late nineteenth and very early twentieth centuries who had grappled with the challenge of creating their own artistic styles and identities separate from the internationally famous Rodin, who was known for his sensual and passionate sculptures of the human form. Indeed, Bourdelle and several of his contemporaries, including Charles Despiau, François Pompon, and Aristide Maillol, had worked in Rodin's studios as *praticiens*—technical assistants—often to earn a living as they pursued their own practices as independent sculptors.

Bourdelle's move into an abstraction and simplification of form that was powerfully influenced by his admiration of classical Greek sculpture set him apart from the realism of Rodin. Today this approach is considered to place Bourdelle among some of the most audacious explorers of modern art, including Paul Cézanne, Henri Matisse, Constantin Brancusi, and Pablo Picasso.[3]

Bourdelle was passionate about incorporating the qualities of architecture into his sculpture, an approach that greatly influenced Angela Gregory's body of work. Peter Murray, director of the Yorkshire Sculpture Park, wrote in 1989 at the time of a major exhibition of Bourdelle's work: "like architecture, his sculptures were built, rigorously constructed from the inside outwards." Murray also wrote that Bourdelle "helped to regenerate sculpture as a significant art form in the twentieth century."[4]

American art critic Hilton Kramer, writing in 1970, observed the powerful artistic confidence expressed in Bourdelle's work. Angela certainly walked out of his studio in 1928 having absorbed that confidence and it served her well throughout her career. Kramer describes Bourdelle's work as encompassing "large emotions, exalted themes, and monumental structures," and indeed his art was often expressed at heroic scale including such monuments as *La France* and *Adam Mickiewicz* in Paris and works such as *The Dying Centaur* and *Hercules the Archer*. A critique written in 1990 by British art historian Claudine Mitchell couples Bourdelle and his work with the themes of nationalism and supremacy of French culture promoted in France during Bourdelle's maturity as an artist, particularly as a weakened France struggled to recover from World War I.[5]

Today Bourdelle's sculptures are held in collections around the world, including several in the Musée d'Orsay in Paris. The Musée Bourdelle, a City of Paris museum dedicated to his vast body of work, is housed in the same studios where Angela learned to wield her chisel as a sculptor and provides not only a spacious setting for Bourdelle's monumental works but also an intimate look at life as an artist in Montparnasse at the beginning of the twentieth century.

Upon reading the Agard article about Bourdelle during her sophomore year at Newcomb, Angela Gregory set out to achieve her dream of studying sculpture with him in Paris. By the 1920s American artists no longer regarded time in Europe as a prerequisite to a successful career. Angela explained to me that in New Orleans, however, France was still considered the paragon of education, culture, and language. Wealthy New Orleans families, particularly French-speaking white Creoles, often traveled to Europe for summer holidays. France was also in Angela's blood. One of her maternal great-grandfathers, Jean Baptiste Brès, immigrated to Louisiana from Villefranche-Sur-Mer, and her mother's extended kin still lived in that town on the Mediterranean. Angela

had learned French as part of her primary and secondary education. Her father, William, had developed a deep bond with France during his World War I service when he boarded with the Charles Martin family in Tours.

The roadblock to getting to Paris was, once again, money. Angela applied for a scholarship to study illustrative advertising at the Paris Branch of the New York School of Fine and Applied Arts (later renamed Parsons School of Design) even though she had no interest in that field of study. She was awarded the scholarship, graduated from Newcomb College, and set sail with a contingent of Newcomb students headed to Europe for the summer. Angela arrived in Paris in 1925, less than a decade after World War I. French attitudes toward Americans at this time were often resentful and bitter, yet by virtue of her connections and her personality, Angela was granted entrée into the warm heart of French family life. Her circle included Charles and Germaine Roszak and their children; the Georges and Cécile Fatou family; Madame Charles Martin; and the Brès relatives in Villefranche. Perhaps it was the warm welcomes she received in France, coupled with her family's status in New Orleans and Angela's youthful inexperience, that led to her occasionally expressing perspectives in letters home that seem "tone deaf" to some of the social and political complexities of the time.

ANGELA KNEW THAT PARSONS was not the right place for her, and with a nine-month scholarship in hand, she immediately set to work to figure out the next steps for her art education in Paris. Angela first wrote a letter to Bourdelle, asking if she might apply to study with him, but she received no reply. In April 1926, without the benefit of any family connection or letter of introduction—driven only by the power of her determination to become a sculptor and her brave dismissal of the era's social conventions—she knocked at the door of Bourdelle's home.

A maid answered the knock; and, although she did not allow Angela to enter, she took pity on the young American and gave her Bourdelle's unlisted phone number. Madame Bourdelle picked up the phone. Angela explained her heartfelt dream of studying with the great artist. The interview with the Master was arranged and he accepted her as a student. Even sixty years later, Angela regarded her admittance into Bourdelle's studio as a miracle, and she felt she owed her life of art to that unknown French maid.

As Bourdelle had directed her, she began attending his classes and critiques at the Académie de la Grande Chaumière. For the next two years, chisel in hand, she learned stonecutting and other sculpting techniques in his private studios, taught primarily by Otto-Charles Bänninger, Bourdelle's *praticien*.

In May 1928, Bourdelle invited her to exhibit two pieces of sculpture: her copy of a sixteenth-century head of Christ from the cathedral in Beauvais,

France, and her portrait bust of a young American woman, Adelaide Mc-Laughlin. His invitation was great validation of Angela's progress and achievements, and it was the first significant exhibit of her work. Also in May 1928, she displayed forty-three sculptures and paintings at the American Women's University Club in Paris. In Georges Bal's review of this exhibit he described Angela as handling "with equal success the sculptor's ébauchoir [chisel] and the painter's brush. The exhibits consist of plaster busts, oil paintings and water-colors. I do not doubt that Miss Gregory will rapidly succeed in ripening her talent, which is still rather youthful, but is full of promise."[6]

Her three years of hard work in Paris and her intense focus on learning all she could about sculpture prepared her for the career she launched immediately upon returning home to New Orleans in July 1928. Her years in Paris and their influence on her later work and life are the subject of this book, the story of a young artist's arc to success after finding and working with the perfect mentor. Bourdelle had prepared her to emerge from the cocoon of his studio and launch her own life of art in New Orleans. His lessons went beyond techniques and propelled her through shifts in cultural and artistic styles, the challenges of making a living as an artist, and of being a woman working in a discipline dominated by men.

When Angela returned home in 1928, she had been away for three years. She viewed New Orleans and Louisiana with fresh eyes. "It was while I was in Europe, cut off from my part of the world, that I began to realize the rare opportunities lying at my own door," Angela remarked ten years later in an interview with *Arts and Antiques*. "I thought of those artists who receive training in New Orleans and leave for other towns—searching to express the new and unfamiliar rather than the indigenous for which they are naturally equipped." She went on to identify herself as an artist historian. "Art is not the copying of nature it is, rather the artist's job to translate what he sees and feels. Consciously or unconsciously he translates the life about him and becomes truly the greatest historian of his environment and civilization."[7]

Angela was particularly drawn to sculpting African Americans, which became her artistic exploration of her homeland. To endure the hot and crushing boredom of that first summer back in Louisiana, she convinced the family's African American maid, Augustine, to pose for her. In this she was following the example of Bourdelle who had so often used members of his household—his wife, his niece, his daughter, his daughter's governess—as models for his sculptures.

In her new studio—built with her father at the back of the family home on Pine Street—Angela created a portrait bust, *La Belle Augustine*, which earned immediate praise. "Sculptor and Artist Give Joint Exhibition at Arts and Crafts: Miss Gregory Begins Dream of Typifying the Southern Negro in

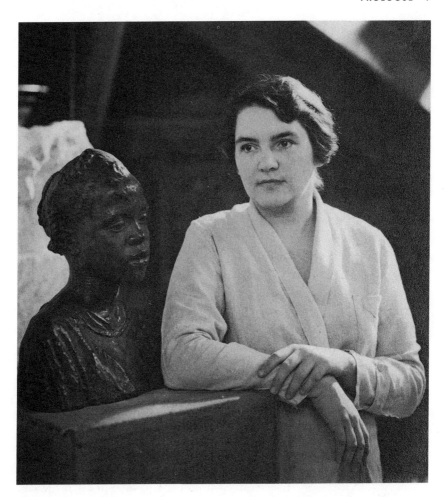

Angela Gregory with her sculpture *La Belle Augustine* (1928) in her New Orleans studio, 1928. Courtesy of Angela Gregory Papers, Louisiana Research Collection, Tulane University.

Sculpture" headlined a review by Jack Gihon of its first exhibition: "it is in this one bust of the negress that she finds an expression that [is] really musical [leading] one to believe that there is a broad and magnificent field for her in typifying the Southern negro in sculpture."[8]

As Angela explained to Luba Glade in 1975, she applied for a Guggenheim Foundation fellowship "so I could have the money to do a series of portrait studies of the Negro people around me. But in the '20s I suppose a white, Southern girl sculptor doing studies of black people was just too unorthodox for the Guggenheim Foundation to consider."[9]

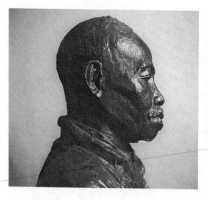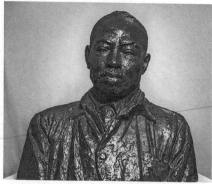

Faithful George (Lewis; 1929) by Angela Gregory.
Photograph by Bennet Rhodes, 2016.

Despite the lack of funding, she went on to create a series of drawings and portrait studies of African Americans. In addition to *La Belle Augustine,* her sculptures in this series include *Faithful George* (Lewis; 1929) and *The Plantation Madonna* (1938). Her mother, Selina, also had made drawings of African Americans, and she was certainly one of Angela's sources of inspiration for these works. Selina had been influenced by Ellsworth and William Woodward's interest in ethnic subjects, including hiring models of African American and Middle Eastern heritage to pose for art classes at Newcomb. In 1941, International Business Machines Corporation (IBM) purchased a cast of *La Belle Augustine* for the company's Sculpture of the Western Hemisphere collection.

La Belle Augustine led to Angela's first major commission; she was hired in 1929 to create an architectural sculpture for a new Criminal Courts building in New Orleans. She had returned from Paris in time to catch the end of the era of architectural sculpture, to enact the lessons she had learned from Bourdelle about the synthesis of sculpture and architecture. Success followed: her other major architectural sculpture commissions, all executed before she turned thirty, were eight portraits in bas-relief for the Louisiana State Capitol in Baton Rouge (1930–31) and a head of Aesculapius as the keystone in the arched entry to Tulane University's Hutchinson Memorial Building (1929–30). In 1932, Angela undertook an architectural restoration project in Septmonts, France, for the trailblazing American engineer Kate (Catherine Anselm) Gleason. Major work done in the late 1930s included the sculptured façade of the St Landry Parish Courthouse in Opelousas (1938–39) and exterior motifs on Tulane University buildings (1939–40).

In 1941 and 1942, Angela Gregory served as state supervisor for the Federal Works Progress Administration's Louisiana Art Project. World War II brought her sculpture work to a halt, and from 1942 to 1943 she was hired by

the Army Corps of Engineers and put in charge of designing camouflage for military installations. I recall how with decorum and emphasis she would slowly enunciate her job title: Assistant Engineer (Architectural). I believe she was especially proud of this title because it combined her father's engineering with Bourdelle's lessons in architectural sculpture. Later in the war she became a personnel counselor for Pendleton Shipyards and the Celotex Corporation, garnering recognition for her management skills.

Angela Gregory never married. She told me there had been three men she might have wed, but she did not want to name them. Angela had known that, for a woman of her era, marriage and children would have meant the end of her path as a productive and serious sculptor. Her mother, Selina, had become the kind of loving helpmate to Angela that Cléopâtre Bourdelle had been to Antoine Bourdelle. Selina managed many of the functions of the household and studio so that Angela could concentrate on her art. Nonetheless, the task of caring for aging parents and elderly aunts fell to Angela in the 1940s and early 1950s, and she compared those years to running a hospital. When Angela had to move to Paris temporarily to execute the Bienville monument, she took her ailing mother with her to continue supervising her care. Selina died near Paris on November 6, 1953.

Angela also had for many years an invaluable and beloved studio assistant, John Edward (Johnny) Anderson Jr., an African American New Orleanian and World War II veteran. I never met Johnny, but I knew his son, Greg, who was still helping Angela occasionally in the 1980s.

Paris may have held her artist's heart, but Angela was deeply rooted in New Orleans for her entire life. A glance at her lengthy résumé shows her as co-founder and board member in 1950 of the Louisiana Landmarks Society, which today still advocates for historic preservation in the city. Her honors and awards were many, but among the most meaningful was being presented in 1960 to General Charles de Gaulle, president of France, at the Bienville Monument, which had been a joint French, American, and Canadian venture. During this official visit to New Orleans, the General was presented with a two-foot bronze scale model of the monument.

Angela was a member of the art faculty and sculptor-in-residence at St Mary's Dominican College in New Orleans from 1962 to 1975, and she created sculptured reliefs for the John XXIII Library at Dominican in 1967. She made a trip to Paris in 1971 for work on an envisioned book about Bourdelle, and she spent hours interviewing and working with Madame Bourdelle; the Bourdelles' daughter, Rhodia; and Rhodia's husband, the highly respected architect and decorator, Michel Dufet.

Angela retired from Dominican in 1976 and was named Professor Emeritus. She continued to travel, exhibit, and sculpt. She focused primarily on small

pieces, completing five medals between 1979 and 1983. From 1980 to 1981, she produced a work of architectural sculpture for Dominican College, *Blessed Mother.*

Among her later exhibits was a retrospective of her and her mother's work hosted by Newcomb's Department of Art in 1981. She was inducted as one of France's Chevalier de l'Ordre des Arts et des Lettres [Knight of the Order of Arts and Letters] in 1982. Her *Beauvais Head of Christ,* completed in Bourdelle's studio in 1928, was displayed in the Vatican Pavilion of the 1984 Louisiana World Exposition in New Orleans. She received alumna recognition awards from Newcomb College (1986) and Tulane University (1988), where in 1940 she had become not only the first woman, but the first person, to receive a Master of Arts degree in Architecture. In 1989 another exhibit of Angela and Selina's work was mounted by the Anglo-American Art Museum (forerunner of the LSU Museum of Art) in Baton Rouge.

Angela Gregory has three monuments to her credit. All stand in Louisiana: John McDonogh (1932–1934) and the Bienville Monument (1952–1955) in New Orleans, and Governor Henry Watkins Allen (1961–1962) in Port Allen. Her sculptural works are held today by numerous institutions in Louisiana including the New Orleans Museum of Art, the Historic New Orleans Collection, Newcomb College Institute, and Tulane University in New Orleans; the Louisiana Art & Science Museum, the LSU Museum of Art, and Louisiana's Old State Capitol Museum in Baton Rouge; the West Baton Rouge Museum in Port Allen; the Zigler Museum in Jennings; and the Imperial Calcasieu Museum in Lake Charles. Details are included in the Appendix of this book.

Major retrospective exhibits of Angela's sculptures and paintings were held at the Taylor Clark Gallery in Baton Rouge in 2012 and at the West Baton Rouge Museum of Art in 2016. Sculptured murals created for the interior of the Louisiana National Bank building in Baton Rouge between 1948 and 1949 have been restored and preserved in place and incorporated into The Gregory restaurant in the Watermark Hotel.

WRITING THE BOOK >

When I first entered Angela Gregory's studio in 1983 I was adrift in New Orleans. The city felt foreign to me. I had arrived the year before when my husband, David Muerdter, took a job there. When Angela told me of her long-held desire to write a book about Bourdelle, I posed a fateful proposition: Would you like me to help? I realize now I was looking for something to give shape to my life in New Orleans and she was offering the armature I craved.

Angela and I quickly developed a strong bond. We sensed the possibilities of collaboration at that first interview, as if we were beginning a scale model of an imagined monument. We liked to say we were "on the same wave-

length" and she often called me a "sympathetic soul." We shared a respect for engineering and science. Her father had designed lifesaving flood control structures for the Mississippi River, and she, as a sculptor of monuments, had often been an artist-engineer. I was educated in earth science; I had hammered and hauled rocks down mountains in Nevada for geological studies, and had run cranes on the decks of oceanographic research vessels in the Pacific Ocean. Angela and I both knew what it was like to be a woman working in a man's field.

Another thing we had in common was our mutual love of the French language. She had learned it growing up in New Orleans and living in Paris. I had learned it as an American child living in Laos and as a university student in Poitiers. And like so many, we both reveled in the glories of Paris. She told me of her lifetime membership in First Unitarian Church in New Orleans, and I told her of the happenings at the suburban version of that church where David and I belonged. I learned of her mother's French ancestors who arrived in Louisiana in the early 1800s and of her family's deep connections to New Orleans. Her stories gave me the city in four dimensions, as if I too had lived through her layers of time. In that studio off Pine Street I found a home in New Orleans.

Who can explain a friendship? There are so many elements: trust, respect, attentiveness, companionship, endurance through the valleys of lives, celebrations at the peaks. We had all that and more, for Angela entrusted me with the duty of expressing her life stories in a book. The strength of our friendship and my belief in the value of her stories have powered me through all these years.

All of our work on the book took place in her studio. I loved the atmosphere there: the abundant light that fed through two-story windows, the exposed walls of barge board, the workbench lined with tools. We worked surrounded by her sculptures of bronze, stone, and plaster displayed on shelves and sitting on pedestals, each piece embodying memory and history. That atmosphere held the riches of her artistic spirit, the mysteries of concept coming into being, of vision finding expression. It was as if her studio and sculptures were participants in the writing of the book.

In many ways it was my own miracle that Angela accepted my offer to help. I was a writer and I loved art but I was not an artist, nor an art expert. Oddly, perhaps, it was not Angela's sculpture that drew me to her, but her personality and her stories that so deserved to be captured and shared in a book.

Angela did not start out wanting to write about herself. Her original intention, for so many years, had been a book about Bourdelle. She saw it as her way of repaying the huge debt she felt she owed the Master, for he had

Angela Gregory in her New Orleans studio, 1986, with *La Belle Augustine* (1928).
Courtesy of Angela Gregory, University Archives, Special Collections,
Howard-Tilton Memorial Library, Tulane University.

refused any payment for the training and encouragement she had received in
his studios. Angela's lifelong friend, American mythologist and philosopher
Joseph Campbell, whom she met in Paris in the 1920s, helped her draft the
first outline of the book. I have a photocopy and it includes a sweet little sketch
that she made of Campbell. He, like Angela, had been captivated by Bour-
delle's philosophy of art and life, much of which he had heard firsthand, for
Campbell had spent many hours in the Master's studios posing for a portrait
bust that Angela completed in 1928.

As part of my research for the book, I traveled to Paris in 1986. Thanks
to letters of introduction from Angela, I met and interviewed two members
of the Bourdelle family who had known her since the 1920s. Madame Rhodia
Dufet-Bourdelle, the Bourdelles' daughter, honored me with a personal tour

of the Musée Bourdelle, the City of Paris museum dedicated to her father's work where she served as director. I took tea with Mrs. "Fanny" Norris Chipman, the Bourdelles' niece, in her apartment on Avenue Camoëns. I carried back to New Orleans their stories and warm greetings to their longtime friend.

Angela and I made a false start on a book about Bourdelle before we decided to change the focus to her experiences in 1920s Paris. Out of this emerged her story of Bourdelle. She did not want our book to be only her memories of the era, so we drew from her voluminous files of letters, her diary, and her art journal written during her years in Paris. These are preserved today in the Louisiana Research Collection at Tulane University. We sought to weave the voice of the youthful Angela of 1920s Paris with the retrospective voice of the mature Angela of the 1980s in New Orleans.

Angela sat in her studio in the evenings and read through the old letters. Whenever she came to an excerpt worthy of including, she read it into the cassette tape recorder on the table beside her. When a tape was full, I took it home and transcribed it. I combined letter excerpts with the prose I wrote in her mature, first-person voice based on my many hours of interviews with her. She then provided feedback and corrections on my drafts. In this way we slowly built up the shape of the book.

After my workdays at Tulane, I often walked the few blocks to her studio. As we sipped wine and snacked on crackers and cheese, I would turn on my tape recorder and ask her questions that had come up as I transcribed the letters. We deliberated about where to go into more detail; and, we discussed what, and who, to leave out. I probed for deeper meaning about how her years in Paris shaped the rest of her life. Looking back on our collaboration I see the similarities between writing and sculpture, as if they are twin creative arts. There is that hard work of finding form, of perseverance, of completion.

Angela and I agreed to barter our arts: my words for her bronze, her sculpture for my writing of her story. There is no doubt I got the better deal. More valuable to me than her pieces of sculpture, however, is the journey we took together writing the book, the deep friendship we formed, and all that I learned from her about life and art. We may have been fifty years apart yet she remains, for me, a modern and successful example of how to be an older woman creator. Now as I move into that stage of life, what I learned from her is more precious than ever. Not that I will ever reach her level of accomplishment, nor possess her abundance of grace, warmth, and humor. She did, occasionally, try to teach me some of her skills in Southern charm: one time she offered her opinion that I needed to soften the message on my telephone answering machine at home, to make it warmer, less businesslike (less Yankee, perhaps). I changed it immediately.

In the years we worked on the book Angela was often a cherished guest at gatherings in our home. Looking through our family photo albums I see she was at the first and second birthday parties of our daughter, Claire, and even at a Christmas dinner when her New Orleans family—a beloved nephew and several cousins—must have been out of town. There was a Mardi Gras when we stopped by her studio to show off our haul of brightly colored plastic-bead necklaces and shiny aluminum doubloons thrown from floats. Not long after Claire was born, all four grandparents visited and Angela hosted drinks and hors d'oeuvres in her studio in honor of "Claire's ancestors," as she called them.

One evening Angela invited David and me to dine with her at Galatoire's, one of the grande dames of New Orleans restaurants. As we savored shrimp remoulade and oysters *en brochette,* she told us stories of her time in the French Quarter in the 1940s with writer Thornton Wilder, who had been a close friend—and with actor Kirk Douglas, whose first wedding had taken place in the garden patio off her studio. At the end of dinner she turned to the waiter and said, "My dear, I had an account here for many years." "Of course, Miss Gregory," he replied as he slid her the check for signing.

The years we worked together were tempered by the crucibles of living and aging. For Angela there was the death of her beloved brother, William; she was too frail to travel to Texas for his funeral. For me, the sledgehammer of my beloved father's sudden death. Angela had handed me the phone when David called the studio with the news. I returned from his memorial service in Oregon, and we kept writing. Angela had both her knees replaced, a major surgery at any age. I got pregnant and had a baby (Claire). And we kept writing. I moved to Seattle in 1988 and we worked on the book long distance; we talked by phone and sent paper manuscripts back and forth in those days before the Internet.

There is one moment in our work together more poignant than the rest. I arrived at her studio one day and, after ringing the bell, heard her voice from inside: "I've fallen and I can't get up. The door's unlocked." I pushed the latch and opened the door, but the safety chain was on. I managed to slide my hand through the crack and twist the button out of the slot. There she was, on the floor. An ambulance arrived and took her to the hospital. She had had a stroke; but, thankfully, she recovered. Later she told me that while she was lying there she had seen her brother, who had already passed, beckoning to her. She had told him: "I can't come yet, William. I have to finish the book."

We finished the manuscript before Angela Gregory died on February 13, 1990. The chapters that follow are in her voice.

A CHILDHOOD FOR ART

GROWING UP IN NEW ORLEANS >

It is autumn 1987 in New Orleans. Golden sunlight pours through the windows of my studio and spills over the crowd of faces gathered there. Shimmering through the leaves of the sweet olive and crepe myrtle trees that surround the house, the light illuminates the profile of a young woman, chin tilted slightly upward. The French-Canadian explorer who founded New Orleans stands nearby looking victorious. A black man, smiling peacefully, rests on a pedestal near the dining table.[1] I know these faces well and have grown used to their company, for they are part of my life's work. They are not faces of flesh and blood but of plaster and bronze, clay and stone, the materials of my trade. I am a sculptor and these are my children, the offspring of my creativity, my years of hard work.

I live in my studio now, the same one that my father[2] helped me build more than fifty years ago. It is attached to the rear of the house at 630 Pine Street that has been my home in New Orleans as long as I can remember, for I have lived here since I was two years old. Along with the sculptures that line the walls, shelves, and tables, the studio is decorated with a pulley and chain hung from a huge traveling crane that runs across the ceiling, designed so I could lift and move heavy pieces of sculpture by myself. Behind louvered wooden screens at the back of the studio are workbenches splattered white from hundreds of plaster castings. There are boxes of chisels, hammers, wire, scraps of marble, limestone, and granite. Running along the edge of the upper balcony is the kind of wrought-iron railing so typical of New Orleans. Worked into this one, however, is my artist monogram: my initials, A and G, in triangular form, stacked one on top of the other. The narrow balcony barely contains the piles of artwork and jumble of sculptures accumulated there. Below, settled comfortably on a desk, is my computer, that genie of the modern age whose wafer-thin disks contain the history, cost, and number of castings of my sculptures.

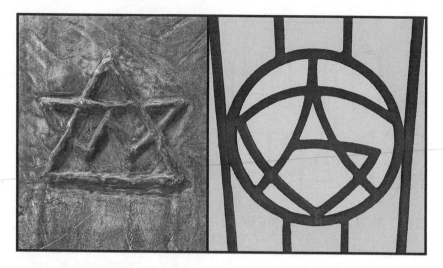

LEFT: Antoine Bourdelle's monogram (stylized AB). Photograph by David R. Muerdter, 2016. RIGHT: Angela Gregory's monogram (stylized AG), modeled after Bourdelle's and used in the railing of her New Orleans studio. Photograph by Bennet Rhodes, 2015.

What you see first when you enter from the street to visit my studio is neither sculpture nor chisel, wrought-iron railing nor computer, but a blue-green door that opens off the garden patio. My door is the same color as another studio door, one on Impasse du Maine in the Montparnasse neighborhood of Paris in the 1920s that led into the studios of the great French sculptor Antoine Bourdelle.[3] That Parisian door opened onto my career as a sculptor. There is no doubt that the turning point in my life was on that day in April 1926 when I summoned the courage to knock on the door of Monsieur and Madame Bourdelle.[4] It still feels to me like a miracle that, after only the briefest of introductions, I was invited to study stonecutting in the great master's private studios. The story I wish to tell here is about my years with Bourdelle and what led me there.

My journey began many years before, in New Orleans, where the foundations for my artistic career were laid. I grew up in a home where art and music were as much a part of life as eating and sleeping. My father was a member of the Tulane University engineering faculty who also had a deep love and understanding of art and music. My mother[5] was an accomplished painter and pianist. She had chosen to give up her career to marry and raise a family, namely my older sister and brother, Elizabeth and William,[6] and me, the youngest. We were known collectively as "Bet, Bun, and Angel." Other children might have been taken to play in the sand pile at Audubon Park,[7]

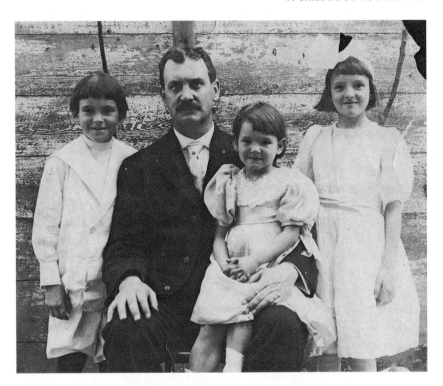

The Gregory children and father. From left: William Brès, William Benjamin, Angela, and Elizabeth Gregory, circa 1906. Courtesy of Angela Gregory Papers, Louisiana Research Collection, Tulane University.

which was just across St. Charles Avenue from our house. Our dear mother, however, packed up pencils, paper, brushes, and paints and took us over to sketch and paint pictures of the live oak trees draped with Spanish moss or of the riverboats that churned up the Mississippi past the levee where she would have us perch.

My first books were art books. One day, when I was quite young, I was showing some of them to a cousin about my age. I was stunned to find her absolutely shocked by the nude torso of *Venus de Milo*.[8] Such nudity had no effect on me for I was used to seeing nakedness in art books, and no one else in my family had ever said anything about nudes being shocking, not even my two maiden aunts, Katherine and Marie Brès,[9] who lived with us off and on through the years.

My family was very close, a closeness typified by my vivid memories of suppertimes. My mother made sure that the food was on the table by six o'clock and that we had at least washed our hands and faces before we sat down; a formal affair! We generally had a hired cook and always had a

washwoman and a yardman in our household, all affordable in those times even on a university salary. Dinner was the only time of day when we all sat down together, and my father would lead the conversation, asking us what we had done in school, what was happening at Tulane, what had happened at my mother's suffragette meetings.[10] Those dinners were the highlight of the day, and I look back on them as the glue that held our family together and kept us close.

Every Sunday evening we gathered in the parlor for a concert prepared by Mama, William, and Betty. Mama would play the piano and sing in her lovely soprano voice. Betty would play the violin and William the cello. My father and I, the non-musicians, would sit together on the sofa as the appreciative audience. Friends often dropped by to listen or to join in if they too were musicians. Many stayed afterwards for a cool drink of lemonade or, in the winter, hot chocolate and chicory coffee. Walter Anderson, who became a famed Gulf Coast artist, and his brother[11] were among the neighbors who often came by for these little gatherings. In that era we lived without television or even radio. Music came only through live performances at the auditorium or the French opera house downtown,[12] scratchy records on the gramophone, or what we could produce ourselves.

Coming from such a family, I had been inspired to try my hand at music. My "Aunt" Mattie Gould, who was the organist for the Unitarian church[13] that our family attended, gave me piano lessons for a while. She came to our house to teach me at the end of her long day as factory inspector at the cotton mills in town, where she was the first woman to ever hold such a position. One day, just before my lesson was to begin, I realized how disinterested I was and how tired she was. I slammed down the lid of the piano and announced that I did not want to learn how to play, that I wanted art lessons. My mother, in her wisdom, agreed. The only time I ever touched a piano after that was to improvise my own discordant melodies, which nearly drove my two aunts crazy. On at least one occasion my mother came to my defense, appreciating the inherent creativity in my keyboard meanderings. She allowed me to continue my improvisations even though my aunts cringed.

My mother's appreciation of creativity and talent for art had been nurtured as she was growing up. Although her family was not wealthy, she had begun private music lessons at a young age. She was a native New Orleanian of French and New England descent, the tenth of eleven children, whose grandfather, Jean Baptiste Brès, had immigrated to Louisiana from Villefranche-sur-Mer, a picturesque village on the Mediterranean coast of France.[14] Mother's family had owned a cotton plantation near Monroe, Louisiana.[15] Wiped out by losses after the Civil War, they sold the plantation and moved to New Orleans, where her father became a cotton broker.

My mother's French heritage was always very important to her and, indeed, to our whole family. The New Orleans of my youth was still very much imbued with the aura of French culture. The white descendants of the first European settlers in the city, called Creoles,[16] were considered the elite of New Orleans society. They lived a very European lifestyle and spoke French fluently. France was regarded as the source of all culture while the Spanish influence on the city tended to be ignored. There were invisible geographical boundaries but quite palpable social delineations within white society. The French Quarter[17] was for the Creoles; the Americans lived on the upriver side of Canal Street, with the wealthiest living in the Garden District.[18] My family lived near Tulane, upriver from the Garden District in what is known as Uptown. Our house was one block off "the Avenue," as we called St. Charles.

I remember going with my family one Sunday to call on Creole friends who lived, as one might expect, in the French Quarter. My father knocked on a big wooden door on Royal Street and we were admitted by a doorman to a driveway that was wide enough to permit horses and carriages to enter easily, a remnant of the pre-automobile era. At the other end of the driveway, set back from the street, was the entrance to the house. Stepping into the home was like stepping into another world. We took lunch with our friends and were served white asparagus, which I remember eating piece by piece with our fingers, just as the French do. The manners, the setting, and the food were all foreign to me.

My father was a "Yankee" from western New York[19] and, despite my mother's European heritage, we lived a very American lifestyle. My mother always hated for me to say that I was "half Yankee," but it is very close to the truth. In fact I am more like three-quarters Yankee, for one of my mother's maternal grandfathers was an Adams[20] from Massachusetts. My father had grown up on a farm, but upon deciding he couldn't face the prospect of rising at 4 A.M. every day to plow the fields, feed the cows, or harvest the corn, he entered the School of Engineering at Cornell University about 150 miles away. He had been fortunate to have a teacher at the Penn Yan Academy, Miss May Ellis (later Mrs. Nichols), who encouraged his aspirations to higher education. Mrs. Nichols was a writer and was to play a role in my own life when she wrote about Bourdelle, whom she had met through me.[21]

My father's family hated to lose him from the farm but did not discourage him from going to college. In many ways they were not a typical farm family. As a boy my father had taken painting lessons that helped foster his great love of art. Then, during his summer vacation from Cornell in 1893, he had served as a guard for the Russian art exhibit at the Columbian Exposition in Chicago.[22] Upon graduating first in his class from Cornell, my father was immediately offered a teaching position at Tulane. He accepted, expecting to

stay for one year, but he ended up spending the rest of his life here. He began teaching mechanical engineering, but soon he became fascinated by the unique engineering problems of southern Louisiana: rice irrigation, drainage, and control of the mighty Mississippi River. He eventually became one of the country's leading hydraulic engineers and developed an international reputation.

I think it was my father's love of art and the fact he was a very handsome man that must have first attracted my mother. Perhaps the bicycle he bought her during their courtship so they could ride around the city together also had something to do with it. She shocked all of her Creole friends when she jokingly told them that she was going to marry a blacksmith, a reference to the iron-working class that my father was teaching at Tulane. Her friends also had difficulty getting used to the idea that Selina was marrying a "Yankee."

When my parents first met, my mother was a student at Newcomb College,[23] the women's unit of Tulane University, where she had the good fortune to study with artist brothers Ellsworth and William Woodward[24] not long after they joined the faculty. The Woodwards had come to New Orleans from the Rhode Island School of Design at the height of the Arts and Crafts era, and they built Newcomb's art and Tulane's architecture programs into schools of international renown. William founded the Tulane School of Architecture, which, many years later, in 1940, was to grant me its first Master of Arts degree. Ellsworth founded the Newcomb Art School as well as the Newcomb Pottery enterprise, a program designed to provide a source of income for the young women graduates of the art school. The pottery they produced achieved an international reputation still recognized today. My mother was one of the earliest Newcomb potters, creating designs (based largely on the flora and fauna of Louisiana) on pots that were thrown by a skillful French potter, Mr. Joseph Meyer,[25] who was hired by the college. The young women never threw the pots, only decorated them. Today certain pieces that my mother painted are worth thousands of dollars, but when I was growing up, Newcomb pottery was just part of our household, something that was used daily. My mother had received several pieces as wedding gifts from her classmates, and my parents gave my mother's pottery as the occasional wedding or graduation gift.

She and my father married in 1898 in the chapel on the old Newcomb campus,[26] which was in the Garden District. That chapel, or rather the stone sculptures that graced the outside, had a powerful influence on my desire to be a sculptor. When I was a child my mother told me many times the story of watching the chapel being built and of the sculptor[27] who had carved the stone angels directly on the exterior. She described the tools he used, the tap-tap-tapping sound of chisel on stone, the painstaking and careful process

that coaxed the angels into view. Sculpture came to mean only one thing to me, cutting stone. Her vivid description impressed me so much that I decided I would learn to cut stone one day. That I ended up learning the art in the studio of a French sculptor seems only natural to me.

Before I ever traveled to France I was already in love with the country, the people, and the language. I learned French beginning in the third grade at the private school that my aunt had founded and led, the Katherine Brès School.[28] Miss Alice Gamotis[29] was my French teacher and each day when she entered the room we all rose and said "Bonjour Mademoiselle, comment allez-vous [Hello Miss, how are you]?" We then recited the Lord's Prayer in French and sang "La Marseillaise."[30] Miss Gamotis held us spellbound with stories of her childhood visits to France and how, as a little girl, she would walk through the vineyards with her father[31] at harvest time. He would bring along a loaf of that wonderful French bread, rub garlic on it, and pluck a bunch of grapes for their lunch. That image of Miss Gamotis and her father impressed me deeply, for I could hardly imagine my grandfather in upstate New York, whom we visited every summer on the farm, doing anything as exotic as rubbing garlic on French bread!

My father loved France too, feelings that sprang from the time he had spent there as an American officer during World War I. He had gone over as a major in the United States Army Engineer Reserve Corps and he was in charge of maintaining the water supply to hospitals. Many Americans were being charged exorbitant rates for renting a room, but my father had the good fortune of enjoying the hospitality of the Charles Martin family in Tours,[32] right in the heart of the picturesque Loire Valley. There, in the home of the Martins, my father had the whole third-floor apartment to himself. Monsieur Martin would often join him after supper in the evening to share a bottle of wine made from the grapes grown right there in the Martins' own vineyard. They absolutely refused to accept any gratuity from him, saying "You have come thousands of miles to help France." My father gave them what he could obtain through the United States Army, including coffee and sugar, which were both very hard to find at that time. Whenever my father passed goods to the Martins my sister and I would soon thereafter receive some kind of gift from them, such as a piece of jewelry.

Monsieur Martin and my father corresponded regularly after the war. When the Martins learned I was coming to France in 1925 they wrote to say "No matter where she is in France, she must send her trunks to us and our home will be her home." Their home, by that time, was in southern France, in the Villa Lolita near Cannes, where they had retired. However, in the last letter that my father ever received from Monsieur Martin, he wrote "I smell the sapin [pine]," meaning he smelled the pine of the coffin. He died soon

thereafter in 1925, as I, by a sad twist of fate, stood outside the very house in Tours where my father had lived with them. Although I never met Monsieur Martin, I later met Madame Martin and we became very close friends. I visited her many times in the 1920s as well as on all my trips to southern France in later years. Her home was truly my home in France.

While my father was away at war, I wrote him a letter on June 17, 1918, announcing my intention to become a sculptor. I was fourteen and in the middle of taking summer art classes in clay modeling and life drawing at Tulane with William Woodward. "I never want to do another thing but clay modeling," I wrote. "I go every day regularly & take clay modeling, & portrait drawing & charcoal. But the clay is the nicest I think. To-day I brought home a cheribs head I made. I have decided to be a sculptor—how do you like that? I made up my mind long ago to be an artist & I think I will like that best of all. Well, I must stop—It's so hot—With loads of love, from, Angie."

The classes I was taking were taught through Tulane's School of Architecture, and the little cherub I created that summer was my first real sculpture. The first time Mr. Woodward and I tried to cast the piece in the plaster mold made from the clay model, we neglected to use any separator to keep the mold from sticking to the sculpture. His knowledge of casting was almost as limited as mine, and both of us were disappointed over the ruined piece of artwork. We tossed the sculpture and its now firmly attached mold into the trash. I couldn't sleep that night, however, and lay awake thinking about how I could save that sculpture. The next morning I rushed to the trash bin and rescued it so that I could painstakingly chip away the plaster off the mold. The original sculpture emerged miraculously intact and we tried casting a second time, coating the mold with a separator substance. The sculpture came out beautifully.

The way I worked with William Woodward on this project was typical of the kind of teacher he was. He never treated me like a child, but always made me feel as if I were a fellow artist. He and his wife[33] were very good friends of my family, a friendship that had begun when my mother was one of his students at Newcomb. William never told me directly that my work was well done, but I always knew he liked it if he told me to take it home and show my mother. That was as close to praise as he ever got.

My experience of staying awake all night figuring out how to save my cherub symbolizes for me why I became a sculptor instead of a painter. At various times in my life, I have been tempted to choose painting over sculpting, but the technical and three-dimensional demands of sculpture have always challenged me in ways that painting never could. Throughout my education at Newcomb and even in Paris, teachers and colleagues encouraged me to be a painter, admiring my work and telling me I was very good. But I

Plantation Madonna (1938) by Angela Gregory. Photograph by Bennet Rhodes, 2016.

honestly believe that painting always came too easily for me while sculpture has never failed to challenge me. Also, the fact that my father was an engineer and was concerned with the structural aspects of buildings, bridges, and dams, nurtured my interest in those subjects from an artistic angle, an interest that only sculpture could satisfactorily fulfill.

Bourdelle once told me that sculpture was something between painting and architecture, and I know he was right. Looking at my sculpture of the *Plantation Madonna*,[34] which has figures of three African American children surrounding their seated mother, I can see exactly what Bourdelle meant. The piece has color because of the patina, but also has structure because of its three dimensions. The color of painting and the structure of architecture must be bridged in the art of sculpture.

I was beginning to build my own first tentative bridges among the arts the summer I took those classes from William Woodward. Summers in New Orleans are stiflingly hot, but I was blissful because I was becoming an artist. Many of our friends fled to the Gulf Coast, some to white mansions full of servants, where the Gulf breezes allayed the onslaught of heat and mosquitoes. Living in the middle of a swamp as we do in New Orleans made life difficult, especially in the days before screens or air conditioning. At least during my own childhood yellow fever was no longer a threat, thank heavens, for we all shuddered at the tales that my mother told of having survived the disease as a child.

Mosquito nets over our beds at night helped keep insects at bay, but it seemed there was always one pesky mosquito that got inside the net to torment us. We kept our food cold in "iceboxes" with ice that was delivered

daily by the iceman. He was our favorite deliveryman because in the summer he would let us kids chase along behind him and hang off the back of his horse-drawn cart, riding it down to the next block where we then scrambled for the pieces of ice that fell from his chipping. The iceman delivered to our house for many years until our family bought an electric refrigerator in the late 1920s. Our fruits and vegetables were delivered daily by an Italian named "Johnny" who had grown tired of making a living in Italy by carrying stones up a mountainside. He had come to America to make his fortune, which he eventually did. Bread, milk, and meat were also delivered to our kitchen door from street vendors or from neighborhood stores.

Our house on Pine Street, the one that is still my home, was built in the 1890s and was one of three original houses on this block. My father bought the house primarily because it was only a few blocks from the University and he could walk home for lunch. In my youth, open ditches ran down either side of the dirt street that also served as a cattle path for the herd from the nearby dairy.[35] Each morning and night the cows were driven to and from their grazing pasture on the levee and their passing was a rather pleasant part of our household's daily routine. Another tradition occurred at four o'clock each afternoon in the warm weather, when my two aunts would descend from their rooms upstairs, dressed for dinner with palmetto fans in hand, to sit on the front gallery, which was usually the coolest part of the house due to the breezes from the nearby Mississippi River.

The furniture inside our house was very simple and streamlined for the era, my mother having been influenced by Frank Lloyd Wright.[36] Heat in cooler weather was provided by coal fireplaces. Light came from the gas fixtures scattered throughout the house. Each bedroom was equipped with a pitcher of water and a large bowl sitting on a washstand. Electricity was not installed until after the hurricane of 1915 when my parents updated and remodeled the house that had been badly damaged during the storm.[37]

Our family life revolved around Tulane University, the First Unitarian Church, and the Delgado Museum (now the New Orleans Museum of Art).[38] Before we had a car we either walked or rode the streetcars to these places. One of the streetcar lines still runs along St. Charles Avenue, just one block toward the river from my house. Another ran along Maple Street, a block to the north or "toward the lake,"[39] as we say in New Orleans. That Maple Street car was smaller than the St. Charles line cars and was called the "Clio" (pronounced cly-o).[40] It looked like the famous streetcar called "Desire."[41]

I practically grew up on the Tulane campus. As a child I often served at the faculty teas, which were usually held in the late afternoon, and I admit to having learned "sleight of hand" at these teas. We children arrived to serve after a day of school. We were often hungry but were not allowed to

help ourselves to the tempting and tasty little finger sandwiches. Hunger prevailed over honesty and we all grew quite adept at eating sandwiches on the sly. I also remember roller skating on the circular driveway in front of Gibson Hall,[42] even though doing so was strictly forbidden because it made too much noise in the open-windowed classrooms. One day, when my father was away at war in France, I came zooming in on my skates off St. Charles Avenue and bumped smack into the president himself, Dr. Robert Sharp.[43] Rather than give me a scolding, he took off his hat, bowed to me, and said "Good morning, Miss Angela. What is the news of your dear father?" I adored Dr. Sharp forever afterward because I was very young and yet he had called me "Miss."

President Sharp was a close friend of my parents, as were many other Tulane faculty members and their families. Visitors to our house were a wonderful and eclectic mixture of engineers and artists, architects and musicians, ministers and suffragettes. Over the fireplace mantle in the dining room, my mother had painted "The ornament of a house is the friends that frequent it."[44] Our home was indeed ornamented by many well-traveled, well-educated, and charming people.

Because my father was a prominent member of the American Society of Mechanical Engineers (ASME), he hosted many distinguished engineers who visited New Orleans. Among them were Lillian and Frank Gilbreth, the famous developers of time-saving systems whose son later wrote the book *Cheaper by the Dozen* about their fascinating family.[45] I was to see Mrs. Gilbreth again several times in my adult life, including one hot July in New Orleans when I spent a day with her. It was on that visit, after we had managed to accomplish every item on her extensive list of tasks in just one day, that she, the great time-saving expert, complimented me on my efficiency!

Another occasional visitor was William Monroe White,[46] one of my father's very first students at Tulane and chief engineer for Allis-Chalmers, where he designed the turbines for Hoover Dam and Niagara Falls. Another student of my father's was the noted engineer Albert Baldwin Wood, who invented the famous screw pump that changed the future of New Orleans by allowing for improved drainage systems.[47] Many of the men who turned out to be the prominent architects in New Orleans in the 1930s and 1940s had been students of my father's because, at that time, the School of Architecture was part of the College of Engineering.

The Woodwards dropped by frequently. Every year on my parents' anniversary, Ellsworth delivered a gift of a painting or drawing he had created for them. Having people such as these in my childhood helped me escape the provincialism that was almost endemic to growing up in New Orleans. My awareness of the fascinating and tantalizing world beyond the city on the river was also fostered by annual summer trips to visit my father's family

on the farm in western New York's Finger Lake District. We traveled on the Louisville and Nashville train,[48] or the "L&N" as we called it, and we always stopped in Washington, D.C., to visit friends and tour museums. Seeing art and discussing the paintings and sculptures with my family were tremendously important additions to my education and world view. My vision was nurtured to look far beyond my immediate environment. This made me quite different from most of my contemporaries in New Orleans, although I wasn't aware of this difference until I went to college.

My first two years of schooling took place at home where I was tutored by my Aunt Marie. My only classmate was little Mary Caldwell,[49] the granddaughter of a Tulane faculty member who lived in our neighborhood. Each morning I walked over to meet Mary at her house. We then walked all the way around the block, pretending that we were going to a "real" school, before ending up back at my house where lessons began. Mary was much brighter than I in many ways, especially when it came to spelling, but one day we had a spelling bee and she left out the "t" in "pitcher." I won, much to the surprise of both of us! I got the prize that day, which nearly killed Mary, but we managed to remain friends anyway!

My first formal art lessons began while I was a student at the Katherine Brès School. Ironically, it was my mother who gave me those lessons, for she occasionally taught art at the school. She had the remarkable ability to be my mother yet also be a wonderful teacher, and she was able to remain completely detached from me as she taught. My other early teachers included Miss Rosalie Urquhart and Miss Henrietta Bailey,[50] who later became famous for their Newcomb pottery. From years of being a teacher myself, I have concluded that nobody can really teach you art, but they can teach you certain techniques and can inspire you, which is just what my mother did. The rest of learning art lies in the wanting to do it, in having the desire and drive to be an artist. I have always felt that I didn't have as much talent as many other students, but I have always had a terrific urge to be an artist and have loved doing artistic work. Talent is important, but it must be driven by love of the work. Discipline must then guide that love.

I remember that at one time in my childhood, discouraged perhaps by too many tales of starving artists, I decided I wanted to be a businesswoman and called myself "Miss Fanny McAngel." I was going to be an executive and make a lot of money and I certainly don't remember anyone telling me I couldn't do just that. Much later in my life, during World War II, when materials were impossible to obtain, there was no work for sculptors, and architects were in the service, I found I did have what it took to be an executive when I worked in personnel in the Pendleton Shipyards.[51] My job was to hire the women, who were essential to the running of the shipyards. I was quite a

good executive, applying my approach to creating sculpture to the technique of handling people. Although I enjoyed the work, I was glad to return to my art when the war was over.

My love of art and my desire to be an artist were as all-absorbing in my youth as they have been during my adult life. In high school I dated a few young men who were pleasant enough, but none of them were interested in art, which was the center of my life. Even during my years in Paris, when I was concentrating so hard on my work in Bourdelle's studio, I found so few young American men who knew anything about art, the passion by which I was so totally consumed. I was determined to make a career for myself as an artist in an era when few women had careers of their own.

As a child, I lived daily with the example of my mother who had given up her artistic career for husband and family. Although I don't recall her ever being regretful about her choice, she was a strong voice in encouraging my pursuit of a career. It was she who convinced my father to let me go to Europe by myself to study art. Years later, after I had established my own studio in New Orleans and was receiving many commissions, she ran the household for me, protected me from many of the routine and daily interruptions, and charmed all the men who came into my life.

Although my mother had not been involved in a career, she had been active in the women's suffrage movement during my childhood, and she used to tote me along to meetings. At that time the mothers of most young girls of my age and social status in New Orleans would have been at the country club, their daughters beside them. But I had a mother who was interested in women's rights and who was a very independent person. Although art was too difficult to merge with the other distractions in her life, she put her energies into areas that did mesh with family life.

My mother's friends included women like Miss Kate Gordon,[52] who not only worked hard for woman suffrage but who also cleaned up the red light district in New Orleans and was instrumental in improving working conditions in the city's factories. She was the woman who discovered there had been funds allotted to a home for wayward boys in New Orleans, and that nothing had been done with the money. Thanks to her pressure, the home was finally built and a young boy named Louis Armstrong[53] was later taken in and raised there. Kate was also instrumental in founding the New Orleans Anti-Tuberculosis Hospital, which opened in 1926. Her sister, Jean Gordon,[54] was also an activist and a friend of my mother's. The Gordon sisters attended the same Unitarian church as my family.

Another powerful model for me was my mother's cousin, Florence Converse, who lived in Boston and worked as the assistant editor of the *Atlantic Monthly*.[55] Cousin Florence helped strengthen my wish for a career as she

was an example of true success in her own field of writing and editing and was always very encouraging of my desire to have a career in the arts.

I was also fortunate to grow up in a family that was very liberal, especially for the South during that era. I remember there was a picture hanging in the Delgado Museum that I used to admire very much. It was a beautiful landscape, and my mother told me one day that it had been "painted by a Negro." I learned right then and there that it didn't matter what color or race you were, if you had creativity, you were an artist: art knows no racial boundaries.

I think that being Unitarian also influenced my family's liberalism. Our minister was the Reverend George Kent,[56] a delightful Englishman who used to ride his bicycle all over town, much to the astonishment of many New Orleanians. The Unitarian Church was a well-known and well-respected institution in the city during my youth. On Thanksgiving, there was always a service held with the congregation of the Jewish Temple Sinai.[57] One year it would be held at our church, the next at Temple Sinai. I lived in an ecumenical atmosphere.

During my high school years, I began to meet other young women who were also interested in art. I remember leaning over the shoulder of a Newcomb student who lived with my aunts and watching her paint a watercolor. I suppose I must have been rather annoying to her, but I was very intrigued. She was painting camphor trees and the light that fell on them, making them all sorts of purple, and I remember asking her, "How do you see those colors? I see them as green and you see them purple." She tried to explain to me what she saw and I understood, perhaps for the first time, that two different people can look at the same thing and each see it very differently. I was thrilled to find someone fairly close to my age who wanted to talk about what I wanted to talk about, namely art.

I also met a living, breathing female sculptor, a young woman in her thirties who was visiting New Orleans with her parents and was staying in the home of friends of ours.[58] She had studied with Lorado Taft of the Chicago Art Institute,[59] who at that time was one of America's best known sculptors. She told me all about Taft and showed me pictures of him and of her work. I never saw her again and don't even remember her name now, but she certainly made an impression on me because by the time I graduated from high school I had decided I wanted to go to Chicago to study with Taft. Years later Taft created sculpture for the Louisiana State Capitol[60] and he was brought to my studio by Mr. Leon Weiss.[61] Weiss was a well-known New Orleans architect of that era and a member of the firm of Weiss, Dreyfous, and Seiferth that designed the "new" capitol in Baton Rouge.

My father, however, was not at all keen on my desire to study with Taft. He wanted to encourage my interest in sculpture, but told me he couldn't

afford to send me to school in Chicago when I could get an education right here in New Orleans at one of the country's finest art schools, namely Newcomb. And, because he was a Tulane faculty member, I could get a scholarship. Well, I didn't want to go to Newcomb. For one thing, they didn't teach sculpture there at that time, and for another it was, frankly, all rather old hat to me. My sister, two years older than I, had already gone to Newcomb and I had been her shadow. I went to every event that took place on campus, from May Poles to basketball games, and it was all just routine. I was afraid I would be bored to death if I went there and besides, I didn't give a hoot about getting a college degree. All I wanted to do was to study sculpture.

My father didn't leave me much choice, however, so I went to Newcomb, and I have always been glad I did. I had excellent teachers and received marvelously comprehensive training there. Newcomb at that time offered several different courses in the arts, including the famous pottery course and metalsmithing, neither of which I could stand, incidentally. I took silversmithing but the noise of beating on metal nearly drove me crazy. I love the sound of stonecutting, but I can't stand the racket of a hammer pounding on a sheet of metal. Stone has a sweet, clear sound, which changes according to the way you hold your tool. Of course, if you hold the tool at the wrong angle, you could cut the stone wide open and ruin it. But at the correct angle, the right chip, chip, chipping, you realize that you are truly creating something. You work with the stone, but you work against metal, beating it into submission.

I tried my hand at pottery too, even throwing pots on the wheel, taught by old Mr. Joseph Meyer himself, but I never could master it. I loved talking to Mr. Meyer and watching him work, and I often stayed after classes had ended for the day just to visit with him. One time he had to leave a little early but he allowed me to remain behind in his studio to work on a piece of pottery. I accidently broke one of his tools and was so conscience-stricken that I didn't sleep that night and I went in immediately the next morning to apologize. He told me not to worry, saying "When you go to France you can buy one for me and send it back." Although at the time France was only a fairytale dream for me, when I did eventually go, I bought him his tool and mailed it back. We remained good friends until his death, and I received many letters from him while I was in France and after his retirement.

As much as I liked Joseph Meyer, I never did enjoy throwing pots. I didn't like kicking the wheel because I wanted to control the clay, not have the wheel control it. I didn't like having to spend hours on a hand-built piece of pottery, building up the coils and then firing and glazing it only to have it come out of the kiln looking entirely different from what I had planned. When I model a piece of sculpture in clay, I control it. And when I put a patina on one of my bronzes, I know exactly how the patina will turn out. If, in

the end, I don't like it, I can remove it. This is not so with pottery and glazes.

But there were many things I did like about Newcomb. One of my instructors was Miss Mary Butler,[62] who became my mentor and who was instrumental in pushing me to get the scholarship that took me to France in 1925. Miss Butler often traveled to Europe herself, leading summer tours of college students, which is the way that many of the Tulane and Newcomb faculty members paid for their trips to Europe. I took watercolor from Gertrude Roberts Smith[63] and Ellsworth Woodward, and I won the coveted Neill Watercolor Medal[64] in my junior year, an unusual achievement since it was usually awarded only to seniors. I had also won an Honorable Mention in my sophomore year. Both awards puffed me up quite a bit, but they also engendered a certain amount of jealously among my classmates, which I found hard to cope with. Later, after my three years in Europe studying with Bourdelle, I went back to Newcomb and looked at my medal-winning painting. It looked very different to me, rather flat and uninspired. The painting had not changed but the way that I looked at the world, as well as the way I painted, certainly had.

In spite of the fact that Newcomb did not offer sculpture, I managed to acquire some experience in sculpting. Albert Rieker,[65] a German sculptor who came to New Orleans after World War I, taught a class at the Arts and Crafts Club,[66] which was located in the French Quarter. I was thrilled to have been asked by Gertrude Roberts Smith to monitor Rieker's class. This meant I was responsible for being there every Tuesday night to be sure that the model was present, the sculpting stands were in place, and the clay available. I have always thought she asked me not only because she knew of my interest in sculpture, but also because of my New England conscience, which I inherited from the Adams branch of my mother's family. It has always driven me to live up fully to any commitment I make, to do a job right if I am going to do it at all. I used to drive down to the class after a full day of school at Newcomb, filling up my father's car with other art students who were taking the class. It was my first real experience working with a sculptor, and Rieker taught me a tremendous amount about the techniques involved: how to build an armature (the wire structure upon which a sculptor then models the clay) and how to handle the clay on the armature.

I also figured out a way to get up to the northeastern United States during the summers so I could spend time in the museums of New York and Washington: I got a job teaching arts and crafts at Camp Allegro in New Hampshire.[67] The first summer I went I had to pay my own way, using money I had earned the fall before by selling Tulane football tickets. In those days, the University gave the seller a certain percentage from sales and I had made $250. Eventually Tulane caught on to the fact that they might as well sell the

tickets themselves, but for a couple years I made a nice bit of extra money that allowed me to escape New Orleans in the summertime. I was more than happy to do so, even though I was going off to camp and didn't know how to swim or paddle a canoe! I eventually passed the canoe test at Camp Allegro. And I got to spend two lovely summers in New England. Each time I was there for six weeks and then spent the rest of my time visiting friends and seeing art in New York and Washington. My sister, by this time, was married and living in New Jersey, so I often stayed with her and her husband.[68]

Whenever I went to New York I always called on Mr. Calvin Rice,[69] secretary of the American Society of Mechanical Engineers and a great friend of my father's. During my first summer up north, Mr. Rice, knowing of my interest in sculpture, took me to meet a friend of his, Charles Keck,[70] who had designed a medal for the ASME. Keck is perhaps best remembered today for his Booker T. Washington monument.[71] He also did the Huey P. Long monument in Baton Rouge, Louisiana.[72] Keck invited me to study with him after winding up my time at Camp Allegro and so I went to work in his studio. He didn't really give me formal lessons, just showed me more about building armatures and other important things, such as when you finish work for the day, clean your tools and put them away so that when you next come in all inspired you won't have to first stop and scrape off hardened clay. He never commented on the unusualness of a young girl wanting to study sculpture. One day, however, he did ask my sister to remain in the studio with us as we worked for he was expecting his wife,[73] to whom he was recently wed. He hadn't yet told her there was a young woman studying with him!

My first opportunity to be an art teacher came when I was a sophomore at Newcomb and Miss Mary Sheerer[74] asked me to instruct the children's classes at the Arts and Crafts Club. I was thrilled and honored to have been chosen for the task and I loved the chance to work in yet another art environment. The children's originality and enthusiasm gave me special pleasure.

It was when I was walking home one day after teaching that I had my first brush with a side of society from which I had previously been sheltered. Back then much of the French Quarter was a red light district, though with its unique architecture and atmosphere, it was also a favorite haunt of artists and writers from all over the world, and many distinguished people lived there. Proper young girls, however, did not normally walk through the Quarter by themselves. But there I was, walking up Dauphine Street, when I passed a man who was just standing there, leaning against a wall, wearing a hat and an overcoat. I can still see him vividly. He muttered something to me I didn't quite hear, although I instinctively knew he was a pimp looking for young girls to add to his business. I just kept walking, with cold shivers running up and down my spine, and thank heavens he didn't try to follow me.

I went right home and told my mother, who promptly sat down and wrote a letter to Mayor Behrman.[75] Within a few days he wrote back to her saying "I will see to it that your daughter will be safe on any street she wants to walk on." I had already decided not to stroll through the Quarter by myself ever again! Today the French Quarter today is a tourist mecca, a mixture of gaudy and bawdy t-shirt shops and bars on Bourbon Street, fine architecture, and old Creole restaurants.

In 1923 during my sophomore year at Newcomb, I encountered the work of Antoine Bourdelle. I was sitting in class one day when Ellsworth Woodward came over to my desk and literally flung the June 1923 issue of *International Studio* at me. "If you are determined to study sculpture, this is the man you ought to study with," he said. The cover article was titled "Bourdelle: Lover of Stone" and was written by American Walter Agard[76] who, by a wonderful and strange twist of fate, I would have the privilege of showing through Bourdelle's studios only a few years later.

Agard wrote of the studios off Impasse du Maine behind Montparnasse in Paris where Bourdelle practiced his belief that the principles of sculpture were the same as those of architecture. Agard explained Bourdelle's conception of sculpture as "primarily decorative, essentially architectural like the work of the Sixth Century and early Fifth Century Greeks and the medieval *imagiers* [image carvers]." A sculptor should not try "to make drapery like actual cloth, flesh like actual flesh, proportions like actual proportions. Stone must be treated like stone, with the limitations and the advantages of its structure, suited to express the more universal and permanent qualities; vigor, power, primary mass and line."

Bourdelle had spent many years working in the studio of the famed Auguste Rodin[77] and in comparing these two artists, Agard wrote of Bourdelle's epic rather than lyrical concept of sculpture, how his desire was to recapture the essence of eras when "there were schools with high respect for stone, a tradition of honest technique and an alliance of the arts to make the monuments adequately expressive of sculptors and the communities in which they live."

The moment I finished reading that article I knew that somehow I had to get to Paris and study sculpture with Bourdelle.

GETTING TO PARIS

THE PARSONS SCHOLARSHIP >————————

At the time I read the Agard article about Bourdelle I had no idea how I would get to Paris or into Bourdelle's studio. Two years later, when I was a senior, my mother happened to read an announcement of a scholarship offered by the New York School of Fine and Applied Arts (now Parsons School of Design)[1] to study at its Paris branch. I showed the announcement to Miss Mary Butler who, after reading it, practically pushed me up the stairs to Ellsworth Woodward's office to talk with him about applying. Much to my amazement I won the scholarship, which was good for nine months' tuition. I had no real interest in the illustrative advertising, costume design, or interior design courses for which the school was best known. My one thought was to get to Paris and the Parsons scholarship was my ticket.

I still needed money to live on. For that I had to ask my father for help, a difficult task because he was adamant against my going. There was more than one story circulating among our friends in New Orleans about young women who had gone to Paris to study the arts and ended up studying French men and wine instead. He too had heard the tale of the young American girl who had ripped off her clothes and had run nude into the Paris streets screaming "I am the Virgin Mary." He hesitated also because, in those days before jetliners crossed the Atlantic, a trip to France from New Orleans took several days: you had to travel by train to New York, which took two nights and a day, then board a ship to France, which took between five and nine days to cross the Atlantic, and <u>then</u> there was still a half-day or night-train trip from the port of Le Havre to Paris. All of this made France seem very far away from New Orleans, especially as there was no telephone service between the two cities at that time.

My mother, however, was all for my going. She understood it was my best chance to pursue a career as a sculptor. Although the realization was growing that Americans did not <u>have</u> to study in Paris to become well-known

and respected artists, Europe was still considered the best place to receive training in the arts. Most of the budding young artists I knew or heard about did all in their power to get to Paris. The Newcomb faculty was also very wedded to the idea of study in Europe, as evidenced by the numerous student tours they took there every summer.

It was, in fact, one of these tours that finally convinced my father to let me go. Miss Mary Butler was planning to take a group of Newcomb girls over for the summer and I was invited to join them on the ship going over. This helped my father feel I would be adequately chaperoned. I also made plans to be met in Paris by Mrs. LeBeuf and her two daughters,[2] friends from New Orleans who were spending the year touring Europe. As it turned out, Miss Butler's sister[3] fell ill at the last moment and she was unable to go, but the tour went ahead under the guidance of another leader.

Many of our family friends were scandalized that my parents would allow me to go off to Europe "alone." From today's vantage point it's difficult to comprehend just what a traumatic event it was for a young woman to go by herself to study in Paris. Young women in the 1920s just didn't do things like that! Yet I had trouble understanding what all the fuss was about. I had already traveled by myself on trips to New England and New York. I knew in my own mind that I was going over with one goal: to somehow study stone-cutting with Bourdelle. I certainly didn't think of it as an opportunity to get away from my parents and go wild.

In June 1925, with my Newcomb graduation and my bon voyage party barely behind me, my Aunt Katherine and I stepped aboard the train for New York and said farewell to New Orleans for what I thought would be one year. In the few days we had in New York before sailing on the *S.S. Andania*,[4] I called on Charles Keck in his studio and was introduced to another distinguished sculptor, James Earle Fraser, who is best known today for his piece, *End of the Trail*.[5] Mr. Fraser gave me a letter of introduction to a former student of his who had left to study abroad and was at that time in Paris. Fraser also gave me a very important piece of advice: he told me not to force myself to be a sculptor but to let it take its course.

In New York I began writing a diary, a habit that I somewhat inconsistently maintained for the next three years and, indeed, for the rest of my life. I still have those diaries, as well as the many letters I wrote home to my family during those years in Paris. Today it can be a bit embarrassing to read what I wrote so many years ago, for I was very young at the time, only twenty-two. I like to think I have acquired a good deal more wisdom in the ensuing sixty-plus years. Those diaries, journals, and letters are important, however, because they represent how I felt at the time, even if my perspective has changed.

After boarding the ship, I waved goodbye to my sister, Betty, her young son, Gregory,[6] and my Aunt Katherine who were all standing on the dock. My sister later remarked in a letter to my parents that I hadn't cried upon my departure and that she hoped I wouldn't be too lonesome or homesick. Why should I have cried when I was heading off to Paris, the center of the world?

On board the ship were several Newcomb students I already knew who were part of the tour group, and I soon made friends with young women from two other colleges, Agnes Scott and Randolph Macon.[7] One of these women, Pocahontas Wight Edmunds, a graduate of Agnes Scott and a descendant of the Pocahontas,[8] became a lifelong friend and was an important link in the chain of people that finally led me to Bourdelle. Poky, as we called her, was from Virginia and was going to Europe to study violin. The first time I met her I could barely understand what she was saying. She somehow managed to speak very rapidly with a deep southern drawl that made her nearly unintelligible. Although I myself am a southerner, New Orleanians do not drawl and I was unused to her manner of speaking. But Poky, who was an extremely beautiful young woman, and I soon understood each other well and eventually became fast friends.

News of the *Andania*'s crossing evidently reached New Orleans via one of the mail pouches that was picked up occasionally by westbound ships. The "Entre Nous" social column in the *Times Picayune* newspaper reported: "News from the Newcomb Unit which is about to land at its first European destination tells us that the 'freedom of the ship' is theirs and that the three long tables at which they sit have become quite famous because of the wit, the laughter and (be it said in hushed whispers) the noise that emanates from them. I should have liked to be there for the departure of the *Andania*—what a sight it must have been to find Newcomb graduates who now live in the neighborhood of New York all coming down to the dock to see this unit off. Angela Gregory was fortunate in having Betty Gregory Ferriss and Miss Katherine Bres both at hand to wave farewell. Angela, by the way, has an armful of letters to friends that is quite bewildering and amongst them is a letter of introduction from Archbishop Shaw to the pope."[9]

"I am particularly interested in watching the development of Angela Gregory's talent—especially as I had a glimpse of the head that she modelled under the direction of Charles Keck whose Vedder head in the Metropolitan museum and whose Booker T. Washington group at Tuskegee are only two of a very wonderful collection of work."

I made my own report of the crossing in a June 28 letter to my Aunt Katherine, or "Tantie" as I called her; I wrote of the less-than-desirable accommodations: "We are [in] absolutely underlined steerage and there are some real immigrants mixed in for langonape [lagniappe, something extra]. The worst

part is the climbing of 3 flights of stairs to get anywhere & two to get to the dressing room. I don't regret coming for its a valuable experience but I only hope I won't have to return this way."

"I made two sketches this morning & caused quite a bit of excitement by sitting on the steps leading to the Captains quarters[10]—and thus preventing him to pass—He came along and said—'If you show it to me I won't charge you anything.'"

"Of course we have all 1st Class priviledges—& I'm sitting in the lovely Saloon now & we stay almost entirely on the 1st Class deck and have Cabin passengers glare at 'those College students who are 'going over' steerage' (in a staccato voice usually) when we monopolise their chairs. . . . There's some fancy-dress dinner (in 1st Class room) Thurs. nite. We don't want to go but we hope we might get something other than food that tastes like Newcomb Dorm food. I'm really having a grand time so Tantie don't take me too seriously."

To my father I wrote a bit about the young men on the ship: "Most of the boys are mere children and too insignificant to even talk to. There are many who sketch—and I was quite amused last nite by a young architect who came over & looked at my sketches & after saying they were 'nice' tried to tell me about values—and how to sketch à la architect. He couldn't understand my impressionism!"[11]

The voyage neared an end and on July 6th, I wrote again to family: "Well—since daybreak the Stewards have been hoisting trunks! I've managed by hook or crook to pack everything & will only have to carry my brown coat (meaning my big one) and my kodak—We won't reach Plymouth till 11 A.M. and its foggy & misty 'to be sure.' To think I'll be in PARIS this time tomorrow!"

We were soon in the English Channel, nearing France. "At Cherbourg we left the 'Andania' in a blaze of light reflected in the still waters and neared the shores of France, amid the cheers of those on board for 'Newcomb.' After a casual inspection by a fat little woman, and attempts to speak French to a barbaric porter 'numero huit [number eight]'—I was finally settled on the Special Students Tour Train Number 2— I was agreeably surprised with French trains. They were better finished inside than I had imagined but the road was the rockiest I have ever travelled."

"My first glimpse of France was the little tumble down stone houses, covered with rose-vines, which sit in the fields of lovely color, between Cherbourg and Paris. The patches of poppies were delightful in the cool green grasses. I had never before realized how red, poppies really were. Yellow, and lavendar wild flowers were profuse along the tracks also and I may say my first impression of France was a mass of lovely colored flowers."[12]

When our train pulled into the Gare St. Lazare in Paris, I found Mrs. LeBeuf and her two daughters, Jeanne and Polly, waiting amid the jumble of the crowd in the station. As it turned out, there was no room in the hotel where they were staying so I joined the Newcomb contingent on a bus headed for the Hôtel Cedre. I sat with my face practically glued to the window, catching my first glimpses of Paris. I was thrilled until I realized we were being taken into the Quartier Latin [Latin Quarter]. On a quiet street we were dumped out before the Cedre but finding no reservations there were taken around the corner to L'Ermitage, 4 rue Quatrefois.

We were all exhausted and disgusted with the accomodations, but my sense of humor lasted fortunately. It was almost amusing, though pitiful, to see each girl disappear with her key to find her room and then invariably return ringing her hands and almost in tears over the fact that she was on the seventh story, that the elevator only went up, and there were only three baths to seven stories! That long looked-for bath hurt the most, I think.

I was "rescued" from L'Ermitage and the Quartier Latin by the sudden reappearance of Polly LeBeuf, who came to tell me that they had found a room for me after all where they were staying, the Hôtel de l'Arcade, 9 Rue de l'Arcade. I have to laugh now over my horror at being taken to the Latin Quarter on what is known as the Left Bank (of the Seine River). In the 1920s, however, and as a newcomer to Paris, I knew only of the Latin Quarter's shady reputation as a neighborhood of bars and brothels. Besides, almost everyone I knew who came to Paris stayed on the Right Bank. One year later I was living on the Left Bank myself, enjoying the atmosphere of studios and students, not to mention prices that were much cheaper. But my life in Paris began on the Right Bank with the LeBeufs at l'Arcade and, because the Parsons School was also on the Right Bank, it was the perfect place for me to start out.

After I had sunk gratefully into my room at the LeBeufs' hotel and had a hot bath, a nap, and a dinner of bifteck [beefsteak] and potatoes at a nearby restaurant, I went out with them for my first real breath of Parisian evening air. It was raining of course, as it so often does, but rain in Paris is not like rain anywhere else. Instead of making things entirely messy and unpleasant it serves as another note in the harmony of a beautiful symphony, as anyone who has seen the Place de la Concorde[13] at night after a rain will know.

That first evening the LeBeufs and I hired a fiacre in the Place de la Concorde and drove up the Champs Élysées, into the Bois de Boulogne.[14] There was just enough glow left from the sunset to turn the glistening Bois into a fairyland. The lakes were dotted with boats lighted with brilliantly colored lanterns and the flashing of the reflections was like the twinkling of an opal in the sunlight. En route we passed the Arc de Triomphe under which lay the grave of the unknown soldier, covered with flowers and with the eternal

flame burning.[15] Every passerby paused in reverence before it and every man raised his hat. We inspected the Luxor obelisk, known as Cleopatra's needle,[16] which stands in the center of the Place de la Concorde. From there we looked back at the Arc de Triomphe, silhouetted against the sunset sky. I was really in Paris.

I didn't have many days for sightseeing before I had to register for my classes at Parsons. Walking to the school across the cobblestoned courtyard of the Place des Vosges[17] made me feel right at home, for it was the inspiration for the architecture that surrounds Jackson Square in New Orleans, the heart of the French Quarter. At Parsons, I was scheduled to meet with the school's secretary, Madame Morin.[18] While waiting in the hall for my appointment with her, I met Mr. Frank Alvah Parsons[19] himself. He was the president of the school, on a visit to the Paris branch, and he came up to speak to me. He was very thrilled at the word "Newcomb" and gave me a most cordial and charming welcome as the scholarship student from that art school.

After meeting with Madame Morin, I decided to sign up for the class in illustrative advertising, commencing on Monday, July 13. With the details of my class registration taken care of, I was free to begin my feast on the Parisian art works that I had dreamed about for years. I started with, what else, the Louvre, accompanied by Polly LeBeuf. "We tried to find the entrance that would lead to the Venus," I wrote in my diary, "and after a few minutes in the Salle des Cariatides I came unawares upon the Venus of Milo—standing in all her grandeur at the end of the Salle de Pan. Oh! Only memory can describe the glorious sensations I felt."[20]

"We wandered on more or less feeling our way for the Niké of Samothrace[21] and as we turned to go up a long pair of stairs we, Polly and I, looked up suddenly and behold! there was that glorious statue of 305 B.C. It stands before a background of burnt orange, tinged with rose madder—and it is all that Mr. Woodward or Miss Butler have ever said of it. But I hadn't really believed them! I didn't realize then <u>any</u> sculptor could cause marble to look as tho it were just fluttering to place. The drapery resembles damp chiffon clinging to the noble form."[22]

Everything was new and exciting to me those first weeks in Paris, including the restaurants. The LeBeufs and I ate frequently at one particularly quaint little place, Bernard's,[23] which had been recommended to us by Mr. Alciatore of the famed Antoine's Restaurant in New Orleans.[24] The tables were on the sidewalk facing the Église de la Madeleine[25] and the food was delicious. I remember eating châteaubriand [porterhouse steak] night after night because the dollar-to-franc exchange rate was so favorable that it made such a meal affordable. We went there so often that before long we even had our own waiter, Maurice, who always greeted us joyfully and seated us at

our favorite table. Bernard's was such a well-known place among New Orleanians that I ran into people from home almost every time I went that first summer. I suppose if I had truly wanted to escape home, I would have avoided Bernard's, but instead I found it rather pleasant to run into people I knew and then spend time touring the city with them. My classes at Parsons were only in the mornings, so my afternoons were free, and I was glad for a little companionship in my discovery of the city.

Even though I was determined not to spend all my time with Americans and to get to know the French, having so many people from home that first summer helped ease my transition into a foreign culture. Once the summer was over and the tour groups had gone home, I did end up making many French friends. The LeBeufs were there for that first year or so and they were like family to me, providing a sense of security without infringing on the new taste of independence I was savoring.

I was with the LeBeufs for my first Bastille Day in France, on July 14, the French holiday that is the equivalent to our Fourth of July because it marks the start of the French Revolution of 1789.[26] What I remember most from that first holiday is the quietness of the crowds and the extreme note of sadness that seemed to pervade the whole city. We stood where we could watch the parade pass around the Arc de Triomphe and the only enthusiasm from the people was the shouts of "Vive Papa Joffre"[27] as the famous old war hero rode by. It was a Paris still subdued from World War I, although I do remember there was great excitement when thirty or forty airplanes passed in groups over the Arc. Hearing and seeing airplanes in Paris was unusual in the 1920s, and the only other time I remember hearing a plane was when Lindbergh arrived in Paris on his famous flight in 1927.[28]

My classes at Parsons had barely begun when I decided I was in the wrong place. The instruction and subject matter seemed awfully dry to me, especially when I was required to spend two full weeks drawing a bottle of olive oil over and over, as if I were working on an illustration for an advertisement. In retrospect I know I learned many things that were useful to me later on, such as paying attention to detail in my work and learning to observe carefully. I think the problem was that Parsons was a great letdown after Newcomb. Admittedly the two schools had very different goals: Parsons was there to teach us to be illustrators for advertising, while Newcomb had been there to teach us to be creative artists. After having won a medal for my watercolor work, it was hard to sit down and spend days drawing a boring bottle of olive oil.

The only course I really enjoyed was "Life Class" and I hadn't been in it very long before the instructor told me that I drew too well and that I didn't need to bother to come to drawing classes, which was stupid and ridiculous

because an artist can never draw too well. I suppose I may have been taking the wrong courses, because the school also offered interior decorating and fashion design, but I had no more interest in those subjects than I did in illustrative advertising. I wanted to be a sculptor and none of the young women I knew at Parsons were really serious about a career in advertising or anything else for that matter! One good thing about Parsons, however, was that they had some very fine French artists and illustrators come into the classes and give stimulating criticisms of our work in French. And, I was taken into some of the finest private collections in the city to sketch and paint the artworks.

Parsons also took us on wonderful field trips including one week in the Loire Valley to visit and sketch the châteaus and a glorious three-month tour of Italy. After the Loire Valley trip I wrote to my family to reassure them about my safety as a young, single American woman in France. "Parisians, since the war are used to seeing American girls alone & in groups on the streets—(For I have never been annoyed in Paris at all). Whereas in the Provinces the people are still not used to it and are annoyed & surprised by it. . . . I really feel safer in Paris than in New York—on the streets. I must say however that the French are unsystematic & rude at times. Gendarmes [policemen] are always nice & polite but even in the Railroad stations two people tell you different directions to take!"[29]

I was already beginning to think about the direction my art education in Paris should take. My scholarship to Parsons was for nine months and, because I was still wild about studying sculpture, I was trying to sort out the rather bewildering array of options available to art students in Paris. I got in touch with David Rubins,[30] the young man who had been James Earle Fraser's student. At that time Rubins was just a young art student like me. He went on, however, to become a noted American sculptor and executed many commissions in the Indianapolis area. He was a faculty member and sculptor-in-residence for many years at the Herron School of Art in Indianapolis.

By 1925 he had been studying in Paris for several years and had some valuable advice for me, which I related in a September 1 letter to my parents: "David Rubins called this afternoon about 5 o'clock and stayed till about 6:30. I was favorably impressed and he seemed to be a very nice young man. Not good looking but with strong features and a nice open face! He recommends a school rather than a studio for he says to watch the various persons in the class, anything from a South American to a New Yorker, and their various methods, is most instructive."

"He went first to the Beaux Art[31] but said he got kicked around and if you stayed about three years you might get somewhere—But that the Beaux Arts is relying on its past history now & is not moving with the times. He said

Bourdelle was the outstanding man and that it would be absurd to go back to the States & miss the opportunity that Paris offers with him. Mr Rubins went to the Julian Academy but highly recommends the Grande Chaumière because of Bourdelle—as Julian's has mostly American [Instructors]. Says some people criticise Bourdelle as he will give one student a half an hour's criticism & pass another by—But he said just to hear that one criticism to the other fellow—was worth while. Also he told me of a sketch class at that school in the Afternoons—without instructor which you pay a small amount to go into—and which is fine to keep one in practice for quick life sketches."

I had heard about the Grande Chaumière and decided I would try and take classes there after Parsons. But first, not wanting to give up on the possibility of studying with Bourdelle in his own studio, I sat down and wrote a letter to the great master. I'm sure that Bourdelle must have received hundreds of letters like this each year from students who hoped to work with him and I'm also sure that he rarely bothered to reply, just as he never replied to my letter.

But I sent the letter off with high hopes and turned my attention to preparing for an afternoon tea at the home of the Fatous, a French family.[32] The Fatous were relatives of Senator Gueydan of Louisiana[33] who was a friend of my father's and who had given me a letter of introduction. I had written to them upon my arrival in Paris and they had graciously invited me out to their home in Enghien-les-Bains, a suburb of Paris. Madame Fatou was the Senator's sister and a native Louisianan who had married a Frenchmen, General Fatou. I was very excited about this tea, for it would mark my first time in a French home. I was looking forward to getting to know a "real" French family.

It was quite a long trip to reach the Fatous: I caught the Métro at la Concorde and changed at Châtelet for the Gare du Nord[34] where I then caught a train. "The trees were all turning red & yellow & were wonderfully beautiful— It was my first glimpse of a Parisien suburb & I was delighted," I wrote to my family on October 4. "Enghien was at one time noted for its Casino on a lovely lake—'but since the war'—(the sentence I heard with everything) the French have not been [able] to care for the lake & it looks like a Louisiana swamp in parts—tho it was wonderfully beautiful in the mistyness of the day with the reflections of the many colored trees."

Madame Fatou was a cute little thing who reminded me of my mother, and I learned that General Fatou had been in charge of the French telegraphic service during World War I. "The daughter Margurite called 'Guite' dashed in & wanted me to play tennis! She speaks no English nor do the three sons— And Mme Fatou insists she is 'rusty'—We all gathered around the table for tea—& ate the usual rye bread & butter which the French always serve so

deliciously with tea—(in charming baskets—) and cake & tartes made with wild raspberries they gathered on the mountains."

"The War debt[35] has been the source of our conversation for weeks—& as the Fatou's referred to lack of this & that because of the war—I asked them their opinion on the subject. They were timid about expressing it till I hastened to explain that—due to the fact that I had so much French blood in my veins—I had the French point of view. Then they told me—that they couldn't <u>understand</u> (that was the word they always used—the French don't seem mad with the U.S. only dazed & disappointed) why America & England had not forced Germany to pay France its war debt & then turns arounds & expects the French to be able to pay America off the bat. They feel it as a moral obligation but simply can't pay—for who has payed for devastated France? Not Germany—France. Every country is down on France it seems."

I suppose we talked more than usual about the war at the Fatous because they were a military family: General Fatou was a career military man and had a cousin who was an admiral.[36] Many years later when the French Navy's officer training vessel, the *Jeanne D'Arc,* docked in New Orleans, I was invited to attend a reception on board where I met the captain of the ship, who turned out to be a Fatou, obviously carrying on the family tradition.[37] I was to spend many more delightful afternoons with the Fatous during the 1920s in Paris, for they frequently invited me out to their home. We often played tennis and bridge, breaking for tea in between the two. Although Guitte, the daughter, was my age, we were miles apart in ambitions and goals and never really had much in common. She always had several boyfriends around and married in her twenties.

Around the same time that I first met the Fatous, I was also introduced to a tall, thin American woman named Marie Scherr[38] who had lived in Paris for many years. Miss Scherr was a writer and she was as refined and delicate as the exquisite pieces of porcelain that decorated her Montparnasse sitting room. She viewed the world with a lovely poetic eye, tempered by the gracious wisdom she had accumulated over her sixty or so years of life. I had met her through Professor John Kendall[39] from Tulane who had provided me with the requisite letter of introduction. Although I had been warned that she did not like being bothered by Americans, she fortunately responded warmly to my letter and invited me to have tea with her some afternoon.

My choice of afternoon turned out to be a rather bad one, as it happened, because I had accepted another invitation to tea for the same time. Being new to Paris, I didn't know about the "pneumatique" system that allowed messages to be delivered rapidly within the city.[40] Telephones were nearly nonexistent in Paris at the time and so, not knowing how to quickly get in touch with either of my hostesses, I decided I would go to <u>both</u> teas. I rushed

breathlessly by Métro between the two, from way down near the Bastille[41] and all the way across town to Marie Scherr's apartment on Rue Nôtre Dame des Champs. I managed not to offend anyone, even if I was awash in tea that afternoon.

Miss Scherr became one of my most cherished friends in Paris. As I left that first day she told me to "drop in anytime for tea," and it wasn't long before I had developed the habit of stopping by her apartment at the end of my day to bring her news of the events in my life. I think that I rather amused her whenever I burst into the calm and ordered atmosphere of her writer's oasis, chattering about the trials and tribulations of being an art student in Paris. She was rather like a delicate flower that you felt might blow away in a strong wind, and she lived very frugally on a small pension of some kind. I was young and full of enthusiasm and physical energy and was a channel to the outside world for her. She lived a very secluded life and focused intently on her work. No doubt this was part of my respect for her, a woman dedicated to her profession. I also loved reading her books, which were very philosophical and which she published under the pseudonym of "Marie Cher." Her titles included *The Door Unlatched* and *Life in Still Life*.[42]

In my years as a sculptor I have often thought of Marie Scherr and her ability to retreat from the outside world, recognizing that doing so is often a necessary part of the creative process. Many years later, when I was teaching at St. Mary's Dominican College here in New Orleans,[43] I used to tell my students that they would face many tough choices if they followed a career in sculpture. I would ask them, "What would you do if you have a date with your best boyfriend on Saturday night at 8 P.M. and at 6:30 P.M. you are in the middle of working on something that if you leave it before 9 P.M. you are going to ruin months of work? What are you going to decide? It's the kind of decision that you will have to make all of your professional life. You might be in the middle of casting a piece of sculpture or putting liquid plaster on clay. You can't just walk out in the middle of it to go out to dinner or a movie. Or, you may be inspired beyond words as you work on a clay model and you know that you are going to get the thing right if you just keep working, but you have a date. Are you going to go on with your inspiration or are you going to go out?" I have had to make those kinds of choices all my life. I usually chose sculpture although I also managed to have an active social life that served as a kind of release from the intense concentration demanded by my work.

The second time I went to see Miss Scherr I took Polly LeBeuf with me, and the topic was politics, just as it had been at tea that first day with the Fatous. "I went to see Miss Marie Scherr again yesterday—& Polly was with me & I enjoyed her so—she's just a dear—& we had a wonderful time discussing

the French with her," I wrote to my family on October 4. "She has lived here five years—& loves the French & understands them & has just been to America & knows matters there. She says she thinks America is divided in sentiments & Coolidge[44] is such a politician that he <u>never</u> commits himself & therefore makes no enemies—and that there is a strong <u>German</u> <u>influence</u> in America at the present moment."

"We feel a storm brewing & I'm awfully afraid Americans have been too gullable with Germans & too ready to forgive, & quick to anger with the French who are patient to the n<u>th</u> degree with America. The tourists look at Notre Dame & the Louvre & say 'These do not belong to France alone—but to the world'—& yet they make France pay the war debt with American dollars & cut the German debt & let Germany pay in marks! Germany who destroyed Rheims cathedral!"[45]

Almost immediately after that tea with Marie Scherr, I left French politics behind and took off on the Parsons trip to Italy to learn about art, life, and politics in that country. We left Paris in early October, traveling by train, and visited all of Italy's major cities and art treasures. That trip was one of the most thrilling things that ever happened to me. I have seen Italy many times since, but none can compare to that first visit. I sat and worked in St. Angelo's and St. Peter's in Rome, the Piazza San Marco in Venice, and the Uffizi in Florence.[46] We sat and sketched for hours in private collections. Our instructors demanded work that contained infinitesimal detail, famous pieces of art reproduced exactly, down to having the highlight on the fifth pearl in a necklace in just the right place. In many ways it was tedious work, but it trained me in the technique of very, very keen observation, which proved valuable for the rest of my career.

This trip was also important because it took a little more of the edge off my ingénue [innocent] American personality. I was more or less taken under the wings of two other American girls at Parsons, Betty and Floryne.[47] Both were a bit older than I and both were from California. Most of the other girls were New Yorkers who were quite sophisticated. There were "episodes" on the trip, like the two Parsons students who were thrown out of a village near Florence because they were drunk and rowdy in a sidewalk café. Such behavior was rather shocking to me but made me wiser to the ways of the world. The trip also furthered my education in European art and helped lay the groundwork for my entry into Bourdelle's studio.

I described this trip in detail in a lecture given to Le Petit Salon,[48] a women's club dedicated to the preservation of architecture and culture in New Orleans's French Quarter, which I presented in November 1928 after my return to New Orleans: "I spent three months in Italy, in the Fall of 1925, and was immediately struck by the happy smiles of the people, as contrasted to the

sad faces of the French. In Milan, at the Scala, I heard the Symphony Orchestra, conducted by Toscanina. They played for the first time Victor Da Sabata's 'Gethsemani' and it was a thrilling occasion."[49]

"I was in Venice on the King's[50] birthday, and the Piazza San Marco was a blaze of color by day, with the many dashing uniforms of the Italian officers and the red velvet banners, with the gilt monogram of the Royal family, which hung from the windows. That night each window was lighted with numerous candles and the flames flickered in the slight breeze from the Grand Canal, giving an uncanny effect."

"I need not even mention the already famous Venetian sunsets—but I cannot resist an attempt to describe Venice as I left it at 8:30 one October morning. As I stepped into our Gondola bound for the station—the sun was rising behind the trees of the Royal Gardens—I glanced back for one last look at the Doges Palace[51] and could hardly believe my eyes when I beheld the full-white moon in a sky which reflected the pastel shades of the colorful sunrise. And both the sun and the moon were reflected in the Grand Canal."

I met the LeBeufs in Florence in late November and wrote to my parents on November 21: "Florence is just the right size & has fascinating shops! And the Galleries & Churches are so chucked full of wonderful art things that its overpowering. Polly took me to see Michaelangelo's David[52]—and was thrilled over my reactions. It was the first finished thing of his I'd seen . . . & it is exquisite. I haven't had any mail for quite awhile—Italian mails are very uncertain. I do hope you have had the few I was able to write while here."

Although Christmas was over a month away, I knew I had to send holiday cards and letters early or else they would never reach home in time. I was already anticipating feeling a bit homesick during the holidays, as I wrote to "My dearest Momsie and Popsie" on November 22, 1925: "Fearing the mails will be crowded I am sending my Christmas letter to you from Florence, and tho it may reach you ahead of time I want it to be sure and get there. . . . My thoughts will go across the thousands of miles to you all—as they do every day—I will be with those whom I may say come next to you my darlings—for the LeBeufs have meant so much to me."

"Tho midnight mass may be alluring in Rome I have been told that Rome is quite deserted by its prelates & ambassadors at that time and knowing I had an opportunity to see my beloved Florence again I will come back here and it will almost be like coming home to my family—I think I would readily give up every other city in Italy for Florence. It is colorful—(much burnt Siena!) and it has mountains and water & the divine blue sky—and old buildings that somehow look new. Strange to say with all its English and American inhabitants it stays the same. Mrs. LeBeuf says its because the spirit of the city grasps them and they enter into it rather than bring new ideas to it."

"I am going to try and make my two months in Paris mean something & hope to have some real work to show. The best Italian work will be exhibited in New York in the Anderson Galleries[53] the latter part of January—The Parson's faculty is very puffed up about it. Several of my things were sent! Darlings—I've tried so hard to always keep level-headed and I hope I have. Mrs. LeBeuf & I always talk things over and she helps me plan things out so nicely—and she assures me I have always acted wisely—It is evidently easy for girls & boys to forget their ideals in Europe when things are so new to them & overpowering—how can they I wonder? But we have decided its because they haven't nice parents & families like the LeBeufs & Gregorys—I want to show you in every way how I've appreciated all you both gave up for me to come and I hope I have & will always."

Soon after I wrote that letter, the Parsons group left for Rome. While I was there I had the honor of an audience with Pope Pius XI, thanks to a letter of introduction to the head of the American College in Rome[54] provided to me by Archbishop Shaw of New Orleans. It was very unusual for a Protestant, such as myself, to be granted an audience with the Pope and I was even allowed to take along Betty and Floryne, who were also Protestant. My letter from the Archbishop, obtained with the help of Mrs. George Denègre,[55] a close family friend who was a devout Catholic and the "grande dame" of New Orleans society, evidently carried a great deal of weight. I understand that today, in the 1980s, an audience with the Pope is usually held in St. Peter's with 20,000 people present. In 1925, however, I was in a very small, intimate group that met with His Holiness. My letter home is evidence of the strange mixture of awe and curiosity that I felt about the whole experience.

"Well, the great event—that of kissing the Pope's ring—is over!" I wrote to my family on November 27. "I'm almost tempted to go in St. Peter's and kiss the toe of the statue but resist such a temptation.[56] I must say I was excited and a little worried—this morning over the prospects of the 'Audience'—and Betty & Floryne—good old fashioned protestants were petrified—tho they'd never have admitted it. We climbed many, many stairs after presenting the paper which read 'Signora Gregory et dua personna [Miss Gregory and two persons]'—to a Swiss guard[57] who wears the most thrilling, yellow, blue & red costume which has been the costume of the Swiss guards since the 15th Century—and finally landed in a huge room in which there was a huge dias—& about one hundred persons in all—lining the walls."

"We were dressed in black robes (rented) and sweet little black lace veils which we purchased for the occasion—and had our beads and medals in our hands—We certainly looked like nuns! We sat there wondering & wondering what we'd do—when one of the attendants—I guess you'd call him—wearing a wonderful crimson costume—approached and asked if we were three—and if

we spoke English. He ushered us and three other Americans into still another room, where we sat <u>wondering</u> for another half hour. There were only about 30 people in that room however and then later we were ushered into a third and then finally escorted into a 4th. There we stood—about 25 in all—about 12 of which were English speaking & probably Americans—& the rest priests or fathers etc—& evidently 'High-monkey monks'—for the Pope spoke to some as he went around & put his hands on their heads."

"I didn't realize until it was all over that we were in the room with the select—for upon going out we passed thru the other rooms & each got more motly than the last. Do you think it was the Archbishop's letter that did it? I was quite puffed up over it. Anyway—finally after another long wait—there was a rustling & his Holiness appeared—he is a sweet looking old man—quite pleasant looking—& I really shouldn't say 'old' for he only looks about 50—[I still remember, more than 60 years later, the ambiance of charm that the Pope radiated as he entered and stood at the doorway beaming at the audience.] He wore the most beautiful white robes—& little red slippers (velvet & embroidered in [gilt]) & a little white cap. As he passed from one to the other—& held out his hand—on which the Papal ring resides—to be kissed—a man with gorgeous purple robes handed out a Jubilee Medal[58]—to each person. I gave the ring a real smack before I realized it—(we were kneeling on a marble floor & it was hard to think under those circumstances). He then stood by the door he had entered by and gave a benediction while all but we three & our other 3 Americans with whom we had originally been 'herded'—crossed themselves & then his Holiness passed into the next room."

I was quite swept away by the experience and was perhaps a bit inebriated by the beauty and grandeur of the Vatican and of Rome itself. The Eternal City[59] was indeed a most "soul-satisfying place" as Marie Scherr described it in her November 21 letter to me from Paris. Her words captured the poetic essence of that great city: "I am delighted that you are charmed with Italy. For an artist or for any one at all sensitive to beauty, it is the most soul-satisfying of places. The way the simplest landscape 'composes,' the way a cypress gives an accent, and the way the generous water gushes in the fountains—all that is a constant source of pleasure. I have been happier in Rome than anywhere else, but the first shock is one of disillusionment. When I first knew it 20 years ago, before the devastating auto, we used to shudder at the train on the Via Nationale,[60]—<u>now</u> the awful motor buses snort all over, even in the narrow streets where there are no sidewalks! But, if you wait a bit, and poke around, all the old magic begins to operate. Sometimes, alone, near St. Maria in Domnica, or St. Giovanni in Paolo,[61] you can catch some little sense of what the old beautiful peaceful time was like. I always like the Aventine, and that exquisite hedge and garden vista in the Villa Malta.[62] You must go

back some time and spend a whole winter. You are at first so torn between Antiquity, the Renaissance, and the 17th and 18th centuries that your mind resembles a grab bag!"

The temptation to stay in Rome for Christmas was strong, but the lure of Florence and Christmas with my "family," the LeBeufs, was stronger and so I returned to Florence. I described my time there in my holiday letter to my family: "We went to Mass at the Aunnunciata[63] which is the swanky church of Florence. They had only a simple Midnight Mass on Xmas eve so we chose the 10:30 on Xmas Day—A special orchestra played thruout the service—the famous Gregorian Chant[64] while four priests in gorgeous yellow & gilt vestments said the Mass—assisted by six priests who held & raised & lowered at certain parts of the services—huge candleabre—at least 5 ½ [feet] tall—The lighting effect was wonderful & the music wonderfully beautiful."[65]

I said goodbye to the LeBeufs two days after Christmas and boarded the train for Genoa and then on to Cannes, France, where I finally met Madame Charles Martin, the wife of the couple in whose home in Tours my father had lived during World War I. Madame was in her sixties when I first met her, a very frail, very attractive woman, one of those exquisite souls you are lucky to meet at least once in your life. She was Swiss by birth and had lived for many years in Sumatra when Monsieur Martin was in business there. She was very well educated, read a great deal, and possessed all the warmth of a sunny Mediterranean day.

When I first met her on that trip in 1925, she welcomed me into her home, Villa Lolita, as if I were royalty, as I described in a letter to my family on December 29, 1925: "Another dream checked off the list—for I am here and have fallen in love with Mme Martin—I spent the night in Genoa with the girls—passed the border customs without having a bag opened and stepped on a French train which was like a pullman[66] in heaven might be—after Italian trains—I met Mme Martin as arranged—in the station & her gardien [caretaker] carried my small bag up to the Villa & we followed."

"No wonder my 'pater [father]' adores the French nation—I consider it a rare privilege to meet and visit such a delightful person. Mme M. speaks beautiful English & thus far little Angel hasn't uttered a French word! Helas [Alas]! We shall see."

"Last night for supper I was given my choice of wines—red, white or cider—I remembered what Papa had said about the cider—& Mme M. was charmed—and produced the same—& said I must tell Papa that I was drinking the kind he had loved."

"The Villa is adorable—also the chien [dog] 'Tommy' and this afternoon I am to see a little of Cannes. I have the sweetest little room imaginable—& a bed that is so soft—and last nite Mme brought me a bottle—crockery wear—

with hot water that kept my feet so nice & warm as I lay between charming linen sheets—covered by a feather down—Oh! yes—In my room Mme M had put a picture of my 'Pater'—one in his uniform which he had given Monsieur Martin! & it looked so cute standing there."

After spending the last few days of 1925 with Madame Martin, I took the train east from Cannes just past Nice to Villefranche-Sur-Mer, a picturesque little town that clings to the edge of the Mediterranean and cradles a harbor laden with fishing boats. Visiting Villefranche was a sort of spiritual home-coming for this was the village my great-grandfather had left for the planta-tions of Louisiana. Remaining in Villefranche was his brother, Charles Brès,[67] who had married and had children, grandchildren, and great-grandchildren. For many years the French and American branches of the family stayed in touch, but all contact was broken during the Civil War. It wasn't until World War I that contact was reestablished when my father made a trip south and met Charles' granddaughter, Madame Jeanne Thérèse Brès Montolivo.[68]

On my first visit it was with a great sense of ceremony that I was es-corted to meet Madame Montolivo, or the Bonne Maman [Grandmother], as she was called. She was rather feeble and confined to her upstairs bedroom, but she had a keen mind and twinkling eyes. I described the event in a letter written to my family on January 8, 1926, after I was back in Paris: "I gave her a little Holy Year Medal blessed by the Pope & she was quite pleased & in return gave me a little ivory case with a little figure of 'Our Lady of Lourdes'[69]—She said in French of course 'You are Protestant but that doesn't matter.'"

I also met the Bonne Maman's daughter, Antoinette, as well as her grand-daughter, Marie-Thérèse,[70] who is still alive today and with whom I am still in touch. I remember on that trip how the French relatives had great fun looking at pictures of my family and deciding which of them looked European and which looked American. About two and a half years later, in the spring of 1928 when my mother came to visit me in Paris, I took her to meet the French relatives. They were thrilled to finally meet a "real Brès," an appellation that evidently did not apply to my father or me! That year of my mother's visit they took us to the street where my great grandfather had been born, the Rue des Poules, a tiny street in the old part of Villefranche. My mother and I promptly took out our paints and sat down to sketch the scene. While we were painting a little blond girl with earrings came toddling down the street and a woman stepped out onto the balcony of the house where our ancestor had been born and called to the child "Angela, Angela, viens ici [come here]!" This frankly gave me the shivers, for I had never before seen or heard of an-other Angela, it being a very unusual name for that era, both in France and in the United States.

During that first visit in December 1925, I stayed at a nearby pension and had breakfast on the terrace. Marie-Thérèse came to fetch me to see the cemetery, followed by Mass in the old church.[71] "The fact that I offered to go to Mass with her—seemed to cover up the horror of discovering that we all—including Tantie & Asche [Aunt Katherine and Aunt Marie] were Protestants!" I wrote to my parents on January 8. "The Cousins—are charming but are conservative as compared to Mme Martin—who is a Modern—tho of the past generation." To my brother I wrote: "It was quite edifying to know [what] type of Frenchmen our ancestors were & I can say without hesitation they were 'crème de la crème [cream of the cream].'"

At the end of my visit in Villefranche, I boarded the train and waved farewell to "the French cousins," peering out the window at the incredibly blue sea as I returned to Cannes to spend New Year's eve with Madame Martin. It was the first of seven New Years I would share with Madame, for in all the years that followed, whenever I was in Europe on December 31, I would try to be at Villa Lolita. She sent me off into 1926 with a one-hundred-year-old bottle of cognac, pressed into my hand as I boarded the train for Paris with the promise that it would keep away colds.

As the train crept north, the blue skies and sunshine gave way to leaden grey skies that threatened snow. I arrived in Paris shivering, as usual, and longing for the warmth of the Mediterranean. After a hot bath and dinner I felt somewhat better and went to find my friend Poky. She was sitting playing her violin in the parlor of the home of Madame Canivet[72] where she was living. She was wearing a white turtleneck sweater and had big tears rolling down her beautiful face. Poky was cold and homesick and, to tell the truth, so was I. She had persuaded me to take a room at Madame Canivet's, and we cheered each other up by making plans to go to a concert together the next night and then going out for a cup of hot chocolate at the corner café, which did wonders for our bodies and souls.

I had decided to move in with Poky because the LeBeufs, with whom I had been living at 6 Rue Colisée in the Hôtel le Colisée, were spending the winter in Italy and southern France. At Madame Canivet's I would be living in the home of a very refined and elegant Frenchwoman, a "grande dame" in the truest sense. She took in several English-speaking young ladies as boarders and provided an almost finishing-school environment. Her home was a fifth-floor walkup in the house where George Sand and Chopin had lived.[73] The five flights of stairs nearly killed me, but the apartment itself was delightful and from my room I had a wonderful view of the rooftops of Paris. We all dined together in the evenings as Madame Canivet made herself responsible for correcting our French. I always felt she was a bit hard on me. Hearing only French was very helpful, but I did develop a bit of an inferiority complex

due to her frequent corrections. All in all, however, it was a good place for me to live and my French did improve, especially since we played bridge almost every night after dinner, in French. Poky and I enjoyed each other's company and we went out often together to concerts, plays, and the opera. I recall that once we paid only eighty cents to hear Heifetz[74] play.

Classes at Parsons started again on January 7, the day I moved to Madame Canivet's. I found it hard to get "back in the traces" but was cheered by encouraging words in a welcome batch of letters that had been waiting for me upon my return from Italy. Among them was a December 9, 1925, letter from Professor Ellsworth Woodward, the head of Newcomb Art School. "Thank you for the nice letters and cards I have been receiving all these slow moving months—I rejoiced anew in your happiness," he wrote. "Our own first, unforgetable visit was lived again. You said that you are not exactly suited in your courses, but you need not take that too seriously. The important thing is that you are there taking in experience and working hard at something. If you improve your drawing, gain in the critical knowledge of things artistic, you will be doing quite enough. Make all the sketches you can and preserve them most carefully. Those sketches and notes will be your future reference library. Don't get infatuated with Kodak photos. A sketch made at the time of your first impression, sticks in the memory forever."

Another letter was from Brandt V. Dixon,[75] the only president that Newcomb College ever had (all the others were Deans), written on December 28: "Mrs Dixon and I were greatly pleased to get your Christmas card from Florence and to note that your thought of us could reach from there across the Atlantic to New Orleans—and this letter, I hope, will help to show you the appreciation we feel—It has been a very lively Christmas here, but not so noisy and boisterous as usual I think—I meet your mother and father occasionally, and they both seem very well and busy. Just now we are having a polar wave thermometer below freezing and snow promised for tonight. We see from the papers that your sister is visiting the home folks. We hope to see her and the baby before they leave—Mrs Dixon and I both send you love and New Year's greetings—best wishes for your future."

I fear that I felt little sympathy for any letters from home complaining of the cold, for I don't remember being warm during any winter in Paris. I may have hated the cold more than others, having spent the first twenty-two years of my life in the warm subtropical climate of New Orleans, so close to the Gulf of Mexico. All I know is that in the 1920s none of the buildings in Paris had central heating and, being the Southern girl I was, the snow and cold felt especially cruel to me.

I did, however, find beauty in the wintertime, as I wrote to my parents on January 11: "Eh! bien [Well] darlings—you should have seen Paris in the

snow. It started yesterday morning and the Place des Vosges with its rows of leafless trees—against the interesting old brick buildings—with the snow falling—was like a dream. I was so enthralled that I dashed over to see l'Église [Church] de Notre-Dame between snow-flakes as it were—and tho it hadn't snowed enuf to leave its impression on the church—still it was a lovely sight to see it surrounded by streets—snow-white & to gaze at it thru the flakes."

My enthusiasm for the beauty of a snowy Paris was shared by Marie Scherr, as she wrote in a January 17 note to me: "My dear Angela, I am so pleased to share your delight in any new beauty of Paris. One couldn't be everywhere, though you made a good choice for Notre-Dame, but I've spent an hour walking all through the Luxembourg Gardens,[76] a magic world of snow, and the light, like ashes of rose, and all the great clipped allées [walkways] looking like some gigantic woodcut by a Master-hand."

If I found the winters beautiful but cold, I had less trouble adapting to the European lifestyle and had begun to adopt some decidedly European habits. "When I go home I'm afraid that I will have to remain a European in my mode of living!" I wrote my brother on January 8. "Its truly delightful. I think I accomplish an awful lot over here—but without that terrible 'American tearing around.' Breakfast—served in my room—tea usually at four & dîner [dinner] at 7:30 a little bridge or conversation—and it all seems so restful when one has done a hard day's work." To this day I long for that little maid at Madame Canivet's who delivered a piping hot café-au-lait, a croissant, a plain roll, and a little jam and butter to my bedside every morning. And who can resist an afternoon break indulging in French pastries in a Salon de Thé [tea room]?

Paris had not totally submerged my "Southerness" however, as I wrote in a January 8 letter to my brother: "By the way—I think I've gotten broad minded about heaps of things since I've been over here, but I'm more provincial than ever about the South. There's nothing like a Southern girl! The French all like Southerners better too as they can't understand the harsh voices of Yankees."

Perhaps my French was just improving, which probably made me a lot more understandable, New Orleans accent or not. One thing I was beginning to recognize was that my prospects for finally getting a chance to study sculpture were definitely improving. Madame Canivet had agreed to put me in touch with a friend of hers who was a sculptor. I was feeling discouraged about ever getting into Bourdelle's studio, for he had never answered my letter. I was also beginning to wonder if studying at the Grande Chaumière, the art academy recommended by David Rubins, would be worthwhile. Bourdelle only went there for critiques twice a month and, as far as I could tell, students were on their own the rest of the time. What I really wanted to do was learn sculpture by the apprentice method: I wanted to work beside an

experienced sculptor to learn his or her techniques and to see how a studio was run. Madame Canivet set up an appointment for me to meet with a Madame Girardet[77] and I had a lighthearted feeling that my plans for life beyond Parsons were really going to take shape.

Around this time, I was also caught up in a flurry of excitement over attending the exclusive Bal des Ingénieurs de l'École Centrale [Engineers of the Central School Ball][78] to which I had been invited by the Roszaks,[79] a charming French family to whom I had been introduced by a friend and colleague of my father's, the American engineer George Orrok of New York.[80] Monsieur Roszak was also an engineer, a member of the faculty of the prestigious École Centrale, the government-run school for engineers, and he was a member of the French branch of the engineering firm of Babcock and Wilcox.[81] The Roszaks had an apartment in Paris and a château near the little village of Dieppedale on the Seine near Rouen. At the time I met them, their family was made up of six adopted children.[82]

Following the protocol of that era, Madame Roszak had called on me first and then, at a later date, she and Monsieur Roszak had invited me out to dinner at Prunier's.[83] Their next invitation was to the Bal Central, an astonishing invitation for it was a great and generous gesture on their part to take an American guest. As I found out later, this kind of generosity was typical of the Roszaks. In the ensuing years, I came to know them very well and spent many delightful times with them at their château. They literally took me into their home and treated me like a member of the family. I have always believed I was exceedingly lucky to experience this side of French life for I have never heard of another American student in that era who had similar experiences.

The Bal Central was an annual event for the school's faculty members and students and was always held in grand style in the ballroom of a plush hotel, such as the Hôtel Continental,[84] where it was held the year I went. It was my first big, formal social event in Paris and although I was accustomed to Mardi Gras balls in New Orleans,[85] I knew that this Bal would be different from anything I had ever experienced before. I worried over what to wear and how to do my hair, wanting to fit in and be appropriately dressed.

I wrote about it in my diary on Saturday, February 6: "Slept late—got haircut and numerous little things—but rested nearly all day. After dîner dressed for the Bal de l'École Centrale—wearing black satin and Venetian shawl and new coat. At 8:45 Louise[86] called a taxi for me and I drove to 1 Place Budapest à l'Hôtel de Fécamps where I met the sister of Mme Roszak, Mme Michel Desonay and we took a taxi with her mother and husband & brother-in-law—a Belgian—for Hôtel Continental."[87] This was the first time I ever met Madame Desonay, whose nickname was "Bill." She and her husband were to become

very dear friends in the years to come and I have continued that friendship with their children and grandchildren today.

I continued: "We danced until 1 am—Those who expected to dance sat in little gilded chairs which were around the walls and the chaperones etc sat behind. The Frenchmen are very formal and bow and scrape a lot. It was very difficult to dance in the crowd and especially Tango to such 'Jazzy-less' music. The Frenchman's 'line' is the same—They all ask 'Aimez-vous la France? [Do you like France?]' 'Depuis quand est vous à Paris [How long have you been in Paris]?' At one we adjourned to the dining room—where a delightful [dinner] was served. The orchestra was peppier and we danced in there until 4 o'clock—[Even all these years later I remember that the Roszaks made sure I never lacked for dance partners that night and that I danced every dance.] We drank Barsac and Champagne and much Avian![88] I sat on M. Roszak's left—I said 'After all there's nothing like water'—He said 'That doesn't sound like an American speaking.'"

"I forgot to mention that the President of France[89] passed in review as it were—with many generals—among whom was the famous General Gouroud (?)[90] with one arm. The people joined in with enthusiasm when the National hymn was played. The President is rather small and not terribly impressive looking—tho he has a merry twinkle in his eye."

"M. & Mme Roszak brought me home in a taxi and daylight was creeping over Paris—and it was raining. I had hardly slept one wink when Louise came with my petite dejeuner [breakfast] and I found it was Sunday morning." As I sat in bed, sipping my café-au-lait, I thought back on the night before and pondered my good luck at meeting people like the Roszaks.

The Bal had taken place around Mardi Gras, a holiday that New Orleans celebrates with great enthusiasm and pomp. In Paris it was nothing and I was disappointed. Here I was in the country that had given Louisiana its Mardi Gras tradition and all I saw were a few straggling maskers along Rue St. Antoine. Of course, it was a holiday and so the maids at Madame Canivet's apartment were out, which meant that when I returned home after trying to find Mardi Gras in Paris there was no one to hear me pounding on the door to get in. I remember being so furious that I sat on the steps and wept until, after about an hour, one of the other boarders, Miss Sadie Hope Sternberg, finally heard me at the door and let me in.

Perhaps Mardi Gras was subdued, just as Bastille Day had been, because France was still recovering from World War I, which had ended less than a decade earlier. It was easy to forget this, being an American student wrapped up in the study of art, even though my own father had seen the war in France. A trip to Reims with Madame Canivet brought it all home to me, however, in a way I can never forget. We went with my friend, Lucille Soniat,[91] a French

Creole from New Orleans, who was in Paris studying at the Sorbonne[92] on a French government scholarship. Lucille spoke such perfect French that Madame Canivet refused to believe she was American. On February 22, 1926, I described our trip in a letter to my family: "We left from the Gare de l'Est [East Station] at 8:30 am and arrived in Reims at 10 o'clock. For the first time in 3 weeks the sun was shining and it proved to be a glorious day—The sky was almost an Italian blue and our first glimpse of the Cathedral was from the West side—silhouetted against the lovely blue of the sky. The scaffolding and the white glass in the windows give it a bleak appearance and then when you get closer and realize that practically every figure is chipped or broken you just rage inside."

"The stone is a rich creamy red—in parts and the sculpture seems to be more a part of the church itself than in most cases. It is much more appealing than Notre Dame—and much more the pure Gothic. The interior is all made over—tho they are still working on it—and the service which we attended was in a little wing in the rear—and was absolutely pitiful—It was crowded— but it was such a shock to go into this vast church and think of the days when Joan of Arc[93] was there and find yourself in a little place which was about as interesting as the 'little Jesuit' chapel[94] used to be."

"After inspecting it from every angle—Mme C. suggested that we take either a car or bus—which are in front of the Cathedral—& go to the battle-fields. I was surprised at her suggesting it—as she hasn't much money—We finally decided to take a car . . . and we found ourselves being escorted by an ex-soldier. The streets are pitiful as they are still piled with debris. There are innumerable new and atrocious apartment houses—all for rent and every now and then a piece of a building standing between two new houses. We drove to Berry au Bac[95] and saw a crater made by the explosion of a bomb in a munition trench of the French—which killed 700 French soldiers at once—& where not one whole body was found afterwards. It was a huge affair & quite strenuous climbing—on a hill—which was once perfectly flat land—like all that surrounds it."

"We passed one place on the 'Canal de [l'Aisne à] la Marne'[96]—where one piece of a wall was standing—the remains of a church—in a village of 1500— which was entirely wiped out. We saw the underground passages to hospitals of the trenchs and the periscope entrance (?) to a German trench. One of the most interesting things was the little concrete underground house where a huge canon was kept which destroyed villages for miles around. It was entirely made of the stones the Germans picked up off the road—& beautifully made! Nerve!"

"We saw many cemetaries—with the white crosses row on row—and wondered after all what it was all about—Mme C. murmured something about

its having been in vain 'parseque nous avons gagné toutes—mais aussi nous avons perdu toutes [Because we won all—but we also lost all].' It does seem terrible that after ten years one can still find bones of the dead and look out on miles & miles of uncultivated land—where as Lucile says 'thousands of bodies must be lying'—I'm all keyed up to write a paper on pacificism—but mainly one on the lack of artistic appreciation of the German race. How could people in the 20th Century dare to destroy any place as beautiful as Reims. Its all very well to look at ruins in Europe—but it does make my blood boil to see ruins made by men living in my own generation."

Carrying the images of destruction in my head, I returned to Paris and tried to turn my thoughts to happier things, namely working toward the creation of my own sculpture. I went to visit Madame Canivet's sculptor friend, Madame Girardet, and became very excited when she invited me to come live with her and work in her studio. I wrote my parents on March 11, 1926: "I am oh! so pleased—for it seems to me a chance of a lifetime—in this way. The thing I have always craved has been conscentration on sculpture or on art. . . . In being with Mme Girardet I would be a member of her family (I imagine she lives alone.)—I would hear excellent French—& I would be two steps from the studio where I would not only model but I would see & perhaps do some stone & marble work & would learn to model things to fire!"

"And darlings all this for 1500 francs—only 300 more than what I have been paying for board alone at Mme Canivets. I have seen the theatres & concerts & all that side of Paris this winter with Poky—here is my chance to concentrate in an inspiring environment—& where I would come in contact with artists and interesting people. You see the 1st night I came here Mme Canivet told me of Mme Girardet & Mme C. had offered to introduce me to her then. The point is that Mme G. is out of necessity, having done so many things—in sculpture a more or less good technitian & from that view point alone, I don't think there will be any doubt—And all the other qualifications are so tempting—to live with her & absorb her love of sculpture & art—& financially to have it cost no more than the Grande Chaumière lessons—Imagine!"

"Her home is delightful & oh! I'm sure it would be idiotic to turn down such a chance. As for names—I don't think that Bourdelle's would mean any more in the States than hers and think what I'd be getting in comparison. Then too—out in Neuilly which is one of the most delightful of suburbs, I'd not have the interruptions and distractions that I would have in the heart of Paris. I will make the arrangements for one month only for I will hear from you all in the meantime but think it would be valuable if it proves all that it promises to be if I stay several months."

As I reread that letter now I have to laugh at my own naïveté. My life would have been totally different if I had ended up in Madame Girardet's

studio. And how could I ever have thought that her name would mean as much as Bourdelle's? If I had studied with Girardet, I would have been just a dilettante. I know that now but at the time I was feeling pressed. My months in Paris on my Parsons scholarship were running out and I had to find something and find it quickly.

I continued: "I'm really just as good an American as I ever was—a better one in fact—but if I seem enthusiastic over the French attribute it to the fact that when people do things like Mme Canivet did in presenting me & Mme Girardet's in offering this I naturally feel that they are a generous fine people. Especially when my experiences are so strikingly opposed & contrasted with those of other Americans who meet & see the rabble in the street."

Madame Canivet had been very generous in introducing me to her friend. In general, I have found that the French are not quite as willing as Americans to open doors for you. Madame Canivet was a charming woman and, due to my slight inferiority complex regarding any quality of charm on my part, I was quite flattered she was willing to help me. I suppose my feeling that I lacked charm stemmed from the fact I had a sister who was brilliant and good looking and a brother who was sweet and easy going. When I was born my parents had wanted another boy and it even took them a few days to decide what to name me. They finally chose the name of the heroine of an 1882 novel my grandmother was reading at the time: *All Sorts and Conditions of Men* by Walter Besant.[97] I never felt unloved in my family, but I never felt all that special either, at least not in my youth. Paris certainly turned out to be my coming of age and I became much more sure of myself. But at the point where I was trying to decide whether or not to accept the Girardet offer, I felt rather insignificant and was quite immature.

The March 11 letter to my parents also reveals that I was feeling a bit self-conscious about liking the French so much. I worried that my family would think I was sounding un-American, letting my French heritage get the best of me and going overboard in my enthusiasm. My father loved the French of course, but he did it in a very poised, Anglo Saxon way. Here I was feeling absolutely exuberant over having this kind of attention paid to me. I know my parents, especially my father, were afraid I would get so enthusiastic I might never come home again!

The experiences I had in Paris in those years stand in marked contrast to those of so many other Americans. The expatriates whose names still have a magical ring today—Hemingway, Fitzgerald, Stein[98]—spent most of their time with other Americans. They and few American students rarely got to see French family life from the inside. My style of living was very different from those legends of 1920s Paris, although I can say we frequented the same cafés! But I certainly didn't have the time or money to spend in Café du

Dôme, Le Select, or La Coupole[99] like they did. When I was in Bourdelle's studio, however, and taking classes at the Grande Chaumière, I would occasionally run across to the Dôme for a quick cup of coffee to get warm while the model was taking a break from posing.

I met one of "those other" Americans when I was a student at Parsons and the whole school was invited to tea at Raymond Duncan's studio.[100] Raymond was the brother of Isadora and pretended to be an artist, dressing in Roman togas and sporting filthy grey hair that was plaited with an equally dirty string. His studio and shop were on the Boulevard St. Germain. The day we went from Parsons he was exhibiting the work of a young artist named Paul Ninas[101] who, ironically, ended up in New Orleans several years later and became quite well known here. When I first saw Duncan I thought to myself, "What a sweet little old lady," for his hair was long and his features were effeminate. His philosophy of living was that you should make your own furniture and never eat food you hadn't prepared yourself. I knew instantly he was a sham, that he was only using the gestures, costume, and atmosphere of an artist, though he was taken seriously by a number of people at the time. My convictions about him were confirmed when, after the tea and still feeling hungry, our group of Parsons students descended on a nearby pâtisserie only to see one of the Duncan contingent there too, buying the "homemade" pastries we had been eating in the studio!

While I recognized that Raymond Duncan was a phony, I knew just as surely that Madame Girardet was a serious artist who had pushed her work to the point where she was a significant sculptor. I was still having a hard time, however, deciding whether this opportunity was the right one for me. Taking Mrs. LeBeuf with me, I returned to her studio in Neuilly one more time, as I described to my parents in a letter dated April 1, 1926: "As I wrote, Mrs. LeBeuf went with me to Neuilly to call on Mme Girardet last Tuesday—She liked Mme G.'s personality & her home & thot it would be a lovely place to work—but said something that had been lurking in my consience— that she thot her work mediocre & weak. Of course, Mrs. LeB. isn't a 'technition' but you know sometimes its the casual 'onlooker' who can size the work up."

"Another thing—Mrs. LeBeuf said she thot that to conscentrate in a studio like that would be wonderful—anywhere but in Paris—for it takes about ¾ hour to get into the Museums & exhibits & the part of my art education that Paris offers most in. In this line Mr. Woodward's statement to me 'that you could receive better technical training in America—but the benefit you will derive from Europe will be the fact of seeing & absorbing its museums etc.' Mrs. LeBeuf would not give me advice & I don't want you to feel that she has advised me against it—She simply gave me her opinion—& that opinion

coincided with what had been my first impression— but which I had subdued in lieu of other things."

In the throes of indecision, I decided to take a weekend break, and I accepted the Roszak's offer to spend a few days with them at their château in Dieppedale, near Rouen. I arrived to find their front steps literally covered with their six adopted children. Each child greeted me with a handshake and a "Bonjour Meese" and from then on I was known as "Meese" to them all. My first evening there they turned on the terrace lights and the house and grounds were like a fairyland with the huge cedar, the moonlit Seine beyond, and tiny lights in the distance.

I found French family life with the Roszaks very intimate and close as I wrote in my diary on April 4: "They don't hesitate to squabble before others but also express their admiration for one another. The children file in from their dining-room to say good nite & are too cute for words. When you meet each member of the family in the morning they each shake hands and say 'Bon jour Miss (meese)—avez-vous bien dormir [did you sleep well]?' Always the same remarks."

"M. Roszak talked to me a long time on his impressions of America as we lingered over our morning chocolate—He said he 'wanted at least one American girl to know what French family life is.' He thinks there is no family life in America—that the dollar is the chief interest in life and that the position of the woman is so peculiar!" He also found the Pullman rail cars in America to be a bit odd, having traveled on several during a trip to the United States. "Angela," he told me once, "I find it so strange that Americans are so proper about morals, but nothing to me is more immoral than the way you sleep on Pullmans. Somebody that you've never seen in your life before sleeps right over you. It's the most intimate situation and yet all you Americans think it is alright and are shocked at French morals!"

That afternoon I went rabbit hunting with some of the Roszaks' older children and an old uncle. I managed to shoot one poor little rabbit but was so dismayed by the act that I have never been able to eat rabbit since. In the evening "comme d'habitude [as usual]" we played bridge. After my frequent bridge playing at Madame Canivet's, I thought that I was getting pretty good, until one evening Monsieur Roszak said to me, "Angela, will you promise me something?" "Of course," I replied. "Promise me you will never play bridge again!" he said. I agreed and for years that promise has provided me with the perfect excuse whenever friends or relatives try to press me into a bridge game. "I promised a Frenchman in 1926 never to play bridge and I cannot break that promise" is my standard reply.

With a clearer head and a refreshed spirit after my weekend in the country, I returned to Paris and finished up my ninth and final month at Parsons,

as I wrote to my family on April 10: "Well—the 9th is over—and I sigh a sigh of relief—9 months finish[ed]—or five years of solid artwork! We spent the last two days at Versailles,[102] sketching . . . and if there's anyplace more divine than Versailles in Spring I'd like to see it! The trees are the loveliest yellow-greens—which make the Palace look like a fairy castle and where we were sitting sketching Marie Antionette's[103] 'hameau [hamlet]'—we could see the sunlite way in the depth of the forest—when all else was in shadow—You look down long vistas of huge trees which are reflected on the ground in wonderful lite & dark patches—And then the fountains! The water all looked silver yesterday—with bits of the blue sky reflected in it—Glorious is the only word. I kept thinking all day how much fun I'd have taking you all around!"

"Paris is so marvellous with its warm sunshine—its blue sky and Springy feeling that I feel 'all up in the air.' Yesterday enroute home I saw that beautiful Arc de Triomphe against the sunset sky— and thrilled anew. The birds are chirping & the sun is dazzling & I must be up and doing."

My spirits were a bit dampened, though, because Poky was getting ready to return home to Virginia and I was going to miss her dreadfully. Knowing she would be gone, I had made plans to move back into the Hôtel le Colisée with the LeBeufs. It was a stroke of fate that, just a few days before I moved from Madame Canivet's, I spent an evening talking with Sadie Hope Sternberg, the fellow boarder who had let me in the door on that miserable Mardi Gras. Miss Sternberg was a bit older than I and she was a writer for the Paris edition of the *New York Herald*. That evening, up in her room, she showed me photographs of all the famous people she had interviewed and one of them was Antoine Bourdelle. The article she had written about him had appeared in the October 25, 1925, issue of the *Herald*. [104]

She knew I longed to study sculpture with Bourdelle and described her interview with him in detail: his studio on l'Impasse du Maine, his beautiful Greek wife who spoke perfect English. She handed me the address of their home and told me I should go knock on his door, present myself, and ask to study with him. I was shocked. "I can't do that," I said defensively. "I don't have a letter of introduction." Whether or not Miss Sternberg understood my reluctance to press my case without a formal introduction, I knew from what my parents had taught me that one never just barged in on a person like Bourdelle. But Miss Sternberg refused to take my protestations seriously and my desire to become a sculptor finally overrode my extreme timidity and sense of propriety.

I chose to go the next day and dressed to look as unattractive as possible. I was determined that I, an innocent young American art student, would not fall prey to the lascivious charms that everyone knew all French artists possessed. My drab brown cloche hat looked positively dreary with my shabby

coat. My eyeglasses, which I had to wear anyway, added an especially book-ish effect. Even so my courage faltered. What on earth was I doing, about to knock on the door of the home of France's greatest living sculptor to ask if I could study stonecutting with him? It was April 14, 1926.

Sitting on the Métro as it clacked and swayed toward Gare Montparnasse, I wondered what my parents back home in New Orleans would think of what I was doing, going to the great Bourdelle's home without a formal introduc-tion, joining the throngs of students who clamored to get into his studio. And he hadn't even answered my letter!

I got off the Métro and paused at the top of the exit stairs to gulp a breath of fresh air before I walked over to a café on Avenue du Maine, sat down, and ordered a coffee. I spent an hour drinking it before I finally got up the courage to walk over to the address written on the slip of paper from Miss Sternberg. My hands were shaking by the time I rang the doorbell at 6 Ave-nue du Maine and a pair of eyes peered at me through the peephole. A little French maid opened the door and in my best French I said that I would like to see either Monsieur or Madame Bourdelle. She told me to wait a minute and disappeared, leaving the door open, only to return to tell me that neither Monsieur nor Madame were "visible [available to receive company]." Per-haps it was the crushed look on my face that made her pull out a paper and pencil and say "Don't tell anybody, but this is their unlisted phone number. Madame Bourdelle is at home now. Go call her from the café."

And then there I was, back in the café again, calling the number on the slip of paper handed to me by the maid. Madame Bourdelle answered the phone and said wearily, "What do you want?" I said, "I want to study with your husband because I think he is the greatest sculptor in the world." Her voice picked up a bit and she said, "Why don't you go to the Académie de la Grande Chaumière where he teaches?" I said that I could go there and work from a model, but I would never learn to cut stone at the Grande Chaumière. "You want to cut stone?" she said excitedly. "A woman and an American and you want to cut stone? My husband will want to meet you. Can you be at the studio at four o'clock? But you have to promise me that you won't stay more than ten minutes."

At four o'clock, incredulous but terrified at my good fortune, I knocked at the blue-green door at 16 Impasse du Maine. The concierge[105] opened the door and I stepped into the studio. I found myself in a maze of stone and plaster sculptures from which emerged a small man with twinkly eyes and a very cordial expression. It was Bourdelle. His face was animated by an incessant play of expression and haloed by a grey-and-white fringe of neatly clipped beard and hair. Above all he was kindly looking and he was smiling. I sud-denly realized there was no need for the drab cloche hat and the shabby coat.

Antoine Bourdelle, 1925, in his studio, Paris, France, wearing his typical work smock. By Agence Meurisse (Bibliothèque nationale de France) via Wikimedia Commons.

He wore a loose grey coat-like garment, which I found out later he had designed himself. The only touch of color was a tiny red rosette, the symbol of his Legion of Honor medal.[106] He dropped his chin to his chest and raised his eyes so they looked straight at me, through me, as if they were penetrating my very soul. Never before in my life had anyone looked at me like that.

He shook my hand and said, "So you want to cut stone?" "Yes," I answered. "Asseyez vous Mademoiselle, je vous en prie [Sit down Miss, please]," he said and then left the studio. When he returned a few minutes later he said, "My *praticien* [technical assistant][107] will teach you stonecutting but you will go to la Grande Chaumière and work from a model in the mornings and will work here in my studios in the afternoons." He instructed me to be present the next day at la Grande Chaumière "vers onze heures [around eleven o'clock]" to hear the critique and to meet his "confrères [colleagues]," confrères being students, as he did not wish to be called their teacher, just a fellow worker. He then handed me one of his visiting cards on which he had written the address of a Monsieur Attenni at 2 rue Platon[108] from whom I should purchase a block of stone to begin my first piece of work.

Everything happened so fast I could hardly keep my thoughts in order, but I knew I had to ask Bourdelle about the financial arrangements for studying in his studio. I told him I knew that the French found Americans distasteful because we always mentioned money, but I had come to Paris on a scholarship, a "bourse," and my father was a college professor, not a rich American businessman. Bourdelle's response was to pull himself up to his full height—he was only about five feet four inches tall—and say, "Mademoiselle, I am an artist, not a businessman. Never discuss money with me." And with that firm yet gentle statement our interview was over and money was never mentioned again.

Thus the miracle had occurred and the dream had begun, thanks to that unknown little French maid who handed me the unlisted phone number. Nine months after arriving in Paris, I was to learn sculpting in the studio of the great Bourdelle. I became the only American ever to study stonecutting with him in his personal studios. The ten-minute visit I had promised Madame Bourdelle stretched into two years that shaped the rest of my life.

THE DREAM COMES TRUE

FIRST LESSONS FROM BOURDELLE >

When I first knocked at the blue-green door of Bourdelle's studio in April 1926, he was at the height of his fame. Some people called him the greatest living French sculptor. Others called him the greatest living sculptor in the world.[1] He had spent more than a decade working in the studio of Auguste Rodin and had become the great master's valued friend and most trusted assistant. Bourdelle's monumental works stood in Buenos Aires, Argentina, in Alsace, and in Montauban, his hometown in southern France. His bas-reliefs and frescoes decorated the Théâtre des Champs Élysées in Paris and the Opera House in Marseille.[2] His portrait busts of well-known figures of the era, including Anatole France, Sir James Frazer, and Rodin,[3] were well represented in museums and private collections throughout Europe. He and his wife were the guests of royalty, yet through it all the Bourdelles remained simple, generous, and kind.

To this day I am still amazed that Bourdelle invited me to come study in his studio without seeing any of my work or knowing anything about my background. I can only believe it was because his wife, who protected him from so many disturbances of the outside world, had allowed me a meeting with him. She had learned stonecutting from Bourdelle, and knew it was unusual to meet another woman who wanted to cut stone. If I had said only that I wanted to study with him, no doubt he would have told me to go to the Grande Chaumière. As it was, I was different. Neither Madame nor Monsieur Bourdelle ever asked me how I had obtained their unlisted phone number.

Bourdelle's impulsive warmth was rooted in his southern heritage. Born in 1861, the son of a cabinetmaker, he spoke with the rolling "r" sounds of his native region, an accent that often made him difficult for foreigners to understand. One of his grandfathers was a goatherder, the other a weaver, and one of his uncles was a stonemason.[4] In *Bourdelle par lui-même* by Gaston Varenne, Bourdelle stated that these three men, along with his father, passed

to him their rich heritage of craftsmanship: "Four gods taught me everything. From my father, the furniture maker and carpenter, carver of figures into wooden beams, I acquired the meaning of architecture. From one of my uncles, the Herculean hewer of stone, I learned to listen to the rock and to pay attention and follow the advice of the stone that speaks to us when it is cut. From my maternal grandfather, a weaver, I came to understand how to make tight knots, how to assign color values to the threads." From his goatherder grandfather, he learned to guide his "capricious thoughts by calling them, braiding them, diverse and grouped, to each other, as with the flock in the lane."[5]

As a schoolboy in Montauban, Bourdelle paid little attention to his classwork. He preferred instead to sit at his desk and draw, to follow the path of his own imagination. Fortunately Bourdelle had a wise teacher who philosophized "if all he wants to do is draw, let him draw." A portrait bust of that much-loved teacher now sits in the Musée [Museum] Ingres in Montauban, France.[6]

Bourdelle's parents had financial difficulties during his school years. The story goes that one day when Bourdelle was about twelve years old, he came home from school and his mother told him to sit down and eat, that she and his father had already eaten. Seeing right through her deception and knowing that in reality there was not enough food in the house for his parents, Bourdelle announced he was quitting school to help in his father's shop. The young Bourdelle quite amazed his father's customers with his skill and talent. One of his first pieces was a carving of the head of a faun for a very elaborate piece of furniture. The customer commented on the quality of the workmanship and was incredulous to learn it had been done by a child.

At the age of fifteen Bourdelle was awarded a scholarship to study at the École des Beaux-Arts [School of Fine Arts] in Toulouse. He remained there for several years before receiving another scholarship to the Paris École des Beaux-Arts, which was considered the finest art school in the nation. There he entered the classes of Falguière,[7] a well-known sculptor from Toulouse whom Bourdelle greatly admired. He quickly found, however, that he could not follow Falguière's style of art; and, the rigid academic atmosphere of the Beaux-Arts soon engendered rebellion in the free-spirited Bourdelle. He left the school and even refused the opportunity to compete for the prestigious Prix de Rome.[8] Bourdelle had little time or patience for competitions, especially one that sent young French artists to Italy to study rather than immersing them in the glories of their own country's masterpieces.

Bourdelle's association with Falguière did not end with his departure from the Beaux-Arts, and he often went to the older sculptor's studio for advice on his work. He had a similar friendship with Jules Dalou,[9] a Parisian

sculptor and neighbor who had been trained by Carpeaux.[10] Both Dalou and Falguière had studios in the Montparnasse neighborhood where Bourdelle would remain for the rest of his life.

The day after I met Bourdelle, I prepared to show up at eleven o'clock for classes at the Académie de la Grande Chaumière, just as he had instructed me. After I threw a few last things in my trunk at Madame Canivet's, Miss Sternberg bid me farewell, saying prophetically as I jumped into a taxi, "You are starting off on your career today." I rushed to the Colisée, dropped my things, and dashed over to the Chaumière to be sure to arrive on time. There was a concierge at the door from whom I bought several little aluminum admission tickets to the modeling and sketch classes. I walked into the classroom and found it filled with students of all nationalities. The cigarette smoke was so thick it was hard to see, but a strong spotlight was leveled at one of the best models I had seen in Paris.

The Grande Chaumière was totally different from any art school I had ever attended. At Newcomb and Parsons you had to be there at a certain hour to paint or at a certain hour to sketch and the instructor was always there to direct you. At the Chaumière, however, nobody leaned over your shoulder. You went whenever you wished, knowing that during certain hours there would be a model posing. In the beginning, I was a bit lost in such an unstructured environment. I mostly learned by myself or by watching the other students. Nobody came over and said, "You should do it this way or that way." On my first day, a fellow student, a young Swiss, took pity on me and showed me where in Montparnasse to buy the materials for my first armature and then helped me to get started building it.

The Académie de la Grande Chaumière had been created so that young artists who could not afford a studio of their own could come work and receive an occasional critique from an established artist such as Bourdelle. The creative atmosphere was thrilling and intense. If the model was posing you never heard a sound. No one was chattering away or making jokes. Everyone was very serious. There was a monitor, Madame Lavrillier,[11] who helped to keep things organized and who made sure there were enough stands for modeling, enough clay, and that the model was there to pose. I remember one day someone burst out singing "La Marseillaise" in class and Madame Lavrillier was absolutely shocked.

I was especially fortunate because during my years at the Grande Chaumière I had, in many ways, the best of both worlds. I cut stone in Bourdelle's studio and had nearly daily contact with him, yet I also attended classes and learned by watching my fellow students. Sadly, the last time I visited the Grande Chaumière, in 1971, the door to the sculpture studio, which had been renamed the "Atelier [Studio] Bourdelle," was shut and locked. I asked a

person in the hallway if any students ever worked in that studio and if any well-known artists came to give critiques. "Oh no," she answered. "They work in their own ateliers by themselves." This trend is not peculiar to Paris. Very few young artists I know today have had or have chosen to work in the studio of an established artist. The tradition of apprenticeship has been put on the shelf, whereas in the 1920s it was the most accepted method of study. No doubt I am biased, but I am still convinced it is the best method for learning sculpture. I wish that more young artists today could have the kind of opportunities I had.

Beginning with my very first day at the Grande Chaumière, after every meeting or critique with Bourdelle, whether in his studio or in class, I would rush home to write down his comments. Because I have a visual memory, I knew that if I wrote it all down I would be able to better recall it later. Those notes have been my artistic bible ever since and I can still recite a dozen or so of my favorite bits of his wisdom by heart, such as "Le seul succès veritable vient de la qualité de l'esprit [The only real success comes from the quality of the spirit]," and "C'est la personalité qui compte [It is the personality that counts]."

Bourdelle was a great teacher who had the power of leaving a student feeling inspired even after a devastating criticism. It was proof of his genius that he could recognize and bring out the personality of each student. His criticisms were always tinged with a sense of humor and were an inspiring glimpse into the beauty of which he was so conscious. Despite his greatness he never forgot the point of view of the student or even the beginner. On my first day of classes he moved from study to study giving a detailed critique to each student. I could see that he was sensitive to the feelings of the person. He emphasized that criticisms were intended for everyone, not just for the work being discussed at the moment.[12] His philosophical and insightful critiques at the Chaumière were so well known that even Lenin[13] is supposed to have sat in on them during a visit to Paris. Bourdelle, unfortunately, did not find out until it was too late that one of the three Russians who had been listening to his critiques happened to be rather famous. He always said he would have loved to have spoken with Lenin.

Bourdelle often stressed the importance of the spirit, the soul, the personality—whatever you want to call it—of the sculptor, believing that an artist's creations are a reflection of his or her own inner qualities. One of his little nuggets, "Do not do mundane sculpture just to get commissions," guided me in refusing to go to Hollywood in the 1930s to do a portrait bust of the movie star Dolores Del Rio.[14] I would have received national publicity for sculpting her, but I was in the middle of my first big commission after my return home from Paris: architectural sculpture for the Criminal Courts building in New

Orleans.[15] I decided not to be sidetracked by a movie star, by the "mundane," as Bourdelle would have called it, which is probably most accurately translated from French as "worldly." Sculpting a movie star certainly would have been worldly and, although I may have missed out on some publicity, I never regretted the choice I made.

After my first day at la Grande Chaumière on April 15, 1926, I captured what Bourdelle had said in my art journal entry: "The only time Rodin spoke of his art he said in referring to some modelling that M. Bourdelle had done for him, 'But you should exaggerate, exaggerate.' But you cannot exaggerate until you know what you are exaggerating. 'You cannot make a centaur until you can make a man.' What is the human figure? It is for the sculptor to catch that part of the human figure that does not die. Make it in stone or clay or something that endures all time—but unless it has that quality it will not endure either."

Bourdelle knew Rodin's art and personality well. In 1893, when Bourdelle went to work for him, Rodin was at the height of his career and already had an international reputation. As Rodin's *praticien,* Bourdelle was entrusted with work that required a thorough understanding of the art as well as great skill, for his task was to rough out sculptures in stone based on Rodin's plaster models. The master would then put on the finishing touches. Such was the practice of the era and Rodin had more than twenty assistants working in his studios to execute the works he conceived and created.

Bourdelle was Rodin's most highly skilled and trusted *praticien,* as well as his valued friend; but, he was never his pupil. Bourdelle had already established himself as an independent sculptor when he went to work for Rodin. The two men were very different. Rodin's sophisticated Parisian personality was in sharp contrast to Bourdelle's sturdy peasant background, the southerner whose infectious laugh and twinkling eyes conveyed a lack of sophistication that bordered on naïveté and that never deserted him in his lifetime.

Art critic Louis Gillet wrote of Bourdelle's time in Rodin's studio: "It is noteworthy that Bourdelle, by the grace of God, is the only living artist who was reared, like those of the past, not in schools or academies but as an apprentice in the studio of a master, receiving his counsels, his experience and his secrets. There is nothing academic about him: all that he knows comes from practice, from reflection and from contact with a great man. Never has he striven for a medal or for a prize."

"Nothing is sadder, when one thinks of it, than the fate of Rodin, that incomparable poet of form, whose whole work nevertheless dissolves into fragments. Though he had the instinct for great things, of all the monuments that he undertook or dreamed, not one was finished. The tyranny of sensation, the charm of detail condemns them to be only a heap of fragments. Their

unity does not go beyond a single figure. The groups fall apart before one's eyes and it is this fault which causes the incurable sense of melancholy in this work of voluptuous nothingness. This disorder teaches Bourdelle; he sees that one cannot get far on this slope of anarchy. One must bring art to reason and restore to it the 'bridle of style.'"

"Without doubt Bourdelle sacrifices deliberately much of exterior charm, the softness of skin, that, in the work of Rodin, strikes the sense so deliciously. But he knows the price he pays and what he gains in exchange. He knows the life of art is not that of the flesh, that it is vain for beings of bronze to compete with creatures of blood, to simulate the radiance of glances, and the yielding warmth of limbs, to have soft eyebrows, hair, and draperies: all these things are ornaments of perishable beings. It is the sculptor's part to create immortal forms."[16]

Rodin was certainly a familiar name to me. When I was growing up in New Orleans his sensuous and beautiful sculptures had been the talk of the art world, and I had carefully studied photographs of his work. My desire to study with Bourdelle, however, had not been influenced by his contact with Rodin. Just like Gillet, I much preferred the rugged strength of Bourdelle's sculpture to the sensuousness of Rodin, the architectural unity that was inherent in every square centimeter of Bourdelle's work to the fragmentary chaos of Rodin, such as *The Gates of Hell*.[17]

Just as Bourdelle had been Rodin's *praticien,* so Otto-Charles Bänninger, a Swiss, served as Bourdelle's *praticien*. It was he Bourdelle asked to instruct me in the art of stonecutting, and the Swiss made clear to me he was doing it only as a personal favor to Bourdelle. The first time I met Bänninger I timidly asked him what he would charge me for his instruction. He replied heatedly, "You Americans! Do you think your money can pay for what I'm going to teach you? The Greeks invented the technique, Rodin perfected it, Bourdelle learned it from Rodin, Bourdelle taught me everything he knew and now I am going to teach you. Do you think dollars can pay for that?"

I was quite taken aback and felt more confused than ever, although I later caught on to the French system of tipping one's professor, which was evidently acceptable to Bänninger for he did end up accepting money from me from time to time. Bänninger and the studio photographer and handyman, Dessausse,[18] were the only ones I ever paid a franc to during my whole time at Bourdelle's. Bourdelle had, of course, upon our first meeting, instructed me never to mention money to him again.

Although I resolved finances with Bänninger, I always had a difficult time resolving other aspects of our relationship. Soon after I started to work in the studio he asked me to go see a movie with him, an art film that showed close-up views of a flower opening, a new and unusual style of film that he

thought I would like. Instinctively I told him I was sorry, but I couldn't go and made up some lame excuse. He kept urging me to go, saying it would be artistic and it was alright, but I kept turning him down. I think he was highly offended by my refusal and no doubt thought I was being a snooty American. Perhaps I should have gone with him, because I think he was probably just being nice and was inviting me to join in the camaraderie among students in Paris. But I was cautious. I wasn't looking for any involvements, especially with someone from Bourdelle's studio! I wanted in no way to jeopardize my position there. The irony is that if I had become friends with Bänninger I probably would have gotten to know Alberto Giacometti,[19] for these two young Swiss men, along with another named Geissbuhler,[20] were all good friends. Giacometti was also studying with Bourdelle at the Grande Chaumière though I don't recall ever meeting him or remember him coming to the studio.

There were other elements, however, in my refusal of a date with Bänninger. I was very aware that my father and mother were making sacrifices so I could stay in Paris and study with Bourdelle. I wasn't about to waste any of my precious time in Paris with people who didn't truly interest me. Despite my refusal, Bänninger continued to be my instructor in the studio and we maintained a good working relationship. There was only one small incident, many years later. He had already married and divorced Germaine Richier,[21] the well-known French woman sculptor who had also worked in Bourdelle's studio in the 1920s, and I was in Paris exhibiting at one of the salons. Bänninger saw and recognized me, but walked right by, completely ignoring me.

He was a very fine teacher, however, and my first assignment from him in the studio in 1926 was to copy a plaster model of an existing piece of sculpture into stone. I did not have a model of my own creation to work from so I chose a copy of a fifteenth-century head of Christ from a Romanesque church in Beauvais, France.[22] I later learned that le Maître [the Master], as all of us in the studio called Bourdelle, was surprised and pleased that I, a young girl, would select a piece of such depth and meaning, one that also happened to be of a period he greatly admired.

To buy the cast of the head from which I would begin my work, I went to the Musée Trocadéro[23] where plaster replicas of many different pieces of sculpture were sold. I carried that big head all the way back to the studio on the Métro because I couldn't afford a taxi. With Bänninger's help, I measured the cast and ordered a block of Pierre de Lens, a form of limestone, from Monsieur Attenni, to whom I had been sent by Bourdelle. I paid two men twelve francs to use a cart to push my stone to the studio and then dump it in a courtyard. Because the stone was so big, I first had to cut it down to a size I could work with. There I was on my knees, chipping away, when Bourdelle passed

through and found me unselfconsciously singing at the top of my voice even though I can't really carry a tune! He said, "Vous aimez votre travail, n'est-ce pas, Mademoiselle [You love your work, don't you, Miss]?" I certainly did! I was finally doing what I had only dreamed about for so many years.

Once I had cut the stone to the approximate size I needed, I asked Dessausse to move my block onto a pedestal in the atelier where Bänninger worked. It was Bänninger who suggested I give Dessausse a small tip for placing the stone. I was grateful for this as I was only beginning to learn the ropes. I felt very timid and was moving cautiously. I wanted to do everything right and not be too much in the way. With my stone in place, Bänninger began to teach me mise-aux-points [placing-the-points], a measurement technique that allows a sculptor to copy a plaster model into stone.[24] The whole process is extremely time-consuming and meticulous; requires a machine; and involves the marking and drilling by hand of hundreds, even thousands, of points. The excess stone is then chipped away between each drilled point to achieve the stone copy of the plaster model.

I quickly learned that sculpting required a physical strength I never would have suspected myself of having. There I was working like a man at the stonecutting even though at Newcomb I had been the student who always tried to get out of exercising because I was worn out from running up and down the stairs between the studios and classrooms of the art school. My arms ached dreadfully at the end of each day from all the chipping with hammer and chisel and from the exertion of constantly lifting the heavy machine back and forth between plaster model and stone. No matter, for I thought cutting limestone was absolutely heavenly. It was a beautiful, soft stone, much softer than marble would have been. I learned in later years that marble requires more skill to cut than limestone. It is a question of personality: limestone is cooperative, whereas marble fights you.

Often when people think of stonecutting they think of "taille directe," which means cutting directly into the stone without the aid of a pointing machine, and watching the sculpture "emerge" from the stone. I have known very, very few sculptors who do taille directe for it is extremely difficult. With the mise-aux-points process, the creative artistic part comes during the clay modeling of the sculpture. The plaster model made from the clay model is the basis for the stonecutting. In my case I was merely learning and practicing a technique, copying someone else's artwork. However, when I finally finished the *Beauvais Head of Christ* in 1928, Bourdelle invited me to exhibit at that spring's Salon des Tuileries,[25] even though technically my piece was a copy. He liked the way my composition of the head emerging from the stone background had made it my own design.

I wrote to my family on April 23 of those early days in the studio:

"Yesterday I was locating the points on the block of stone to correspond with those on the cast & it necessitated hacking a lot—If this keeps up I'll be a muscular woman! The modelling [at the Grande Chaumière] is 'ça vaing [coming along]' also—tho is diffult [difficult] too with such competition as the class affords. . . . And so it goes—I will fill my Saturdays (which I have decided to 'take off') with sightseeing & dates but I assure you I'm working from 9 to 12–2:30–to 5 every other day & I love it."

Bänninger seemed pleased, if not surprised, with the progress I was making in the studio. "He seems so excited if I do anything intelligent & told me to-day it was 'épatant'—can't spell it but it means 'astounding' or something extravagant!" I wrote on April 27. "Just 'cause I found the 'point' exact! Wonder if he thinks I'm a moron not to be able to!"

"I'm learning lots & the stone work just fascinates me and he had a darling little hammer made for me and I'm almost ready to agree with Fraser's statement 'that when you get used to it—marble or stone is as soft as clay'—I see Bourdelle everyday & he always comes up & speaks to me. My first criticism will be Thursday & we hope for the best."

"Half the interest of the Grande Chaumière is the students. One Suisse girl came to Paris for only one month 'just to have two criticisms from Bourdelle.' She says he's so inspiring & yet so human—for he said the other day— 'Do not think of me as your professor—I am only a fellow-worker who wants to help you.'"

Bourdelle was always generous in his acceptance of other styles and approaches to sculpture. He didn't want his students to all turn into little Bourdelles. There is a story that when Matisse[26] tried his hand at sculpture, he showed his work to Rodin, who provided little encouragement because he didn't like work that was different from his own. Bourdelle, on the other hand, was quite the opposite and when Matisse showed him the sculpture, Bourdelle encouraged him to continue even though the work was quite different from his own style.

One of the greatest things about Bourdelle is that he worked with Rodin for a long time and admired many of his qualities yet emerged with a terrifically different style. He successfully broke away from the older master's powerful influence. I believe that Bourdelle was the link between the generations, between the realism of Rodin and the abstraction of later masters. Bourdelle's architectural sense contained and controlled the emotionalism and sensuousness of Rodin's work. Rodin himself foresaw Bourdelle's link to future generations. "Bourdelle is a beacon of the future," he said. "I love his sculpture, so personal, so expressive of his sensitive nature, of his fiery and impassioned temperament. And I find in it a certain delicacy which is proper to the strong. Impetuosity is the characteristic of the talent of Bourdelle."[27]

I have always been saddened by the fact that Bourdelle's name is not better known today, although interest in his work is achieving something of a revival and requests for casts of his sculptures pour into the Musée Bourdelle from all over the world. Bourdelle, in his lifetime, never had an agent, and he was not one for self-aggrandizing, which probably hindered the promotion of his work. Timing too had something to do with Bourdelle being somewhat "lost" to art history. The Musée Bourdelle was not founded until after World War II and yet Bourdelle died in 1929. If the museum had followed closer to his death, rather than war and destruction, his work might have achieved recognition sooner.

When I started work in Bourdelle's studio in 1926, however, he was a big name in sculpture. My family in New Orleans was as thrilled as I over my good luck at getting into his studio. My Aunt Katherine wrote on April 27: "We have just finished reading all your letters telling about your arrangements and beginning work with the great Bourdelle; it is certainly thrilling to think of you away over the ocean working away at your beloved art, chipping the lifeless marble into life and beauty—Ahwee [Marie] and I are both delighted that things have come your way so beautifully and I know that your enthusiasm spells success—Its going to be so wonderful to be the aunt of a famous sculptor." My father, whose opinion I cherished, echoed Aunt Katherine's sentiments on April 28: "We are quite thrilled over Bourdelle," he wrote. "Prof Woodward just rang up to say that it is wonderful for you to be with the man he had in mind first."

I was the only American in Bourdelle's studio where the atmosphere was almost as international as the Grande Chaumière. He had assistants and helpers of many different nationalities, and the mixture of accents that filled the studios was charming but terribly confusing at times! I heard French accented with Swiss German, Rumanian, Greek, and, of course, Bourdelle's own inimitable accent of the Midi. The Rumanian accent belonged to a young woman called Fainsilber, whose husband was in Paris studying to become a doctor.[28] She helped around the studio with such things as covering the clay to keep it moist. She also pursued her own interest in art, sketching and modeling in the studio.

Fainsilber and I became very good friends and she helped me a great deal in adjusting to studio life. She had been there longer than I, was a bit more courageous, and gave me little clues about how to get along with different people, guiding me so I wouldn't step on any toes. I had never met anyone from Eastern Europe before and to me she seemed like the Rock of Gibraltar, the salt of the earth. She was good, she was solid, and there was no foolishness about her. She was as serious and as hardworking as I was, which I found tremendously refreshing.

I often loaned Fainsilber money, as she and her husband were just barely scraping by. Sometimes toward the end of the month she would run a little short. I didn't have a lot of money either, but I had more than she. I was happy to help her and she always paid me back promptly. To save money, Fainsilber made her own clothes. I remember that one day I admired a suit that she had sewn, telling her that I didn't know how to sew. She was astonished and asked "How can you be a sculptor if you can't sew?" She had a point, but I managed to be a sculptor anyway.

Another very important person in the studio was Paul Dessausse, the handyman and photographer, a Frenchman in his forties whom I always called "Monsieur Dessausse." His role is difficult to describe because he undertook such a wide variety of essential tasks. He was a true jack-of-all-trades and a faithful helper who did everything from take photographs of sculpture to build armatures. He fixed anything in the studio that was broken, ran errands for le Maître, packed sculpture for shipping, and made sure that there was coal for the little pot behind the stove.

Dessausse was always very kind and helpful to me. When I returned to Paris in the 1950s to work on the monument to Bienville (the founder of New Orleans), I found Dessausse working as a guard in the Rodin museum. The Bienville monument, which stands twenty-six feet high and is in front of the Union station in New Orleans, was a joint project between the United States, Canada, and France.[29] I had gone to Paris to enlarge the sculpture and have it cast in bronze. I hired Dessausse immediately to help me when I found out he was willing to work for me whenever he had a day off from the Rodin museum. Dessausse was a master craftsman and was as hardworking a studio assistant as I could have wanted. Without him I'm not sure I could have completed that massive monument in only three years.

In the 1920s, however, my closest friendships in the studio were with members of Bourdelle's own family, which included Madame Bourdelle, who was Greek, and her sister's daughter, Fanny Bunand-Sevastos,[30] who was studying painting with her beloved uncle. Fanny, whom Bourdelle called "Zezette" as did the rest of us in the studio, was about my age and spoke perfect English. Zezette was, and still is, a beautiful and talented woman with classic Greek features. During those years in the studio, she and I became very close and our friendship has endured for the more than sixty years since we first met. Zezette's stepfather, Paul-Louis Couchoud,[31] introduced Anatole France to Bourdelle thus beginning a long and important friendship between those two famous men. In the Couchoud drawing room, Bourdelle induced France to pose, nude torso, for the portrait bust that they both ended up signing, so much did France identify with Bourdelle's work.

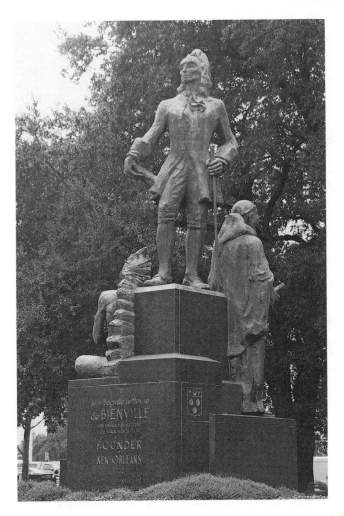

The *Bienville Monument* (1952–55) by Angela Gregory. Photograph by David R. Muerdter, 2015.

The international and congenial atmosphere of the studio greatly enriched my daily life and work. Even the maze of ateliers itself was fascinating, huddled together at the end of the dingy little Impasse du Maine, which is today Rue Antoine Bourdelle and is the site of the Musée Bourdelle. As one studio became too full to work in, Bourdelle would move to an empty one. That there were so many of these filled-up studios is proof of how incredibly prolific Bourdelle was. Even those of us who worked closely with him had difficulty grasping the abundance of his works. Today the full rooms and courtyards of the Musée are further testimony of his artistic fecundity.

Scale model (left) and armature (right) of *Bienville Monument* in Angela Gregory's
New Orleans studio, circa 1951. Hanging on the wall is Gregory's bas-relief of Thomas
Jefferson done for the exterior of the Louisiana State Capitol (1930–31). Courtesy of
Angela Gregory Papers, Louisiana Research Collection, Tulane University.

Bourdelle's ability to create and produce so many beautiful sculptures
stemmed from his own fervor and capacity for work. This created an atmo-
sphere in the studio of intense hard work, tempered by le Maître's kindness
and generosity to all of us who worked with him. I might be there, working
in the studio, when Bourdelle would come in and say to us, "Pull up an arm
chair," an arm chair being either a piece of stone or a hunk of wood. He would
then start talking about Isadora Duncan, whom he greatly admired and who
appears frequently in his work, or about religion, or about anything else un-
der the sun.

One day, soon after I began working at the studio, a student brought him
a record of Galli-Curci,[32] the famous opera singer. Bourdelle sat listening to
it, enthralled, as I described in my journal: "The first week—when I was chip-

ping off the excess stone in the court yard—the little Roumanian girl came running out and said, 'Venez, entendre la musique [Come, listen to the music].' Someone had lent 'le Maître' a portable victrola[33] and he was about to play a Galli Curci record. As he sat listening to it—with bent head and his finger on his nose—as so many French people do—he was so childlike and so thrilled—& would turn with a nervous jerk—occasionally to see if the record was finished."[34] He later asked someone who had seen Galli Curci perform if the singer was beautiful. No, was the reply, she is hideous. Bourdelle was disappointed, asking "How can anyone with such a lovely voice be ugly?"

Perhaps it was listening to the Galli Curci record that prompted Bourdelle to compare the art of music to the art of sculpture in a lecture at the Grande Chaumière, which I noted in my journal on April 29: "Someone argued with Bourdelle once over whether music or sculpture was the greatest art. Music—replied Bourdelle . . . it requires a group of people in a symphony or one single genius to interpret it for others. But once a bit of sculpture is made it stands—and withstands rains & storms & sunshine—has its appeal to everyone right there."

The balance between space and solid volumes was very important to Bourdelle in the composition of his sculptures. One of his greatest pieces, *The Dying Centaur*,[35] illustrates particularly well le Maître's concern with composition. The *Centaur*, which was completed long before I arrived in the studio, is a striking figure of that mythological creature. He stands dying but defiant. The human body is lithe and sinewy, the hooves and legs of the horse body are thick set and solid. One critic called this piece "the most touching work, the most profoundly moving that a sculptor has ever created."[36] People would ask Bourdelle, "Why did you make him dying?" He would answer, "A god dies when they don't believe in him anymore." Madame Bourdelle told me in 1971 it was her favorite piece of her husband's vast body of work.

The whole composition is based on a square and every line in the composition is at right angles to another. Bourdelle made the head lying down along the shoulder so that the centaur's head and arm would make one line, according to Madame Bourdelle. This sculpture illustrates exceedingly well Bourdelle's concern for the architectural side of sculpture. Madame Bourdelle once told me that every detail was so remarkably cared for that the Master's assistants, aiding in the sculpture's enlargement from the first model, found themselves incapable of carrying out his instructions because the composition demanded such exactitude. Bourdelle believed that imprecision was anti-sculptural.

The sculpture does indeed communicate a god-like feeling, as a Spanish American poet[37] experienced firsthand when he came one day to see Bourdelle about doing his bust. The poet, as Madame Bourdelle recalled, was taken

Sculptures by Antoine Bourdelle, including (left) *The Dying Centaur* (1911–14), displayed in his studio in the Musée Bourdelle, Paris. Photograph by David R. Muerdter, 2016.

on a tour of the studios. When they came to the *Centaur,* the visitor sat quietly in front of it for a long time without speaking. Then he got up, bowed, kissed Madame's hand, and said, "Thank you. It was like a prayer."

Bourdelle's synthesis of sculpture and architecture is expressed powerfully in the *Dying Centaur.* He took his work one step beyond lifelike and into the realm of simplification, which is what sets him apart most distinctly from Rodin. Bourdelle's early work, however, does reflect a strong Rodinian influence. This includes the *Monument to the Dead of Montauban,* his first major commission, received in 1897 while he was working in Rodin's studio. Bourdelle created a maquette, a very small-scale version, of the proposed monument to the native sons of Montauban who died in the war of 1870.[38] He then presented the maquette to the members of the committee charged with overseeing the work. They were shocked by what Bourdelle showed them. The impassioned and violent expressions and the attitudes of the four figures conveyed the full horror and anguish of war. The monument was certainly not the academic and pious sculpture that the committee must have anticipated.

After much controversy and many years of hard work, the sculpture was unveiled in 1902 only to be met with mixed reviews from the critics, as well as the townspeople. Today the only complete cast of the monument stands in Montauban, for all but one of the plaster casts was broken when they were shipped by rail from Brussels where, to save money, Bourdelle had sent the monument to be cast in bronze. The surviving cast is named *The Great Warrior of Montauban* and bronzes of that piece are in the Hirshhorn Museum and Sculpture Garden in Washington, D.C. and the Musée Bourdelle in Paris. Although the Montauban monument may have been very Rodinian in style, the break with Rodin was at hand, when, in 1900, Bourdelle created the *Head of Apollo*.[39] The story goes that when Rodin saw the sculpture he understood right away that his former *praticien* had broken from him. Bourdelle's own style was obvious, incorporating the architecture and simplification of sculpture from the Middle Ages. Rodin's utter subservience to copying nature was the antithesis of Bourdelle's theory of translation and simplification of form, his synthesis of architectural elements.

I visited the Rodin museum soon after starting my work in Bourdelle's studio and wrote down my impressions in a letter to my family dated April 30, 1926: "Last time I went to the Rodin Musée I was less impressed than usual—Of course Bourdelle was and is compared to Rodin—but do not confuse it. His work is more vigourous than Rodin—with that same magic stroke but I have never seen one thing in pictures, in his studio or the Musée which was in any way as sensuous & suggestive as Rodin's lesser things—You see I admit that there is that quality in some of his (Rodin's) work—but I do believe him to be—up till Bourdelle's appearance one of the greatest <u>technitions</u> of modern times."

"I can only wish & hope for the opportunity for you to come & to visit the studio & meet 'le maître.' Now that I am settled to routine & so happy in my choice I am not hectic or swept off my feet—but unusually calm. Don't for goodness sake expect me to be a genius—I may fail utterly."

While I don't think my parents worried that I might "fail utterly," my father remained concerned about my being "on my own" in France and was suspicious of Frenchmen's intentions toward me. In the same letter I reassured him that Bourdelle "was a gentleman always," as was my tutor and the other men in the studio. As it turned out, Bourdelle himself was very fatherly toward me, and he was quite dedicated to protecting me from any untoward attentions of young men.

Although I was always touched by Bourdelle's father-like concern for me, what I most appreciated and, indeed, what I needed and sought from him, was encouragement in the development of my artistic talent. My determination to become a sculptor never flagged, but my belief in my own ability

sometimes did. Any kind of positive comment from le Maître immediately restored my belief in myself, as I described in a letter to my family dated May 5, 1926: "Yesterday Bourdelle gave me a criticism on my stone-work & made me chisel to show him how I work. When I finished he said: 'Vous tappez bien Mlle, très bien [You tap well Miss, very well]'—I could have hugged him—And then he gave me some valuable pointers—and admired the stone which he says comes from Nimes—Its really the first criticism he's given me & because it said something nice I am pleased—He takes everything in with a glance and warned me about various possible accidents I could make."

Soon after these comments, I attended a lecture he gave at the École de l'Architecture, which I described in my journal on May 6, 1926: "M. Bourdelle commenced by reading extracts from a book he is writing. Seeing that it was too deep and too abstract for the audience he threw it down and commenced to talk and to argue. He said that a good sculptor must know how to handle every medium and that an average architect draws the plans for a building but could never in anyway carry out his designs. A Greek woman next to me said something about the proportions of the Parthenon and he said, 'Mais, Mme vous savez—ma femme est Grec, ma femme est Grec [But, Madame you know—my wife is Greek, my wife is Greek]—' striking his chest as he said it, 'est j'ai le Parthenon dans ma maison [and I have the Parthenon in my house].'"

Madame Bourdelle's father was Michel Sevastos[40] of the distinguished Sevastos family in Greece. She possessed the archaic type of Greek features: triangular face, wide brow, high cheekbones, and beautiful blue eyes. Her features often appeared in Bourdelle's sculptures and she was his helpmate and support in the truest sense of the word. She had come to Paris as a young woman to study with Bourdelle and she had become quite a good sculptor in her own right. Madame was Bourdelle's second wife and he once told me, "I always have to do everything twice, even marry!"

I first met Madame Bourdelle after I had been in the studio for about a month. "Wednesday a funny thing happened," I wrote to my parents on May 14. "I was working in my room—just off the main studio & I heard someone enter the studio—Knowing Bourdelle wasn't in I said 'Que voulez-vous Madame [What do you want Madame]?' A charming little woman in black with lovely blue sparkly eyes said in English: 'I want to leave a note for the Roumanian girl'—Well—then she said 'You need not be afraid to let me go into the studio without you as I am Mme Bourdelle.' all in beautiful English. She stopt in to see my work on her way out & I told her how much I enjoyed it—& she said 'I think you are very sweet'—I saw her again today on my way out—Elle est très gentile [She is very nice]."

Bourdelle called his wife "la grande directrice de ma vie [the great manager of my life]" and she kept the burden of outside disturbances off her husband. May Ellis Nichols noted this role in a 1931 article in the *American Magazine of Art:* "Madame Bourdelle gladly abandoned her own career to devote herself to her talented husband, and who shall say that her sacrifice was not just the element needed to transform Bourdelle's ceaseless energy, creative imagination, and great native talent, into that glorious, intangible thing we call genius?"[41] Le Maître once told me that he would always ask his wife's opinion when he worked on a piece of sculpture, but he had to leave the room when she first looked at it because he was so conscious of what she might say. I have often felt that if he had not married Cléopâtre Sevastos he might have been just another French artist. She nurtured and illuminated his genius.

Le Maître and Madame Bourdelle had one child together, Rhodia,[42] who was a young girl when I first knew her in Paris. As an adult, Rhodia became the Director of the Musée Bourdelle in Paris. Bourdelle also had a son from his first marriage, Pierre,[43] who became a muralist and sculptor in New York

Angela Gregory (left) and Madame (Cléopâtre Sevastos) Antoine Bourdelle, Susse Foundry, Paris, France, 1955. Courtesy of Angela Gregory Papers, Louisiana Research Collection, Tulane University.

and taught at C.W. Post College in Greenvale, Long Island. I met Pierre in the 1920s, when he came to visit his father's studio. Many years later, after Bourdelle's death, I delivered to Pierre the bronzes his father had left to him.

Madame Bourdelle was always very kind to me. After the Master's death in 1929, I continued to correspond with her; and, I returned to work in the studios in 1932, this time under her direction. I spent many hours visiting with her on subsequent trips to Paris. We became close friends and she asked me to call her "little mother." In the 1950s when I was in Paris working on the Bienville monument, Madame Bourdelle was quite elderly and her family asked me to stay with her one night when they were out of town. She still lived in the same apartment on Avenue du Maine and we slept in the same room, I on a couch, she in the bed. I was very amused when she said to me, "Angela, we are all artists, so let me see you nude. I want to see how you look nude, because I always thought that you had a beautiful figure." When I took my clothes off and stood before her, she said, "I'll tell you what is wrong with you. Your neck is too short. If you had a longer neck you would be quite beautiful!" Alas, my neck has never grown any longer but I have always cherished that memory.

Madame Bourdelle's dedication to her husband's memory and his art, after many years of discussions and meetings, enabled her to convince the City of Paris to dedicate a museum to his works. Construction of the Musée Bourdelle began in 1949 and it incorporated his former ateliers on Impasse du Maine, the dead-end street now cut through and renamed Rue Antoine Bourdelle. Writing in March 1969, Madame Bourdelle described her husband as having been put away by the French for twenty years before their rediscovery of his work. She also writes of Bourdelle's contribution to art: "Today's creators, through their tendencies toward a synthetic sense, have well understood the true significance of the monumental revolution that Bourdelle, here more than 50 years ago, founded and led."[44]

One of the many American friends and acquaintances who visited Paris in the 1920s while I was studying with Bourdelle was Professor Lionel Marks,[45] a college classmate of my father's at Cornell. Marks was a distinguished engineer on the faculty at Harvard and editor-in-chief of the widely used *Mechanical Engineers' Handbook,* popularly known as the *Marks Handbook.* He was traveling in Europe and looked me up after the Roszaks gave him my address. The evening I saw him we went, of all places, to the Folies Bergère![46] "He wanted to know what I'd like to see," I wrote to my parents on May 14. "He suggested a review—So it ended by my going with him Wednesday evening to the Follies Begère—Can you picture me with a Harvard professor at the Follies? . . . He explained everything so nicely—and after all being who he is he would never have <u>suggested</u> it if there had been doubts

in his mind & I was not going to misjudge his opinion or be prudish—and so we went."

"Papa he's one of the most charming engineer friends of yours I've ever met! I don't know when I've enjoyed meeting anyone more! After the 1st Act that was 2 hours long—he said if I didn't want to stay to say so—Well—he and I decided it was a 'childish attempt to be naughty' & rather boring on the whole & so we left." Although we left early, we had seen Josephine Baker,[47] the star of the show and the darling of Paris at that time. She had appeared on stage in her famous banana costume, which was nothing but a bunch of bananas around her waist. The fruits were plucked off one by one before she climbed to the top of a palm tree with incredible catlike grace. The audience adored her and the only reason we left was because of the vulgar act that followed.

I was to see Josephine Baker two other times in my life. Once, in 1927, I was seated at a table next to her in a hotel dining room. I recognized her immediately, of course, and remember she was wearing a white satin dress and turban that was dramatic against her dark skin. The next time was in the 1950s when I had the good fortune of meeting her in her own home in the Dordogne region of France. I went with my friend Desha who, with her husband Jean Delteil, or Myrio,[48] as he was called on stage, had danced their way into fame, performing before kings and queens and presidents in Europe and the United States. I had met them during an engagement in New Orleans and we had become great friends. Desha once told me, "Isn't it wonderful to be dancing one's way around the world?"

Desha was also the subject of many pieces of sculpture by American artist Harriet Frishmuth.[49] She had an incredibly lithe and beautiful body that gave any sculpture of her a special radiance. She and Jean retired in 1948 having opened their own dance studio in Bergerac, France, not far from where Josephine Baker lived. When Desha took me to meet Miss Baker in 1954, I found a much plumper woman than the one I remembered from the 1920s. She was dressed rather simply and was still quite beautiful. She had nearly her entire family living with her—her sister was making pastries when we visited—and she had set them up with dishwashers, clothes washers, everything they needed.

After that evening at the Folies Bergère in 1926, I would have liked to take Professor Marks to Bourdelle's studios. The Master and Madame were always most generous and gracious about allowing me to show people through, but Marks' schedule did not, unfortunately, permit such a visit. I did, however, seize an opportunity to take the LeBeufs: "It was about 3 o'clock and tho Bourdelle usually does not arrive till 4—he was there—working in 'my' little atelier—where he moved his work a few days ago—in order to be warmer

after his recent illness," I wrote to my family on May 18, 1926. "I asked if I might bring them in & he said 'Mais oui, oui, <u>oui</u> [But yes, yes, <u>yes</u>]!' When I reëntered he was standing waiting to greet them."

"Mrs. LeBeuf has promised to write you her impressions! I need only add that she who never gets excited was in raptures! And was quite taken with his personality. He asked if Janet were not an artist—& then said 'M<u>me</u> je ne peut pas dire cette chose à vous—il faut que je dis cette chose à votre fille qui vous resemble beaucoup. <u>Elle est très jolie</u>—elle a une figure très intelligente [Madame I cannot say this to you—I must say this to your daughter who resembles you very much. <u>She is very beautiful</u>—she has a very intelligent face].'"

"After they left I thanked him for having allowed me to ask them in—and he said, 'Si vous jamais avez l'occasion de inviter quelqu'un içi—ils sont toujours [If you ever have the occasion to invite anyone here—they are always] (welcome).' Wasn't that a nice thing to say? He's such a dear! Then he said: 'Votre amie est delicieuse elle a des yeux jolie et une figure intelligente.' 'Une jolie Americaine [Your friend is delightful she has pretty eyes and an intelligent face. A pretty American]'—Naturally the LeBeufs were as delighted as I over his appreciation of Jane's good-looks! Mrs. LeBeuf thot him so naïve & so unaware of his great fame. But I will let her tell her impressions."

"The last few days have been most inspiring working near 'le maître' who never hesitates to give me a criticism when he thinks I need it—Did I tell you that the philosopher Bergson's daughter[50] is in the modelling class? She has a strange impedement in her speech—& it is agony to hear her talk—but remarkable when you realize that tho she is stone deaf she learned French & speaks it well."

I liked Jeanne Bergson very much. She was rather robust, always very gracious, and a bit older than most of the rest of us. The first time I heard her speak it was excruciating, but when someone finally explained to me that she was deaf my admiration for her was unbounded. She took notes all the time during Bourdelle's critiques at the Grande Chaumière. Madame Bourdelle once told me that her husband did not at first realize that the deaf girl in his classes was Bergson's daughter. When he realized that she had great difficulty understanding him, especially since he tended to speak so fast, he took to writing down his corrections especially for her. Her father saw these writings one day and Jeanne told Bourdelle, "My father says that you are a philosopher sculptor and he asked me to tell you that he would like to come see you." Bourdelle replied, "Oh, but my child, I have so much to do. I do not have the time to receive visitors. What is your father's name?" Wherewith all the students cried out, "Henri Bergson!" "Ah, if it is Bergson, that is something else entirely! I will be very pleased to receive him," said Bourdelle.

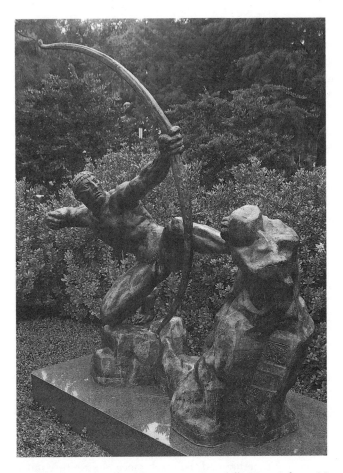

Hercules the Archer (1910) by Antoine Bourdelle, New Orleans Museum of Art's Sydney and Walda Besthoff Sculpture Garden. Photograph by David R. Muerdter, 2015.

The two men became great friends and Madame Bourdelle recalled that Bergson, whose theories centered on intuition, spoke of sculpture as if he himself were a sculptor. Bourdelle would explain his work and Bergson would immediately grasp its meaning. He told Bourdelle once, "What strikes me in your work is that the detail contains the total." Speaking of Bourdelle's *Hercules the Archer*,[51] Bergson told him, "I have the impression that if the Hercules were to be demolished and there only remained a leg or an arm, one would be able to reconstruct it."

Bergson grasped well the essence of Bourdelle's work and his philosophy about sculpture. *Hercules the Archer*, of which Bergson spoke, was first exhibited in 1910 at the Salon de la Societé Nationale des Beaux-Arts [Salon of the

National Society of Fine Arts][52] in Paris. The *Archer* is one of Bourdelle's most celebrated works and it was this sculpture that had served as my introduction to Bourdelle: it was featured in the 1925 *International Studio* magazine flung at me by Professor Ellsworth Woodward when I was at Newcomb. Many years later, after World War II, I arranged for the Delgado Museum in New Orleans (now the New Orleans Museum of Art) to purchase a cast of *Hercules the Archer*. The sculpture was a bargain at the time because France was financially devastated from the war and Madame Bourdelle was willing to sell it for very little.

Bourdelle's real fame dates from the exhibition of the *Archer*. A friend whose figure Bourdelle admired had posed for the sculpture, though he could only give le Maître ten hours and the model was made in that very brief time. The friend was later killed in World War I. Stanley Casson wrote of the *Archer* in his 1929 book, *Some Modern Sculptors,* describing it as "one of the most inventive and satisfactory sculptures of to-day." Casson considered the *Archer* a "turning-point in modern sculpture." "Tenseness rather than motion is portrayed . . . motion seized at the summit of its tension. It is a work which the vocabulary of Rodin could never have expressed." Casson noted the architectural qualities of the *Archer* were contained in so much of Bourdelle's work. "It might be the central figure of a pediment of a temple and yet it is an essentially modern conception: it shows Heracles as we know him to have been but as no ancient actually thought of representing him. This is not archaizing, yet no Greek would have given anything but praise to such a work."[53]

The relation of sculpture to architecture was the great message of Bourdelle and he possessed the true spirit of a builder. He believed that detail and ensemble must be conceived together and that each piece of sculpture must possess the three qualities of "sensibilité, intimité et synthèse [sensitivity, intimacy and synthesis]." Any piece of sculpture must have these qualities so that its harmony resembles the completeness of a symphony orchestra; every instrument plays its part toward creation of the whole sound.

Because of my training with Bourdelle, I always think of sculpture as part of architecture. When I returned to New Orleans from Paris in 1928, I was fortunate that architects were still incorporating sculpture into architecture and my work was in great demand. After World War II, with the Gropius[54] influence, the use of sculpture as decoration ended. But for those years in between I practiced all that I had learned in Bourdelle's studio and received four major commissions over a short period of time.[55]

My first big commission was for the sculpture on the exterior of the Criminal Courts building that stands at the intersection of Tulane Avenue and Broad Street in New Orleans. I modeled those sculptures in clay and then cast them in plaster myself, the first big casting job I had ever done. Bourdelle

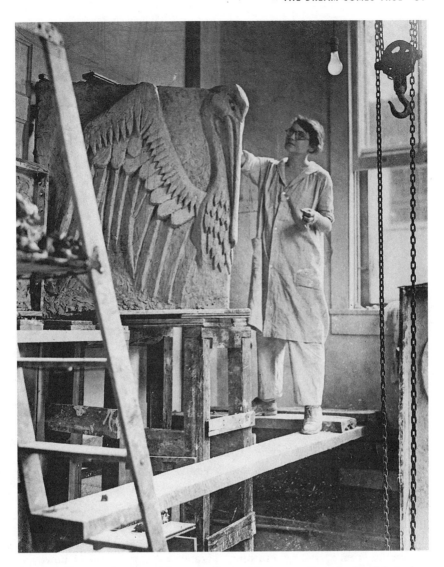

Angela Gregory in her New Orleans studio working on a pelican for the Criminal Courts Building, 1929. Courtesy of Angela Gregory Papers, Louisiana Research Collection, Tulane University.

always used a professional caster, Monsieur E. Benedetti, which is why I had not learned the techniques. For the Criminal Courts job I literally worked from books, French books, and the casts turned out to be usable, although they were much heavier than necessary. I sent the casts to a quarry in Indiana where professional stonecutters enlarged and transferred my designs into

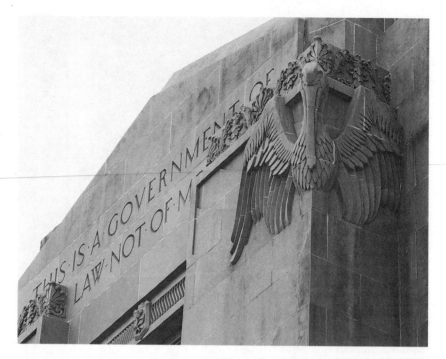

Pelican (1929–30) by Angela Gregory on Criminal Courts Building (now Orleans Parish Criminal District Court Building) in New Orleans. Photograph by David R. Muerdter, 2015.

stone. I finally learned to refine my casting techniques when I returned to Europe with my father in 1930 and took lessons from Benedetti.

The Criminal Courts commission led to work on several bas-reliefs for the new Louisiana State Capitol in Baton Rouge,[56] which was begun in 1931. In 1932, I returned to France with Kate Gleason, the highly successful American woman engineer, to renovate and decorate her home, La Tour Carrée, in Septmonts, France.[57] Before returning to France with Miss Gleason, however, I had also received a commission from Tulane University to sculpt a head of Aesculapius, the Greek god of medicine, for the entrance to the new medical school building in downtown New Orleans.[58] The building was already completed and the only place for the sculpture was the keystone in the arch over the entrance, an interesting limitation. I didn't find it discouraging though, for when a sculptor works with architecture there are always limitations and they just become part of the challenge. Making the pieces of the puzzle fit together is what makes the combination of sculpture and architecture so exciting. I chose to cut the portrait of Aesculapius in stone myself, my first stonecutting work since the *Head of Christ* in Bourdelle's studio.

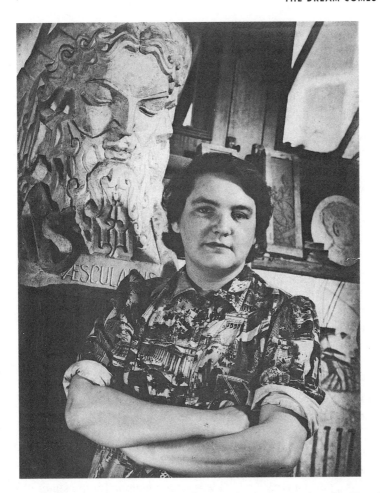

Angela Gregory with her sculpture of Aesculapius (1929–30), in her New Orleans studio, circa 1939. Courtesy of Angela Gregory Papers, Louisiana Research Collection, Tulane University.

I still believe that *Aesculapius* is one of the best pieces of architectural work I have ever done because I spent a tremendous amount of time on the original sketches. I worked from a collection of small portrait busts that Dr. Rudolph Matas,[59] the famous surgeon and Tulane faculty member, had collected in his travels around the world. There were probably 15 or 20 of those little busts and I spent hours drawing them. Then I found the perfect model for Aesculapius's beard in the old man who used to sit out in front of the Cotton Exchange building in New Orleans selling newspapers.[60] He had a big, full beard like Santa Claus and one day, after noticing him for several weeks,

I summoned the courage to ask him if he would come pose for me in the studio. He agreed and spent an entire Sunday afternoon sitting for me. I still have the studies I did of him and it is his glorious beard that inspired the one that appears on my *Aesculapius.*

I'm sure many other artists would not have gone into the same amount of detail that I did in my original research and studies for *Aesculapius* but Bourdelle had trained me to take this kind of thorough approach to my work. I started out by asking the question "Who was Aesculapius?" and worked from there. I learned an important and rather ironic lesson from this piece: I could not make a living as a sculptor by cutting the stone myself. The process was too time consuming. I could have sent it to a stone quarry, just as I had done for my Courthouse pieces, but I was determined to see if I could do all the work in my own studio. That was when I realized you cannot use Renaissance techniques to meet deadlines and make a living as a sculptor in the twentieth century. You can put so much energy into producing the stone carving that you stop the flow of your creativity, unless you are a Bourdelle or a Rodin and can hire several assistants. That is what I finally did for *Aesculapius.* I hired an assistant[61] and taught him the mise-aux-points system. We completed the piece on time but I never again undertook a stonecutting commission.

I have never regretted the time I invested learning to cut stone in Bourdelle's studio for I learned so much more than just techniques. What I will always cherish most is the almost daily contact that I had with le Maître and his wife and the ever-present excitement of being in the studio and never knowing who might walk through that blue-green door or what the next day might bring.

I wrote in my journal on May 19: "I was working alone [in the studio]—when Mme Bourdelle came in—She said 'I believe you are the only person who works in this house.' She gave me a criticism on my work—telling me to be prudent but not too slow about getting my planes—as the little holes meant nothing just so. The bell rang and she dashed to meet 'a gentleman who wants to see my ateliers.' A little while later 'le maître'—came in—He said—'You enjoy your stone-work do you not Mlle? I can see you do.' In answering him I made a mistake in my French which he corrected—I thank[ed] him and told him I appreciated being corrected as that was the only way I could learn French. 'You must speak constantly Mlle and if you like we will talk to one another and I will correct you.'"

"In speaking of French we fell to talking of the beauty of French and Italian languages. He said that during the time of Charlamagne[62] there were two languages in France—the pure French and the patois—of the provences. It was Charlamagne who decided that the pure French should be the National

language—but the patois stayed in the provences & is still spoken to-day. He said several sentences in his patois of Montauban and told me it was very much like Spanish. I could not understand one word! He said that French was the most exact of languages—therefore all the laws of countries are written in it. And that Italian was 'trop sucré [too sugary]'. Spanish was vague also."

"A little later Mme Bourdelle returned with the two gentlemen and they spoke of Bourdelle's work in Argentine.[63] He said something about a tentative order from Niguargua [Nicaragua]—but said 'things are so unsettled there now that it is postponed.' 'Oh yes'—replied the gentleman—'Its the U.S.A. who poked her finger in there & stirred up trouble.' 'Yes,' said the other man, 'Americans who come over here and throw their dollars around'—etc. etc—. All this time I tried not to hear—& M. and Mme Bourdelle said not a word. When he was quite done, M. B—turned to me and said 'Vous écoutez Mlle [Are you listening Mademoiselle]?' I replied 'Un peu [A little]'. The two men nearly curled up! And continued to tell M. Bourdelle of the qualities of young Americans!"

This was a very embarrassing incident for me, especially since I tried to keep a low profile in the studio. What the men said was typical of attitudes many people held toward Americans at that time. Even my French friends expressed their anti-American feelings although I never felt any animosity directed at me personally. The funny thing was that most of the French really liked Americans. I believe that the negativism stemmed from the fact that the United States was a big, rich country riding the crest of a wave of success at that time, while Europe was still rebuilding, piece by piece, after the devastation of World War I. Many felt the war debt was an unfair burden. Also, the exchange rate between the dollar and the franc was so favorable that Americans in Paris often spent money freely and conspicuously. Back home, in the United States, newspapers were filled with ugly headlines of the hatred that France felt for America. Yet there I was in Bourdelle's studio receiving the most considerate treatment, the most spontaneous expressions of hospitality and generosity imaginable.

When anti-American propaganda reached such a pitch that everyone was on edge and the French government was divided by internal discord, I was amused to note that the spark of French humor was still alive. Crossing the Place de la Concorde one day in an omnibus, the controleur [ticket collector] shouted "Voilà la Place de la Concorde [There is the Place of the Concord]," and as we traveled across the Seine, he pointed to the flag-draped Chambre des Députés [Chamber of Deputies] and shouted, "Voilà la Place de la Discorde [There is the Place of the Discord]."

In reality, around this time, I was feeling more a part of Parisian life than ever before. At Bourdelle's invitation I had been invited to the Vernissage of

the Salon des Tuileries.[64] The Vernissage, literally translated as "the varnishing," was the preview of the Salon's exhibition to which only artists and their guests were invited. Attending was one of many experiences I would never have had if I had been just another student at one of the academies. The exhibit was held in a huge hall bursting with artwork of all varieties. Strolling through confirmed my feelings of the vastness of the field of sculpture and almost overwhelmed me with the sense that I could never learn all I needed to know to be a sculptor.

"I went to the Vernissage of the Salon des Tuilleries of which Bourdelle is the Vice-President," I wrote my father. "My Suisse teacher & more advanced class-mates were exhibiting & I felt quite in the swing of Paris art life—going about congratulating etc. My teacher said—'Mais il faut que vous envoyez quelque chose l'année prochain [But you must send something next year].'"[65]

I did indeed exhibit at the Salon des Tuileries, not the next year but in 1928, and it was the culmination of two years of hard work in Bourdelle's studio.

FULLY ACCEPTED

GRANTED THE KEYS TO BOURDELLE'S STUDIO ✕—

The financial sacrifice my parents were making so I could stay and study, first at Parsons and then at Bourdelle's, always haunted me. "I said to Mrs. LeBeuf, that I felt so selfish <u>wanting</u> so much when a year ago I was satisfied with nine months," I wrote to my family on June 21, 1926. "She replied that each day in Paris produces a new opportunity & little did I dream a year ago that now I'd be talking, knowing & working with perhaps the greatest living sculptor—At least one whose name will echo for many generations." I tried to justify my parents' sacrifice by working as hard as possible. "I can count on my fingers (on one hand)— how many days I've really rested since I started," I wrote to my father on June 3. "If success is built on <u>work</u> it won't be my fault if I don't get there."

I was only about halfway through the *Beauvais Head of Christ.* "Its a long & exacting 'travail' and as my teacher says—hard on the nerves—And when you realize that I do only that from 2:<u>30</u> to 6—usually—& have done so for two months—its rather slow work too!" I wrote in my diary on June 10. "Bourdelle said to-day—during his criticism at the Chaumière—'A sculptor must be the composite of many contrary things. He must have the knowledge of a philosopher, the simplicity of a child—the soul of a poet and the science of a mathamatician.' Something to live up to, n'est pas [isn't it]?"

It was a lot to live up to, but Bourdelle was constantly instructing me, both by example and by lesson, in how to achieve this goal. One such instruction occurred on a Friday in June when le Maître came into the studio very excited because the son of Paul Gauguin[1] was coming to see him that afternoon. He was the child of one of Gauguin's South Pacific unions and, like his famous father, was a painter. When he arrived, we gathered around to meet him. He was very dark, tall, and impressive; and, he said he had a painting in the Salon des Tuileries exhibit that he would like Bourdelle to see. All of us piled into a taxi and went up to the Tuileries. It was evening by this time and

the exhibit was closed, but because Bourdelle was an officer, we were able to get in. The two of them stood there sharing opinions about the paintings and sculptures as we students eavesdropped intently. Later, as they came to Gauguin's painting, Bourdelle stood in front of it for a long, long time before he turned and said, "Worthy of the name Gauguin." I have always felt that Bourdelle was not truly impressed with the work and was struggling to find something appropriate to say.

Bourdelle's lack of candidness surprised me a bit for he did not usually hesitate to express his true opinion of a piece of art. That was what made such outings valuable lessons as, for example, the day he took a group of students on a walk through the Musée du Luxembourg.[2] "Looked at Dalou's monument to Delacroix—"[3] I wrote in my art journal on June 24. "'A pendulum of bronze swinging in the air' [said Bourdelle]. Wonderful modelling but 'this is not sculpture. Dalou forgot what Cézanne[4] never failed to remember. That when he was painting a landscape he was <u>creating</u>. Dalou has given us a photograph not a creation.'"

As the end of my first year in Paris approached I found myself desperately wanting to spend more time working with Bourdelle. I asked him directly whether or not he thought I should stay. "To-day an opportunity presented itself to chat with 'le Maître'—I will write you all he said to me," I wrote to my parents on June 22. "I told him that my parents had wanted to know about my continuing to study with him—but as it would be a sacrifice on their part for me to stay I wanted his opinion on the subject. He replied that it was something he couldn't answer—for he did not know the circumstances which would confront me when I did return home. If I stayed & became 'forte [strong]' would I know people who would get me to do great monuments? Whether or not I should continue to work—he didn't like to say—Its too serious a subject. 'After all,' he said, 'its all with you.' 'If Joan of Arc had waited to ask anyone whether she could run the English out of France—they'd be here yet'—'It is up to you & you alone Mlle.'"

"He said he had had many American students—who after a short period of study had gone home—'But where are they now? dropped into nothing—because they were not 'assez forte [strong enough]'—'All I can tell you is that to be an artist one should study at least three or four years in Paris'—'With the knowledge you have now—you will also go home & be nothing'—That of course is not literal but what I interpreted his sentences as—for he says he does not know the circumstances that will greet me in N.O."

"He said—'To be a sculptor you must model—& not only model but create compositions (just what Mr. Keck said—) Model—model—model.' 'It is all very well for you to work in stone—for you are learning your 'metier [craft]'— but you are only copying—if it were a head you had made yourself

Letter from Angela Gregory to her parents, Paris, June 22, 1926. Courtesy of
Angela Gregory Papers, Louisiana Research Collection, Tulane University.

you would be creating'—'Il faut avoir beaucoup d'énergie Mlle [It's necessary
to have lots of energy Miss]'—I talked on & said my mother had 'beaucoup
d'énergie [lots of energy]'—He replied: 'Vous êtes une douce enfant [You are
a gentle child].—' I said 'what no energy'? for he meant 'gentle' for 'douce'—
He replied—'Vous avez d'énergie mais vous êtes plutôt douce [You have en-
ergy but rather you are gentle] 'Vous êtes très timide Mlle [You are very timid
Miss].'"

"About an hour after our interview Bourdelle came in & took my chisel
& hammer from my hand & said 'Voyons—qu'est-ce-que c'est [Look—what
is this]?' & showed me the next process. It was like a little pat on the shoul-
der. He said Baninger didn't like his 'butting in' on his student—'Il est jaloux
[He is jealous]' and so he wouldn't help me much on that account. But the

'gesture' was appreciated—I forgot to say when he told me I was 'douce [gentle]' he said 'I am that way too—too much & its for that reason I have had to work 'enormement [enormously].'"

I put that letter in the mail to my parents, crossed my fingers, and hoped they would agree to letting me stay another year. That rather lengthy conversation with Bourdelle was a turning point in my relationship with him. It was the first time he had ever sat down and really talked to me about my future in the studio and about what course my work should take. I felt that he had begun to take me seriously for the first time, that he realized I was not just another American who wished to spend a little time in his classes at the Grande Chaumière or in his studio and then rush home to say I had studied with him. I felt a tremendous pressure to justify myself to him as well as to my parents.

It also meant a great deal to me that he recognized my timidity and even identified with it a bit. This gave me courage to continue, as did his comments about Joan of Arc, for Joan happened to be a very popular person in my family—my father had discovered her and "fallen in love" with her when he was in France during World War I. While Joan may have taken her inspiration from "divine voices" I had no such luck and had to rely on my own good sense and intuition to guide me, which fortunately have almost always led me in the right direction.

On July 5, 1926, after celebrating the 4th of July by going to a service at the American church[5] and by admiring the many American flags that draped Paris, I wrote in my diary: "Worked without stopping till 6:30—Only found 14 points at that.[6] When Bourdelle came he said: 'Voilà la grande travailleur [Here is the great worker].' Before going went to say aurevoir [goodbye]. He was working—& talking & told me if I were not 'presser [in a hurry]' to sit down & talk awhile—I did till nearly 7:30. He said artists could never lead social lives as well [as] produce good work. Therefore an artist should not marry a rich woman who love[s] to go out in the gay world."

"He said since the war French manners are different—people do not rise as quickly as they used to for the wounded. He told how during the war a Frenchman was rude to an American—& it angered him to see his countrymen rude to 'those boys who had come to the aid of France.' And that there were many people payed by the German Gov't. to anger the French against the Americans.[7] Also said when the soldiers were arriving at Gare Montparnasse—some Americans—without arms & legs were about to get into a fiacre—when some French people grabbed it. He was so upset by such rudeness that he ran a long way & called a taxi for the boys—who tried to stick a 10 centime piece in his pocket—He swiftly lifted the lapel of his coat which was covered with plaster and showed his little decoration[8]—& they waved to him saying

'Merci—Good-bye.'" The decoration that Bourdelle lifted his lapel to show to the Americans was the little red symbol of the Legion of Honor, the only spot of color on the grey coat-like garment he always wore.

Bourdelle's response to his countrymen's rudeness to the American veterans was typical of the kindness he showered on all who came within his aura. His was a personality that generated a sort of hero worship in so many of those who came to know him. Anyone working closely with him could not help but feel his greatness: his constant groping after the real and spiritual, always with the perception of its beauty; his generous giving of himself, his knowledge, and his help; his constant seeking to bring out the best in those around him, helping them to express and mature their talents and to grow in perception and vision. I never saw an ugly side of him. His work was accomplished in a spirit of joy and, through this spirit, he built up around him an atmosphere charged with the thrill of the search for beauty and its expression.

Times like that afternoon in the studio, when no one else was around and we sat and talked of the American soldiers, I hold almost as dear as the sculpting techniques I learned from him. He was a holistic teacher who understood that all parts of an artist, from spiritual to technical, had to be developed and nurtured in order to achieve real success in art and in life. I learned from his attitudes that a real artist should be above pettiness, above the jealousy and competitiveness that sometimes overtake the artistic process. Bourdelle was above all this because he had a complete feeling of security and believed in what he was doing. He never swerved from the integrity of his thought no matter what pressure was brought to bear. He always knew what he wanted and where he was going. His procedures were direct, leading to quick solutions that were correct, decisive, and enthusiastic. Once having decided on a way he was never embarrassed by indecision or superfluous fears. He was not preoccupied with trying to please or displease, with whether he would encounter praise or blame. He was concerned only with realizing to the fullest extent of his ability the image he set out to make.

There have been many times in my own career when I have had to accept harsh criticism as well as praise, to work with committees that loved my proposals and others that hated them. Bourdelle, by his example and training, prepared me well. At first his candid criticisms of my work, although extremely useful, sometimes sent me into the depths of despair, for at Newcomb and Parsons I had sailed through all my art classes and was quite accustomed to plenty of praise. I had never had my faith in my artistic abilities shaken until I reached Bourdelle's studio where suddenly I was in a much bigger world than the small, circumscribed world of art I had grown up in.

Of course, whenever Bourdelle gave me a good criticism, my spirits soared, as I wrote to my parents on July 8, 1926: "This morning Bourdelle

came for the 'corrections' at la Grande Chaumière—He looked at my little figure and said, 'Pas mal, pas mal du tout. C'est fait avec l'intelligence et la volonté—mais ce n'est pas profond parceque vous ne savez pas assez, mais il y a un qualité en dedans [Not bad, not bad at all. It is done with intelligence and with will—but it is not profound because you do not yet know enough, but there is a certain quality in it].'" I took this to mean that he saw potential in my work and that though I was still a rank beginner in many ways, I had done something that really had quality in it—it was crude, because I hadn't yet acquired the knowledge and technique to push it further—but it had quality. No doubt he looked at my work as one might look at a child's drawing and see charming potential in it even if it doesn't have any technique.

Later that afternoon in the studio, he told me "'Mlle you should stay in Paris & continue to work.' . . . 'You cannot become a sculptor in so short a time & if you go home now—all will be wasted & will have been in vain'—I have never known an artist so even tempered—so gentle—and I feel so sincere. And tho he is of a different race, I feel a great trust in him and I hope I have not misjudged—Mrs. LeBeuf—after meeting him has never failed to agree with me—Taking into consideration that he doesn't think the average American has much 'goût [taste]'—& that there's no reason why he should influence me to stay—save that he sees I have the 'volonté [will]' & the love of my work—I can't help but feel this trust is well founded."

"To-day he was tearing the work of a young student—a German I believe—to pieces." Making three little squares of clay and piling them one on another Bourdelle said, "'Copy these 3 little squares exactly—the angle at which they rest one upon another etc—copy that exactly and you will have the principle of sculpture. If you can copy these cubes you can copy that figure. I told this to some American students and they never returned.' You see we American students have the 'rep' of coming to Paris to go home & say we have studied with 'so & so'—& so the French naturally don't believe when we say we are serious."

Soon after that day it was my turn to receive a negative criticism. "What a life!" I wrote my parents on July 23, 1926. "Yesterday Bourdelle came to the Grande Chaumière for corrections. . . . He gave pretty severe criticisms & when he came to mine said—I had my bones placed wrong—& it was 'Terrible.'" I continued my letter that night: "Probably just as well I didn't finish this letter in the last stretch as I was fearfully depressed. You see when you've been told your good qualities in your work—all your life & your bad ones mentioned only on report cards—it comes rather hard to be told your bad qualities as frankly—as the Maître did hier [yesterday]. Specially as Bourdelle had orated for sometime on the fact that sculpture was not a question of possessing talent—Talent is only a very tiny bit of it all but that it was a case of

intellect—If you apply your brain to it, you can be a sculptor. The sensibilité [feeling] comes out if there's any—the intelligence is the thing—So when he said 'Pas de conscience [no awareness]' to me—on top of all that—I was feeling rather crushed."

Bourdelle's telling me that my work had no "conscience" illustrates for me another important difference between painting and sculpture. I can paint a picture and feel no great intellectual challenge. I sense and feel intuitively the colors and values that should go beside each other. I paint well because I am fascinated by color, but I don't necessarily have to be concerned with form. I can just play with the color. But you can't do that with sculpture. When I'm modeling a piece of sculpture, every little piece of clay that I stick on has to relate to the whole and if it doesn't relate the way it should, I have just created a new lump of clay. A sculptor must always be thinking of the whole form, the unity of the structure. When I first started working with Bourdelle, it was difficult for me to grasp this concept. It finally came through to me, however, and I learned that successfully executing this concept requires great concentration.

Soon after Bourdelle's "pas de conscience" criticism, I was feeling a bit homesick and out-of-place in French culture when I received the long-awaited reply from my father saying I could stay for another year. I plunged forward in my work with a renewed spirit of enthusiasm. This was reflected in the quality of my work, for the next Monday Bourdelle gave me a wonderful criticism. I happened to mention to him I was "si fatiguée [so tired]" and he told me "to take a day off every once and awhile—I replied that I thought I'd reposé [rest] for a week—and when I said I hated to do it because I hated to 'laisser mon travail [leave my work]'— he beamed & said to do it and he'd tell the Concierge[9] to give me the keys to the studio whenever I wanted to work. So yesterday afternoon I went back to work & was the only one there. Mr Desource [Dessausse] came in about 6 o'clock to say 'Aurevoir' but otherwise I reigned alone—I had to chuckle to myself when I thought of my having full entrée to Bourdelle's studio in August 1926—& the full responsibilité [responsibility] of locking it up when in August 1925 I was harass[ed] as to how I could enter the sacred portals."[10]

I vividly recall that evening when Bourdelle gave me the keys. I was chipping away in the smaller studio where I worked when Bourdelle came in. I don't think anyone else was there at that hour. He looked at my stone carving of the *Beauvais Head of Christ* and then, much to my surprise, he gave me a little slap on the shoulder and said "Quel sacre type," which, roughly translated, means something like "hell of a fellow," although I have never known a French person who could accurately translate this for me. He was evidently very pleased with my progress, for he said "Mademoiselle vous pouvez faire

tous que vous voulez chez moi [Miss you can do whatever you want here]." Then leading me out to the little room occupied by the concierge, he told her she could give me the keys to the studio whenever I wanted them, that I could come at any hour—nights or Sundays—to work. There was no witness to this event but for me it was one of the highlights of my time in his studio. Up until then I had been careful to stay in the background and work as hard as I could, not wanting to abuse in the least my status as a guest, not wanting to ever give him any cause to say "It's not good that you work here anymore." So when he granted me the keys, I knew I was fully accepted. For the first time, I began to feel truly at home in the studio.

My one big problem was my health for, throughout my entire time at Bourdelle's, I struggled against illness and fatigue. I was pushing myself extremely hard and suffered frequently from what I thought at the time were colds. It was not until many years later in New Orleans that I learned I had allergies to several of the materials I worked with every day including clay, plaster, and stone dust. I have also since learned that many stonecutters used to die early deaths of lung disease because of their constant exposure to stone dust. Once I began to wear a mask over my nose whenever I worked in my studio I was able to eliminate many of my health problems. I didn't know that, however, in Paris in the 1920s, and I spent a lot of time sick in bed feeling frustrated that I couldn't be up and working in the studio.

My parents knew I was not well much of the time, and they were extremely worried about me. Tuberculosis was still a serious concern and they were always afraid I had caught that dread disease. My father wrote me a letter telling me he was considering sending my mother over to Paris for a few months, and I know that more than half the reason was just to check up on me. Bourdelle was concerned enough about my health that, just before he left on his August vacation, he advised me to take better care of myself. "To be a sculptor one must have health and be strong," he said, "so can't you go away and rest with some American friend?"

I decided to follow Bourdelle's advice and take a break from my work. I made plans for a brief trip to London. Paris was dead in August anyway, with absolutely nothing going on and there wasn't much reason to stay. Nearly everyone and anyone were on vacation and the studio and the Grande Chaumière were both closed. I chose to leave Paris on the same day as the LeBeufs, who were sailing home to New Orleans. I hated to see them go for they had been my family in Paris and I knew I would miss them dreadfully.

"The night before we all left Paris—the LeBeufs wanted to take a taxi ride up the Champs Élysées to the Arc de Triomphe to have one last remembrance," I wrote my father from London on September 10, 1926. "We picked the cutest old taxi driver who was thrilled when we wanted to have a last

glimpse of his Paris—who ever said that Paris taxi drivers had no soul! He let us get out and stand under the Arc! Popsie every time I go there I get a thrill but on Tuesday night—oh! I can't tell you how it felt. The wind was blowing very strong—& the flame from the grave[11] was leaping up in the air 'As if it were trying to escape'—Jane said—It was oh! so impressive."

"I hope you will agree that I did best to come to England. I remember that you & Moms said I must make decisions about travelling myself—London is a most surprising place—I feel like laughing all the time—but maybe that's just my peculiar sense of humor! I asked a bobby a direction & he said 'Are you walkin' loidy'—? When one does the wrong thing—they make you feel like two pence! For instance—the creature at the desk said 'Sign the register'—& then hands me also a slip that all Americans have to fill out saying 'If you're American fill this out'—I did the latter & then the former. Well—it seems the register is only for 'Britishers' & the whole hotel force 'fell upon me' as it were! Too amusing—their shocked expressions at such desecration!"

"There are no great vistas as in Paris—and so far there haven't been any monuments to thrill me—but I must not judge too quickly—The British Museum is a revellation—& you'd love all the ancient dug-up things—I was overcome by the Elgin Marbles[12]—they are as wonderful as everyone says they are."

"You can't imagine how funny it feels—oh of course you can for you had the same feeling when you came home—I guess—but what I started to say—was the feeling of contrast of an Anglo Saxon country after 14 months of Latin countries. I haven't adjusted myself yet. I find myself thinking in French & expecting everyone to act like the French—The English on the streets are so happy in contrast to the Parisians & so much calmer. The first thing I noted on arrival was the extreme quietness—& dignity with which things were moving. I expected London to be noisier than Paris! Paris is nervewracking with din & just about kills me sometimes." (It was not until many years later, in the 1950s, that the blowing of auto horns in Paris was forbidden.)

On September 16, I wrote to my parents: "Have eaten every thing from Yorkshire pudding to Scotch broth! The 'sweets'—in the ways of puddings— like 'maple syrup roll' are delicious but the French can cook meat & fish like no other peoples. Funny the soups & deserts & salads are quite 'tasty' with seasoning & yet the meats & vegetables & fish especially have no taste. Whereas French waiters—particularly the old ones are terribly picturesque & amusing—the English ones are pitiful I find—Maybe its because they are of my own race."

"The classes are as distinct here as in France—perhaps more so—& I can hardly ever understand conversations around me as I do even in French in Paris. You know Papa, that I think the main problem with France's political

state at present is a psychological one. The contrast will be more apparent when I go back—but still right now I don't seem to feel that France's appearence is any poorer than that of England. I can't agree with the LeBeufs when they say they saw more dirty & ragged people in London than in Paris—[though] the conductors on the tramways and buses in Paris have never seen a bath! I know!"

While in England I made a trip to Oxford and, through a series of letters of introduction, met a young couple who took me punting. The note introducing me had been scribbled hastily by an Englishwoman I had met and it read, "Miss Gregory is in Paris studying sculpture." The woman's handwriting was so poor however that the young couple thought it said "Miss Gregory is in Paris studying scripture," and they talked about theology and the Bible the whole time we were punting. Just when I had thought to myself, "My God I can't keep up with this conversation anymore," the young husband said to me, "What are you planning to do with your study of scripture?" We finally got things straightened out and I told them about my work in Bourdelle's studio.

Returning from England to my beloved Paris was truly a homecoming and I remember the tears of happiness rolling down my cheeks as my train pulled into the Gare du Nord. I knew immediately I was back in France when I saw hordes of people pouring in the door marked "Sortie [exit]" and going out the door marked "Entrée [entrance]." Even my colorful, if drunken, taxi driver delighted me as he sang "La Marseillaise" at the top of his voice all the way to my hotel.

My life immediately moved into high gear again upon my return. With the LeBeufs gone, I moved from the Hôtel le Colisée to the Hôtel du Danube at 58 Rue Jacob on the Left Bank, where I paid $32.12 per month for my room and demi-pension.[13] On moving day, October 5, 1926, I wrote to my father: "Yesterday I was just 'knocking off' at the studio about 5:45 when Bourdelle came. He gave me such a hearty welcome that I felt quite happy—He patted me on the cheek & said 'Mieux—mais pas assez rosé [Better—but not rosy enough]'—He sat & chatted—till it got dark & cold—& then we all said good night."

"I find this side of the river so gloomy—& I miss the cheeriness of the Colisée. The lunch to-day was quite good & I enjoyed resting & having some place to come at lunch time—so you can't have everything. My daily route takes me by the Luxembourg Gardens—which are always are so lovely." Although I may have found the Left Bank a bit gloomy, the convenience more than made up for it. The Left Bank was certainly not as touristy as the Right Bank and prices were, in general, much lower. I had chosen to live at the Danube because it had been recommended to me by several friends from New

Orleans who had stayed there. Two of them were living there at the time I moved in, Mrs. Walmsley and her daughter, Lucinda,[14] and had to recommend me to the owner before I could even get a room there. I have to admit, however, that I missed the elevator in the Colisée. Elevators were a Right Bank luxury and I had to walk up four flights of stairs to my room at the Danube.

All the artists lived on the Left Bank—there were a lot of painters up in Montmartre, but the sculptors and a great many other artists were in the Montparnasse neighborhood. Most of the other students at the Grande Chaumière and the people in the studio lived in Montparnasse as well. They would never have considered living on the Right Bank and, in fact, would probably have ostracized me if they had known I had been living there. The Right Bank was for tourists and the nouveaux riches [newly rich].

By the time I moved to the Left Bank I had been in Paris for over a year and my French had improved greatly. I was taking weekly lessons and was surrounded by the language in the studio and on the streets. My comprehension was quite good although my accent was atrocious. Bourdelle found my mistakes so amusing that he once asked me never to learn to speak French correctly! But sometimes these mistakes proved positively embarrassing, such as the time I took Madame Martin to meet Bourdelle. She was in Paris to visit her son[15] and, in a letter to my parents dated October 13, 1926, I told them of seeing her: "I should really never loose my faith in the French and say anything against them—for after all they are certainly sweet—& mighty kind to me! I took Mme Martin to lunch—& she was distressed that I dispensed 53 francs for a meal! My only regret was that—'mère Coco's' where we used to be able to get the same meal for 40—is so augmenté [increased]!"

"After lunch we went to the Luxembourg museum—stopping at my room so Mme M. could give me another flask of the ancient cognac to drive away colds next winter—There is nothing old fashioned in her ideas of art! She can appreciate all kinds—& is indeed intelligent—We then went to Bourdelle's—& as I went in—he called that Baïenger had called to see me & my work—& as he bowed to Mme M. I introduced them saying she had been so kind to my father during the war." What I did not mention in this letter was that I had introduced Madame Martin to le Maître as "la femme avec qui mon père a habité pendant la guerre [the woman with whom my father lived during the war]." They both blushed and I must have too when I realized what I had said. I did later tell my father this story and he was furious with me for having embarrassed Madame Martin, the only time he was ever really mad at me.

My letter continued: "Bourdelle told her I was 'très gentile [very nice]'— but I must get strong—& later when I went back to get my smock after saying good-bye to Mme Martin—Bourdelle said 'Une femme charmante—je suis si contente que vous connaissez des personnes comme elle en France [A

charming woman—I am so happy that you know people like her in France].'
(Sweet n'est ce pas [isn't it]?) I told him how I came to know her—and he
exclaimed 'Oh! your father fought in the war?' And 'ça c'est gentile [that's
nice]' when I told how kind they had been to Papa and now to me."

"Later he burst in to where I was working—with the two little French
girls who come to draw—(about 12 - 14 years old) & he said to them 'Voilà une
petite Americaine! Son père avait été à Paris dans la guerre—et maintenant
elle est venue pour étudier la sculpture [Here is a little American! Her father
was in Paris during the war—and now she has come to study sculpture].' The
point of this is—I've been seeing those two little girls & talking to them for
months & nobody ever thot of telling them who I was—but the fact that 'son
père était dans la guerre pour France [her father was in the war for France]'—
immediately lifted me to a realm." I remember that Bourdelle even took me
out to the concierge and, with great excitement, introduced me again to her
even though she knew me well by this time!

"The reason I write all this is to prove that such a spirit does exist among
the French! The spirit that <u>before</u> & during the war we were told <u>did</u> exist &
which now everyone says is 'sentimentality & absolutely doesn't <u>not</u> exist'—
Its just politics—all this hate of France & America[16]—I'm sure—We laugh at
them—they laugh at us—but I don't think they hate us like the fool newspa-
pers try to make you think."

As my French improved, Bourdelle would occasionally ask me to trans-
late his critiques at the Grande Chaumière for the other English-speaking
students, as I reported in a letter to my family dated October 7. It is amusing
to note from this letter that, although I had been in Bourdelle's studio for
more than five months, he still did not really know, or bother to remember,
my real name. He always called me "la petite américaine," or simply "Made-
moiselle." "Bourdelle gave charming criticisms & I had to interpret for him for
some of the dumb-bells," I wrote. "It was good for my French & kept my mind
working on what he was saying—He gave me a very helpful criticism."

I recorded the correction, for which I had served as interpreter, in my
art journal: "The details and the ensemble should be constructed at the same
time—not one & then the other—If you work one part out in further detail
than the other you are doing what would happen if a violinist in a symphony
orchestra stopped playing a part—because he found it too hard & waited
till the rest of the orchestra had gone on playing—Not to be precise is anti-
sculptural."

Once again, Bourdelle had gone straight to the heart of the principles of
sculpture, principles that have guided me ever since. For instance, the first
sculpture I did upon my return to New Orleans from Paris was a portrait bust
of our black maid, Augustine.[17] One of the things that makes it a good piece

is that I worked it all out at the same time; it is a very spontaneous ensemble. For example, I didn't wait to do the plaits in her hair until I was all finished, but rather worked them out in concert with her eyes, her nose, her shoulders. At any point in the process of sculpting her, all parts of the portrait were carried to the same degree of completeness—I didn't do one thing and then another. It all came together at the same time. And precision also entered into this sculpture, for example the precision of getting the mouth in the right place in relation to the eyes.

While I modeled Augustine in clay and then cast her in plaster, the same kind of working out process also applied to the *Beauvais Head of Christ* that I did in Bourdelle's studio. The *Head* was not just a flat surface, it was three-dimensional, emerging from a piece of stone. Because I was using the mise-aux-points process, all that I saw in the early stages of my work on the stone were the drilled holes. I then began to chip away. Although the nose was the highest point, I couldn't just do the nose and then move on to the chin. I had to chip off a little bit all over the surface of the stone—all the parts of the sculpture had to emerge together. The whole thing was always in the same stage of roughness or "finishedness." On the day I finally finished the *Head,* I hardly realized I was done except that there were no more drilled holes visible. I knew then that I had made an exact copy of the original.

Knowing when a portrait such as the one I did of Augustine is finished is more difficult and I think the human tendency is not to know when to stop. Sometimes an artist, even a painter, needs someone to grab her hand and make her stop. This is exactly what happened to me with *Augustine*—I showed it to a very fine painter friend[18] and told her I was going to stylize it because I didn't really want to do realistic work. But my friend said "Don't touch it!" And so I didn't and I have always been grateful that I stopped when I did for I would have messed it up if I had continued. That sort of thing has happened to me often—just as I would be ready to take that next step, to take a piece into abstraction, I would be stopped by either my own artistic intuition, a friend, or an architect.

Much of Bourdelle's work is realistic also and is meticulous in its detail, from research through execution. When he was working on the monument of General Alvéar for the Argentines, which he undertook just before World War I and was placed in Buenos Aires in 1926, he carefully crafted the many details in the general's uniform. However, in all the studies that Bourdelle did for the monument, the general was always hatless. Madame Bourdelle told me in 1971 that the committee in charge of the monument protested when shown the studies—a general astride his horse without his hat! Impossible! It was military regulation that he wear his hat. Bourdelle attempted to put a hat on the general but found that the bicornered, feathered creation

made it impossible to maintain the architectural balance of the composition. Bourdelle even tried a study with the hat in the general's hand, but nothing worked.

Le Maître explained to the committee that from the point of view of volumes and harmony of masses, the general could not be wearing or even holding his hat. The committee was not sympathetic—they cared only for the military regulations. Finally, Bourdelle found a solution. "But of course," he told the committee, "you are absolutely right. The general can't be on his horse without his hat. But this was not a general who was there only to march in parades. He was a hero who saw combat and participated actively. He was the general who led the men in the charge. And in the battle, he lost his hat! It is therefore possible that when he returned victorious from combat, he was without his hat!" He was laughing to himself when he said this, of course. But the committee accepted the story and General Alvéar still rides today in Buenos Aires, sans chapeau [without hat].

Much of the initial work for the *Alvéar Monument* was done during World War I when Bourdelle had taken his wife, daughter, and niece, Zezette, out of the city of Paris and into the safer region of Montauban. While there Bourdelle spent many hours in the stables of a military barracks drawing the horses, stirrups, and reins to arrive at the perfect design for Alvéar's horse. After hundreds of drawings he finally chose one particular horse to serve as his model, but the captain of the barracks refused to loan the animal to him for further work. Bourdelle asked the man, "Why the devil don't you want to give me this particular horse when you are willing to give me any number of others to work with?" "Because," replied the captain, "the one you have chosen is the best horse in the caserne [barracks]!" This greatly amused and pleased Bourdelle. Even though he did not know much about horses, he had managed to select the best one simply on the basis of the animal's quality of form.

I discovered the rather bad form of some of my fellow art students in Paris when a group of them came to visit the studio in October 1926. Fainsilber usually showed such visitors around but because she was already busy conducting a group of guests through one of the other studios, Bourdelle asked me to answer the door. I wrote about this to my father on October 23, 1926: "I told them to wait—& Bourdelle asked me to take them to #16 (you see there are several ateliers where the bronzes etc are kept) & to ask Mme [Fainsilber] to add them to her 'tour'—A young Spaniard dashed up at me when I returned to show the way & said 'Vous travaillez içi [You work here]?' in vicious tones—How I ever got into the sacred precincts I'll never know but it is annoying to feel that they are all clamoring—But of course its only

natural. One student had asked to visit the studios & had brought numerous others with her!"

Earlier I had let my parents know about the problem of my fellow students' jealousy: "I am having to keep quiet about drawing there [in the studio]—as I have a bad enough time as it is combatting the questions of jealous students at the Grande Chaumière—I have to think mighty hard so as not to be indiscreet—as of course they would all like to be there & wonder how I got there & not only wonder but ask."[19] I could understand their jealousy at my good fortune to be in the great Bourdelle's studio, but it was very embarrassing to be asked directly how I had gotten in there. At least by this time I had stopped worrying about my own status in the studio and almost always felt I was welcome.

In late October, I was made to feel even more welcome when I was honored with an invitation to the Bourdelles' home. I went with Madame Fainsilber, following a discussion that Bourdelle had had with a friend in the studio about his collection of art and antiques. Le Maître then asked us if we were interested in seeing this collection. "The room was jammed with interesting things," I wrote in my diary. "A lacquered desk affair, which le Maître found on the Impasse du Maine—a Rembrandt, a Titian[20] & many others hang on the walls and Bourdelle pointed out to me the lovely little painting of his grandparents[21] & said it was his second painting—'Oh! if I had chosen painting—but I chose sculpture instead!'"

"He showed us an interesting wooden figure he had just bought & another worm eaten—wonderfully colored one which he said he payed 8 francs for—A gem. Lots of his things he bought from Rodin—for Rodin despite his success was always in need of money & sold his 'gems' to his friends."[22]

I described the visit in a letter to my father on October 23: "Bourdelle then showed us the lovely pieces of wood carving—the paintings & the furniture which he loves so much—& Madame chatted gayly & made us feel 'at home'—After a few minutes Madame F—(the Roumanian) & I left—& parted at the corners—& she said—'Comme les deux sont gentiles [How nice the two are]'—and it is true. It made me think of the times I have gone to the Woodwards & Mr. W. has shown his latest acquisition. You are the only person I've mentioned this to—for I don't dare breathe it near any other students as they are so jealous! And I know Bourdelle only invites the people like Mme F. & the Suisse 'chez lui [to his home].'"

Madame Bourdelle lived in that same apartment until her death in 1972. It was a typical French apartment that you entered through a dark hallway off the street and then up two flights of stairs. The Bourdelles lived surrounded by the things they loved. The living room held a huge chair in which le Maître

always sat. Bourdelle, who was a small man, had always seemed to fit perfectly into that chair, yet it was so big that Madame Bourdelle and I comfortably sat in it together the last time I went to see her in 1971. I remember from my first visit with Fainsilber that the table in the dining room was piled high with Bourdelle's papers and paintings. He almost always rose very early in the morning and did many little watercolor sketches on cheap paper, his way of beginning the day's flow of artistic inspiration. When Fainsilber and I were invited to sit at the table with them and share a glass of wine and a bit of cheese, Bourdelle simply pushed aside the pile of papers to make room for the food. His casualness delighted me and in the sixty years since I have never felt badly about just pushing aside the piles of work in my own studio whenever guests arrive.

By the time of my first visit to the Bourdelles' home, the long bright days of summer had given way to the much shorter days of fall. Because the studio did not yet have electricity, the light was only adequate enough to work until early dusk, as I told my parents in a letter dated October 28, 1926: "It gets dark—a little after four now and so I don't accomplish much—tho the electricity will be installed in the studio in a few days—I started a drawing—in the main atelier as it was too dark to see on my side for the stone work."

"There is a young French Jew who comes to do some drawing for Bourdelle & he asked le Maître to go over to one of the private galleries to see his paintings which are on exhibit—Le maître asked M̲m̲e̲ Faïnsilber & her husband—& patted me on the shoulder and said 'le prochain fois [the next time]' & turned to M̲m̲e̲ & said 'because there won't be room for M̲ll̲e̲ in the taxi if you all go'—M̲m̲e̲ F. assured him that her husband could sit with the chauffeur if necessary & I could go—So we piled in a taxi & rode across the river to the gallery—It was a small exhibit but very interesting and it was splendid to hear Bourdelle's opinion of the various paintings. Yesterday M̲m̲e̲ Bourdelle came to the studio—with 'le ministre d'Uruguay'—& his wife[23]—She said she thot the next thing I did in stone would go faster—I hope so!"

Visitors such as the Minister of Uruguay were not unusual and I spent as much time as I could in the studio not only to work but also because I didn't want to miss any of the fascinating people who came to see Bourdelle. Whenever there was someone at the door whoever was available in the studio at the time would go to answer it and often it was I who did so. I remember that one day I opened the door to an old man who asked to see Bourdelle but because le Maître had told me he did not wish to be disturbed, I explained that Bourdelle was not available. After I closed the door, le Maître asked who had called for him and when I told him the man's name he sent Dessausse dashing after him down l'Impasse du Maine, for it turned out to be an old friend from the Midi. Bourdelle was quite distressed that he might have hurt

his friend's feelings and the two had a long visit together, with the "vieux co-pain [old friend]" showing Bourdelle his paintings. Then there was the day I opened the door to a man with a Romanian accent who walked in and asked, "Do you recognize me?" I had to confess to him that he looked familiar but I did not know him. He laughed, pointed to a portrait bust sitting on a stand nearby, and said, "But Mademoiselle, you see me everyday. I am the man in that portrait, Monsieur Simu!"[24]

In 1927 I opened the door several times for the famous Indian philosopher Krishnamurti[25] when he came to the studio to pose for Bourdelle. At that time Krishna was a young man in his twenties, very handsome and striking, and the first Indian I had ever seen in person. He had been "discovered" while still a teenager in India by Annie Besant, an American woman and a President of the Theosophical Society.[26] When I first met him, Krishna was well on the path to worldwide fame and leadership that continued until his death at age ninety in 1986.

Another frequent visitor was the great architect, Auguste Perret,[27] considered today as the father of modern French architecture. Bourdelle had collaborated closely with him on the building and decorating of the Théâtre des Champs Élysées. Perret was also the first to use reinforced concrete in his buildings, a material that was to have great influence on subsequent architecture.

Because I was very young and timid during my years in Bourdelle's studios I did little more than open the door for these famous people and escort them to whichever studio Bourdelle was working in at the time. I would never have dreamed of trying to strike up a conversation with them. But they added a great deal to the general excitement of being in the studio and I loved the unexpected quality of never knowing who was knocking at the door. Just learning to cut stone and being with Bourdelle would have been enough, yet here I was seeing and meeting people I would never have met any other way. I felt as if Paris were coming to me.

The great French art critic Louis Gillet was an admirer of Bourdelle and often came to the studio. He wrote of Bourdelle in *Beaux-Arts Chronique des Arts et de la Curiosité* in 1931 at the time of the Bourdelle Exposition at L'Orangerie: "His place in modern sculpture remains very great. He has indicated its way for a long time. He uprooted it from the disorder of sensuality, he gave back to it a discipline; no one has done more than he, by his examples, to return the art to the empire of intelligence."[28] Bourdelle certainly forms an important link in modern art, appearing at one of the most critical periods of art history and helping to turn the tide of Impressionism to a more disciplined, controlled approach. The "beacon of the future," as Rodin had called him, set the stage for those who came after him.

As a sculptor of monuments and medals, Bourdelle often worked with committees charged with overseeing the execution of the piece. These committees frequently visited the studio, such as the one I mentioned in my diary on October 30: "Worked all day—when it started getting dark—I drew in charcoal—Bourdelle came & said 'Drawing is the most essential thing after all.' A committee came—about some medal & there was much talking, arguing & gesticulating—Bourdelle sitting quietly by—I whispered 'aurevoir' & sneaked out & came home to a nice hot cup of chocolate with the Walmsleys."

I have often thought back to that image of Bourdelle sitting quietly while the committee discussed and argued. I have tried to follow his example, but have often found it hard to do. I have realized, however, that it was frequently Madame Bourdelle who met with the committees. I think that le Maître probably found it difficult to sell his own work, just as I do. I don't mind having someone come into my studio and say, "I like this sculpture and would like to buy it. How much does it cost?" But to have to promote my own work or to dicker over prices is very, very difficult. I think it's because I feel toward my sculptures the way that parents must feel toward their children. How would a mother feel if someone came up to her and said, "I'd like to borrow your little boy for a couple days. How much do you want for him?" It's very hard to put a price on something you love, cherish, and have put a lot of heart into. My mother always used to tell me, "Every time you do a piece of sculpture it's like you're having a baby. You go through the same agony. You get all excited about doing it and then you realize all the work involved. By the time it's finished you're just exhausted and then somebody comes in and likes it and you're thrilled to death." That's what the whole creative process is about I suppose.

By November 10, 1926, my creative processes in Bourdelle's studio were given a boost with the installation of electricity, which gave me several more hours each day in which to work. The next day, November 11, was Armistice Day and in the evening I wrote to my parents: "I'm pretty weary—but I must tell you about the very impressive 11th in Paris. I attended the Services at the American Cathedral[29] at 10 o'clock—It is a beautiful edifice—& the organ delightful—I was quite favorably impressed with Ambassador Herrick[30] . . . When they sang Kiplings 'Recessional'[31] I nearly 'went under'—For the choir is very beautiful—& 'Lest we forget' was rather touching after the Ambassador words—to the effect that '8 years later—we are not celebrating a great Victory with pomp & glory but rather 'in the spirit of thanksgiving'—of a great deliverance.'"

"From the Cathedral I went over to the Champs Élysées where I met the Walmsleys—& from there we saw the parade pass—A cannon went off at eleven & not a sound was heard save a yelping dog off in the distance—until

cannon boomed one minute later & the hats went on [and] everyone said 'ça-y-est [that's it]'—(Their favorite expression). General Gouraud passed & cheers of 'Vive le General Gouraud'—The only enthusiasm which broke the spell of the sadly quiet atmosphere. When I clapped for the General—a French woman on my left turned & said to me in English, 'That is General Gouraud. He lost his arm in the Dardanelles'—He is Military Governor of Paris."

"At 5 o'clock we attempted to see General Gouraud rekindle the flame at the Grave of the Unknown Soldier—but the crowds were impossible & we could barely see the heaps of flowers on the Grave." In 1930 my father and I did have the opportunity to see General Gouraud, with General Pershing,[32] rekindle the flame at the tomb of the unknown soldier. On that same occasion my father actually met General Pershing, under whom he had served in World War I.

At this point I was spending a lot of time drawing in the studio, making sketches from Bourdelle's sculptures, an exercise that taught me much about the depth and detail of his work, as I wrote to my parents on November 13, 1926: "I arrived chez Bourdelle very late as I had to take snap-shots of my work at the Grande Chaumière but when I arrived Bourdelle said 'You've come to work? Good for you'—I worked on a drawing I am making in charcoal of the head on his statue of France[33] for which his niece 'Zezette' posed. Glory—when I try to draw from his work—I realize how simplified it all is—& what a wonderful amount of drawing he has back of it all—& its mighty hard to 'catch the spirit' he has in it. I've understood his work a great deal more minutely since I've tried to draw from it."

"Mama's letters—written so many months ago—came yesterday—You need never worry about the 'Rodin influence'—Bourdelle knew him personally as well as a student & co-worker but there is nothing sensuous about Bourdelle as there undoubtably is about Rodin—Compare their work—& Rodin's looks weak in comparison. I once heard Bourdelle say that Barye[34] the animal sculptor was 'peut-être le plus grand sculpteur modern—plus grand que Rodin [perhaps the greatest modern sculptor—greater than Rodin].'"

"The weather has been quite mild & dry all week—but as it <u>always</u> rains on Sunday—I hear the rain beginning to patter now!—Sometimes I think I can't stick it out—& that art isn't worth it all—but when I am at work—particularly chez Bourdelle—where '<u>work</u>' is the keynote of the atmosphere—I am happy."

The drawings I did during this time taught me everything about Bourdelle's work, for I was forced to analyze his sculpture more intimately and thereby learn in detail about its composition, force, and structure—all that made it "Bourdellian." This experience reinforced my belief that drawing truly is the basis for all other art. If you can't draw, you can't sculpt. I almost

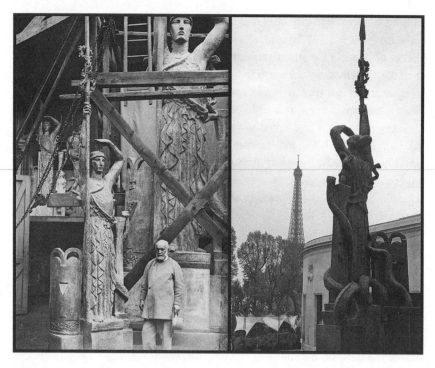

LEFT: Antoine Bourdelle with *La France* (1922–25), early 1920s. © Musée Bourdelle (MB Ph490)/ Roger-Viollet / The Image Works. RIGHT: *La France* on terrace of the Palais de Tokyo, Paris, with Eiffel Tower. Photograph by David Muerdter, 2016.

think it doesn't even matter what you draw as long as you are analyzing as you draw.

A cast of *La France,* which I mentioned in my November 13 letter, stands today looking out over the Seine in Paris, on the terrace of the Palais de Tokyo.[35] Bourdelle had completed this sculpture in 1925, fulfilling his commission to create a statue commemorating the intervention of the United States Army in World War I. I had first seen *La France* at the 1925 Exposition des Arts Décoratifs, an exposition that had shaken the art world to its roots with exhibits by such as Le Corbusier.[36]

As in so many of his works, Bourdelle had asked members of his own family and household to model for *La France.* Zezette's beautiful and classic Greek features with high cheekbones and dramatic eyes are represented in *La France*'s face. Because Bourdelle felt that Zezette's arms were too skinny, the statue's arms were modeled from Miss Florence Colby,[37] an American friend of the Bourdelles' who lived with them, taught English to their daughter Rhodia, and was like a member of their family. Madame Bourdelle was also a

frequent model for her husband. Seeing her on an almost daily basis, I could understand why for she had a goodness of spirit that illuminated and highlighted her considerable external beauty.

One of the many sculptures for which Madame Bourdelle posed was *La Vierge d'Alsace* [*The Virgin of Alsace*] and on the head of this sculpture is the "torchon" or scarf that she always wore to protect her thick, black braided hair from the stone dust in the studio. *La Vierge d'Alsace* is a strong and lyrical figure, the Madonna holding up her child, his arms outstretched so that his body forms a cross. Bourdelle sculpted it on commission from a woman in Alsace who had made a promise to God during World War I: if He spared her hill from the Germans, she would erect a monument there. Full-size casts may be seen today on that hillside in the Vosges Mountains of Alsace as well as in the inner courtyard of the Musée Bourdelle in Paris.

While le Maître often used family members for models and once did a charming little cupid using Rhodia as the model, he also hired professional models to come into the studio and pose for him. One favorite Bourdelle family story concerns an older model who came to the studio one day looking for work. Le Maître told the woman to come in and undress and he saw at once that she was old. He decided to sculpt her just that way, although a bit exaggerated. He made her very gay and fat, and sort of tipsy and dancing. When the model saw what le Maître was making of her, she was furious and didn't come back for any more sessions. But the world today has this aging model to thank for the rather whimsical *Vieille Bacchante* [*Old Bacchante*] sculpture.[38]

My own models continued to be Bourdelle's sculptures and I received an uplifting critique on my drawing of *La France,* as I recorded in my art journal on November 16, 1926: "Criticized my drawing of head of 'France'—& said there was some fine qualities in it—it was a good drawing—but that I should study the values in order to get the big planes & feeling of roundness—'Travaillez par instinct où intellect [Work by instinct or intellect].' Detail & mass must work together—Can't take your head home & leave your hands & feet behind—When eating—you feed your whole system—not just one part—Logical."

While my artistic soul was being fed at Bourdelle's, my physical body was often fed with good French food, which I truly did enjoy despite an occasional homesick yearning for some of my mother's thick, black chicory coffee and a fried egg! "I have just come in from a very delightful afternoon—I mean evening—with the Walmsleys," I wrote to my parents and aunts on November 17. "We went down to a famous little restaurant in the Quai D'Anjou—which is a veritable 'hole in the wall' but which serves the most delicious 'poulet roti [roast chicken]' you can imagine—In order to have this famous dish you are obliged to send a 'pneumatique' (special delivery) 'en advance [in advance]'

so they will be sure to have enuf. And they have a book in which every name from the Fairbanks to Melba & McAdoo[39] are inscribed—After dinner we stopt for coffee at the 'Deux Magots'[40] right by St Germain des Près & watched funny people pass—& enjoyed the luminous reflections on the wet streets."

"Bourdelle came to the Grande Chaumière to-day & I am glad to say that my wish came true—He told me I had made great progress—& that my drawing was influencing my work and 'Mlle je suis bien content avec le progress que vous avez fait [Miss I am very happy with the progress you have made]'—He called Baïnenger over to see it—& said 'Don't you think she's improved' & turned to me & said—'The things you did before were not like this'—Then to the Monitor—'You know Mlle comes 'chez moi pour travailler le pierre avec Baïnenger et pour dessiner un peu [to my place to work in stone with Bänninger and to draw a little]' etc, etc—It pleased me that he added 'pour dessiner [to draw].'

"Please don't take this too much to heart—but I wanted you to know I had been striving to improve & that Bourdelle saw progress—Of course my first things were so bad—that this grade of progress doesn't mean much—save that I'm not standing still—Le maître told me my drawing was 'pas mal du tout, du tout [not bad at all, at all]' to-day—When I hear him talk—and stress drawing—and say 'Drawing is everything—the rest is 'la blague [a joke]'—I know I am studying with the right man. He emphasises the same essential principals that my professors at Newcomb did—But somehow I am just beginning to 'see'—I hope I will be capable of further progress & with this encouragement shall work even harder."

"He is so generous & kind—He is working on a monument[41] now & enlarging it from the 'maquette'—& called every one in the studio—Mme F., his niece & me & showed us how it is done—He goes out of his way to help other people—I have never seen a person so pleased to serve others & so ready to share his experience & knowledge—He destroys every theory of the jealousy of artists."

Madame Bourdelle reiterated le Maître's praise, as I noted in my diary on November 19, 1926: "Mme Bourdelle came when I was chipping and said 'This has helped you with your work at the Grande Chaumière hasn't it? When my husband came in for lunch I asked him how the young Greek boy was progressing—and he said—'but guess who has made great progress? La petite Americaine—You see the mise aux points did help her.' He was very pleased with the progress you have made.'"

The next day was a Saturday and I worked at the Grande Chaumière in the morning and in the studio in the afternoon before I joined the Walmsleys for tea at Rumpelmayer's.[42] I felt I had to be almost secretive about going to such a posh place, which was on the touristy Rue de Rivoli on the Right

Bank, for it was "the" place for tea in Paris. If my fellow "starving artists" at the Grande Chaumière and in the studio had found out I had been there, they would have been shocked and surprised! The plushness of Rumpelmayer's, with its marvelous and expensive concoctions of ice cream and chocolate, was certainly in stark contrast to the places on the Left Bank where I usually took tea.

This outing was indicative of the almost double life I led in Paris. Although, like most students, I didn't have much money of my own to spend, I was often treated to rather fancy restaurants by family friends from New Orleans who came through Paris or by people like the Roszaks who took me to the restaurant in the Eiffel Tower once. I even had a friend, Madame Loyson,[43] the daughter-in-law of excommunicated Roman Catholic priest and liberal religionist "Père Hyacinthe" Loyson, who lived on the elegant Rue du Bac in the very studio where Whistler[44] had worked. I often went there to take tea with her and her daughter. But no matter how much I enjoyed these outings I always took pains not to mention them in class or in the studio.

MASTERING TECHNIQUE

THE REWARDS OF HARD WORK >

Paris was in the cruel grip of winter when I wrote to my parents on December 1, 1926: "Its horribly cold tonight—I had to run to keep warm coming home. I sat close to the stove & drew—at the studio this afternoon as I was afraid of the cold place where the stone is! You should see my <u>fur lined</u> shoes I wear in the studio—They are charming—Lined with rabbit."

I certainly needed such shoes for Bourdelle's studio had cold, hard concrete floors and lots of glass windows and walls. The only stove was located in the big studio where le Maître usually worked. When he invited me to come draw, I kept my work so close to the heat that Bourdelle remarked they would "eat grillée [grilled] Américaine for dinner tonight" if I wasn't careful! Because my *Beauvais Head of Christ* was set up in one of the unheated studios and could only be moved with great difficulty, my stonework slowed considerably during the cold weather.

Conditions at the Grande Chaumière were somewhat better for the school kept a stove going to keep the model warm. I continued with my classes. "Bourdelle's 'corrections' were most inspiring & interesting to-day," I wrote to my parents on December 1. "Gave me a helpful criticism—& showed me many faults that I had never dreamed of—but which then seemed so apparent— He despairs of the bad equipment—crowded [and] badly-lighted ateliers—& sympathises if we don't seem to be able to study the model closely—Nevertheless he gave some harsh criticisms to students who had obviously not 'observed' enough. I chipped & drew a little to-day. Le maître is working lots these days & his niece comes often too."

"It has been fearfully cold yesterday & to-day—dry—but penetrating & I have worn every heavy garment I possess. Oh! I almost forgot to tell you that I went to St. Sulpice[1] Monday afternoon to hear <u>Widor</u>[2] play—It was in honor of the rehabilitation of the 'Grand-Orgue [Big-Organ]'—I enclose the

program which I'd like you to preserve—The <u>Bach</u>[3] was the most beautiful of all—and the altar was a blaze of candle lite—Most inspiring."

I remember braving the cold to go early for the Widor concert and was rewarded for my fortitude by ending up second in line. The one person in front of me was a French woman who became extremely annoyed when a little man carrying a portfolio tried to cut ahead of her and go in the still-closed door. She said to him, in French, "You can't go ahead of me! I've been standing here for an hour." To which he replied, bowing and taking off his hat, "Mais pardon, Madame, moi, je suis Widor [Excuse me, Madame, but I am Widor]," much to her embarrassment!

To escape the Parisian weather, my friends the Walmsleys went south. "I anticipate hearing from them soon—àpropos of what I understand is a thing called 'Sunshine,'" I wrote facetiously to my aunts on December 3. "I remember way back in my prehistoric being—that I saw a lite that scientists and Southerners term 'sun', but that was so long ago that I'm not quite sure if I saw it then! One is never sure of the sunshine they say—but one can always bet on the rain—Do you know what rain is? Its 'the enveloping state of Paris'—When I sail from Europe I am going to drop my <u>umbrella</u> in the ocean—just as people drop a new hankie when they sail from home. It will be my <u>mute</u> testimony of <u>tribute</u> to the 'force of rain'—and if its raining when I pull into the American shores I'm going to let out 'a <u>barbaric yell</u>!'—I'm in a fascious [facetious] mood so don't take me too seriously—I'm quite attached to rain—Its part of my existance as it were."

The bitterness of December 1926 wasn't just in my imagination. Newspapers reported on the severe cold throughout France and of heavy snows in the Alps and the Pyrenées Mountains that blocked trains. My life was warmed, however, by the Bourdelles' invitation to hear a young Roumanian friend of Madame Fainsilber's play the piano. Even though I knew it would be casual I debated a long time over what to wear and was pleased when Bourdelle admired the red scarf I had chosen to drape over my black dress. That evening with them was very much the kind I was used to spending with my own family in New Orleans: a little music, a little refreshment, much warmth and friendliness. I wrote about it in a letter to my parents dated December 8, 1926: "Their 'ethics' if you can call their point of view of life—its 'spontaneous'—it has no 'parlour finish' it is the politeness that springs from the heart as naturally as they speak. Their hospitality—is genuine—its inate!"

"We arrived about 5 o'clock chez lui or eux [at their home]—and they took us immediately into 'goutte [snack]'—which was composed of tea and patisserie—We all sat at a long table—The musician had prepared a lovely program and played beautifully—Their niece came in later—& the little daughter

came in & listened to one number—& came over & thanked me for the stamps—You are a dear, Popsie to send them—I told M<u>me</u> B. that my father would always feel indebted to the French for their kindness to him during the war—& she must not exaggerate the stamps."

The stamps were a gift from my parents to the Bourdelles. Only a few months after I had arrived in the studio, le Maître had rather timidly asked me if my parents could send over some American stamps for their daughter's collection. I had been only too happy to fulfill this request, for I was very pleased to find some small way to repay their extreme generosity to me. From then on, whenever I saw Rhodia, le Maître or Madame would have her graciously express her thanks for the stamps, often in English, while mother or father stood by, beaming with pride.

The pride and interest that the Bourdelles showed in my own work and occasions such as the intimate concert in their home made me feel all the more a part of Parisian life. "I am really knowing Paris this year—the Paris of the Students," I wrote to my sister on December 11. "I see the side of the 'dabblers'—& then turn right 'full face' to their greatest craftsman! Their view is to enjoy everything as you do it—not to separate play & work—I don't mean that they play when they work—no—they are very serious—but I mean that they have a mental viewpoint towards 'work' which is delightful—For instance—I adored 'my work' at Newcomb—but my pleasure was another thing—Now I am absolutely content with 'work'—and pleasure if its related to that work."

Despite these assertions to my sister, I did take time off from my work for the pleasure of the Christmas holidays. I decided to join the Walmsleys in Toulon, where we enjoyed an English-style Christmas at the Hôtel des Iles D'Or in Hyères.[4] I then spent my second New Year with Madame Martin at Villa Lolita. I wrote to my sister on January 3, 1927: "I came to Cannes on Thursday last and it is so nice to be with M<u>me</u> Martin again. She begs me to thank you for your 'greeting' & sends kindest regards—It felt like 'coming home'—to reach here for New Years—!"

"I will go to Nice for a day or two in order to see the Cousins at Ville-franche & to let the Walmsleys show me a bit of their beloved Riviera. Yesterday M<u>me</u> Martin took me to Antibes which is an ancient old sea town—& we could catch a glimpse of the snowy mountains of Italy—despite the fact that it was a little cloudy—We could see Nice—as a flecky mass of white—against the blue oh! glorious blue of the Mediteranian (can't spell it)."

"The day before we took a long walk up in the hills behind Cannes—& the air was so fresh that I was hardly tired at all—and usually I flop after 2 ½ hours of walking! I feel so rested! It is cold as soon as the sun-sets—& as soon as you step in a shadow. It is strange to see all the 'tropical' plants—the

cactus—the palms, century plants & Spanish daggers—& roses!—heavenly—& yet the season is just begun & they say 'when the mimosa blooms!'"

"M<u>me</u> Martin had your snap shot with Gregory framed in a little frame with the American flag as design—to greet me in 'my room'—And New Years eve—M<u>me</u> left me nibbling nuts and excused herself & soon I heard strains of the 'Star-Spangled Banner'—& I dashed into the parlour to find her at the piano—& a little Christmas tree—blinking with candles—! Oh! She is a darling!"

After a brief visit with the Brès cousins in Villefranche and a bit of touring with the Walmselys, I returned to Paris by train, stopping for the night of January 12. "There's the funniest little provençal 'femme de chambre [chambermaid]' in this hotel and she asked me about my opal ring," I wrote my parents. "She told me she was very supersticious so much so that she never changes her 'chemise [blouse]' on a Friday (probably no other day either) because once she did & she felt it was 'un peu [a little] indiscreet' & was sure of it when later in the day she was 'fired' from her hotel!"

"There was a most uncouth American couple in my Compartment to-day—as far as Avignon! They were going around the world! The wife said 'Well, at least we won't take a back seat when we go back to Portland—'cause we've seen more than some of them who have gone around the world—We must join the Country Club too'—Of course we talked to one another later & she said to me "What is your nationality?" & looked a little weak when I said American—We talked of 'Art' & 'old Masters' in a most intelligent (?) way & the husband who was really the worse of the two said, 'Now—frankly—don't you think our art in America is as good as in Europe? Why the murals I saw in Salt Lake City were just as good as what I saw in that room in Rome.' (Meaning the Sistine Chapel) My head still aches from the effects of that conversation—But he was gallant & heaved all my valises down & out for me."

On my first afternoon back in Paris "I trotted over to the studio & found Bourdelle quite alone—sitting on a little stool working on the monument which is to be place[d] in the Place d'Alma[5]—eventually," I wrote my parents. "I sat & chatted with him & told him how lovely I found 'La Provence' & how beautiful his France was—We spoke of Mistral[6] & his poetry & I said how I'd love to read it—if I could even read the translation—So he recited some for me in provençal & explained some of the words & expressions & said 'But how can that be translated?'"

"He was most 'sympatique [nice]' & told me about a little incident that had occurred at the studio—which caused me to say: 'Oh! Maître I often fear that I am in your way here in the studio'—He said 'Oh! but that's not to apply to you M<u>lle</u> you are à côté [to the side] & if you 'deranger'ed [bothered]' me I'd say so—' Later as I was about to leave he said—'Now you must get back

to work again & do some good things in stone—a demain n'est pas [until tomorrow right]?'"

"Mme Fainsilber was not there but M. desource [Dessausse] came in & oh! it felt too good for words to be back again 'in the fold'—My vacation was just long enuf to make me crave to be back at work & I feel most inspired—He is a sweet old 'maître' and worthy of the admiration the world bestows."[7]

Winter gave way to spring and with the change of seasons came the time for me to take stock of my progress and plans. Once again I felt I needed another year in Bourdelle's studio and, once again, I was tortured with guilt for having to ask my parents for more money and more time away from home. I had reassured them that Bourdelle was not encouraging me to stay in France forever, that he had always said I must return to my own setting and not try to compete with the thousands of sculptors in Paris. But first I must be able to stand on my own two feet. Yet again my generous parents granted me another year.

The Bourdelles also were aware of my parents' generosity. My father continued to send the stamps for Rhodia on a regular basis and had given them a subscription to the *National Geographic Magazine*.[8] Madame Bourdelle wrote very sweet thank you letters to my parents for their gifts. I enjoyed my work in the studio so much that I even turned down an invitation to lunch at the home of one of Marie Scherr's friends, Raymond Almirall[9]; it was for a weekday afternoon and I didn't want to sacrifice any time at Bourdelle's. My refusal astonished Mr. Almirall for he was unused to having his invitations declined and, even though he was a bit miffed, he wanted to meet me all the more. I ended up going over on a Saturday and we discovered a rapport that was really wonderful. Uncle Ray, as I soon came to call him, was a semi-retired American architect living in Paris with his two sons[10] who were both about my age and studying architecture at the École des Beaux Arts, just as their father had done. Uncle Ray was always trying to set up dates for me with his son Joe. Indeed Joe and I enjoyed each other's company very much, but his father's pushing rather squelched any interest we might have had in each other.

At the time I met Uncle Ray I had no idea of his stature as an architect but I later learned that, after studying architecture at Cornell University and the École des Beaux Arts, he had opened his own practice in New York in 1896. During those years in New York he was commissioned to design a number of buildings in the metropolitan area, including several Roman Catholic churches, the Brooklyn Central Library, and several hospitals. After serving in France during World War I, Uncle Ray returned to Paris in 1924 as an unofficial representative of Welles Bosworth who was the architect for John D. Rockefeller, Jr. on the restoration of several famous buildings. In recognition

of Uncle Ray's architectural restoration work at the Palace at Versailles and the Trianon, he was made a Chevalier of the Legion of Honor. He died in 1939 at his home in New Rochelle, New York.[11]

When I knew him in Paris in the 1920s, Uncle Ray was always giving me advice on how to pursue my career in the arts. That was just the type of person he was. He was accustomed to telling young people, especially his own children, what to do. Because of his reputation and vast experience, I was only too happy to listen even if I sometimes chose to not follow his counsel! I think Uncle Ray was rather intrigued by me for he had never before met an American student who was as dedicated to her work as I was. I certainly didn't fit the popular "flapper"[12] image of the all-play and no-work young American woman.

Saturday lunches at Uncle Ray's elegant apartment in the Place du Panthéon[13] quickly became a habit. Marie Scherr was usually there, as was her friend Edna Vollmer,[14] a young American woman who had been studying art in Paris for two years. Uncle Ray often included French friends whom he had met through his work on projects in France.

One of the pieces of advice that Uncle Ray gave to me was to take some drawing lessons from another artist, Monsieur L. F. Biloul.[15] I was supremely happy doing all of my work in Bourdelle's studio but Uncle Ray thought I should have some exposure to other artists. Edna was taking lessons from Biloul, and she and Uncle Ray kept pushing me to go with her. Finally, out of curiosity to see what it would be like to work with another artist, and just to get Edna and Uncle Ray off my back, I went and took a few lessons. I felt rather guilty the whole time and never mentioned this experience to anyone in the studio. Here I was, a nonpaying guest in Bourdelle's studio, yet I was going off to pay to take lessons from another artist. Nonetheless the experience was most instructive for I realized anew the quality of Bourdelle's genius and his ability to teach and inspire students. I found Biloul pretty average in comparison. He used the classroom method of instruction and there was no question about who was the teacher and who was the pupil. He possessed none of Bourdelle's attitude of students being "confrères." "My admiration for Bourdelle has been strengthened by the comparison," I wrote to my father on March 6. "I don't want to be critical (& this is between you & me) but while Bileul expounds & criticises as does Bourdelle (I mean même espirit [same spirit]) I realize that he lacks that quality which raises Bourdelle above the common herd—call it the spark of genius if you will—What I mean is that Bourdelle can rip your work to pieces but leave you inspired to go on & do better, whereas I feel limp & listless and at sea after Bileuls."

"I can't afford to be too critical but I realize now more than before, why I feel the urge to go on!—I wouldn't have—if I'd studied with anyone else—I

mean I would have been satisfied to go home with the few months of expe-
rience I had had—never realizing the hugeness of my subject—Bourdelle has
opened my eyes as it were and I see the whole thing clearly—How really big
& overpowering is the field of art—and how much a <u>student</u> has to conquer
before he becomes an <u>artist</u>. The thing is to master technique over here &
create chez moi [at home]."

My hard work learning technique was occasionally rewarded by a thrill-
ing critique from Bourdelle that helped me keep going, as I wrote to my Aunt
Katherine on March 8: "I say 'thrilling' because he left me so inspired! He said:
'You like to work in stone don't you M<u>lle</u>? I can see it makes you very happy.'"

"I stopt in to see Miss Scherr enroute home this evening & she was just
finishing tea so gave me some & we looked at her various photos & prints of
Europe. She is a dear! I can't quite describe her. She is so reserved & yet so
human & so spontaneous. 'Now do drop in Angela & tell me all the exciting
things that happen'—I know she thinks my enthusiastic—I should say 'hectic'
point of view of life a most amusing one."

"I wanted to walk home—& decided to take a short cut—You should have
seen where the short cut landed me. It was dark & in a few minutes I was
completely lost—Streets always go the way you don't expect them to in Paris!
Spring is funny here! The rain & sunshine battle daily—but fortunately its
balmy & I can wear light dresses & a sweater & winter coat instead of wool
dresses! After so many months—its a great relief indeed."

Clothing wasn't terribly important to me, although I did enjoy dressing
up occasionally to go out. During the weekdays, however, especially when I
was working at the Grande Chaumière in the mornings and the studio in the
afternoons, I wore warm and practical, if shabby, work clothes, and I didn't
much care what I looked like. One day I came dragging into the dining room
at the Hôtel du Danube. I was exhausted as usual after standing up for three
hours modeling at the Chaumière. There were only a few people in the room
and I couldn't help notice a young Irish couple[16] who smiled conspiratorially
at each other when I walked in. I immediately felt conscious of being talked
about. As the days wore on, this couple continued to appear regularly for
lunch and it became increasingly and annoyingly obvious that they were
indeed talking about me. As it happened, Mrs. Bruce,[17] a charming southern
woman I had met at the hotel, approached me one day and said, "Angela,
that couple who come for lunch in the dining room are having a party this
evening and they would like to invite you." Miffed at the way they had been
making me feel uncomfortable, especially since I had overheard their nick-
name for me, something like "little black bob-tail," I replied to Mrs. Bruce, "I
wouldn't miss one hour in Bourdelle's studio to waste my time with people
who rudely sit and talk about me."

Late that evening, after the party, Mrs. Bruce knocked on my room door. She described a delightful party where James Joyce,[18] who had just published his *Ulysses,* had been among the guests. (Sixty years later I learned that the man in the young Irish couple was probably Arthur Power, who was a friend of Joyce's.) Later the party had moved to Gertrude Stein's apartment on Rue de Fleurus![19] I have regretted missing that party ever since. I learned the hard way from that experience to never care what people say about me!

On March 15, soon after missing the Stein party I wrote to my mother: "I dropt in to see Miss Scherr late yesterday as I'd spotted an antique ring I rather liked & wanted to ask her about it—I burst in on a tea-party—or rather an English friend & Edna were there—Edna & I walked home together. Its so nice to meet a sensible fine American student who has gotten only the good & beautiful, out of her years abroad. She is 'established' over here—having her most attractive apartment & studio—& has only been home for two weeks in two years—despite the fact that she is the only child."

"You never wrote me just what Miss Butler said about my work with Bourdelle, but have referred to it several times—so it couldn't have been optimistic. Judging from things other people have written I sometimes wonder too what they think of my slow methods. Miss Butler would be shocked to know that I'm still working on the Beauvais Christ! She thot the method so slow. I hope to finish it by June at least & then the technique will be mastered!"

"Just compare the thorough mise aux points method I have learned to the experience that has come to two American girls who are studying with someone here who has advised them to drop modelling for several years & do only stone work. Imagine. And the gastly part is that he is teaching them 'taille direct'—which means just cutting directly into the stone without the guide of mise aux point. A thing that even Michaelangelo couldn't master. The little Swiss does a taille direct every year or so—but he has been working in stone for years—& always mise aux points."

"I am perfectly satisfied for I know I am right & in the best environment. Its so easy to loose self-confidence when you're alone. The LeBeufs used to keep my superiority-complex working—& just now I'm feeling rather 'flat'— Uncle Ray Almirall 'peps' me up when I see him."

I was also "pepped up" by a dinner invitation to dinner at the home Mr. and Mrs. Harlan Miller.[20] Mr. Miller was second secretary to the American ambassador, Myron T. Herrick, and Mrs. Miller was a sculptor. It was the Ambassador himself who had introduced me to the Millers. I had had a letter of introduction to Ambassador Herrick from Senator Ransdell[21] of Louisiana, who was a friend of my father's. When I met the Ambassador, he was most cordial and gracious. I remember him telling me "I am a widower and I don't

entertain socially, so I will introduce you to my First Secretary, Mr. Miller, whose wife is a sculptor."

I wrote to my parents about the party on March 24: "I was much amused on Tuesday nite to see how my stock went up when it was mentioned that I worked chez Bourdelle. Funny world. One gentleman dashed up when the evening was half over & said, 'Oh Miss Gregory, Mr. Miller has just been telling me that you work in Bourdelle's studio—I have a friend who wants to study with him & do you think'—& his voice trailed off leaving me to judge the rest. I said 'I think not'—but will be glad to help her if she comes to the Gr. C.' It seems she is some famous marquise etc—& I almost said 'Bourdelle doesn't give two rats who people are!'"

Although Bourdelle didn't "give two rats" for people's social standing I have to admit that I felt painfully aware of my lack of social identity in Paris when I was in the company of people like the Millers, who were very sophisticated and wealthy New Yorkers. In New Orleans my social position was assumed; everyone knew my family and my background. To the Millers, however, I was just another little American studying art in Paris. I felt rather overwhelmed by their elegant lifestyle although they were always very gracious to me. I did enjoy talking with Mrs. Miller about sculpture but even though I had lunch with them several times after that first dinner, I never did see any of her work.

My rather low self-esteem in the presence of the Millers was balanced by an ever-increasing confidence in my artistic abilities. "Its work, work, work every day & night & nothing is obtained without work," I wrote to my father on March 26. "You are a darling to be so generous about my wanting to stay—& just now I am feeling that perhaps I'm not so selfish after all if in one year I can make the progress Bourdelle seems to feel I have—Oh! I've so long to go yet that the thot is weakening but it seems less far away & so worthwhile now. He is so far above the pettiness of artists—he is a great genius & I am indeed fortunate to have been given this priviledge of knowing & working with him."

His genius was certainly not without its lighthearted side and Bourdelle laughed as hard as the rest of us at the April Fools' Day antics that I described to my aunts in a letter written April 2: "Yesterday was April 1st & French spirit was all agog—Various models came dashing into the ateliers with hopeful expressions only to find someone had played 'Poisson d'Avril [April Fool]' upon them & that there was no job awaiting them."

"I stopped in Edna's yesterday & she had a little basket for me—such as you only see in France—filled with chocolate poissons d'avril & crayfish & shells—She & Miss Scherr know all the French 'tricks!' The candy was purchased at a confiserie [candy store] called 'A l'Enfant Jésus [At the Baby

Jesus]'—Isn't that weird? I am leaving in a few minutes to go & call for 'our dear M.S.' (as Edna refers to Miss Scherr) & Edna to take them over to see my stone work & incidentally the studios. I am very pleased at the thot."

Marie Scherr and Edna had been listening to me talk about my work for months and it was very important to me to take them through the studios. Miss Scherr was a very reticent person and her eagerness to see my work at Bourdelle's was a great compliment to me, as well as to le Maître. "You see M<u>me</u> Bourdelle very kindly offered to take them thru all the studios on Saturday—which was extremely kind on her part," I wrote to my parents on April 6. "When she found that Bourdelle had not arrived at the studio she insisted on taking us to their home so they could meet him—He was most gracious and it was a very pleasant half hour spent in their home. To-day—Miss Scherr said she & Edna had sent their cards to M<u>me</u> Bourdelle with a few tulips—& I am sure that will please her very much. I wrote Madame Bourdelle a little note of appreciation."

Miss Scherr wrote to me on April 3, thanking me for the studio visit: "Dear Child, I want to tell you—(and congratulate you) how fine I think your winter's work has been. I have not the technical knowledge to appreciate all the difficulties, but I can see the aesthetic result. I can also see from Madame's manner and from the Maître's how much real interest they take in your work. Next year, you will stride ahead, these months of apprenticeship over. It was a great pleasure to see Bourdelle and to hear him talk. I feel more and more what a musician he is in his stone—all these vast shapes move to a great sweep of inner harmony. Looking at him, one might believe him a musician. Don't you think so? Nothing <u>plastic</u> escapes those eyes of his. Many thanks, dear child, for making it possible for Edna and me to meet the Bourdelles."

Miss Scherr advised me to take a little "vacances de Pâques [Easter vacation]," a break from my work, and encouraged me to see the original *Beauvais Head of Christ*. The sculpture had originally been placed on a church in Beauvais but had been removed and was now on display in the town's museum, as I told my parents in an April 11 letter: "Mrs. Walmsley & Lucinda & I have decided to leave here Thursday morning & go up to Amiens—& see the wonderful cathedral there—stay a day or so—and then go down to Beauvais and come back to Paris about Tuesday next—I have written Monsieur le Conservateur du Musée [Curator of the Museum][22] to be sure I can get in on Holidays to see the head. . . . A year ago on the 14<u>th</u> of April I went to [Bourdelle's] studio with quaking knees—on the 19th of April I started work there! I will be in Beauvais & Amiens to celebrate the anniversary."

I told my aunts of my plans for the trip in a letter written April 13: "I waited till nearly seven at the studio last evening so as to be able to tell mon maître 'aurevoir' because I am going to take a few days 'vacances de Pacques—Mon

maître was so sweet & said 'I suppose you are going with friends—too bad for the most beautiful place & where you should go—is Poitiers'—& then he started raving about its wonders—'Envoyez-nous les cartes-postales Mlle tout de suite—de jolis columns [Send us postcards Miss right away—of pretty columns].' He's an old angel!"

"You asked me once, Asche if I ever saw many flowers in Paris—On nearly every street one can find a little flower shop—& on all the principal corners or Place's—there are always quaint little stands laden with every brilliant sort of flower. I even saw black iris at a little stand by St Germain des Près—the other day."

From Beauvais, I sent my parents a postcard with a picture of the head on it, dated Easter Day, April 17, 1927: "Here's the famous head! Will make a few notes in my sketch-book tomorrow to help me with the details—The stone is very much the same as my pierre de Lens & is indeed a beautiful piece of sculpture. So you understand now why its taken so long to copy."

I wrote to my aunts: "We've had a most amusing & interesting day—wondering around the old streets of Beauvais & hunting up the old houses. We attended a High Mass at the cathedral & were pretty well frozen after a half hour. The cathedral was never finished—& there is little more than the façade & choir—but the height is terrific & it could never be heated I'm certain. (Not that they'd try) I saw the famous 'tête du Christ [head of Christ]' & greatly revelled getting a close-up study of it—& will go to the Musée [Museum] again tomorrow to make a few sketches that may be of help when I get back to work in Paris."

My close-up look at the original *Head of Christ* helped clear up some of the details of the features, particularly the beard, for the plaster cast I was working from was a pretty bad copy. I returned to the studio from that trip with fresh inspiration, feeling that the *Beauvais Christ* was one of the finest relics of the fifteenth century.[23] My sculpture was quite different from the original of course because of the way I had composed the head emerging from the stone background.

My *Beauvais Head of Christ* still sits today in my studio. I have never been able to part with it. I have loaned it for display several times including to the Vatican Pavilion in the 1984 World's Fair in New Orleans.[24] When I look at the *Head*, I still feel a tremendous sense of pride over having finished it and I see that it marks the starting point of my whole career. Undertaking it was like diving: I plunged in and didn't drown but came up and just kept on going. That sculpture is the symbol of all my childhood ambitions to be a sculptor, from the time I listened to my mother's stories of the stonecutter carving angels on the Newcomb Chapel. It is the embodiment of having achieved my dream of working in Bourdelle's studio. It is one of my most precious children.

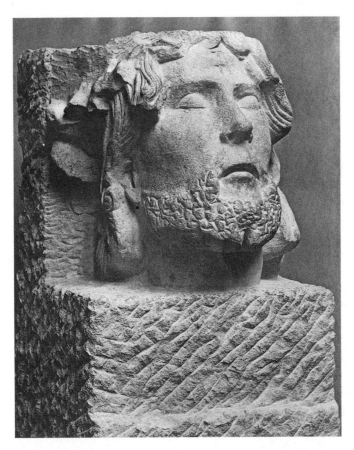

Beauvais Head of Christ (1926–28) by Angela Gregory. Courtesy of Angela Gregory Papers, Louisiana Research Collection, Tulane University.

Soon after the trip to Beauvais I began reading the news of terrible floods on the Mississippi that were threatening New Orleans. I became very concerned about my family's safety. A clipping from the *New York Herald, Paris*, dated Friday, May 6, 1927, reported on the Mississippi flood with a headline that read "France and the Mississippi Flood": "French sympathy for the sufferers by the Mississippi flood has been touchingly shown, and as Ambassador Herrick said yesterday, it proves above all else the deep and lasting friendship of the two peoples, unequalled in any epoch of history. Mr. Herrick repeated the old truth feelingly: 'It is in misfortune that real friendship is found.' But the interest of the French in Louisiana, and in fact in all of the Mississippi Valley, is doubly logical. New Orleans and even St. Louis are full of French tradition . . . but for some eccentricities in the tenor of world

events, the whole of the Mississippi Valley and the vast west-land beyond would be French today."

Concern about the flood continued to plague me, as I wrote to my Aunt Katherine on May 8: "The Walmsley's & I are rather harassed about the flood situation & watch the papers with an eagle eye. Papa's letter last nite from Mobile says 'not to worry'—but a lot has happened since that was written! Everyone comes up to me & with sympathetic tones—just as tho someone had died—asks me about my home. They say 'Quel idée de faire une ville plus bas que la rive [What an idea to build a city lower than the riverbank]!' I hasten to explain that La Nouvelle Orlèans [New Orleans] was founded by the French & the discussion ends there."

My father, being an internationally recognized hydraulic engineer, participated in the planning for the methods New Orleans could use to control the high water moving southward along the Mississippi toward the city. For years he had been championing the cause of a spillway, a controllable break in the levee system placed upriver from the city that could be opened in an emergency to divert flood waters into Lake Pontchartrain. He had been to Washington twice with a committee of New Orleans citizens to plead the spillway cause, once before President Harding[25] and once before President Coolidge. As I read the Paris reports on the flood in 1927, I learned that New Orleans had been saved when a portion of the levee north of the city had been blown up to create an emergency spillway. A little white flag had been dropped from a plane to signal the explosion. Two weeks later, in a letter from home, I found out that it had been my own dear father who had the honor of dropping the signal. Construction of a permanent spillway system was authorized the year after the 1927 flood.

When my concerns over the flooding were past, I was able to turn my full attention back to my work. "I'm feeling very, very 'subdued' & impressed this evening. I'll tell you why," I wrote to my father on May 16. "This afternoon I was thinking about six o'clock that I'd leave my weary work & go home via Miss Scherr's as I haven't been to see her in two weeks—I was detained & as it was too late—went on chipping."

"About 6:30 Bourdelle, Mme Bourdelle & a young friend of theirs came in & Mon Maître—presented me to the friend—(He remembers my name now—& is always saying 'Mlle Gregory'—rolling the r!) He was in one of his very earnest moods and he turned to the lady & said: 'Look at what Mlle has been doing'—& turning to Mme B. 'Regardez, Maman—c'est epatant ce qu'elle faites—Elle est epatante! Elle a enormement de volonté [Look, Mother—it is splendid what she has done—She is splendid! She has a great deal of will].' He turned to the friend again and said—'I've only seen one other woman, my wife—who could do stone work—who had the patience to carry it thru. There

are few women who have the character to finish it as its very difficult.' This of course is the gist—In French it was much more forceful & short-cut! & effective."

"And then Popsie—with all the sincerity of his personality and no 'blague [joking]' or a slight trace of humor but all earnestness he turned to Mme B. & said: 'Mlle a beaucoup de volonté et c'est ça qui conte. Si elle pourra rester içi pour assez longue temps elle fera quelque chose [Mademoiselle has a lot of will and that is what counts. If she can stay here long enough she will do something]! (Word for word practically.) Son travail à la Grande Chaumière n'est pas si bien que sa pierre—mais c'est parceque de créer quelque chose est difficile—mais avec sa volonté elle arrivera et ses choses là ne sont pas mal du tout [Her work at the Grande Chaumière is not as good as her stonework—but this is because to create something is difficult—but with her will she will succeed and her things there are not bad at all].'"

"Oh! Popsie you must know how much it means to me—for finally I know how little inate talent I really have & what I've done is just from steady labor—& what Bourdelle said is what I'd rather hear him say than anything in the world. Mme B. chatted with me a little later in English & said 'Did you understand everything my husband said? You must write and tell your father. You know Rodin once told my husband that he'd rather have a student who had character than to find one that was very talented—For talented people rarely go far & achieve greatness wheras character will mean everything. You know they say—'Genius is the ability to work.'"

"I told her Bourdelle had inspired me to do the stone & she said 'Inspiration has nothing to do with it—its character'—Bourdelle himself once told me that—there were two kinds of art students—Those who are 'douée [gifted]' & those with 'volonté [will]' & they were both capable of getting far. I cannot tell you what a wonderful personality he has. He's so generous in everything he does—so big! I sometimes think I may exaggerate—& then I see him so do some kind thing that pushes all doubt away."

"Prices are soaring in every single line as far as I make out—If you can send me a little more money next month I may be able to 'catch up'—I had to order a spring coat unfortunately—The one I have is two years old & I wear it daily to the studio—which means it gets rather messy—Therefore I had to have one to wear when I'm dressed up. You see its just not comme il faut [as it should be] to go out in Paris without some kind of coat & so I chose the cheapest way out & am having one made by Miss Scherr's couturier & I hope it will be only $20.oo! I hate spending money on clothes!"

I was temporarily distracted from worrying about money when, on May 22, 1927, all of Paris went crazy with excitement over a young American named Charles Lindbergh. He landed his plane at Le Bourget airport[26] after

his historic transatlantic crossing and was greeted by thousands of cheering French men and woman who waved tree branches and shouted "Il est arrivé [He has arrived]!"

Lindbergh's arrival launched one of my most memorable and favorite episodes in studio life. Bourdelle's niece, Zezette, and I began to scheme to get her uncle to do a portrait of the famous and daring aviator. I used what connections I had at the embassy to contact Ambassador Herrick and begin the arrangements. I wrote to my parents on May 24: "It is going to be hard to describe to you the peculiar existance since Sunday morning—which I have been experiencing. I shall always regret that I was fool enuf to refuse the Walmsley's invitation to go with them to Le Bourget to see Lindbergh arrive! They were among the millions who greeted 'the lad' who has done more to seal the friendship of America & France than anything since the coming of the Yanks in 1917—Paris went wild—& still is!"

"So Sunday—Zezette Bourdelle's niece & I were labouring over Lucinda's[27] portrait or Zezette is doing a portrait of L—& I a portrait in clay—Of course we were very much excited over Lindbergs flight & safe arrival and I said 'Why don't we do his portrait?' Zezette responded with gusto & said 'Oh! I thot of that too!'—I said jokingly—'Why not? I know Mr. Herrick & could arrange it'—She took me seriously—& told her uncle at lunch—Well, eliminating details we have 'pressed' Bourdelle into service as it were & now we are wild for <u>him</u> to do Lindbergs portrait. It would be the homage of the greatest French sculptor & the greatest in the world to the young American flyer—the greatest flyer in the world!"

I chatted with Uncle Ray and then on his advice called up the Ambassador's home and the embassy, but like thousands of others, was refused. It was a question of pulling wires, so I got in touch with Mr. Miller, the Ambassador's First Secretary, who agreed to meet with us. Mr. Miller was most gracious and I merely presented Mademoiselle Bunand-Sévastos who had a request to make. She explained that she had thought of getting in touch with Mr. Herrick through the French embassy, but as Mademoiselle Gregory was the first American ever to have been permitted in Bourdelle's studio, and as I was fortunate in knowing Mr. Miller, she had chosen that means of approach.

Mr. Miller seemed impressed and said immediately that there would be no difficulty in arranging a rendezvous between Bourdelle and the Ambassador and offered one for ten o'clock the following morning. "Bourdelle is greatly amused by it all," I wrote to my parents on May 24. "He doesn't seem to grasp what it would mean for him—I must say we didn't give him much time to think! Anyway he gets a big kick out of our enthusiasm & this afternoon every moment or so he'd call out—'Mlle Gregory—(a pause & then—) Lingbergh!' I stopt in chez eux [at their home] to give the final data about the

date to-morrow with Mr. Herrick & as I was going out—Bourdelle said—'Mlle Gregory—if le jeune [young] Lingbergh <u>does</u> come to the studio I'll be sure to ask him de embrassez vous [kiss you]!'—Ha, ha!"

"Well—Zezette is to go as interpreter to-morrow & I hope sincerely they'll put it across—Any way I've been able to run my legs off for Bourdelle & at least try one thing to show my gratitude to him. Miss Scherr doubtless thinks me insane but is amused at my hectic existance & wild ideas & I aim to amuse! To have been able to achieve the rendez-vous with the Ambassador is a bigger feat than you can imagine for the Embassy is nearly insane with the thousands doing everything in their power to get to Mr. Herrick or his secretaries—Bourdelle leaves Saturday for Belgium at the request of the King & Queen[28]—& Lindbergh flies to England, but we hope to be able to arrange something for a future date."

The next morning, May 25, I wrote to my parents: "I've just been called down stairs by the visit of Zezette et [and] Mon Maître—She had promised to phone & tell me the outcome of the 'audience' & instead they decided to stop by the hotel & told me. The dears! Bourdelle was much impressed with Mr. Herrick—thot him 'si fine [so fine]' & had such a striking head. Well— the request has been made & we hope that something will come of it all— Perhaps Bourdelle will meet the aviator in Belgium at the big dinner the King and Queen have invited Bourdelle to attend—No doubt the aviator will be invited—too!"

I continued the story of the Lindbergh saga in a May 26 letter to my parents: "Another hectic day—I was so appreciative of the visit of mon maître & his niece. She asked me this afternoon to help her write a letter of appreciation to the Ambassador for he was so kind to them & do listen to what happened this afternoon! She went with her step-father[29] to the reception that the Presidency of the Chambre des Deputées [Chamber of Deputies] tendered to Lindbergh and was one of the few 'outsiders' invited—being an intimate friend of M et [and] Mme Buisson the President.[30] Ambassador Herrick caught sight of her in the doorway and waved his hand to her to come over & he presented Lindbergh to her saying—'Mr. Lindbergh I want you to meet the niece of a very great sculptor—' Bourdelle & toute le monde [everyone] was naturally much impressed when they heard of it! And a representative of the paper who was there came up to find out who she was!—to have been introduced by the Ambassador caused much excitement. The Ambassador gave Bourdelle a word (card) so he can get in touch with the aviator in Brussels on Saturday."

"[Zezette] is very charming & very beautiful and has been so excited about the affair & said 'I think you & I are the only ones who realize what it would mean for my uncle to do Lindbergh's bust'—She was so upset because

she got to meet him & I didn't—not that I cared—So asked a friend to try & get a card for me to go to the reception at the Sénat [Senate]. It may or may not materialize. I think the Ambassador's 'geste [gesture]' this afternoon showed his impression of Bourdelle's offer and that he had been frappé-ed [struck] by Zezette—Its a great life!"

I wrote to my parents on May 28: "I've seen the famous Lindbergh! Zezette & I & her little sister saw him as he issued forth from the Senate yesterday—Thousands were waiting to scream & yell as he drove out with the Ambassador and we enjoyed the enthusiasm of the crowd (which seemed mostly French) more than any crowd I've seen in France."

"Last night Zezette invited me to go to the Gala given at the Theatre des Champs Élysées for Lindbergh & the proceeds to go to the families of aviators who have given their lives. Lindbergh is a beautifully poised youth—very refined & very 'gentil [nice]' looking but certainly doesn't look over 17! Zezette & I went up to the Officiel Box to pay our respects to the Ambassador during the 'Entre' acte [Intermission] & so I got a good look at him. The Ambassador put out his hand to shake mine but chairs & people prevented the actual handshaking so he smiled & shook his own in pretence. I was happy that he remembered me." Just as Herrick turned to introduce me to Lindbergh the lights went down and the act began! "Never has anything so united France & America," I added. "No wonder Ambassador Herrick adores the boy who managed to work the miracle for which he has been striving for so many years."

Sadly, despite all our efforts to bring Bourdelle and Lindbergh together, le Maître never did do his portrait. The young hero's schedule did not permit time for a sitting before President Coolidge ordered him back to America. It was the only time in Bourdelle's career that he asked to sculpt someone. That his wish was not granted left history poorer. His homage would have been worthwhile and, as far as I know, there never was a portrait bust done of Lindbergh.

Soon after, le Maître and Madame made their trip to Belgium to attend a dinner in Brussels honoring the greatest savants of France.[31] The Queen received Bourdelle after the dinner and told him about her love of pastels and of some of the difficulties she was having with her technique. In a burst of enthusiasm over the subject of pastels, he remarked that he would love to see the Queen's work and her Majesty invited the Bourdelles to the castle the next day. Le Maître described this visit so vividly to us in the studio upon his return that I almost felt I had been present too. He told us he had had a wonderful hour or so giving a lesson to the Queen.

In the midst of their work they had heard a whirring overhead. The Queen excused herself saying she must pay homage and wave farewell to

the great young American. The Queen of Belgium, Bourdelle, and Madame Bourdelle stood at the window and waved to the tiny moving spot against the sky, which was none other than the *Spirit of St. Louis* carrying Lindbergh westward. A few minutes later the King came in with apologies to Bourdelle for his lateness, explaining he had been compelled to go to the flying field to say goodbye to the aviator.

Bourdelle spoke glowingly of the graciousness of their majesties. He reported he felt so at home that when the young princess came bouncing in that he forgot and called her Mademoiselle. They walked through the royal garden and the Queen picked a bunch of roses for them. Bourdelle saved those roses and brought them to the studio for us. Zezette later painted a little oil of one with dropping petals and Bourdelle sent the painting to the Queen.

Upon leaving the castle, the Bourdelles returned to their hotel in the royal automobile. Bourdelle described in his enthusiastic way how great crowds of Belgians had gathered around the hotel entrance expecting to see their beloved tall King and Queen emerge from the auto. No doubt the crowds were surprised when an unfamiliar small man with a halo of white hair and beard and his petite, dark-haired wife emerged instead, and entered the hotel.

SELINA ARRIVES

A BROKEN LEG SHATTERS HAPPY PLANS ›———

Summer arrived and on June 2, 1927, I wrote to my parents: "Its raining and I was so dog tired as usual on Sunday morning that I am propped up in bed scribbling. Mon maître has been ill but the dear old fellow is allright again and will be back at the studios on Monday—He hates for 'tout le monde [everyone]' to know that he's ill naturally—so even M̲me̲ Fainsilber hesitated going to inquire of his health. We're always having daily news from M. desource [Dessausse] but on Friday she decided to go & asked me if I wanted to go with her. We were glad we went for he & Madame seemed to be glad to see us—He looked quite well & showed us some interesting books."

"Madame said she saw I could understand everything that was said in French now—She is a darling & has as forceful a personality as her husband. She said 'Is your father going to let you stay a long time? He should for you mustn't go home too soon for [if you do] Paris would mean nothing to you sculpturally and would only be a dream if you are studying seriously. My husband has had so many students who have gone home too soon and who have not been strong enough to stand against the influences they receive in another place.' Yesterday she came to the studio with a French lady & as usual introduced 'la petite Américaine' & when she was leaving said 'Goodbye darling—' She sort of bubbles over with happiness."[1]

My own happiness was at full boil because I had received word that my mother was coming for a visit in July, less than one month away. Zezette and I immediately began to lay plans for the three of us to make a trip to Brittany. "Your letter [with] the glad tidings of Mama's departure for foreign shores reached me happily yesterday morning!" I wrote to my father on June 9. "The poor old roof of Bourdelle's studio nearly blew off with excitement. Congratulations & happy remarks flew every way! The celebration may [I] add was not only because my Mother was coming but because I had such a dear generous father—As Zezette said 'What a wonderful man your father

must be! But of course—he's an American—If he'd been a Frenchman with the same conditions he'd have come to Europe, & let your mother stay—I think he's lovely!'"

Zezette was not the only one in the studio who was impressed by American men for one day Madame Bourdelle, laughing to herself, came into the atelier where I was chipping away on the *Beauvais Head of Christ*. She stopped and told me she had just sold a Bourdelle bronze to an American businessman[2] who most certainly did not fit the image that Europeans had of such men, for when he had started to write out the check in payment for the bronze, he had said, "May I make the check out to Anthony and Cleopatra?" Madame Bourdelle had said it was fine with her, but she had better call the bank first. According to Madame the banker, being French, laughed and said 'Yes, of course.' Madame Bourdelle's comment to me was, "Don't tell me that American businessmen aren't romantic!"

The weather in Paris had turned glorious and I went on a picnic to Chantilly[3] with a group that included Zezette and the Fainsilbers, as I told my aunts in a letter written June 11, 1927: "We bycycled—they having rented for 8 frs. each—three bycycles for the day. I took my turn & was delighted to find I had not forgotten how to 'monter un bycyclet [ride a bicycle]'—We left at 9 A.M. & returned about 10 P.M. in a jammed packed train—for a Frenchman's idea of happiness is to go to la campagne [the country] on a 'fête [holiday] day'[4]—We ate French picnic fashion more or less all day long—which meant—hunks of bread & chocolate—hunks of cheese, slices of meat bottles of beer or water, hard boiled eggs—slices of cucumber & tomatoe. Its really much more picnicky than our way—once you get used to it!!"

"We sat and watched the sun drop behind the chateau and the shadows creep across the long stretches of lawn. The forest & parc of Chantilly is more beautiful in my mind than that of Versailles. Its more 'intime [intimate]' of course & less regal. To go with 'mes comarades [my friends]' was very interesting for they are ever conscious of the beauty around them. We wandered a bit in the very wonderful musée [museum] in the chateau and wandered out again—for the crowds were not only horrible—it being a big fête day but we—even the hardiest of us, were very fatigued by the unaccustomed over dose of fresh air that we had had all morning."

Soon the day of my mother's long-awaited arrival dawned. "The sweet Momsie is here—a week has passed and I still have to hug her & run over & feel her to make myself really believe its true," I wrote to my father on July 3. "This is actually the first moment I've had to write to my Popsie tho we have thot & talked about you ever since the darling arrived."

"I put on my glad rags and dashed to the French Line[5] last Monday morning & was told the train would get in the Gare St Lazare at 11:33. It was then

about 10:30 so I went on to the Gare to make sure & waited there until the train drew in. The 1st person I saw was the darling Babe & as the train slowed down I opened the door & hopped on! & in! My head swam for quite a few minutes I assure you!"

"Later Monday afternoon we wandered out & over to the 'Deux Magots' & sat & drank café & gazed at funny people & St. Germain des Près—It poured rain & we had quite a time getting home again—This afternoon we are to go to Enghien [the Roszaks] & tonite to Mr. Almirall's to supper—Darling seemed so awfully tired at first and I was awfully worried at first—but yesterday she seemed more herself & much less tired."

All of our happy plans were shattered only a few days later when the concierge at the Hôtel du Danube pounded on our door at the ungodly hour of 6:30 am to deliver, in error, a glass of milk that she thought I had ordered. I described what happened next in a letter to my father dated July 9 and written on letterhead of The American Hospital of Paris[6]: "Mama & I were both asleep—& attempting to answer the door—Mama jumped out of bed—As she did so she slipped—or jumped—We were both half-asleep—and the next thing I knew—Baby was saying 'I've broken my leg!' For a few moments, I didn't register—but when I did I could see the bone jutting out & I realized her leg was broken. I admit I lost my head—for I began to cry—to see the darling doubled up in pain—crying 'I've broken my leg'—was awful."

"The hotel people thot I'd just lost my head—& that nothing was wrong—I sent the poor old concierge to phone Dr. Béniot—the doctor I've been going to and to whom I had taken Mama yesterday—but the line didn't answer. We managed to get her on the bed with the aid of two hommes de chambres [male housekeepers] & then I went down to phone."

"While I was waiting for exchange to answer—'American Hospital' flashed thru my mind—So I said to Exchange 'L'hopital American [American hospital]'—I asked them to send me a doctor at once—with one glance [he] said—it was broken & that darling should be taken to the American Hospital for X-Rays & to have it set. Darling has been such a sport—& each little doctor & nurse comes in & pats her on the hand & tells her how young she looks for 58—& what a sport she is."

"I will see the Bourdelles & Zezette in the morning—& how sorry we'll all be that Brittany is 'off'—for they liked Darling so much—I will try to find a place nearer the studio & quieter to take Momsie back to from the hospital— she will probably be there (hospital) 4 to 7 days."

As the news spread about my mother's accident, I received concerned and sympathetic letters from friends and relatives. Marie Scherr wrote on July 13 from London where she was vacationing: "My poor dear little Angiepomme. I have just received word from Edna of your poor Mother's accident. It is

dreadful and I can imagine your dismay and all that your Mother must be suffering. Please tell her how deeply sympathetic we are—What a sad end to all your happy plans for a summer in Brittany."

From Ellsworth Woodward in New Orleans came a letter dated July 19: "Your father just called with the dreadful news of your mother's accident. What an outrageous monkey-wrench for fate to throw into the machinery of her holiday and yours! To spend ones time in a hospital bed instead of delectable days at Quimper [Brittany]—we are dreadfully upset. Of course we are trying to believe that the break is in a good place and will mend rapidly so that by September you may both take the belated holiday."

"I wish in the mean time that there was some thing we could do to help amuse and console. Fortunately you have plenty of friends close at hand who can do that. I shall hope that the weather is cool. The boiling which I had to put up with in hospital stays in my memory as the worst feature of my experience. Give your mother our love and sympathy. You both have a reserve of cheerful courage which will find the best in a distressing situation."

With my mother in the hospital, it was impossible to continue my previous work schedule. I did, however, occasionally stop by the studio just to see what was going on. I had not been there for several days when I had a definite feeling that, for some reason, I should go. When I walked in Bourdelle was talking to a tall, young American man. Le Maître turned to me and said, "Mademoiselle, I am so glad you have come. My wife was to show this compatriot of yours through the studios, but she has been detained at the Greek embassy, so will you show him through?"

I was pleased beyond words, for Bourdelle handed me a huge bunch of keys to the studios that no one besides le Maître and Madame opened. The young American and I started off and I was amazed at the educated and knowledgeable comments he made at every studio we came to. When we reached the last studio I said, "You understand Bourdelle's work so well, technically and in every way, that you must be a sculptor." I nearly fell over when he replied "Oh no," and handed me his visiting card that read "Walter Agard." He was the American art critic who had authored the article that had first inspired me to study with Bourdelle, the "Bourdelle, Lover of Stone" article in *International Studio* that Ellsworth Woodward had flung on my desk my sophomore year at Newcomb. Agard was in Europe, traveling during a break from his work as professor at the University of Wisconsin. He was a great admirer of Bourdelle's work, particularly its architectural qualities. Our meeting led to a friendship that endured for many years.

That astonishing coincidental meeting was just one example of the many times that events in my life have come "full circle." Another such event occurred when I was sculptor-in-residence at St. Mary's Dominican College in

New Orleans. I had dashed over to my office on a Sunday afternoon, some-
thing I rarely did. On my way in I passed a security guard[7] who greeted
me and asked if I was Miss Gregory. When I told him yes, he said he had
been wanting to meet me for many years because his grandfather had been
the sculptor who had done the stonecutting on the Newcomb Chapel! Well,
I nearly expired for here was the grandson of the man who, thanks to all
my mother's stories about those stone carvings, had inspired my career as a
sculptor! We chatted for awhile and I asked if he had any of his grandfather's
work, which I told him would be quite valuable now. He replied that he only
had some of his tools. I took down his name, which I still have in my files,
but I never saw him again. I just never pursued it. Perhaps some part of me
wanted to keep the lovely coincidence of this meeting intact.

While my mother remained in the American Hospital, I searched for new
accommodations for us. She was unable to climb stairs and the Hôtel du
Danube had no rooms available on the ground floor. I had already moved out
of the hotel, taking a room at a pension near the hospital so I wouldn't be
spending half my time on the Métro between Neuilly, the suburb where the
hospital was located, and Montparnasse. On Sunday, September 4, I wrote to
my father from my mother's room in the hospital: "Mama is sitting in her big
arm-chair by the window—with 'the leg' perched up—and I am on her bed. Its
a marvellously constructed bed—it winds up—so you can be either perched
up or down flat! Yesterday—after lunch at Uncle Ray's—on his suggestion
Edna went with me to look at the studio room at the University Club[8]—4,
rue de Chevareuse—(between Blvd Montparnasse & rue Notre Dame de
Champs)—for I was afraid that it being on the ground floor would cause it
to be too damp—However upon finding it had a cellar below & was one step
from the ground—it seemed eligible. It is rented for 1000 frs. ($40.00) per
month—& there is a Salon, called the 'International Salon'[9]—It has sky-lites
all on one side with curtains—so that it has the appearance of a real studio.
Heating à la chauffrage centrale [central heating]—There will be cots which
appear as lounges in the day time—in fact the whole appearance will be a
studio-apartment rather than a bedroom. It looks out on a charming garden—
& the courtyard is attractive."

"The heat was a little too much for me last week & I feel so tired & weary
that I've decided I must get a little rest before I really begin to work again. So
I'm going off and leave the darling again & visit the Roszak's for a few days.
Mama could never make the trip in her present state so we've discarded the
idea. I think the rest & relaxation will do me good."

The trip was just what I needed, as I wrote to my aunts on September
7: "I came up here to the Chateau Dieppedalle—chez M et Mme Roszak—
yesterday afternoon & at last I've found that thing called REST—Oh! how I

wish you were here with me! I am at present taking a sun-bath—and if the écriture is a peu [writing is a little] wobbly its because I'm squinting! There [is] a 'deliscious' breeze blowing—and the boats which go up & down the Seine in front of the Chateau—lend a little 'movement' to the otherwise 'dead country'—The garden is a mass of flowers—and the trellis covered with roses—The six little Roszak's—are quite sweet and I'm so amused at their calling me 'meese'—You see French people called young girls 'Mlle'—with out the name. So they just translate it & I haven't the heart to tell them how funny it sounds. They have done wonders since I was here in 1926—There is a beautiful tennis court—fixed my [dears] with a cunning little terrace at the end for 'spectators'—and the court is bestrung with electric lites so that one can play at night! 'Épatante [Fantastic]'—I say—I left Mama in good spirits yesterday and I think she's a darling to let me run away for a little rest—She & I both feel we must not get too dependent on one another."

When I returned to Paris, we moved into the room at the American Women's University Club, commonly known as Reid Hall, where we happily settled in. The Hall served as home and meeting place for American students. I had always avoided it for that very reason, because of my desire to meet as many Europeans as possible. But by the time I moved there with my mother I had already established my French "roots," had my French friends, and felt free to meet and enjoy the other Americans who were living in or just visiting Reid Hall. Not only was I able to secure a ground floor apartment, but meals could be obtained in the dining room as one wished and there were evening activities in the Salon. Add to these benefits convenience, for the charming courtyard was just across the street from the Grande Chaumière and Bourdelle's studio was a relatively short walk away.

The Hall was directed by Miss Dorothy Leet,[10] a charming and talented young woman who was a skillful manager and who became a dear and lifelong friend. She served as director of the Hall from 1924 to 1938, and again from 1946 to 1964. Among her awards from the French government were Knight (1934) and Officer (1949) of the Legion of Honor. Over the years she served on numerous committees and boards that promoted international student exchange programs and scholarships, was national secretary to the Foreign Policy Association in New York, and was president of the International Federation of University Women from 1952 to 1956.[11]

By October, ensconced in our new home and with my mother recuperating nicely, I was happy to get back into full swing with my work, as I described to my father in a letter written October 7: "I've been working at Bourdelles in the mornings—with an English woman, Mrs. Milward[12] who has been a friend of the Bourdelles for many years & who was in his 1st Class at the Gr. Chaumière. We have taken a model for the portrait, for 4 mornings

a week and I have been quite enthused with what I've been accomplishing. I have been doing some drawing in the afternoon—but I am trying not to do too much & my schedule is certainly a very light one at present."

"Bourdelle is such an old dear & asks twice a day about Mama and is as kind as always. It was interesting to see him 'up in the clouds' when he was doing the Hindu Messiah's portrait—He is more 'on the earth' now. Its wonderful to see such enthusiasm for a man of his years."

The Hindu messiah I mention was, of course, Krishnamurti. He was one of the most beautiful men I have ever seen, as evidenced by Bourdelle's stunning portrait bust. I think that Bourdelle captured in Krishna's portrait the same marvelous qualities contained in his head of Apollo: simplicity, strength, and character. Bourdelle was very taken with the young Hindu and told me once that if he were younger he would put away his sculpting and follow him. Their friendship lasted for Bourdelle's lifetime and then was carried on by Madame Bourdelle and Rhodia.

Krishna was quite young when he was posing for Bourdelle and the story is told that although the girls were all crazy about him, he seemed quite indifferent to them. Bourdelle found this surprising and said, "Krishna, I don't understand. I, who am now old compared to you, am still sensitive to the feminine charm, but you seem to be completely indifferent although you are a young man." Krishna answered, "You think you are younger than I am, but you are not. I had many lives before you did, many more lives, and I had that sort of satisfaction and pleasure with women in different lives. But now I am old and have had enough of it." Bourdelle was a bit dumbfounded by Krishna's reply, but was moved by it.

Bourdelle's impressions of Krishna's philosophy are expressed by the beauty of the portrait bust, just as le Maître's love and admiration for Ludwig van Beethoven's[13] music are expressed in his hundreds of sketches and numerous sculptures of the German composer. Bourdelle thought he resembled Beethoven in appearance, especially as a young man when he had possessed the same kind of untamed and voluminous hair so characteristic of Beethoven.

As my mother continued to regain strength, she had more opportunities to view le Maître's creations firsthand and to see me at my work in his studio. Her true purpose in coming to France, however, had been to determine the cause of my constant tiredness and poor health, as she told my aunts in a letter dated October 10, 1927: "Angel is so carried to the heights of Bourdelle that it is a pity she is not built like the big Englishwomen who sculpt. But I encourage her to keep up the ideals, for as soon as we lose them, where do we land? I am sure Angela did not wear warm enough clothes. The old brown

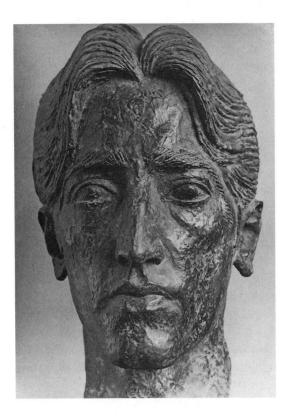

Jiddu Krishnamurti (1927–28) by Antoine Bourdelle in Musée Bourdelle, Paris. Photograph by David R. Muerdter, 2016.

sweater suit of Betty's, I am fixing into a sort of smock to wear at Bourdelle's under her smock. Any old thing does, but it has to be warm."[14]

On October 11, my mother wrote to my sister and her husband: "Angel went over to Bourdelle's today with great vigor after her drawing yesterday. She certainly has grasped anatomy and that is the great battle. We are happily fixed here at the American University Women's Club and Angela has not been as comfortable or so near Bourdelle's. It is also one rue de [one street from] la Grande Chaumière at rear gate, so Angel can go over to the 'croquis [sketch]' classes in the afternoon. She brought back some fine sketches this evening."

"We are more thankful that we came here. It is simply lovely. Vespers in St. Luke's 'tin chapel'[15] just ten steps from our door at 5:30 on Sunday. A lovely concert and coffee and dancing in the assembly hall, making a very lovely opportunity for one to hear good music for nothing and enough social life to keep the students from getting restless or homesick. Miss Leet, the manager, is a lovely young woman from New York."[16]

After a long hiatus from keeping up in my journal, I resumed writing on October 12, 1927: "Bourdelle took us in to show us the portrait of Kristian-murti. He used the putty colored clay because it is less flattering than ordinary clay. It is the most wonderful piece of modelling I've ever seen!" I understand much better today Bourdelle's reasons for choosing to model Krishna's portrait in that particular color of clay because I have learned through the years that clay can be very misleading, especially when the clay itself is a beautiful color. Lighter putty-colored clay allows you to see the form better and helps you to better correct your errors. It helps you push a piece of work as far as possible and to the most complete point. In Bourdelle's portrait of Krishna this technique resulted in work that was small and intimate in scale yet monumental in spirit.

On October 27, after a criticism at the Grande Chaumiére, I wrote in my journal: "'La verité depasse le compass [The truth goes beyond the compass].' Just as the letter in literature represents the thot and the 'esprit [spirit]' is other than the letter itself, so the compass gives us the truth but there is still the 'esprit' which must be 'caught.'" It is true that the esprit of which Bourdelle spoke can be expressed in a sculpture. Before it can be translated into art, however, this spirit must first exist in the soul of the artist. If you haven't got it in yourself, you can't put it into your work. I wrote of this in my journal entry of November 8 after his criticism at the Grande Chaumière: "How can I make you realize that it is 'l'esprit qui conte' [the spirit that counts]? It is the man's personality & character that makes the work what it is."

Bourdelle often repeated this philosophy and over the years that I knew him, I gradually began to think of it as typifying his whole attitude toward life and art. With this lesson Bourdelle helped me learn that sculpture is not just a matter of reproducing the form with the compass. The compass gives you exact measurements, the dimension from the nose to the eyes, for example, but sculpture goes way beyond measurement, just as Bourdelle's portrait of Krishnamurti went far beyond being a simple representation of the man. When I returned to Paris in 1932 and studied again in Bourdelle's studio, this time with Madame Bourdelle because le Maître had died in 1929, she taught me the technique of using calipers to do a portrait. I applied it to the portrait of a person I was sculpting, but there is no truth to that portrait and I have never liked it because I stopped too soon. I didn't push it beyond a system of measurement and into the realm of personality and feeling, both my own and that of the subject.

Bourdelle spoke of the importance of the structural basis of sculpture during that same November 8 criticism: "When you do a figure you must remember that under this skin there is a system of structure that holds it all together and makes it solid. Just as, when you go to make soup—& you turn

on the water—you do not stop to think that that water reaches you instantly because the city of Paris is a mass of pipes & structure. So trees & human figures are built on structures."

Structure and skeleton were very important to Bourdelle and he considered them thoroughly in everything he created. He once said that the outside of the statue should be held from the inside, almost like a horseman holds the reins of a horse. When planning a figure he considered the skeleton as the foundation. Even if the statue was to be clothed, he would first model it in the nude to be sure that the proportions and position were correct.

Bourdelle used to tell us the story of working on Rodin's *Balzac*,[17] a dramatic robed figure that stands at the intersection of Boulevards Raspail and Montparnasse in Paris. Bourdelle spent months working on the anatomical structure of the knees for that sculpture. He knew that Rodin would eventually drape cloth over them, but even so, the figure had to be absolutely anatomically correct.

As I struggled to incorporate Bourdelle's discipline and high standards into my own approach to sculpture, I asked him to write me a letter of recommendation. In planning for my future, I had decided to apply for a grant from the Guggenheim Foundation.[18] The Guggenheim Fellowships were much sought after, of course, and very difficult to get. I had already applied for one in 1925, just prior to coming to France, but my efforts had been in vain. On the advice of a friend of my father's, I decided to keep my name before the committee each year. Uncle Ray helped me fill out the application. I then asked Bourdelle for the recommendation, explaining that I wished to apply for a bourse [scholarship]. When I did so he didn't even wait for an explanation but dashed out of the room and proceeded to write the letter. I was very proud to possess that letter for it further strengthened my feeling that I need never have any fear of being unwanted in his personal studios.

The letter was dated November 15, 1927, and the English translation read as follows: "It will be necessary for you to continue your work of sculpture in stone and of modelling in clay for another year or even two. Also, you need to go on with your study of drawing from the living model in my private ateliers. Your sculpture in stone is very fine, and you have already acquired valuable knowledge of form, but sculpture is an art so far-reaching and so profound that you must press on in your research, developing more and more the great qualities of which you have already given proof. Your future in art, which is most promising, demands at least another year—I would prefer two—of continued study in my ateliers. To your mother and to you my affectionate regards, Antoine Bourdelle."

Around the time that he wrote this letter I think he was feeling especially proud of me, for I had finally finished the *Beauvais Head of Christ* after some

seventeen months of arduous work. I hardly paused to celebrate, however, for I immediately plunged into new work I had put off in favor of finishing the *Head*. I was busier than ever and, with my mother improving all the time, she began to feel like getting out and seeing more of Paris.

Later in November we had a visit from Dr. Rudolph Matas, the world-famous surgeon from the Tulane Medical School and a close family friend who was also a member of the American Hospital's Medical Advisory Board in the United States. He was on a brief trip to Paris and, after he checked on my mother and found her doing well, I had the great pleasure of introducing him to Bourdelle. They were both very small men, about the same height, and they stood talking to each other, in French, as only two brilliant people can do. I was thrilled to be able to present the greatest sculptor in the world to the greatest surgeon in the world.

Eleven years later, back home in New Orleans, after I had established my own studio and reputation as a sculptor, I received a letter from Dr. Matas, dated July 1, 1938, in which he recalled his visit to Bourdelle's studio: "My dear Miss Angela, It is very lovely of you to have reminded me of the beautiful days in Paris when I saw you laying the foundations for your own immortality. I can still hear the voice of the great master saying: 'Oh mon cher Monsieur, quel bon heur d'avoir connu cette belle fille! Son talent est un vrai trésor qu'elle ne tardera pas long a verser par toute votre terre Louisianaise à mains pleines d'or [Oh my dear Monsieur, what good fortune to have known this lovely girl! Her talent is a true treasure that she won't wait long to pour throughout your Louisianian land to hands full of gold]!! And who can now deny 'que le bon maître était aussi bon prophète [the good master was also a good prophet].'"

My mother's presence in Paris really did change my life and, in many ways, for the better. She had a wonderful knack for meeting people. Whereas I had been trying to keep to myself and concentrate on my work, she pulled me into more of a social life which, I have to admit, I found rather enjoyable. We managed to remain quite independent of each other though and she was, of course, always supportive of my work in the studio and at the Grande Chaumière.

Around mid-December, Herbert Stone,[19] a New Orleans family friend who was living in Paris, appeared at one of Reid Hall's Sunday evening Salons and came over to speak to my Mother and me. These Salons, organized by Miss Leet, were one of the best parts of living at the Hall. The programs often introduced young musicians who needed an audience. Sometimes there was a speaker; and, Tolstoy's daughter[20] spoke to us once. Stone returned again the following Sunday, this time bringing a young friend and fellow student at the Sorbonne, Joseph Campbell.[21] Joe was a Columbia University[22]

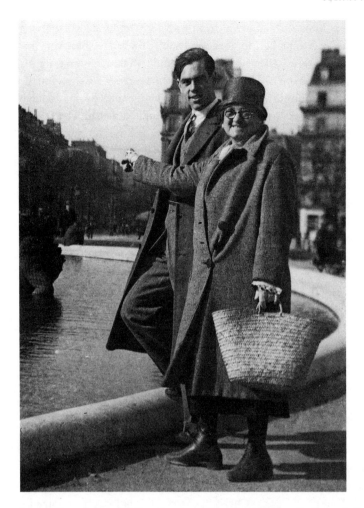

Joseph Campbell and Selina Gregory, Place de la Nation, Paris, 1928. Copyright ©
Joseph Campbell Foundation (jcf.org). Used with permission. Courtesy of Angela
Gregory Papers, Louisiana Research Collection, Tulane University.

graduate who was at the Sorbonne on a fellowship. He later went on to be-
come a very distinguished philosopher, mythologist, and writer, and he was a
professor for thirty-eight years at Sarah Lawrence College.[23] He received the
1985 National Arts Club Gold Medal of Honor in Literature and, before his
death in 1987, he completed a six-part Public Broadcasting Service series with
Bill Moyers on mythology.[24]

I remember that after the Reid Hall program that night there was music
and Joe asked me to dance. We began to talk about what each of us was do-
ing in Paris and he said, "So you're studying sculpture. I don't know a thing

about art." I might have walked away from him right then, except he was such a good dancer. So to make conversation I said, "There are some very interesting people who come to Bourdelle's studio and I often open the door for them. Just this morning I opened the door for Krishnamurti." "Krishnamurti!" he exclaimed as he suddenly stopped dancing. I had not expected him to have any idea who Krishna was, but it turned out that Joe had met him on a ship going to London a few years before and was thrilled to know that Krishna was in Paris. Though the two of them had become quite good friends their paths had not crossed since. When Joe met him on the ship, he had no idea Krishna had a worldwide reputation as a philosophical and religious leader.

The year was drawing to a close and, with my mother still a bit weak, we decided to spend Christmas in Paris. I attended a midnight mass at St. Eustace[25] with two other people from Reid Hall using a ticket Miss Leet had offered to me. "Unfortunately our places were behind the altar & the people walked in & out & over us & frankly I did not feel religious in the least," I wrote to my father on December 26. "The 'Noël'[26] was beautifully sung but the other music was less inspiring so we left a little after one."

"Mama & I had a little Christmas tree—& our many little packages piled around—and at 2:30 A.M. instead of going to bed we sat up & squealed with delight over our cadeaux [presents]—I haven't had a real Christmas for so long I was literally childish! Miss Scherr sent me a quaint little match box with a lovely card saying—that the divine spark didn't need lighting but the studio fire does. Edna sent me an ancient livre [book]—cut out like a box. Lucile gave me a lovely flower—& Uncle Ray gave me a luscious box of candy when we went there to supper last night. The nicest gift of all—was 'The Crock of Gold' by James Stephens[27]—It is the most delightful book I've read in years. The inscription reads—'To—Mrs. Gregory & Angela from Herbert K. Stone & Joseph Campbell—Paris, Christmas 1927.' It was Joseph's choice as book so Mr. Stone tells us—& they wanted to give us something together. We have greatly enjoyed reading it aloud."

"We really had a most delightful time. Mr. Stone came to dinner with us here. He has pepped up so since meeting Joseph & Mama that he's quite an amusing old dear. . . . At 7:30 we went to Uncle Ray's to supper—Edna & Jo a. were there—& we enjoyed the quietness of a 'home.' We sat around the fire & talked for awhile—& Mama & I came back to the Club in time to join in the caroling of the 'Students & Artists Club'[28]—which was having its big Christmas dinner here. We watched the dancing—I say watched as Joseph Campbell wasn't there to ask me to dance."

"I must say I was dead to-day—but went to the studio for a little while. Was delighted with the pictures that M desausse had taken of the 'great stone head'—They are épatant [fantastic]."

As 1928 began I was working on the portrait bust of a beautiful young American woman, Adelaide McLaughlin,[29] who was also staying at Reid Hall. Seeing her across the dining room as we sat eating one day, my mother had said, "If you want a beautiful model, there she is." So thanks to my mother's artistic eye and knack for meeting people, we introduced ourselves, got to know her, and she consented to pose for me in Bourdelle's studio.

I introduced Adelaide to le Maître the first day I took her to the studio and he too was very struck by her classic features and beauty. Even though he was nearing the deadline for finishing his monument of Mickiewicz, he decided to do a portrait bust of Adelaide himself, much to Madame Bourdelle's despair, for she was greatly concerned about his finishing the monument on time. Bourdelle advised me a great deal on my own portrait of Adelaide and, a few weeks later, used it as the starting point for his own work. I considered this a great honor.

"I am very thrilled because Bourdelle has asked me to give him a clay cast of the head I'm doing now so he can continue it!" I wrote to my father on January 22. "Miss McLoughlin has consented to pose for him." Then, in my letter, I refer to the fractured French I used when Bourdelle had entered the studio and was surprised to find us there.

"He nearly died with laughter yesterday—& said 'Mlle if your career as sculptor doesn't work you might try French'—You see I said 'Oui, nous vient d'arrivons [Yes, we comes arrive].' Instead of saying 'Oui, nous venons d'arriver [Yes, we just arrived].' It evidently sounds queer to a Frenchman for Bourdelle collapsed into a chair & laughted like a child. As his laugh is contageous we all were hilarious—Periodically he would dash into the room & laugh. He said he couldn't work all morning because he kept thinking of my 'phrase [sentence].'"

In my February 2, 1928, journal entry, I recorded Bourdelle's critique of my clay model of Adelaide: "'Très interessante Mlle—un peu froide, mais c'est bien construit—interessante [Very interesting Mademoiselle—a little cold, but it is well constructed—interesting] Oui, vous pouvez l'exposer. Si vous n'avez pas l'intention de faire un moule je voudrai l'avoir fait parceque j'aurai besoin pour que je puisse employer votre buste et c'est moi qui payerai pour la moule [Yes, you could exhibit it. If you do not have the intention to make a mold I would like to have one made because I will need it so that I can work from your bust and it is I who will pay for the mold]!'" I assured him I was having a mold made anyway and it was something I could use later as well. But he insisted on paying for the making of the mold.

The next day, as I was working on Adelaide's head, Mama, Joseph Campbell, and his father[30] visited the studios and were shown around by Madame Bourdelle. "When we saw Bourdelle he greeted Mama cordially and said—

'Madame, votre fille travaille très bien—Elle aime beaucoup son travail [Madame, your daughter works very well—She loves her work very much]'—Mama replied—That she'd <u>like</u> to believe so—Bourdelle got very intense & said—'Avez-vous vu sa tête à coté—C'est <u>très</u> bien?—et la pierre [Have you seen her head next door—It is very good?—and the stone]?'"

"I told him that Mama had always wanted to do painting & sculpture & he turned to her & said, 'Ah! Madame—if one has had art in ones life—no matter what comes to them in live [life] they will be happy because of this possession.'" [31]

I decided to take a break from art and the work of sculpture for a few weeks and travel with my mother to southern France to meet Madame Martin and the Brès relatives in Villefranche. I described our trip in several letters home, beginning with a letter to my father dated February 13: "Never has France seemed so beautiful to me as on this trip South—Avignon swept me off my feet—again—The Palais des Papes [Palace of the Popes][32] by moonlite was incredibly beautiful. . . . Les Baux[33]—sitting in ruins on the rocky—solid rock hills—was uniquely thrilling. We were tired Saturday and so did not stop in Marseille as we had planned—but reached Cannes at 8 in the evening. We missed Madame Martin at the Gare [train station]—and so came up to [Villa] Lolita where Tommy barked his greeting."

"Sunday dawned a beautiful day with its blue, blue sky—so blue that Mama burst into my room in the morning to know if it were 'really true'! . . . This afternoon M<u>me</u> Martin suggested we take the drive of the Corniche d'Or [Gold Coastal Road]—as far as Agay—Mama was overcome with the beauty of it all—and the view of the Alpes [Alps] in the distance—It was indeed a wonderful afternoon for 80. cents apiece."[34]

I wrote to my aunts from Villa Lolita on February 17: "This lovely sunshiny weather of the Riviera, so like our own has gotten into my lazy Southern bones and I eat and sleep and do not write the letters that I'd really like to have energy enuf to write. Yesterday was the 1<u>st</u> rainy day I've seen on the Riviera and so we spent the afternoon at the Cinema—Saw 'Apartments à Louer' and 'Music-Hall'[35]—both American films—The 1<u>st</u> stopped so abruptly that I'm sure it was cut in half—The other was most amusing."

We then traveled to Monaco and Nice where we watched a Mardi Gras parade. I continued the letter to my aunts on February 20: "We went in the afternoon to Montecarlo,[36] & I taught my Mama how to gamble. She's better at it than her daughter & won 80 frs.—Yesterday we had places on the 'Tribune [Grandstand]' in order to see the Revue pass—They had floats dating from 1874—! & they were crude compared to ours but very effective & more amusing—The maskers that accompany the floats carrying enormous grotesque heads are the most effective part of the whole parade. Yesterday

between 2 and 4:30 they were permitted to throw what they call plaster confetti—I enclose 'samples' in the little piece of paper—It stings if thrown hard—so its necessary to wear wire masks to keep from being mutilated."

"The weather is glorious & this afternoon we are going over to get our hairs cut so as to be presentable on Wed. or Thursday when we go to see the Cousins."

I described our time with the cousins in a letter to my sister written February 25: "We had a delightful day in Villefranche with the Cousins—Mama's French was most effective & the dear old Mme Catherine Brès Montolivo[37] was quite overcome with emotion at meeting a real Brès. She presented Mama with a handsome cane to carry to Papa—a cane which belonged to her father Joseph Brès—who visited Grandpa Brès[38] in Monroe so many years ago. Mama says that after meeting the French Brès she's more than ever proud of her French blood! I felt the same way 3 years ago—& more so now after knowing so many French.We enjoyed the Carnival in Nice—staying there five days. I don't want to be 'snooty' but N.O. can put it all over on theirs!"

In the same letter, I wrote of my plans for when I got back to Paris: "The Salon [des Tuileries] will be April 20th & I hope to send two portrait-busts & my little duck but don't know—Also will have a little showing of my work at the Club[39] for the benefit of my French friends."

The little duck I mention in this letter was really a goose and was the result of some of the drawing Edna Vollmer and I had done together. We had gone to a park that included a small zoo. I had quickly sketched this one little goose, capturing the moment just before he turned to look skyward at a passing airplane. It was actually around the time that Lindbergh arrived in Paris. From this sketch, I had sculpted the goose, a piece that had a lot of life to it.

This little goose has always been one of my most popular pieces and I have sold many, many casts of it through the years. My first sale was to Tiffany's[40] in Paris, a sale made on the advice of Dr. Henry Durand,[41] a wealthy American I had met in Paris. He was interested in sponsoring young American artists and musicians, one of those backers of young people with potential for careers in the arts. He gave me a little squirrel pin once and explained he was giving them to all the young people he met as he went through life, particularly those in Europe who might have careers in the arts. He wouldn't tell me who else had received pins, but said, "Maybe fifty years from now you will meet somebody with this little Tiffany squirrel." Much to my regret I lost my own pin somewhere along the line and I have to admit I have yet to meet anybody else wearing one of his pins, but Dr. Durand's idea was a good one!

I had my goose cast in bronze, and when Dr. Durand saw it he told me that Tiffany's had a wonderful collection of bronze animals. At first I had no desire to try and sell it. Then one day I got up the nerve to hop in a taxi and

go over to the Right Bank, goose in hand, and walk into Tiffany's, which was located in the most expensive part of Paris. On the way over I had been thinking I would ask $50 for my sculpture, but at the last minute had decided that if it was worth $50, it was worth $75. When the man behind the case filled with bronzes asked me my price I told him $75. He replied that was more than they paid Monsieur Pompon[42] who was a very well known animal sculptor. I turned to go, and then the man said, "Oh, but we'll buy it!" And so I made my first sale of sculpture, walking out with $75 in my pocket. My little goose was sent to be sold in the Tiffany's in New York and, when I returned home a few months later, I went into the store and asked what it had sold for. They told me, "$125," so the next time I sold the piece, I sold it for $125!

I was contemplating sending my little goose to the Salon des Tuileries exhibition. As an officer of the Salon's organizing committee, Bourdelle ensured that his qualified students were invited to exhibit at this annual event. Bourdelle himself, as well as many other well-known artists, exhibited there. It was truly "the thing" to be asked to participate in this Salon. Unbeknownst to me the deadline for submitting work to the 1928 Salon occurred while I was in southern France with my mother. The Bourdelles came to my rescue, however, and sent in the necessary application and fee so that I could exhibit the *Head of Christ.* When I returned to Paris and discovered they had done this, I was astonished and flattered beyond words. Bourdelle's desire to see me exhibit the *Head* was a complete surprise because it was, after all, a copy. But obviously he had seen enough originality in it to feel it was worthy of exhibit, along with my head of Adelaide, which would be completed by the spring when the Salon took place. Bourdelle's decision to allow me to exhibit the *Head* made Bänninger furious because he, evidently, considered it to be just a copy. Bänninger's reaction didn't surprise me and I ignored it, taking pleasure instead in Bourdelle's vote of confidence in my work.

My mother and I returned to Paris from southern France in early March, bearing with us the many paintings and sketches we had each made on our trip. We had stopped in Marseille to see Bourdelle's bas-reliefs in the Opera House and I found them unearthly in their beauty. Once back in Paris I took some of my paintings over to the Bourdelles' home to show them. It was the first time Bourdelle had ever seen any of my paintings and I could tell that he was, quite frankly, very surprised by their quality for he praised them highly. Later he told me, upon seeing a still-life I was working on, that he thought I painted like Matisse! To have Bourdelle, the great master who taught me sculpting, praise my paintings underscores so powerfully the irony of my choice to be a sculptor rather than a painter. Perhaps I really was more talented as a painter, but it was sculpting that captured and held my heart and ambitions.

I recorded both Monsieur's and Madame Bourdelle's reaction to the sketches from my trip in my journal on March 7, 1928:

"Mme Bourdelle: 'Comme elle a travaillé beaucoup [How she has done much work].'

Bourdelle: 'Le chose important c'est qu'elle a travaillé beaucoup et surtout bien. C'est pas du tout le travail d'un amateur [The important thing is that she has done a lot of work and above all good. This is not at all the work of an amateur]. Vos peintures sont bien Mlle parcequ'elles sont surtout bien dessiné [Your paintings are good Mademoiselle because they are above all well drawn].'

Mme Bourdelle: 'Ça l'aidera de faire la peinture, n'est pas [It helps her to paint, doesn't it]?'

Bourdelle: 'Mais, oui parcequ'elle construit [But, yes because she constructs]. Mlle quand vous painte un clocher comme ça (Carcassonne) il faut que vous pensez que vous contruisez un clocher—et que vous pensez—de la lumière autour le clocher. Et bien, c'est la même chose que quand vous faites un monument. Il faut penser aux mêmes choses [Mademoiselle when you paint a bell-tower like this (Carcassonne) you have to remember that you are constructing a bell-tower—and that you are thinking—of the light around the bell-tower. Well, it is the same thing when you create a monument. You have to think of the same things].'"

Soon after showing my paintings to the Bourdelles, I wrote to my father on March 8 about my plans for my work on Adelaide's head: "Your letter of February 23rd has just reached me. I had just come in from ordering a hunk of marble—which I hope to begin work on on Monday. I have decided to copy Miss McLoughlin's portrait in marble."

"It was interesting at the marble cutters—to see the work being done—M. Atenni sells all the marble to Bourdelle for his work and is going to sell me a block large enuf to do the portrait—for 190. frs & for 100. frs will have the largest hunks cut off so the worse part of the work will be eliminated. Bourdelle prefers for me to 'chercher les points [find the points]' if I possibly have time as he thinks it will be more helpful."

I was actually on the verge of running out of time, for my mother and I had made our reservations to sail home in late April. I was unsure I would be able to finish Adelaide's portrait bust in marble, which was already done in plaster, as I explained to my father: "I doubt if I can finish it in the marble in one month—as the heads must be delivered to the Palais du Bois by April

5th—The Vernissage will be <u>May 4th</u> instead of April 20 as I first thot—How I wish you could be here on that day. Its always an interesting thing to see all the artists glowing over their work!"

In the end, my Mother and I did change our sailing date so that we could attend the Vernissage. "My two heads will have to be left after my departure—as nothing can be taken from the Salon before its close. I shall arrange with an 'emballeur [packer]' to ship them to me later—& have some responsible friend to see that they are sent O.K!"

"Last night Mr. Stone and Joseph Campbell came over to 'welcome us to their village' (Paris) as they expressed it—It was rather cheering to receive a pneu [pneumatique] from Joe—to me & 'mother dear'—saying he was 'darn glad we were back'—Joe was rather excited because his Mother[43] had just written him that for his Birthday a year from this one which is in a few weeks—he'll receive a trip home 'around the world.'"

"We were amused at their enthusiasm over our sketches. Bourdelle had sent me way up in the clouds with his compliments—telling me that I could sell them like hot-cakes if exhibited—& that I was 'très douée comme peintre [very gifted as a painter].'"

On Thursday March 8 my mother wrote to my father and two aunts in her rather telegraphic style: "Angel's joy complete after Bourdelle's wonderful criticism of her 12 <u>oils</u> done in Avignon, Les Baux, Cannes, (Cimiez-<u>Nice</u>) Carcassonne, Montauban, Villefranche[44]—and the Invitation to Exhibit at Salon des Tuileries (4th May) and narrow escape we had made by probably <u>not arriving</u> till 8th for name to go into the Catalog—Also possibility of selling all of these small sketches—For we feel we ought to sell everything—And yet—we think you'd all enjoy them!"

Her letter continued over the next several days, reporting on our activities: "Snow & 27° still. Then Sun. 11— we went to Louvre at 11 A.M. & spent over an hour in '<u>Modern</u> Gallery' <u>Degas</u>, Van Gogh & Cezanne, Monet & <u>Manet</u> & others.[45] Degas was the man who paints women washing their hair or feet or half-sitting in a 'bath-tub.'"

Edgar Degas was related to the Mussons of New Orleans. His mother was the daughter of a Louisiana cotton merchant and from October 1872 to February 1873, Edgar and his brother René visited their uncle Michel Musson, who lived in New Orleans.[46] I later got to know several members of the Musson family in New Orleans and saw the beautiful bronzes that Degas had left to them upon his death, as well as his fabulous pencil drawings of members of the family.

My mother's letter continued: "Angel can not start her marble work till Thurs. as the block has to be chipped off for her—so she is only drawing in the

A.M's—(Its too cold to do anything really) <u>Colder</u> than any time except about one week around Christmas time."

She added more to the letter on Monday, March 12: "Angel & I went to the Rodin Musée this afternoon on Ave. des Invalides and then walked back up Rue du Bac looking in Antique Shops & peeping into Courtyards and across Blvd Raspail up to Notre dame de Champs & to rue de Chevreuse—All the better for it but tired—It was so cold, but gave us rosy cheeks! Rodin—well he certainly was fond of the same thing—Bourdelle is away up on a Pinacle compared to him—The Greek wife's wonderful influence & the Greek Art must have some thing to do with B's spiritual attitude to art—He is Great!! & it is wonderful, that he is so interested in our Angel for he has had bad luck with the Americans he had to instruct at 'La Grande Chaumière.'"

She continued on March 13: "[Angela] has had to pay 75F [francs] for the 'accepting to Exhibit at Salon'—and it seems like F.s [francs] soon mount up—If she had had tuition to pay, I don't know how she could have done it. The <u>Sunshine</u> was glorious Sunday and Monday—but cold oh so cold—Fortunately, The U. Club gives good heat and warm 'hashy food.'"

The warmth and food at the University Club were always accompanied by intellectual nourishment at Bourdelle's studio. On March 15, 1928, I wrote in my journal what he said to a group of visitors at the studio: "Bourdelle ask [asked] them to ask questions & someone wanted to know if Bourdelle used Dynamic Symmetry & what he thot of it. It was like turning on a button. Bourdelle began to talk—He said that among his pupils was—Mlle Bergson the daughter of the great philosopher. Tho she is deaf & dumb she took notes on Bourdelles lectures by reading his lips. In this way her father became eager to question Bourdelle about his ideas & his sculpture. 'The sculptor works in a material that is eternal—stone—that is the difference between his work and human material, flesh & blood which must perish. The sculptor tries to 'translates'—If a human figure were left upon a mountain side—it would perish with the ravages of time whereas—stone is eternal. 'Mortal defects'—therefore should not enter into sculpture.'"

"Bergson once asked Rodin why the sculpture on Parthenon was so beautiful—Rodin he said did not answer him—'Was it because he did not want to or because he couldn't?—' asked Bourdelle. 'Because he didn't want to' replied Bergson. However he did say—'Because of the marvellous play of light & shade.'"

"If, said Bourdelle, you had a statue in sculpture, say—a peasant with a basket on its head—and this statue was badly done—all details false—all proportion wrong—do you think that the play of lite & shadow on it would make it beautiful? If however it was beautifully sculpted—then the lite & shadow

would only be a part of it—it cannot make it good or bad—'C'est le sculpteur [It is the sculptor]' who makes it beautiful or not."

Joe Campbell was very intrigued by the differences between Rodin and Bourdelle and on February 21 he had written to me: "I've also been to the Rodin Museum, and the contrast with your little Bourdel's studio is quite interesting. The lack of variety and of repose I found surprising, and I couldn't help thinking of all the wonderful variety 'chez Bourdel.' Everything Rodin ever did seems to be throbbing and uncomfortable."

In Bourdelle's studios the atmosphere was somewhat subdued for le Maître was ill and he often stayed at home. After one stint of absence from the studio he teased some of us: "'L'atelier est triste sans le patron n'est pas? Vous devriez venir à la maison avec des mouchoirs plein de larmes! Vous êtes tous ingrats [The studio is sad without the boss isn't it? You should have come to the house with handkerchiefs full of tears! You are all ingrates]!'" I wrote in my journal on March 15.

Although I was well aware that Bourdelle was quite frequently away from the studio, I did not grasp that his health was declining. I suppose I expected him to live forever, in that way young people have of viewing death. Little did I suspect he would die within two years.

ART AND FRIENDSHIP

GETTING TO KNOW JOSEPH CAMPBELL ⟩

About a week after Bourdelle's return to the studio, Krishnamurti had lunch with le Maître and Madame at their home, as I wrote to my Aunt Katherine on March 24, 1928: "Oh! I must tell you about what happened last Tuesday— About 8:30 in the morning—Zezette phoned to tell me that M<u>me</u> Bourdelle asked her to let me know that Krishnamurti had lunched with them the day before and they had spoken to him of Joe Campbell and he had begged them to tell Joe to speak to him after his conference which was to be Tuesday nite at the Theosophical Society Hall[1]—and M<u>me</u> B. wanted us & Joe to know about the Conference."

"I sent Joe a pneumatique which he found when he went to his room at 7 o'clock so he was all excited when he turned up at the Conference about an hour later. He met Krishnamurti on the ship coming to Europe (some years ago) and they became devoted friends—Joe didn't know for months, (until he read in the paper) that Krishna was called the Hindoo Messiah etc! So Tues. was the first time he heard K's 'message'—He grasped Joe's hand as he went down the aisle (hadn't seen him for two years)—& they had a chat with one another afterwards & arranged to see one another in Paris in June when K. returns from America."

I recall that I went to hear Krishna speak with Lucille Soniat and Clare Wadleigh, an American friend.[2] To me, Krishna's ideas sounded like the Unitarianism I had been raised on. Joe had come in late to the speech and took the only seat left, a tiny strapontin [fold-up seat] on which he had to perch because he was so tall. I remember Joe telling me later that he went to Krishna's hotel afterward and they talked far into the night.

I think that reunion with Krishna changed Joe's life, just as meeting Bourdelle changed mine, for Krishna was to become a powerful and directive influence on Joe's thought and philosophy. In the years that followed my departure from Paris, I received several letters from Joe in which he told me of

the times he saw Krishna. Bourdelle too runs like a common thread through many of these.

On July 17, 1928, from London, Joe wrote to me only a few months after I had returned to New Orleans: "Just before leaving Paris I had a delightful talk with Krishnamurti. He filled my head with astonishment at his own magnificence. Krishna, more than anyone I know, is like the person I have wanted to be." On August 21, he wrote from Deauville, France: "After a delightful visit to Krishnamurti's castle in Holland,[3] I can scarcely think of anything but the wisdom and beauty of my friend. I walked with him in the woodlands which are all about his home. He answered me my questions and thrilled to the beauty of trees. He gave me a great deal to think about, and set me off on a quest for something which I scarcely understand. Every time I talk with Krishna something new amazes me."

"Krishna's place in Holland is called Eerde—and it was given to him by the baron who owned it. There are five thousand acres of lovely woodlands, with a fine old castle set in the midst of everything. A moat is around the castle, and in it are goldfish as big as carp, water-lillies, and white swans. Gardens are there with an old wall around them, and outside the wall are the trees. The place is peaceful and very beautiful."

He sent a letter from Paris written August 27–31, 1928: "The letter which you received from Bourdelle must have been delightful—the little quotations sound exactly like le maître: 'Le seul succès véritable vient de la bonne qualité de l'ésprit, c'est à dire des réalitiés de l'âme [The only real success comes from the good quality of the spirit, that is to say the realities of the soul].' That's good enough for a motto!—It says a very great deal—and the more one thinks about it, the more it says. Bourdelle is a wise little man—and even to think of him is inspiration."

On September 9, 1928, in another letter from Paris, he sent me some quotes about art: "'Art does not tell us of any one individual's passion, love, or regret, in this or that particular situation, but it tells us of Passion, and Love, and Regret themselves. We go behind then, in art, from the particular-in-time to the general-in-eternity. However small be the size of the thing the true artist creates, there is in that thing something of the totality of the universe.' Now what do you think of all that? It rings echo in my mind of things which Bourdelle used to say. That's a bit of wisdom which a Hindu gentleman named Jinarajadasa[4] had to give me. He seems to me a very wise little man."

The "wise little man" who was influencing my life was still Bourdelle, of course. I wrote to my sister on March 25, 1928: "He [Joseph Campbell] & I & Mama went up to the Trocadero in the afternoon and heard a paper written by Bourdelle (which he was to have read himself but illness prevented) and enjoyed walking among the wonderful casts of sculpture from the various

Cathedrals of France. We also heard a very interesting lecture on stained glass windows—illustrated by glasses made from scrapes from the 12th & 13th Centuries. It was interesting to inspect the way they are made 'close up'—This afternoon Joe & I are going to a 'Soirée' at Zezette Bunand's (Bourdelle niece)—and I am curious to see what it will be like! She has also asked Adelaide McLoughlin—'La belle Americaine'—who posed for me."

On March 25, I wrote more about the soirée at Zezette's (whose other name was Fanny) in my diary: "Went to Fanny Bunand's to a Soirée—with Joe at about 5 o'clock. She looked lovely in a Lanvin[5] model. Joe enjoyed the Couchoud apt. which is filled with wonderful books and many things by Bourdelle & memories of Anatole France who was a great friend of Fanny's stepfather. Joe & Mr. Stone came to dîner [dinner]—to celebrate Joe's 24th Birthday—Afterwards went into concert where Pachmann[6] played beautifully. Danced afterwards—Enjoyed it lots!"

About a week later I learned from the Guggenheim Foundation that I had not received a fellowship. My reaction was fairly philosophical, however, partly because at this point in time I was feeling ready to go home. I had been away long enough and a Guggenheim would have meant at least another year in Paris. "So now my future is definitely settled and a 'calmness has entered my soul,'" I wrote to my father on March 31. "For as much as I longed to go home & be with you and all the family—the thot of a possibility of staying on in Paris hung over me a tiny bit—and now at last every trace of shadow is removed."

"Bourdelle asked me just the other day if his letter had been of service to me—and he said one nice thing that I will treasure always. I said I'd like to stay until I was stronger in my work & he answered—'Oh! You are already prepared & able to work alone (assez forte [strong enough]) & when you go home you must keep in touch with me by letter & send me photos of your work and I'll write you back my criticism.' It was a sweet offer—I haven't seen him to tell him that I didn't 'measure up to the Committee's' judgement—but I know he'll say as I did 'They just don't know good sculpture when they see it.'"

"Last night we celebrated Bun's birthday by going to hear 'La Tosca' at the Opèra-Comique [Comic Opera]—Wm Martin the much talked of young American tenor was starred and he has a beautiful voice.[7] Mama asked Joe Campbell to go with us to represent Bun as it were—& as he loves music so much we enjoyed having him along. We ended up at the 'Cupola'[8] the new Café—Restaurant of Montparnasse—where we drank malted milk that tasted like the real thing!"

"On Tuesday last we had a party in our studio. Monday evening—Joe burst in to say that his mother had had the Manager of the Hotel Chambord (where his father always stays) to send him a huge bunch of roses—&

a birthday cake (with 24 candles) & that the Manager had added a bottle of champagne & he wanted to know if he couldn't bring Mr. Stone around & celebrate. I borrowed one of the girl's Victrola's & they entered to a 'burst of music'—The cake was delicious & the champagne equally so—Joe never has tasted liquor so Mr Stone drank his share & most of mine! We went to the 'Cupola' for dinner afterwards as Joe's guests."

"Spring has reached Paris at last—and its lovely in its fresh green—and despite the April showers, everyone is 'cheerful'—I am busy doing Clare Wadleigh's portrait & am working now on Miss McLoughlin's head which I am doing in marble. I had it 'pointed-up' & am only doing the finishing part—It cost me 800. francs stone & all—which is awful but it was absolutely foolish for me to try & point it up myself when I have so little time left and it is so fatiguing. It will be a good piece to exhibit."

Clare's father was Dr. Henry Wadleigh,[9] the Episcopal minister who oversaw St. Luke's Chapel, which my mother and I called the "Tin Chapel" because of its tin roof. The Chapel sat more or less in the backyard of Reid Hall and opened onto Rue de la Grande Chaumière. We often attended Sunday vespers in the chapel and Clare frequently came to the Sunday evening Salons at Reid Hall. She was quite a bit younger than I, was a gifted painter, and had consented to pose for me.

Besides the portrait bust of Clare and the marble head of Adelaide, I was also working on sketches of Joe Campbell for a portrait bust, as I wrote to my sister on April 4: "Joe is posing for me now—and its interesting to do a man's head after nothing but girls—and his head is very sculptural—I'm going to have a little exposition here at the Club—on May 12th painting & sculpture and drawings etc—to show my French friends particularly—whats been keeping me busy these 3 years."

"Of course you know by now that I didn't get the Guggenheim. I was rather surprised at my mingled emotions of relief and regret. Bourdelle was quite distressed and was a perfect dear & said 'We will begin again next year!' I am sorry—not to have gotten it—for Bourdelle is getting old—but its best that I go home on account of the family. Bourdelle said to me not long ago, that I had work[ed] well over here & was quite prepared to go home to produce—And he was dear enuf to tell me to send him photos of whatever I do—so he could write me his criticism and kept in touch with what I do."

Before my time in France ran out I wanted to show my mother the cathedral at Chartres,[10] so over the Easter weekend, she, Joseph Campbell, Herbert Stone, and I all went together. At that time the village of Chartres was still relatively untouched, its lovely medieval houses intact, although most of these were later destroyed during World War II. I wrote to my father on April 11 from Paris: "We had the thrill of our lives in Chartres! We went up

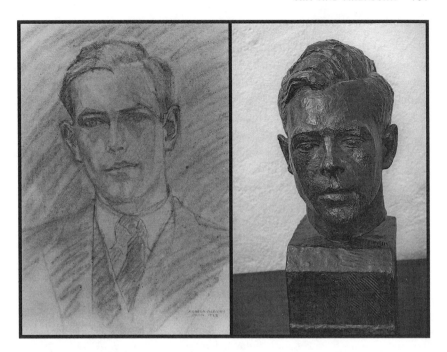

LEFT: Drawing of Joseph Campbell (1928) by Angela Gregory. Copyright © Joseph Campbell Foundation (jcf.org). Used with permission. Courtesy of Angela Gregory Papers, Louisiana Research Collection, Tulane University. RIGHT: *Joseph Campbell* (1928) by Angela Gregory. Copyright © Joseph Campbell Foundation (jcf.org). Used with permission. Photograph courtesy of Cheryle Van Scoy, 2016.

Saturday on the 12:45 Train—and left Paris a blaze of sunshine & warmth. By the time we reached Chartres it was pouring."

"The cathedral is so lovely in a misty rain & particularly at nite against the black sky—It seemed all white and ghostlike—Sunday was a lovely day—and we 'assisted at [attended]' High Mass which was very impressive—with the Bishop[11] preaching & blessing the mob! . . . It was very thrilling to sit at [and] gaze up at those Gothic arches that shoot up & up—& to hear the organ peal—& gaze at the almost impossible to believe true colors of the 13th Century windows."

"In the afternoon I sketched from the Porte Guillaume[12]—gazing up at the Cathedral—with old rambly houses in the foreground. Joe protected me from the mob—which quickly gathered. Mr. Stone & Mama were off gazing at the quaint streets & when they came back we had decided that we just hadn't had enuf of Chartres—Mr. Stone came on back to Paris Sunday nite—and Joe & Mama & I stayed thru till Monday nite."

"Monday dawned a gorgeous day & we were very happy that we <u>had</u> stayed. Joe had his wonderful German field glasses—& with them we examined every piece of sculpture of each portal & most of the stained glass windows. Its amazing how much one can see & understand of the whole cathedral—after such a careful study of all the details—I came back to my sculpture with a clearer vision of what I wanted to do & a keener sense of critical analysis that [than] I've had in a long time." It was an extraordinary treat to have Joe along with his field glasses for we saw details that go unseen by most observers. I have to admit I was surprised and a bit shocked by some of the rather risqué sculptures on the cathedral that one can really see only with binoculars. I have been back to Chartres many times since, but there has never been a trip equal to that one in 1928.

Upon our return to Paris my life accelerated to a pace that was nearly stunning, although I did manage to squeeze in a dinner at Bernard's, the little restaurant where the LeBeufs and I used to go so often for lunch. "Old Maurice—our waiter was as cordial as ever and grasped our hands as we left the Restaurant—much to Joe's delight," I wrote to my aunts on April 14. "We went afterwards to the Theatre des Champs-Élysees & saw the Russian Ballet.[13] The 'Lac des Cygnes [Swan Lake]'[14] was the piece de resistance & the costumes were lovely—We enjoyed wandering in the Lobby in the Entre'acte—and gazing with solemn admiration at Bourdelle's lovely fresques [frescoes]—After the theatre we went to the 'Cupole' & drank malted milk—This is an example of my 'wild life' in Paris."

Seeing Bourdelle's frescoes and bas-reliefs in the Théâtre des Champs Élysées that night of the Russian Ballet performance filled me anew with awe over their grace and beauty. I knew that Bourdelle had contributed greatly to all aspects of the Théâtre, including the architecture, working with Auguste Perret and the painter Maurice Denis.[15] Le Maître's sculptured limestone bas-reliefs grace the façade while the colorful frescoes line the foyer. The bas-reliefs in particular mark the twentieth century's realization of the value of architect-sculptor collaboration to create a harmonious result.

In my 1971 interviews with Madame Bourdelle, she recalled that Bourdelle had done all the stone sculpture in one year in order to meet the inauguration date of the theatre. He first composed the façade as a whole and then broke it up into the five bas-reliefs one sees today. The frescoes were done after the marbles and he worked terribly hard on them. The walls were brought to him in his studio where he then painted on wet plaster. One was of the goddess Diana,[16] a figure he had decided he had made too young in his preparatory drawings. The very day they brought him the wall to paint he was still not satisfied with the goddess, but then, quite unexpectedly, there was a knock at the door and a beautiful woman entered the studio asking "Do you need a

model?" "Undress and put yourself right there," Bourdelle said for he could see she was just the person he needed to paint his Diana. In the moment he needed her, she had shown up. He said, "One would say something divine works next to me." That fresco turned out to be one of his most beautiful ones.

Isadora Duncan and Nijinsky[17] both figure prominently in Bourdelle's work for the Théâtre. Although the two never danced together in real life, Bourdelle brought them together in his frescoes and bas-reliefs. Le Maître was a great admirer of Isadora and he was absolutely captivated by her movements, attending as many of her performances as possible. They had met and had become good friends. Bourdelle did thousands of sketches of her dancing, most of which were done not in the presence of the model, but from memory. "Bourdelle never missed a performance by Isadora, dumbfounded by her breathless rushing, her abrupt stopping, her passionate and quivering flights, her frenzies of despair expressed in dynamic violence and, at times, in tenderness and love." Bourdelle saw the dancer "express before his eyes in an extraordinary plastic way all the feelings that his expressionistic leanings made him want to sculpt."[18]

In an age when women did not show their calves or ankles in public, Isadora's free-spirited Grecian dress and uninhibited style of dance were a sensation. She inspired admiration in some, consternation in others. According to Dufet, Bourdelle often had premonitions and, during one of Isadora's performances, had been overcome by a fearful feeling. He told his wife they were watching a dance of death. As they left the theater, Bourdelle noticed a black car pull around to the stage door for Isadora and thought it resembled a hearse. "Next day, Isadora's two children were drowned in the Seine, trapped in that same car. The superb drawings that relate to that tragedy and that dramatic evening are entitled *Fate's Warning*."[19]

Bourdelle often spoke of Isadora during the years I was in his studios. I saw her once, a statuesque figure dressed in flowing white robes gliding past the Luxembourg Gardens. I did not realize at first it was she, but later when I told Bourdelle I had seen a Greek statue walking down the street he said, "That's Isadora." When I told him I was going to see her dance, he begged me not to for he thought it was tragic to see her dance now; the time to have seen her was at the height of her career. I remember a woman who came around to the studio and solicited a donation of sculpture from Bourdelle that would be sold to help pay off Isadora's debts. He gladly contributed but after the woman left I remember him saying, "My wife will be furious that I gave away an original plaster!"

By April 1928 the head of Adelaide that I had modeled in clay had been used to make a plaster cast and from that a copy in clay, or estam-page, for Bourdelle. Working from my estampage saved the Master hours of

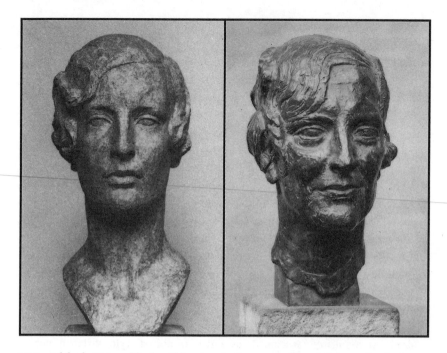

LEFT: *Adelaide McLaughlin* (1928) by Angela Gregory in Bourdelle's studio, Paris. Courtesy of Angela Gregory Papers, Louisiana Research Collection, Tulane University. RIGHT: *La Belle Américaine* (1928) by Antoine Bourdelle, based on a clay copy made from Gregory's head of Adelaide. Courtesy of Angela Gregory Papers, Louisiana Research Collection, Tulane University.

construction and building up. I then had the extraordinary, if overwhelming, opportunity to observe him change, correct, and improve upon my work, even as he told me several times that his transformations were only because we each "saw" Adelaide differently.

During these sessions, Madame Bourdelle was present to hand him his tools. Normally she was the only one allowed to stay in the room while he modeled because of the intense concentration required. Watching Bourdelle work made my last month in his studio the most exciting and educational of my whole time in Paris. I described these events in a letter to my father on May 1, 1928: "I have been going at such a steady pace that I just stayed in bed this morning & feel so much more rested—I have to meet Bourdelle at 3 o'clock at the studio—for he has a rendez-vous with Adelaide to work on her bust—I want to begin at the beginning for the first day was the most eventful & one of the turning points in my career. To go back to Sunday, April 22nd."

In the studio with me that day were my Mother and Joe Campbell, who was posing for the sculpture I was making of him. Bourdelle invited us all in to where he was working and critiqued my head of Adelaide as she modeled and he worked on the estampage. I captured his words in my journal entry of April 22, 1928: "Bourdelle made me take a paper & pencil and mark down all the faults he found in my head of A. McL. In particular: The eye, heigher at the outside corners than in the inside corners. The master: 'I am going to make them larger than nature, but that is my personal desire, it does not change the drawing of the eye.'

"Forehead not high enuf. Maître: 'You did not give Mlle enuf intelligence'— By bridge of nose—there were holes above the eyes—which do not exist. On nose above nostrils—a plane not indicated [drawing of nose with plane indicated] I had filled in space entirely. Large open space left in forehead— Completely false—Should have been filled in. Profile from left side very good—But must do a lot to the mouth. Later—added on a lot over bridge of nose.'"

When I now compare my head of Adelaide to his I realize that I saw her as a very classical, rather coldly beautiful person. He saw her more romantically and sculpted her that way. I remember that one day when I was working on my portrait of her, Bourdelle came in, looked at it, and asked me if it was the same head he had seen before! What had happened is that someone had praised it the previous day, and I had gotten excited and overworked it, losing something in the process. Madame Bourdelle told him he was cruel to indicate my faults so frankly. "'On the contrary', replied le maître, 'Mlle Gregory should be very glad for me to do so. I am helping her by showing her, her mistakes. I am doing something for her that I have never done for anyone else. I have never permitted anyone to be present before when I have worked from a model.' With its mistakes—you can go to the Salon in the Grand Palais [Great Palace][20] and you will not find a head as well done as that of Mlle Gregory's—No sculptor in France to-day can do a portrait any better."[21]

What an incredible statement for him to make to me! As I re-read these letters and journals all these years later and think back on my last month in Bourdelle's studio I realize he was making a special effort to bolster my confidence. He was trying to teach me as much as he could in the time that remained to us before I returned home to New Orleans. He was preparing to send me out into the world on my own. No doubt, with his gift for premonition, he had some sense that we would not see each other again. I, however, was planning on coming back to Paris to continue my work with him after a year or so at home. Obviously he knew our time together was ending.

I hardly noticed his extra attention and advice in my breathless haste to prepare for the fast approaching Salon des Tuileries and to finish Joe's head

and Clare's portrait. In addition I was arranging and preparing for the exhibition of my work at Reid Hall. I described all this in the May 1 letter to my father: "I finished Joe's head Sunday (April 29) morning and as I said (Adelaide & I) we had tea with the Bourdelle's that afternoon. Yesterday I fixed the stand for Joe's head & its to be cast to-day—Its pushed further than anything I've ever done & its very much like the model. He wants to send his mother a copy in bronze."

"In the afternoon I was to go to the Laying of the Corner-stone of the Amer. Dorm. [American Dormitory] of the Cité Universitaire—with the Durands—[22] who wanted me to meet Dr. Homer Gage & hear Ambassador Herrick speak.[23] I was working on Clare's portrait & Mme B. & the Master came in. She asked if I could possibly stay until 6:30 with the Master as she didn't like to leave him alone. As it was the first time they'd ever asked a favor of me—I accepted & so when the Durand's called for me I sent the[m] away (Mama with them) without me—saying 'Duty first.'"

"It so happened that the great art critic Louis Gillet came to see Bourdelle—& some young painters were there & I heard all their 'interview'—Gillet is perhaps the greatest art critic of our age—& I was thrilled when Bourdelle showed him his portrait of Adelaide & presented me as 'l'auteur de l'origional [author of the original].'"

"Then to-day when present at the seance [session] with Adelaide I murmured when gazing from Bourdelle's chef-d'oeuvre to my plaster-cast of her head—'Ça me fait de la peine—de regarder la mienne [It is painful for me—to look at mine]'—Bourdelle stopt & said 'Whats that Mlle?' [He] put down his tools & walked over to my plaster & said—'Mais, non, il ne faut pas dire ça, votre buste est très bien—très bien'—la mienne est une autre façon de travailler etc [But, no, you must not say that, your bust is very good—very good—mine is another way of working etc]' (such modesty,—such greatness to explain so sweetly the difference between his work and mine.) I told him that tho I had always admired his work that now I have seen him work—I understand it better than ever before'—He replied—that he was glad—tho I had not seen him push it as far as he was capable—but he added 'vous êtes plus forte, vous êtes plus capable de me suivre maintenant [you are stronger, you are more capable of following me now].'"

A few days before the Salon, a huge truck came to the studio to pick up my *Beauvais Head of Christ* and transport it to the exhibition hall. I told the driver I would take a taxi and meet him there, but he said, "Why pay for a taxi? I'll give you a ride!" So Joe, who had been posing for me, and I clambered up into the cab of the truck and we jolted off. We cruised up the Champs Élysées just at dusk as the lights came on and we surveyed it all from the extraordinary height of the truck. I never enjoyed the Champs Élysées so much!

On May 3, I wrote to my father of the upcoming opening of the Salon: "The Vernissage of the Salon des Tuileries is to-morrow afternoon—In the morning the President[24] will officially open the Salon in the presence of the exhibiting artists—& their friends will come by invitation at 2 o'clock—& Saturday the doors are open to the public—I went out this afternoon to be sure that I was well placed & found that I had been placed just off the large Hall—& very well indeed—with good lighting on both the pierre [stone] & the cast of Adelaide McLaughlin."

The great day of the Salon's opening arrived and I was thrilled beyond words. The *New York Herald, Paris,* published a review by Georges Bal on Friday, May 4.[25] "Today is Varnishing Day at the Salon des Tuileries which is held in the Palais de Bois at the Porte-Maillot, having been obliged to leave the terrace of the Tuileries Garden. But this rather sordid installation is to be replaced next year by a building better fitted for the exhibition."

"In the meantime this year's Salon covers within its wooden walls and cardboard roofs a large area containing nearly 3,000 works of art: paintings, statuary, drawings and engravings. In the numerous rooms on each side there has been arranged a kind of loggia in which the pictures are grouped. The sculptures are spread throughout the exposition." The article goes on to mention the names of the Americans exhibiting at the Salon, including "Angela Gregory, a Roman head in stone and a portrait of Miss McLaughlin in plaster."

I described my impressions of the Salon in a May 7 letter to my father: "Bourdelle as always when he is in a small or large group—was the centre of interest—& his admirers followed him from Sculpture to painting—hearing his tributes, criticisms & explanations. His Sapho and masque [mask][26]—cast in colored glass—a startling beautiful thing—caused much comment—and the work of his strongest student—a young Greek Apartís[27]—startled the whole place!—He had a life sized figure in plaster of an old woman—She was the famous Rodin model for his Eve[28] and one could see that she had once been very beautiful—The committee wanted to 'throw it out'—the morning of the Vernissage—but Bourdelle's enthusiasm for it as splendid sculpture—I think had a lot to do in keeping it 'in.'"

"Bourdelle made some nice comments about my portrait of Adelaide to the mobs following him about—& told me that a priest was quite excited [about] my tete de [head of] Christ." What I didn't tell my father directly, but which he probably sensed, was that exhibiting at the Salon des Tuileries was tremendously important to my career. It was my artistic debut and it gave me real credibility as an artist when I returned home to New Orleans. I could say that due to Bourdelle's invitation I had exhibited in Paris, the very center of the art world.

Antoine Bourdelle (center) with students at Salon des Tuileries, Paris, France, 1928. Angela Gregory in white hat behind Bourdelle's left shoulder. Courtesy of Angela Gregory Papers, Louisiana Research Collection, Tulane University.

I remember that Bourdelle took me over to see Brancusi's *Bird in Space*,[29] a sculpture that was generating much excitement. I was thrilled by this very abstract and startling work. Bourdelle pointed out the artist to me although he did not introduce me. Among the other exhibitors were Bourdelle, Fanny (Zezette) Bunand-Sevastos, who had four paintings on display; Elizabeth Chase,[30] who was another American student of Bourdelle's at La Grande Chaumière; Bänninger; Giacometti, who had two figures in the exhibition; Mateo Hernández; André Lhote; Piet Mondrian; Fainsilber from the studio; Henri Matisse; François Pompon; Germaine Richier; and Maurice Utrillo.[31]

Joe Campbell also attended the Vernissage, at my invitation. He wrote a letter to me the following day, May 5: "Thank you very much for the vernissage invitation, and for the help which you gave me in figuring out the complicated plan of the palais. After my expedition into the fantastic regions at the far end of the long hall, I hunted around for you and your mother, but had no luck. When I see you again I shall ask about 'l'oiseau dans l'espace [the bird in space],' and the nice red and black quadrangles painted upon the

white background."[32] I was always explaining art to Joe and he has credited me with having introduced him to the world of art. He got a little "hands on" instruction a few years later when he visited me in New Orleans just at the time I was preparing to make a plaster cast of my clay model of *Aesculapius.* Joe rolled up his sleeves and pitched right in, helping me pour the plaster into the mold until far into the night.

About ten days after the Vernissage, my exhibition at Reid Hall opened. I had invited all my French and American friends from Paris and environs— the Roszaks; the Desonays; Madame Canivet; the Fatous; Marie Scherr and Edna Vollmer; Uncle Ray and Joe Almirall; even Ambassador Herrick! And of course my dear Monsieur and Madame Bourdelle, Zezette, and other friends from the studio. Much to my chagrin, I was out at the time Bourdelle honored me with his visit.

The exhibit included nine of my sculptures, fifteen oil paintings, and nineteen watercolors that formed the essence of my three years of work and travel in Europe. Once again, Georges Bal, in the Sunday, May 13, 1928, *New York Herald, Paris,* wrote of my work.[33] He noted that I handled "with equal success the sculptor's ébauchoir [chisel] and the painter's brush. The exhibits consist of plaster busts, oil paintings and water-colors. I do not doubt that Miss Gregory will rapidly succeed in ripening her talent, which is still rather youthful, but is full of promise. As a sculptor Miss Gregory has executed excellently modelled busts, marked with much expression, of Miss Adelaide McLaughlin, Miss Clare Wadleigh, Miss Terry Fischer,[34] Miss Lucinda Walmsley, and that bust full of character of Mr. Joseph Campbell." Of my paintings, which were from my travels in southern France, he wrote that "the artist gives a faithful impression in a few strokes" and noted that they were "rendered harmoniously in the most correct tones."

Floating on the success of my exhibit, I began packing for the voyage home. I went to the studio for the last time on Wednesday, May 23, to say goodbye to le Maître and his family. Everything was very confused and hectic. I recall feeling not so much dazed as numb. While my mother spoke with Madame Bourdelle, I wandered over to the other side of the studio and looked up to see I had been followed by le Maître. To actually have to say goodbye to him would have left me speechless and before I could "come to" he had leaned over and kissed me on the cheek, saying rather apologetically in referring to his beard, "Moi je pique, n'est-ce pas [Me I prickle, don't I]?" That remains engraved on my mind as our parting moment, for I was never to see him again. I left the studio in a sort of fog and returned to the preparations for sailing home.

Finally, on the 27th of May, on board the *S.S. De Grasse,*[35] I reflected on those last days in Paris in a letter to my father: "I cannot quite realize that we

are on our way home. The last weeks in Paris were so hectic—& Mama & I both caught colds at the last minute and have been very tired & wretched. So we slept to-day until about 5 o'clock & tonite after a good dinner and a beautiful sunset—we are feeling ourselves again."

"I am happy to be speeding home to you—but it was hard too to leave Paris—Friday afternoon all our friends dropped in to say good-bye—and so we didn't have the hecticity of farewells at the train. Only Joe & Dr. Durand were there. If it had not been for Joe I fear we would never have gotten packed or off—He helped us every nite last week and all day Friday tore about with us finishing up odd jobs."

"And Friday nite—Mama, & Joe & I had dîner together. Joe had taken us to lunch at Cupole and so we went to Bernards to dîner & then took a perfectly wonderful ride thru the Bois[36] afterwards. It was a cool fresh evening—with moonlite—& so lovely that we all hated to think it was the last nite together in Paris."

"We made the Boat-Train so calmly in the morning—that it was quite a new experience for me! We waved to the two 'boy friends'—until we went round the bend—Joe towering high above all the others—The trip up to Havre was very easy and we got on board about 2 o'clock. Our cabin was quite impossible so I reported at once to the Purser & we were changed to one where Mama didn't have to go up & down so many stairs. A lovely box of roses was handed to me—addressed to 'Miss Angela Gregory & her Mother dear'—from Joe—& a telegram from Lucile Soniat. And I was sitting clutching the roses & talking sculpture to a cute little Mrs. Nichols to whom Dr. Durand had introduced me at the train—& suddenly I realized we were moving—& that the horizon of la belle France was far behind—It was best that way—for it would have been horrible to have felt the wishes creeping between us & land."

EPILOGUE

THE MASTER PASSES—BOURDELLE'S DEATH ⟩—

While I was working on the sculptures for the Criminal Courts building, I learned of Bourdelle's death on October 1, 1929. His passing devastated me; for not only had I lost a dear and wonderful friend, but also my mentor and my maître in the truest sense of the word. I could never turn back to him again, never learn any more from him. He was gone and I was truly on my own.

Soon after his death, I received a letter from Elizabeth Poucher,[1] a young American friend of Walter Agard and a distant relative of Marie Scherr. Elizabeth had been in Paris when the dear Maître died, as she wrote to me in a letter dated October 5, 1929: "To-day I attended his funeral. His work has been such an inspiration to me for years I felt I must pay that slight honor to him. No doubt you have many friends here who will write you in detail about the funeral. All I can offer you is a glimpse from the sidewalk across from his atelier."

"What impressed me first was the cosmopolitan crowd; the artists with seeing eyes and faded cloaks, the dignitaries in high silk hats; a young mother who kept telling her babe of hers then two months 'regarde-là'; the ladies in black velvet and mink who stretched out their hands to be kissed by gentlemen, the delivery men and women who had forgotten their errands, and the large quantity of international youth—students surely—all there because of love for the Maître. The flowers were magnificent. The most beautiful of them all in red and copper from 'ses éleves [his students]' was placed in the rear of the platform facing the hearse, and directly beneath it was a large spray of Easter lillies."

"It was very stirring to see so many of his students walking before the hearse, and such a large group of friends behind it. It seemed to make a 'pattern'—the circle of universality or mutual love for him surrounding him.

Do you know what I mean?" I knew exactly what she meant and I wished that I could have been there to help form that circle.

The world's newspapers carried the notices of Bourdelle's death. The *New York Times* of October 6, 1929, carried an article with the headline "On the Passing of Bourdelle."[2] "His passing removes from the contemporary scene one of France's strongest sculptors, a sculptor whose genius has made itself felt, honored and loved in two hemispheres. Although nearly 70 years old, he died fully in harness. A few days before, he had been supervising some casting work at a foundry."

"It would be a hard and desiccated heart that could not respond to this sculptor's finest messages; that could fail to feel profound emotion in the presence, for example, of the heroic 'Vièrge' erected on an Alsatian hilltop— the most noble of all World War monuments it has been called. But his work, if one choose to draw a rather suspect differentiation, appeals to the mind as well. In this sense, heart and mind attained, in much that he accomplished, a happy balance of reciprocity. Indeed, Bourdelle impresses one as having been a singularly balanced genius."

Although Bourdelle was gone, I went back to France several times in the following years and I became very close to Madame Bourdelle. In 1930, my father and I made a trip to Europe together and I returned to the studios at l'Impasse du Maine for the first time since le Maître had died. While the ateliers could never be the same again without his presence, Madame Bourdelle carried on his spirit and began her long and eventually successful struggle to establish the Musée Bourdelle.

In 1932, after finishing my commission for Kate Gleason and the restoration of La Tour Carrée in Septmonts, I returned again to the studios on l'impasse du Maine, this time for studies with Madame Bourdelle. During this period Rhodia and I became quite good friends, sharing a model as we worked together.

World War II intervened and, although we corresponded extensively, there was a more than twenty-year gap before I again saw Madame Bourdelle, Rhodia, or their dear American friend Miss Florence Colby. During the war my one thought had been to somehow get Madame Bourdelle out of Paris and to America, but it never happened. It was 1953 before I returned to Paris when I spent two years there working on the Bienville monument.

Finally, in 1971, I returned once more with a grant from the Shell Oil Foundation through St. Mary's Dominican College in New Orleans, where I was sculptor-in-residence. On that trip, I wanted to gather as much information as possible about le Maître for a book, to be combined with the notes, letters, and journals that my family and I had preserved. Rhodia and her husband, Michel Dufet (who was a well-known and distinguished designer

of modern furniture and who, at one time, owned the best modern furniture shop in Paris), took the two of us out to their home in the country near Fontainebleau[3] for a weekend. There Madame Bourdelle and I sat and talked for hours as I taped our conversations.

The last time I saw her was when I went to say goodbye to her in Paris before I returned to America from that trip. She was living in the old home at 6 l'mpasse du Maine where, thirty-five years before, I had timidly gone to ring the doorbell. We sat and talked at great length about life and especially about death. When we finally embraced and said goodbye at the door at the top of the stairs we somehow both knew it was for the last time. She stood at the door and said, "Now when you go down the stairs, Angela, don't look back." She died the following year at the age of ninety.

FROM LEFT: Claire Muerdter, Nancy Penrose, Angela Gregory, in Gregory's New Orleans studio, 1985. Photograph by David R. Muerdter.

APPENDIX

LIST OF ANGELA GREGORY'S
SCULPTURAL WORKS, 1926–1983

ITEM*	TYPE OF WORK	DATE CREATED	LOCATION IN 2017, IF KNOWN†
Beauvais Head of Christ (Bourdelle's Studio, Paris)	Head copied into stone	1926–28	Collection of Newcomb Art Museum, Tulane University, New Orleans
Goose (Bourdelle's Studio, Paris)	Miscellaneous sculpture	1927–28	Watermark Hotel, Baton Rouge, Louisiana
Terry Fischer (Bourdelle's Studio, Paris)	Portrait bust	1927–28	
Joseph Campbell (Bourdelle's Studio, Paris)	Portrait bust	1928	Collection of Opus Archive & Research Center, Pacifica Graduate Institute, Carpinteria, California
Napoléon Gourgaud du Taillis (Bourdelle's Studio, Paris)	Portrait bust	1928	Collection of Imperial Calcasieu Museum, Lake Charles, Louisiana
Adelaide McLaughlin, (Bourdelle's Studio, Paris)	Portrait bust	1928	
Clare Wadleigh (Bourdelle's Studio, Paris)	Portrait bust	1928	
Lucinda Walmsley (Bourdelle's Studio, Paris)	Portrait bust	1927–28	
Augustine (family name unknown) "La Belle Augustine"	Portrait bust	1928	Collection of Newcomb Art Museum, Tulane University, New Orleans
Elizabeth Freeman	Portrait in bas-relief	1928	
Roger Freeman	Portrait in bas-relief	1928	
Brandt Van Blarcom Dixon	Memorial/portrait in bas-relief	1929	Dixon Hall lobby, Tulane University Uptown Campus, New Orleans
George Lewis, "Faithful George"	Portrait bust	1929	Collection of Newcomb Art Museum, Tulane University, New Orleans

*Creation location is New Orleans unless otherwise indicated. †Sculptures held in collections may not be displayed.

Title	Type	Date	Location
Private Grave in Hastings, Nebraska	Headstone	1929–30	
Criminal Courts Building	Architectural sculpture	1929–30	Orleans Parish Criminal District Court, New Orleans
Aesculapius, Keystone	Architectural sculpture	1929–30	Tulane University School of Medicine, Hutchinson Memorial Building, New Orleans; Plaster maquette in collection of Pennington Biomedical Research Center, Baton Rouge, Louisiana
Adolph Jastram	Portrait, full length	1930–31	
Eight Portraits in Bas-Relief	Architectural sculpture	1930–31	Exterior of Louisiana State Capitol, Baton Rouge, Louisiana; Plaster models in collection of West Baton Rouge Museum, Port Allen, Louisiana
Allen Brès	Portrait bust	1931	Collection of West Baton Rouge Museum, Port Allen, Louisiana
Lintel for Fireplace Mantle in La Tour Carrée and Restoration of Related Buildings (Septmonts, France)	Architectural restoration	1932	Collection of LSU Museum of Art, Baton Rouge, Louisiana
Philomela (Bourdelle's Studio with Madame Bourdelle, Paris)	Miscellaneous sculpture	1932	
John McDonogh	Monument	1932–34	Duncan Plaza, New Orleans; Maquette in collection of The Historic New Orleans Collection, New Orleans
Rita Stem Reynick	Portrait bust	1933	Collection of Louisiana Art & Science Museum, Baton Rouge, Louisiana

ITEM	TYPE OF WORK	DATE CREATED	LOCATION IN 2017, IF KNOWN
Robert Glenk	Portrait bust	1933	Collection of Louisiana State Museum, New Orleans
W. J. Warrington	Portrait bust	1933	Collection of New Orleans Museum of Art
Woodward Way, Newcomb College	Memorial plaque	1933	Woodward Way, Tulane University, Uptown Campus, New Orleans
Boy on Dolphin, Garden of Mathilda Geddings Gray in Lake Charles, Louisiana	Garden sculpture	1934	Maquette in collection of Imperial Calcasieu Museum, Lake Charles, Louisiana
Laura Graves	Portrait bust	1934	
Jack Sparling	Portrait bust	1935	
John Canaday	Portrait bust	1935	Collection of LSU Museum of Art, Baton Rouge, Louisiana
Lincoln Stark Ferriss	Portrait in bas-relief	1935	
Gregory Stark Ferriss	Portrait in bas-relief	1935	
William Benjamin Gregory	Portrait bust	ca. 1935	West Baton Rouge Museum
Pelican	Medal	ca. 1935	Collection of New Orleans Museum of Art
Bulldog for Friend in Washington, D.C.	Miscellaneous sculpture	1937	
Edgar Silver for Silver-Burdett Publishing Company, New York, New York	Memorial/portrait in bas-relief	1937–38	
Silver-Burdett Publishing Company, New York, New York	Bookends	1937–38	East Baton Rouge Public Library, Main Branch, Baton Rouge, Louisiana

Subject	Type	Date	Location
Irby Plaque, Newcomb College	Memorial plaque	1938	Sculpture Facility, Woldenberg Art Center, Tulane University, Uptown Campus, New Orleans
Richard Welling	Portrait bust	1938	Collection of Zigler Art Museum, Jennings, Louisiana
Plantation Madonna	Portrait, group	1938	Collection of Newcomb Art Museum, Tulane University, New Orleans; collection of LSU Museum of Art, Baton Rouge, Louisiana
St. Landry Parish Courthouse	Architectural sculpture	1938–39	Opelousas, Louisiana; models in collection of Imperial Calcasieu Museum, Lake Charles, Louisiana
Fountain Study	Miscellaneous sculpture	1938–40	
McAlister Auditorium	Architectural sculpture	1939	Tulane University, Uptown Campus, New Orleans
Howard Tilton Memorial Library (Renamed Jones Hall), exterior and interior motifs	Architectural sculpture	1940	Jones Hall, Tulane University, Uptown Campus, New Orleans
Elizabeth Gregory Ferriss	Portrait bust	before 1942	
Lincoln Stark Ferriss, Child Bust	Portrait bust	ca. 1943	
A.S. Aloe Company Building	Lettering and motif	1946–47	
Henry Plauche, Cotton Exchange Building	Memorial/portrait in bas-relief	1947	
William Harris, Boston Club	Memorial/portrait in bas-relief	1947	Maquette in collection of West Baton Rouge Museum
D.H. Holmes Company	Bas-relief	1948	

ITEM	TYPE OF WORK	DATE CREATED	LOCATION IN 2017, IF KNOWN
United Celotex Workers Building, Marrero, Louisiana	Title for building	1948	
Urban Maes, Touro Infirmary	Memorial plaque	1948	Touro Infirmary, New Orleans
Louisiana State University, Baton Rouge: Cafeteria and Men's Dormitories	Architectural sculpture	1948–49	Hatcher, Hodges, and Johnston Halls, Louisiana State University, Baton Rouge, Louisiana
Louisiana National Bank, Baton Rouge	Sculptured murals	1948–49	The Gregory Restaurant, Watermark Hotel, Baton Rouge, Louisiana
Woodlawn School in Bertrandville, Louisiana	Architectural sculpture	1948–49	
Pelican Motif for Railing around Seal in Lobby Floor	Bas-relief	1949	Louisiana State Capitol, Baton Rouge, Louisiana
Sculpture on Pediment (Arm of Liberty Form), New Orleans City Hall	Architectural restoration	1949	
Harold Stream, Jr.	Portrait bust	1950	Maquette in collection of Imperial Calcasieu Museum, Lake Charles, Louisiana
"Old Sawney" in Honor of William Robert Webb, Webb School, Bell Buckle, Tennessee	Memorial/portrait in bas-relief	1950	The Webb School, Bell Buckle, Tennessee
Jubilee, St. Mary's Dominican College	Medal	1950	
Sister Stanislaus, Charity Hospital	Memorial/portrait in bas-relief	1950	

Subject	Type	Date	Location
William Benjamin Gregory, School of Engineering, Tulane University	Medal	1951	
Andrew M. Lockett, Louisiana Engineering Society	Medal	1951	
James M. Todd, Louisiana Engineering Society	Medal	1951	
Tulane University Seal	Seal	1951–52	
Jean Baptiste Le Moyne, Sieur de Bienville (New Orleans and Paris)	Monument	1952–55	French Quarter at Decatur and Conti streets, New Orleans; Maquette in collection of Louisiana's Old State Capitol Museum
Moise Dennery	Portrait bust	1952–55	
Charles Payne Fenner, Jr., Charity Hospital	Memorial/portrait in bas-relief	1952	
Robert Estachy	Portrait bust	1952	Collection of Louisiana Art & Science Museum, Baton Rouge, Louisiana
A.B. Paterson, New Orleans Public Service	Memorials/portraits in bas-relief	1953	
First National Bank of Lafayette, Lafayette, Louisiana	Architectural sculpture	1953	Acadiana Center for the Arts, Lafayette, Louisiana
Selina E. Brès Gregory, upon Death in Paris	Death mask and hands	· 1953	
St. Gabriel Catholic Church, St. Gabriel, Louisiana	Architectural sculpture	1953	St. Gabriel, Louisiana

ITEM	TYPE OF WORK	DATE CREATED	LOCATION IN 2017, IF KNOWN
Martin Anding	Portrait bust	1955	
Molly Amsler	Portrait bust	1957	
Selina E. Brès Gregory, School of Engineering, Tulane University	Memorial/portrait in bas-relief	1957	
Katita Stark	Portrait bust	1957–58	
Leslie Staub	Portrait bust	1958	
Ron Scharff	Portrait bust	1958	
Harnett Kane	Portrait bust	1959	Maquette in collection of LSU Museum of Art, Baton Rouge, Louisiana
Joseph Schenthal	Portrait bust	1959	
Dillard University	Seal (re-design)	1961	
Governor Henry Watkins Allen	Monument	1961–62	Eighth Street opposite Courthouse, Port Allen, Louisiana
High School Emblem	Unknown	1962	
Last home of Jean Baptiste Le Moyne, Sieur de Bienville	Memorial plaque	1962	Rue Vivienne, Paris, France
St. Fiacre Wall Fountain, Christ Church Cathedral	Garden sculpture	1962	Christ Church Cathedral, St. Charles Avenue, New Orleans
St. Louis, Archdiocesan Administration Building	Architectural sculpture	1962	Walmsley Avenue, New Orleans

Boy with Geese	Miscellaneous sculpture	1963	Collection of Louisiana Art & Science Museum, Baton Rouge, Louisiana
Rooster	Miscellaneous Sculpture	ca. 1963	
Sesquicentennial of the Battle New Orleans	Medal (and incorporated into design of United States postage stamp issued 1965)	1963–64	Collection of Newcomb Art Museum, Tulane University, New Orleans
Dr. and Mrs. Louis J. Bristow, Bristow Tower, Southern Baptist Hospital	Memorial/portrait in bas-relief	1964	
James Marshall Robert Award, Society of Engineers	Medal	1964	
Civil War Centennial, National Commemorative Society	Coin medal	1965	
Judge Felix Voorhies	Memorial/portrait in bas-relief	1965	Longfellow Evangeline Park, St. Martinville, Louisiana
John XXIII Library, St. Mary's Dominican College	Sculptural decorations	1967	St. Mary's Dominican High School, New Orleans, Louisiana
Louisiana Library Association Literary Award	Medal and plaque	1967	
General George E. Pickett, International Fraternal Commemorative Society	Coin medal	1968	
Kneeling Madonna with Child	Miscellaneous sculpture	1968	
Seymour Weiss	Portrait bust	1968	

ITEM	TYPE OF WORK	DATE CREATED	LOCATION IN 2017, IF KNOWN
St. Louis for St. Louis Cathedral, Jackson Square, New Orleans	Memorial/portrait in bas-relief	1968	
Standing Madonna	Miscellaneous sculpture	1968	
Albertus Maximus, St. Mary's Dominican College	Medallion, sculptural decoration	1970	St Mary's Dominican High School, New Orleans, Louisiana
Joseph Lykes	Portrait bust	1970	
Joseph Lykes with William & Thompson	Portrait bust	1970	
Louisiana Council for Music and Performing Arts	Medal	1970	
81st Anniversary Convention Medal, American Numismatic Association	Medal	1970–72	
Louisiana Purchase, National Commemorative Society	Coin medal	1971	
In Honor of M. Petenelli, Cultural Attaché of French Consulate	Medal	1973	
Bishop Jeanmard of Diocese of Lafayette, Louisiana	Portrait bust	1974	Chancery, Diocese of Lafayette, Lafayette, Louisiana
Zita (Mrs. Luther Templeman)	Portrait bust	1974	New Orleans Museum of Art, New Orleans
F. Edward Hebert	Portrait bust	1976	Maquette in collection of Imperial Calcasieu Museum, Lake Charles, Louisiana
Seymour Weiss (half scale)	Portrait bust	1976	

Title/Subject	Type	Date	Location
Illustrious Order of the Plimsoll Mark	Medal	1979	
Mayo Clinic Alumni Association's Medal President's	Medal	1979	
Pendleton Lehde, Tulane University School of Engineering	Memorial/portrait in bas-relief	1980	539 Boggs Center, Tulane University, Uptown Campus, New Orleans
Visual Arts Award, Bolton High School Alexandria, Louisiana	Medal	1980	
Blessed Mother, St. Mary's Dominican College	Architectural sculpture	1980–81	St. Mary's Dominican High School, New Orleans, Louisiana
Chimney Sweep	Miscellaneous sculpture	1981	
Cougar, John Kennedy High School	Miscellaneous sculpture	1981	
Lawrence Brès Eustis	Portrait bust	1981–83	
Paul Tulane Society, Tulane University	Medal	1982	300 Boggs Center, Tulane University, Uptown Campus, New Orleans
Lloyd Cobb	Portrait in bas-relief	1982–never completed	
Eleanor and William Burkenroad Award, Tulane University	Medal	1983	
Douglas Smith Anderson	Portrait in bas-relief	no date	
Frances Brès	Portrait bust	no date	
Martha Bruce	Portrait bust	no date	
St. Denis Villere	Portrait bust	no date	

NOTES

Angela Gregory's correspondence, art journals, and diaries, unless otherwise noted, are located in the Angela Gregory Papers, Louisiana Research Collection, Tulane University, in New Orleans, Louisiana.

PROLOGUE
1. Antoine Bourdelle to Angela Gregory, July 23, 1928.
2. Agard, "Bourdelle: Lover of Stone," 194.
3. "Bourdelle and the Gods."
4. Murray, "Émile Antoine Bourdelle 1861–1929," 11, 15.
5. Kramer, "Bourdelle: The Age of Innocence," 192; Mitchell, "Entrepreneurs of the New Order: Bourdelle in the Park," 101.
6. Bal, "The Week in Paris Art," 5.
7. Anonymous, "Angela Gregory," 6.
8. Gihon, "Sculptor and Artist Give Joint Exhibition at Arts and Crafts," 2.
9. Glade, "The Uptown Lady Who Helped Decorate New Orleans, Angela Gregory," 26.

ONE ⟩ A CHILDHOOD FOR ART
1. Portrait bust of Adelaide McLaughlin Moise (1905–1986), American friend in 1920s Paris; sculpture of Jean-Baptiste Le Moyne, Sieur de Bienville (1680–1768), a Canadian naval officer who served as three-time governor of the French colony of Louisiana (intermittently from 1702–43), who, in 1718, chose the site where New Orleans was built; and sculpture of George Lewis (1859–?) who worked as a janitor at Tulane.
2. William Benjamin Gregory (1871–1945).
3. Émile-Antoine Bourdelle (1861–1929).
4. Cléopâtre Sevastos Bourdelle (1882–1972).
5. Selina Brès Gregory (1870–1953).
6. Elizabeth Gregory Ferriss (1899–1942) and William Brès Gregory (1901–1984).
7. Audubon Park, originally called Upper City Park, was established on land annexed by the city in 1870 and purchased in 1871. It was named after artist and naturalist John James Audubon (1785–1851) and was designed by American landscape architect John Charles Olmsted (1852–1920).
8. *Aphrodite*, also known as the *Venus de Milo*, is a sculpture produced around 150 BC in Greece and thought to have been sculpted by Alexandros of Antioch. It is displayed in the Louvre Museum in Paris.

9. Katherine Brès (ca. 1861–1937) and Marie L. Brès (ca. 1864–1942) were Selina Brès Gregory's sisters.

10. Selina Brès Gregory was a member of the Equal Rights Association Club founded in 1896.

11. Walter Inglis Anderson (1903–1965) had two brothers: Peter Anderson (1901–1984) and James McConnell "Mac" Anderson (1907–1998).

12. The French Opera House, at the corner of Bourbon and Toulouse Streets, opened in 1859 and burned to the ground in 1919.

13. Martha D. Stephens Gould (ca. 1863–1923) served as the Orleans Parish Factories Inspector. The First Unitarian Church New Orleans was located at South Rampart Street (now Danneel) and Jefferson Avenue from 1902 to 1958.

14. Selina Brès Gregory's grandparents were Jean Baptiste Brès (1788–1842) and Marie Seghers Brès (ca. 1794–1856); her parents were John Baptiste Brès, Sr. (1820–1907) and Elizabeth Adams Brès (ca. 1832–1904); and her siblings were John Baptiste Brès, Jr. (ca. 1851–1895), Edward Brès (1853–1910), Lizzie Brès (ca. 1855–?), Joseph Ray Brès (1854–1913), William A. Brès (ca. 1857–?), Claudia Brès (ca. 1858–1860), Katherine Brès, Marie L. Brès, Alfred C. Brès (1866–?), and Claude Francis Brès (ca. 1873–1901).

15. Breston Plantation was located in Columbia, Caldwell Parish, Louisiana.

16. Creole is an ambiguous word. In the late 1700s it meant free people of color or people of mixed racial heritage in New Orleans. After Louisiana came under American control in 1803, the city's residents of French and Spanish heritage adopted the word to distinguish themselves from the newly arrived American settlers.

17. The French Quarter, also known as the Vieux Carré (Old Square), is New Orleans' oldest neighborhood, and is the site where Bienville established the city in 1718.

18. A neighborhood of historic mansions centered along St. Charles Avenue.

19. William Benjamin Gregory's parents were Ezra Eugene Gregory (ca. 1846–1922) and Mary Elizabeth Bush Gregory (1848–1922). The family farm was in Benton, Yates County, New York.

20. One of Angela Gregory's maternal great-grandfathers was Joseph Adams (1791–1834).

21. May Ellis Nichols (ca. 1863–1949) was a writer and poet.

22. The World's Columbian Exposition in Chicago was open to the public from May to October 1893.

23. H. Sophie Newcomb Memorial College was founded in 1886.

24. Ellsworth Woodward (1861–1939) and William Woodward (1859–1939).

25. Joseph Fortuné Meyer (1848–1931).

26. The Newcomb Chapel, designed by Philadelphia architect Wilson Eyre (1858–1944), was built in 1894 and 1895, and was located on the Washington Avenue campus of Newcomb College. The chapel was demolished in 1954.

27. Joseph Domenget (ca. 1856–1911).

28. The Katherine Brès School was open from 1911 to 1927.

29. Alice Gamotis (1857–1942).

30. France's national anthem.

31. Laurent Gamotis (1805–1871).

32. Charles Gustav Martin (1853–1925) and Anna Théophile Joséphine Nick Martin.

33. Louise Amelia Giesen Woodward (ca. 1862–1937).

34. *The Plantation Madonna* was completed in 1938. There are several casts in private collections. This sculpture was part of a series of portrait studies of African Americans.

35. Possibly Cloverland Dairy Company, which was established in 1907, and opened its doors at 3400 South Carrollton Avenue in 1924.

36. Frank Lloyd Wright (1867–1959) was considered the most influential architect of his time.

37. The hurricane on September 29, 1915, killed 275 people along the Gulf Coast.

38. The New Orleans Museum of Art, located in City Park, opened in 1911 as the Isaac Delgado Museum of Art.

39. Lake Pontchartrain is a 630-square-mile estuary north of New Orleans.

40. The Clio streetcar line opened in 1867 and ended service in 1932.

41. Tennessee Williams, *A Streetcar Named Desire* (1947).

42. Gibson Hall was built in 1894 and still houses most of Tulane's senior administrators.

43. Robert Sharp (1851–1931) served as acting President of Tulane University from 1912 to 1913 and president from 1913 to 1918.

44. Quotation is from Ralph Waldo Emerson. See Bosco and Wilson, eds., *The Collected Works of Ralph Waldo Emerson: Volume VII: Society and Solitude*, 65.

45. Lillian (1878–1972) and Frank Gilbreth (1868–1924) were pioneers in modern management techniques focused on worker efficiency and time management. Their son, Frank Bunker Gilbreth, Jr. (1911–2001) co-authored *Cheaper by the Dozen* (1948) with his sister, Ernestine Gilbreth Carey (1908–2006).

46. William Monroe White (1871–1949).

47. The screw pump, invented in 1913 by Albert Baldwin Wood (1879–1956), was capable of pushing large volumes of water out of the bowl-shaped city of New Orleans and into Lake Pontchartrain, thereby making more land available for development.

48. The Louisville and Nashville Railroad operated from 1850 to 1982.

49. Mary Palmer Caldwell McFarland (1904–1989).

50. Alice Rosalie Urquhart (1854–1922) and Henrietta Davidson Bailey (1874–1950).

51. Pendleton Shipyards built vessels for the United States military during World War II.

52. Kate Gordon (1861–1932) was founder of the Equal Rights Association Club in 1896.

53. Louis Armstrong (1901–1971) was a seminal figure in the evolution of jazz and a major figure in twentieth-century music. He was sent to the Colored Waifs' Home, a facility off City Park Avenue, in 1910 and then again in 1913–14.

54. Jean Gordon (1865–1931).

55. Florence Converse (1871–1967) was born in New Orleans and graduated from Wellesley College in 1893. She worked on the editorial staff of the *Churchman*, a

weekly news magazine published in New York, before joining the *Atlantic Monthly*, an American magazine of literature and opinion, in 1908.

56. Reverend George Kent (1856–1940) was minister of First Unitarian Church New Orleans from 1911 to 1920, and from 1929 to 1934.

57. Temple Sinai, founded in 1870, was located until 1928 on Carondolet Street at Tivoli Circle, which later became Lee Circle.

58. Clyde Giltner Chandler (1879–1961) created a memorial sculpture for the State Fair of Texas in 1912 and she maintained a studio in Santa Monica, California, from 1936 until her death. Her parents were William Walker Chandler (1848–1934) and Flora Augusta Giltner Chandler (1857–1953).

59. Lorado Zadoc Taft (1860–1936) was a sculptor, author, and educator at the Art Institute of Chicago.

60. The Louisiana State Capitol was a project of Governor Huey P. Long (1893–1935) who served as governor from 1928 to 1932. The Capitol was dedicated in 1932; Taft did the pioneer and the patriot groups on the capitol steps.

61. Leon Charles Weiss (1882–1953) was co-founder of the Weiss, Dreyfous, and Seiferth architectural firm that designed many public buildings in Louisiana in the 1930s.

62. Mary Williams Butler (1863–1937) was a Newcomb potter and assistant professor in drawing and design at Newcomb College from 1907 to 1934.

63. Gertrude Roberts Smith (1869–1962) was a faculty member at Newcomb College from 1889 to 1934.

64. Painter Mary L. Schultz Neill (ca. 1835–1901). After her death her book club established the Mary L. S. Neill Water Color Medal to be awarded to a student in the Newcomb Art Department.

65. Albert Rieker (1889–1959) was a New Orleans sculptor whose work included a statue of Bienville for the Louisiana State Capitol.

66. The Arts and Crafts Club of New Orleans was formed to enrich the city's artistic heritage.

67. A camp for girls in Silver Lake, New Hampshire.

68. Henry Stark Ferriss (1897–1970).

69. Calvin W. Rice (1869–1934) was Secretary of the American Society of Mechanical Engineers from 1906 to 1934.

70. Charles Keck (1875–1951) was a sculptor based in New York whose works include two statues in Statuary Hall at the United States Capitol, one of which is of Governor Huey P. Long.

71. Booker T. Washington (1856–1915) was a leading African American educator. Keck's sculpture, *Lifting the Veil of Ignorance*, was dedicated in 1922 in Tuskegee, Alabama.

72. The *Huey Long Memorial*, installed in 1940, is Long's gravesite and is located outside the Louisiana State Capitol in Baton Rouge.

73. Anne Collyer Keck (1900–1982).

74. Mary Given Sheerer (1865–1954) was instrumental in launching the Newcomb

Pottery enterprise. She taught pottery and china decoration and was a Newcomb faculty member from 1894 to 1931.

75. Martin Behrman (1864–1926) was mayor of New Orleans from 1904 to 1920, and from 1925 to 1926.

76. Agard, "Bourdelle–Lover of Stone," 194; Walter Raymond Agard (1894–1978) was professor of classics at the University of Wisconsin.

77. François Auguste René Rodin (1840–1917) was a French sculptor for whom Bourdelle had worked as a *praticien* [technician who roughs out the sculptures].

TWO › GETTING TO PARIS

1. New York School of Fine and Applied Art, Paris Atelier, was formally renamed Parsons School of Design in 1941. Gregory always referred to it as Parsons.

2. Zema Hill LeBeuf (1872–1946), and her daughters Marie Zema Marguerite (Polly) (1905–1982) and Jeanne Louise (1907–1952).

3. Mary Williams Butler had two sisters, Jeannie Ursula Butler Howcott (1880–1930) and Beulah Lyon Butler Johnson (1883–1937).

4. A Cunard Line passenger ship launched in 1921.

5. American sculptor James Earle Fraser (1876–1953) whose iconic *End of the Trail* (cast 1918) features an American Indian on horseback.

6. Gregory Stark Ferriss (b. 1924).

7. Agnes Scott College, founded in 1889, is located in Decatur, Georgia. Randolph-Macon College, founded in 1830, is located in Ashland, Virginia.

8. Pocahontas Wight Edmunds (1904–1999) was a descendant of Amonute Matoaka Pocahontas Rebecca Rolfe (ca. 1596–1617), the Powhatan Algonquian woman who negotiated with English colonists in Jamestown, Virginia, and married Englishman John Rolfe (1585–1622).

9. Votre Amie, "Entre Nous," 4. The letter from Archbishop John W. Shaw (1863–1934), who led the Archdiocese of New Orleans from 1918 to 1934, was to Pope Pius XI, Ambrogio Damiano Achille Ratti (1857–1939), Pope from 1922 to 1939.

10. Captain Arthur T. Brown (1878–?).

11. Date on letter is June 31, 1925, but it was likely written on July 1, 1925.

12. Diary entry, undated.

13. Large public square at the eastern end of the Avenue des Champs Élysées.

14. Large public park on the western edge of the city.

15. The Tomb of the Unknown Soldier, now honoring soldiers killed in both world wars, is located at the base of the Arc de Triomphe, which lies at the western end of the Champs Élysées.

16. The Luxor Obelisk, one of three in the world called Cleopatra's Needle, was a gift from Egypt to France and was installed in the Place de la Concorde in 1833.

17. The oldest square in Paris, located in the Marais neighborhood on the Right Bank. The Parsons School was at 9 Place des Vosges.

18. Possibly Sarah Marx Morin.

19. Frank Alvah Parsons (1866–1930) was Director of the New York School of Fine and Applied Art from 1911 to 1930.

20. The Salle des Caryatides and Corridor de Pan are rooms in the Louvre Museum.

21. The Winged Victory of Samothrace, Greek (ca. 220–185 B.C.).

22. Diary entry, July 10, 1925.

23. Restaurant Bernard, 31 Place de la Madeleine.

24. Jules Louis Alciatore (1863–1934) was proprietor of Antoine's Restaurant in the French Quarter.

25. Église de la Madeleine [Church of the Magdalene], consecrated in the nineteenth century, is built in the style of a Greek temple.

26. The Bastille was a state prison in Paris stormed by revolutionaries in 1789.

27. Joseph Jacques Cesaire Joffre (1852–1931) was the general responsible for the French World War I effort until 1916.

28. Charles Lindbergh (1902–1974) was an American aviator and the first to fly solo non-stop across the Atlantic, arriving near Paris on May 21, 1927.

29. Letter written August 7, 1925.

30. David K. Rubins (1902–1985) served on the faculty at the Herron School of Art and Design in Indianapolis from 1935 to 1970.

31. École Nationale Supérieure des Beaux-Arts [French National School of Fine Arts] is heir to an art academy founded in the seventeenth century.

32. Georges Fatou (1867–1944) and his wife, Cécile Gueydan Fatou (1875–1944), had five children: Nelly Marguerite Fatou (1898–1904), Jean Eugène Fatou (1899–1979), Jacques Pierre Fatou (1901–1975), Georges "Geo" Fatou (1903–1996), and Marguerite Nelly "Guitte" Fatou (1905–1994).

33. Henry L. Gueydan (1867–1952) was Louisiana State Senator from 1908 to 1912.

34. The Métro, the Paris subway system, includes stations at Place de la Concorde; Châtelet; and Gare du Nord, which is also a railway station.

35. The United States was pushing for World War I debt repayments from France, which the French considered unfair in light of their sacrifices during the war and American loans to revitalize the German economy.

36. Louis Fatou (1867–1957).

37. Robert Fatou (1895–1981) commanded the French Navy cruiser *Jeanne d'Arc* from 1946 to 1947.

38. Marie Scherr (1875–1957).

39. John S. Kendall (1874–1965) was a professor of Spanish at Tulane and also a writer and historian.

40. A letter sent via a series pneumatic tubes linking Parisian post offices.

41. The Bastille is a neighborhood just east of central Paris.

42. *The Door Unlatched* (1928) and *Life in Still Life* (1926).

43. Angela Gregory was instructor, sculptor-in-residence, and professor of art at St. Mary's Dominican College from 1962 to 1975.

44. Calvin Coolidge (1872–1933) was President of the United States from 1923 to 1929.

45. The Notre-Dame Cathedral of Reims, built between 1211 and 1516, was heavily damaged during World War I.

46. Rome's Castel San Angelo (123–139 A.D.) is a fortress built as a mausoleum for Emperor Hadrian; Saint Peter's Basilica (completed in 1626) in Rome is the tomb of Saint Peter; Piazza San Marco is the main public square in Venice; and the Uffizi Gallery in Florence is an art museum that opened to the public in 1769.

47. Elizabeth Estill King (1899–?) and Floryne Miller.

48. Founded in 1924, Le Petit Salon evolved into a significant French Quarter historic preservation community; Photocopy of Gregory lecture in Penrose personal collection.

49. Teatro alla Scala opera house; Italian conductor Arturo Toscanini (1867–1957); Victor de Sabata, *Gethsemani: poema contemplativo per orchestra* (1925).

50. Victor Emmanuel III (1869–1947) was King of Italy from 1900 to 1946.

51. Palazzo Ducale Venezia, with fourteenth-century foundations, is on the Piazza San Marco.

52. Michelangelo di Lodovico Buonarroti Simoni (1475–1564), the great Italian sculptor, painter, poet, and architect. *David*, a fourteen-foot marble statue created 1501–1504, is considered one of the world's greatest masterpieces.

53. The Anderson Galleries were located at 489 Park Avenue, New York.

54. Rev. Eugene S. Burke (1887–1951) was rector of the American College in Rome from 1925 to 1935.

55. Edith Bayne Denègre (1863–1936) traveled widely and was married to New Orleans attorney George Denègre (1854–1930).

56. Pilgrims visiting the Vatican's St. Peter's Basilica traditionally touch or kiss the foot of a statue of St. Peter.

57. Pontifical Swiss Guard, Swiss soldiers who, among other security duties, guard the gates of Vatican City, headquarters of the Roman Catholic Church.

58. Jubilee, or Holy Year, 1925 was declared by Pope Pius XI. The origin of Christian Jubilee goes back to Law of Moses.

59. Rome has been referred to as the Eternal City for centuries.

60. A street in Rome.

61. Church of Santa Maria in Domnica is thought to date to the seventh century and features a great mosaic; Santi Giovanni e Paolo is a basilica church in Rome first built in the fourth century.

62. Aventine Hill, one of Rome's seven hills on which the ancient city was built; Villa del Priorato di Malta is on Aventine Hill.

63. Basilica della Santissima Annunziata in Florence was founded in 1250 and features frescoes by important Renaissance artists.

64. Repertory of unaccompanied chants sung in Roman Catholic liturgical services.

65. Letter written December 25, 1925.

66. An American railroad sleeping car.

67. Charles Antoine Jérome Brès (1784–1822).

68. Jeanne Thérèse Brès Montolivo (1853–1929).

69. An apparition of Mary, Mother of Jesus, that appeared in Lourdes, France, in 1858.

70. Marie Antoinette Montolivo Scoffier (1878–1958) and Danielle Marie Thérèse Scoffier Segond (1904–1995).

71. Église Saint-Michel [Saint Michael's Church] was built in the 1750s.

72. Madame Louise Canivet (ca. 1859–?).

73. George Sand was the pseudonym of French writer Amantine-Lucile-Aurore Dupin (1804–1876); composer Frédéric François Chopin (1810–1849) was among Sand's lovers.

74. Lithuanian-born violinist Jascha Heifetz (1901–1987) is considered by many the greatest violinist of all time.

75. Brandt van Blarcom Dixon (1850–1941) was President of H. Sophie Newcomb Memorial College for Women from 1887 to 1919 and husband of Eliza Carson Dixon (1852–1930).

76. Jardin du Luxembourg, on the Left Bank, is one of Paris' most beloved public parks.

77. Berthe Imer Girardet (1861–1948) was born in Marseille, France, and she first exhibited her sculpture in 1890. In 1925, the Parisian gallery Jean Charpentier held a retrospective exhibition of her work.

78. École Centrale Paris is a government-sponsored university-level engineering school founded in 1829.

79. Charles Louis Roszak (1882–1929) and Germaine Tardif Roszak (1896–1940).

80. George Alexander Orrok (1867–1944).

81. Babcock and Wilcox Company was founded in 1867 in the United States.

82. Roger Georges Gothy-Roszak (1916–1981), Simone Lucienne Dumont-Roszak (1916–2014), Jean Rodolphe Gabriel Roszak (1918–2007), Suzanne Roszak (1921–2010), Charley Roszak (1921–?), Raymond Albert Roszak (1923–1970). (A seventh child, Jacqueline Madeleine Laurence Roszak (b. 1924), was adopted later.)

83. Maison Prunier, 9 Rue Duphot, founded 1848, specialized in seafood.

84. Hôtel Continental, at the intersection of Rue de Castiglione and Rue de Rivoli, was among the era's finest hotels.

85. Mardi Gras, or Fat Tuesday, is the day before Christian Lent and at the end of a season of parades and balls in New Orleans.

86. Concierge and maid at Madame Canivet's.

87. Marcelle Émilie Germaine "Bill" Tardif Desonay (1904–1983). Bill's mother was Charlotte Berty (1870–1948) and her husband was Michel Louis Bernard Julien Desonay (1892–1968). Her husband had two brothers, both Belgian: Jean Desonay (1886–1948) and Henri Desonay (1896–1955). The next generations of Desonays with whom Angela Gregory remained friends and in touch includes Bill's daughter Monique Jeanne Simone Desonay Vincent (b. 1932), and Bill's granddaughters, Christine Hélène Caroline Marcelle Louise Vincent (b. 1960) and Caroline Sophie Elisabeth Vincent Anfry (b. 1966).

88. Barsac is sweet French wine; Evian is bottled spring water.

89. Gaston Doumergue (1863–1937) was President of France from 1924–31.

90. General Henri Gouraud (1867–1946) was a French general during World War I, High Commissioner of Syria and commander in the Levant from 1919 to 1923, and Military Governor of Paris from 1923 to 1937.

91. Lucille Soniat (du Fossat) (1898–1989) was a lifelong friend of Angela Gregory's.

She owned and ran a French-language bookshop in New Orleans' French Quarter in the 1940s.

92. The prestigious Sorbonne (now Paris-Sorbonne University) was founded in the thirteenth century.

93. Saint Joan of Arc (b. ca. 1412–1431) helped lead the French army to victory against the English and their French allies in 1429.

94. A new chapel had been built in 1924 on the Loyola University campus in New Orleans.

95. The cemetery near Berry-au-Bac became a national cemetery in 1925. Nearly four thousand French soldiers killed in World War I are buried here.

96. A canal that connects the Aisne and Marne valleys.

97. Besant, *All Sorts and Conditions of Men*. The wealthy and well-educated young heroine, Angela Messenger, worked to transform the poverty and deprivation of late nineteenth-century London.

98. Ernest Hemingway (1899–1961), F. Scott Fitzgerald (1896–1940), and Gertrude Stein (1874–1946) were American writers in Paris in the 1920s.

99. Cafés in Montparnasse neighborhood.

100. Raymond Duncan (1874–1966) and his sister, dancer Isadora Duncan (1877–1927).

101. Paul Ninas (1903–1964) is described as the "Dean of Modern Art" in New Orleans where he lived and worked from 1932 until his death.

102. The Château [Castle] de Versailles, fifteen miles southwest of Paris, was the political capital and seat of the French royal court from 1682 to 1789.

103. Marie-Antoinette (1755–1793) was Queen of France from 1774 to 1792.

104. Sternberg, "Sculptor Bourdelle Blames Socialists for Decay of Art," 10.

105. Madame Chaput.

106. Bourdelle was named a Knight of the Legion of Honor in 1909, an officer in 1919, and achieved the highest rank, Commander, in 1924.

107. Otto-Charles Bänninger (1897–1973) was a Swiss sculptor and also a student of Bourdelle's.

108. Ulysse Attenni (1874–1938).

THREE ＞ THE DREAM COMES TRUE

1. Louis Gillet (1876–1943) was a French art historian who called Bourdelle the unquestioned master of French sculpture since the death of Rodin; Anatole France, pseudonym for Jacques Anatole Thibault (1844–1924), was a French writer who won the 1921 Nobel Prize in Literature and called Bourdelle the greatest sculptor in the world.

2. *Monument au Général Alvéar [Monument to General Alvear]* (1913–1923) honors General Carlos María de Alvéar (1789–1852), a key commander in the Argentine fight for independence from Spain and Argentina's ambassador to the United States from 1837 to 1852. This monument stands in Buenos Aires as well as in the Musée Bourdelle in Paris; *Monument aux Morts de Montauban [Monument to the Dead of Montauban]* (1893–1902) was installed in 1902 in Montauban, France;

La Vierge á L'Offrande [The Virgin of the Offering] (1919–22) is a six-meter stone sculpture installed in 1922 in Niederbruck, Alsace, France, and a cast is also in the Musée Bourdelle; The Théâtre des Champs Élysées is a performance venue in Paris inaugurated in 1913 on Avenue Montaigne near the Pont de l'Alma. Bourdelle, who was artistic advisor on the project, sculpted bas-reliefs and painted frescoes; Bourdelle's pigmented frieze is in the interior of the Opera House in Marseille.

3. Sir James George Frazer (1854–1941) was a British anthropologist, folklorist, and classical scholar. The Frazer and France busts are in the Musée d'Orsay in Paris. France is also in the Musée Bourdelle and Frazer is in the National Portrait Gallery, London. The Rodin bust is in the Musée Ingres, Montauban, France.

4. Paternal grandfather, Antoine Bordelles (1781–1857); maternal grandfather, Jean Reille (1814–?); father, Antoine Bourdelle (1820–1906); and uncle, Jean Lucien Bourdelles (1821–1883).

5. Varenne, *Bourdelle par lui-même*, 10.

6. The teacher's name was Monsieur Rousset; the Musée Ingres owns collections of paintings by Jean-Auguste-Dominique Ingres (1780–1867), a proponent of French Neoclassical painting, and sculpture by Antoine Bourdelle. Like Bourdelle, Ingres was a native of Montauban.

7. French sculptor and painter Jean-Alexandre-Joseph Falguière (1831–1900).

8. A French government scholarship for art students to study in Rome.

9. Aimé-Jules Dalou (1838–1902) was a French artist known for his monumental sculptures.

10. Jean-Baptiste Carpeaux (1827–1875) was known for the anatomical realism of his sculptures.

11. Madame Lavrillier was Marguerite Cossaceanu (1893–1980), a Romanian student of Bourdelle's.

12. Bourdelle's criticisms are gathered into the two volume *Cours et Leçons à l'Académie de la Grande Chaumière* [Classes and Lessons at the Academy of the Grand Chaumière], published in 2007 and 2008 by Paris-Musées.

13. Vladimir Lenin (1870–1924) was a Russian revolutionary thinker and political figure.

14. Dolores del Rio (1904–1983) was a Mexican actress and Hollywood movie star.

15. The New Orleans Criminal Courts building (now Orleans Parish Criminal District Court building) was constructed in 1931. Gregory's sculpture includes enormous pelicans, figures of Liberty and Justice, and six panels depicting Louisiana history.

16. Gillet, "Bourdelle Number," unpaginated.

17. Rodin worked on *The Gates of Hell* for 37 years (1880–1917). It was first cast in 1926–28 and is considered the defining work of his career.

18. Paul Dessausse.

19. Alberto Giacometti (1901–1966) was an innovative Swiss sculptor whose works incorporated surrealism and existentialism.

20. Arnold Geissbuhler (1897–1993) was a Swiss sculptor and student of Bourdelle's who went on to practice his art and teach in the United States.

21. Germaine Richier (1902–1959) was a French sculptor who exhibited widely in Europe and the United States in the 1940s and '50s.

22. The *Beauvais Head of Christ*, now identified as sixteenth-century, is a sculpture from the Saint-Sauveur de Beauvais church in Beauvais, France. Angela Gregory's limestone copy is now owned by Tulane University.

23. Musée de Sculpture Comparée [Museum of Casts] was founded in 1882 and was located in Palais du Trocadéro (now the Palais du Chaillot), which is across the Seine River from the Eiffel Tower.

24. See Hoffman, *Sculpture Inside and Out*, 171, for an illustrated explanation of this technique.

25. Annual art exhibition first held in 1923, organized in opposition to the Salon of the French Academy, and displayed in a hastily constructed building dubbed the Palais du Bois [Palace of Wood]. Bourdelle was a founding member.

26. Henri Matisse (1869–1954) was a French artist, painter, sculptor, and designer.

27. Cortissoz, "The Field of Art," 557.

28. Novitza "Fanny" Moscovici Fainsilber (1901–1969) and her husband, Sigismond Fainsilber (1903–1947).

29. The *Bienville Monument*, which features Bienville, the Recollect Franciscan priest, Athanase (sometimes spelled Anastase or Anatase) Douay (b. late 17th century–?) and a Bayougoula Indian man, was relocated in 1996 to a small park at Decatur and Conti streets in the French Quarter of New Orleans.

30. Théophania "Zezette" Camille Bunand-Sevastos Chipman (1905–1998) was the daughter of Antonin Bunand and Anthippe Sevastos Bunand Couchoud (1879–1950), sister of Cléopâtre Sevastos Bourdelle.

31. Paul-Louis Couchoud (1879–1959) was a French philosopher and writer and the second husband of Anthippe Sevastos.

32. Amelita Galli-Curci (1882–1963) was an Italian-born American opera singer.

33. A Victor phonograph invented around 1905.

34. Journal entry, undated.

35. *The Dying Centaur* (1911–1914) is displayed in the Musée Bourdelle and is sometimes referred to as *The Wounded Centaur* or *The Last Centaur*.

36. Thiébault-Sisson,"Lettre de Paris," 1.

37. Probably Nicaraguan poet Rubén Darío (pseudonym of Félix Rubén García Sarmiento) (1867–1916).

38. The Franco-German or Franco-Prussian war of 1870–1871 in which France was defeated by a Prussian-led coalition of German states.

39. Casts of the *Head of Apollo* (1898–1909) are in the Musée Bourdelle and the Musée d'Orsay in Paris, among several museums.

40. Michel Sevastos (1843–1924) was the father of Cléopâtre Sevastos Bourdelle and Anthippe Sevastos Bunand Couchoud.

41. Nichols, "Bourdelle," 185.

42. Rhodia Dufet-Bourdelle (1911–2002).

43. Pierre Bourdelle (1901–1966) was the son of Antoine Bourdelle and Stéphanie Van Parys (1877–1945).

44. Bourdelle, "D'erreur en erreur tu t'éclaires, pourvu que tu aimes toujours."

45. Lionel S. Marks (1871–1955) was a British-born professor of mechanical engineering at Harvard University from 1894–1940 and was the author of *Mechanical Engineers' Handbook*, first published in 1916.

46. The Folies-Bergère, a Parisian music hall known in the 1920s for nude and near-nude performers.

47. Josephine Baker (1906–1975), born Freda Josephine McDonald, was an African American dancer in 1920s Paris.

48. Desha Podgorsek Delteil (1899–1980) was a dancer and actress in Europe and the United States. Her husband, Henri Jean Raoul Delteil (1899–?), danced as Myrio Delteil.

49. Sculptures by Harriet Whitney Frishmuth (1880–1980) for which Desha Delteil posed include *The Vine* (1921–1923) and *Joy of the Waters* (1917–1920).

50. Jeanne Adèle Bergson (1893–1961) was born deaf. She was the daughter of French philosopher and writer Henri Bergson (1859–1941) who won the 1927 Nobel Prize in Literature.

51. Casts of *Hercules the Archer* (1910) are in the Musée d'Orsay and Musée Bourdelle, Paris, and the New Orleans Museum of Art.

52. Founded in 1862, the Société Nationale des Beaux-Arts sponsors an annual salon, or exhibition.

53. Casson, *Some Modern Sculptors*, 37.

54. Walter Adolph Gropius (1883–1969) was a German American architect who founded the Bauhaus (1919–33), a German design school. Bauhaus architecture favored function and eschewed ornamentation.

55. Architectural sculpture for the Criminal Courts Building in New Orleans (1929–30); the Louisiana State Capitol, Baton Rouge (1930–31); Tulane University's Hutchinson Memorial Building in New Orleans (1929–30); and La Tour Carrée, Septmonts, France (1932).

56. Subjects were historic male figures important to Louisiana's development: Edward Douglass White (1845–1921), Louisiana United States senator (1891–1894) and United States Supreme Court Chief Justice (1910–1921); Thomas Jefferson (1743–1826), third President of the United States (1801–1809); Judah P. Benjamin (1811–1884), Louisiana United States senator (1853–1861), Confederate Secretary of War (1861–1865); Judah Touro (1775–1854), merchant and philanthropist; Paul Tulane (1801–1887), founder of Tulane University; Louis Moreau Gottschalk (1829–1869), composer and concert pianist; John James Audubon (1785–1851), naturalist and illustrator; and Charles Gayarré (1805–1895), historian.

57. Kate (Catherine Anselm) Gleason (1865–1933) was an American engineer and businesswoman and the first female member of American Society of Mechanical Engineers. La Tour Carrée was a thirteenth-century tower purchased by Gleason in 1924 in Septmonts, France, a village devastated during World War I.

58. *Aesculapius* (1929–30) remains in place on the Tulane University School of Medicine Hutchinson Memorial building, New Orleans.

59. Rudolph Matas (1860–1957) was professor of surgery at Tulane University from 1895–1927.

60. The New Orleans Cotton Exchange building opened in 1921.

61. René Henri Bonée (1889–1983) was a marblecutter in New Orleans.

62. Charlemagne (Charles the Great) (ca. 747– ca. 814), King of the Franks, Christian Emperor of the West.

63. The Alvéar Monument.

64. The 1926 Salon des Tuileries was held in the Palais de Bois, Porte Maillot in Paris.

65. Undated letter, May 1926.

FOUR > FULLY ACCEPTED

1. Émile Gauguin (Emile Marae e Tai) (1899–1980) was the son of French painter and sculptor Paul Gauguin (1848–1903). Émile's mother, Tehura, was a Tahitian.

2. In 1750 the Musée du Luxembourg became the first French museum open to the public. In 1818, it became the first French museum of contemporary art.

3. Dalou's monument to French Romantic artist Ferdinand Victor Eugène Delacroix (1798–1863) is in the Jardin [Garden] du Luxembourg, which is near the Musée de Luxembourg.

4. Paul Cézanne (1839–1906), French artist and Post-Impressionist painter.

5. The American Union Church was located just off the Champs Élysées.

6. Part of the mise-aux-points process.

7. French anti-Americanism after World War I was rooted in perceived United States isolationism and indifference toward France regarding war debts and reparations.

8. Legion of Honor pin.

9. Madame Chaput.

10. Letter to family written August 8, 1926.

11. The Tomb of the Unknown Soldier.

12. The *Elgin Marbles* are a collection of classical Greek sculptures acquired by Thomas Bruce (1766–1841), the Seventh Earl of Elgin. In 1818 the collection was purchased by the British Parliament for the British Museum.

13. Fixed rate for room, breakfast, and one other daily meal.

14. Edith Walmsley (1863–1941) and her daughter Lucinda (1897–1978) were friends from New Orleans.

15. Charles-Saint Martin.

16. Related to American demands for repayment of the World War I loans to France.

17. Augustine was a young African American woman who worked as a maid in the Gregory household. The sculpture of her, *La Belle Augustine,* was completed in 1928.

18. Possibly Helen M. Turner (1858–1958), an Impressionist painter who had returned to New Orleans in 1926 after thirty years in New York. Turner was a close friend of Angela Gregory.

19. Letter to parents, October 20, 1926.

20. Rembrandt van Rijn (1606–1669), artist of Holland's seventeenth-century "Golden Age"; Tiziano Vecellio (ca. 1488–1576), known as Titian, Venetian artist of the sixteenth century.

21. Likely *Père et Grand-mère de Bourdelle*, which depicts Bourdelle's father and maternal grandmother (Jeanne Marie or Marie Elisabeth Muratet [1814–1900]) and is found in the Musée Bourdelle in Paris.

22. Diary entry, undated.

23. Alberto Guani (1877–1956), Uruguay's Plenipotentiary Minister to France from 1925–26 and his wife, Lucinda Martins Rosso (1885–?). The couple probably visited the studio to discuss the Dr. Francisco Soca (1856–1922) memorial. Bourdelle worked on the monument in 1927 but it was not installed in Montevideo until 1935.

24. Anastase Simu (1854–1935) was a Romanian academic and art collector who founded the Simu Museum in Bucharest. Bourdelle modeled Simu's bust in 1920.

25. Jiddu Krishnamurti (1895–1986) was a religious teacher and thinker.

26. Annie Besant (1847–1933) was a British social and political reformer and supporter of Indian nationalism. The Theosophical Society, founded in 1875 in New York City, is a spiritual and educational movement based on Hindu concepts of reincarnation and karma.

27. Auguste Perret (1874–1954).

28. Gillet, "L'Exposition Bourdelle," 1. L'Exposition Bourdelle was a retrospective of Bourdelle's work that opened February 15, 1931, at the Pavillon de l'Orangerie in Paris and featured more than 300 works of sculpture, drawings, and paintings.

29. The American Cathedral in Paris was founded in the 1830s to serve the American community and is located midway between the Seine River and the Champs Élysées.

30. Myron T. Herrick (1854–1929) was the United States ambassador to France from 1912 to 1914 and from 1921 to 1929.

31. Kipling, "Recessional," 109.

32. General John Joseph Pershing (1860–1948) was the World War I Commander-in-Chief of the American Expeditionary Force.

33. A cast of *La France* (1922–25) was erected at the L'Exposition Internationale des Arts Décoratifs et Industriels Modernes [International Exposition of Modern Decorative and Industrial Arts], an international exhibition held in Paris in 1925 that was important to the promotion of Art Deco and that had immediate and worldwide impact.

34. Antoine-Louis Barye (1796–1875).

35. The Palais de Tokyo, 13 Avenue du Président-Wilson, today houses the Musée d'Art Moderne de la Ville de Paris [Museum of Modern Art of the City of Paris] and the Site de Création Contemporaine [Site for Contemporary Arts].

36. Charles-Édouard Jeanneret Le Corbusier (1887–1965) was a Swiss architect, urban planner, painter, writer, designer, and theorist. His exhibit in 1925 was titled *Pavilion de L'Esprit Nouveau* [Pavilion of the New Spirit] and it showcased his innovative architectural concepts.

37. Florence Bryant Colby (1880–1969).

38. *Vieille Bacchante* (1903).

39. American actor Douglas Fairbanks (1883–1939) and his wife, Canadian-born actress Mary Pickford (1892–1979); Australian singer Dame Nellie Melba (1861–1931); and William G. McAdoo (1863–1941), United States Secretary of the Treasury, 1913–18.

40. Les Deux Magots Café was frequented by famous writers and artists.

41. Monument to Polish poet and champion of Polish national freedom Adam Mickiewicz (1798–1855) was modeled from 1908 to 1928. This monument now stands in Paris in the Jardin [Garden] d'Erevan on Cours Albert 1er.

42. A pâtisserie on the Rue de Rivoli founded in 1903 by Austrian Anton (Antoine) Rumpelmayer (1832–1914).

43. Laura Bucknell Loyson (1871–1958), wife of Paul Hyacinthe Loyson (1873–1921) and daughter-in-law of religious reformer Charles Loyson (1827–1912), also known as Père Hyacinthe. Laura and Paul Loyson's two daughters were Marthe (1900–1987) and Emilie Pauline (1907–1987).

44. James Abbott McNeill Whistler (1834–1903) was an American-born artist active mainly in England.

FIVE > MASTERING TECHNIQUE

1. The Roman Catholic Église [Church] St. Sulpice, built in the seventeenth century, is located in the neighborhood of the Luxembourg Garden and is famous for its pipe organ.

2. Charles-Marie Widor (1844–1937), a French organist and composer, was organist at St. Sulpice from 1870 to 1934.

3. Johann Sebastian Bach (1685–1750) was a German composer.

4. Toulon and Hyères are in southern France, close to the Mediterranean Sea. The Grand Hôtel des Iles D'Or, 62 avenue des Iles-d'Or, was built in 1850.

5. Bourdelle's *Monument to Adam Mickiewicz* was originally installed in the Place de l'Alma in 1929 before its relocation to Cours Albert 1er.

6. Frédéric Mistral (1830–1914), a French poet who led a revival of the Occitan (Provençal) language and literature, was awarded the 1904 Nobel Prize in Literature.

7. Letter to parents written around January 14, 1927.

8. Official magazine of the United States National Geographic Society.

9. Raymond F. Almirall (1869–1939).

10. Joseph Janer Almirall (1902–1968) and Francis Cusachs Almirall (1907–1965).

11. Almirall's Beaux-Arts design for the Central Public Library at Brooklyn was never built, though he designed three Brooklyn branch libraries that were built. Hospitals included Fordham and Gouveneur hospitals in New York City, and Seaview Hospital in Staten Island, New York; William Welles Bosworth (1869–1966); John Davison Rockefeller Jr. (1874–1960).

12. Young women in the 1920s who behaved and dressed boldly and unconventionally.

13. The plaza to the west of the Panthéon, which is an eighteenth-century church turned mausoleum located near Luxembourg Garden.

14. Edna Martha Vollmer (1900–1977).
15. Louis-François Biloul (1874–1947).
16. Arthur Power (1891–1984); the woman is unknown.
17. Bruce Hough Bruce (1891–1952).
18. James Joyce (1882–1941) was an Irish writer. His *Ulysses* novel was published in 1922.
19. Salons held in Gertrude Stein's apartment at 27 Rue de Fleurus were frequented by an international set of artists and writers.
20. George Harlan Leaf Miller (1893–1986) was Second Secretary of the United States Embassy at Paris from 1924 to 1928. His wife was Harriette Gowen Miller (1892–1971).
21. Joseph Eugene Ransdell (1858–1954) was Louisiana's United States Representative from 1899–1913 and United States Senator from 1913 to 1931.
22. Musée de [Museum of] Beauvais.
23. Now considered to date from the sixteenth century.
24. The 1984 Louisiana World Exposition (May–November 1984).
25. Warren G. Harding (1865–1923) was United States President from 1921 to 1923.
26. Le Bourget, an airport seven miles northeast of Paris, opened to commercial aviation in 1919 and was the only Paris airport until 1932.
27. Lucinda Walmsley.
28. King Albert I (1875–1934) reigned from 1909 until his death. His wife was Queen Elisabeth (1876–1965). In 1928 Belgium hosted the largest exhibition of Bourdelle's work in his lifetime at the Palais des Beaux Arts [Palace of Fine Arts] in Brussels.
29. Paul-Louis Couchoud.
30. Fernand Émile Bouisson (1874–1959) was President of the French Chamber of Deputies from 1927 to 1936. In 1927 his wife was Madeleine Beaugez Bouisson.
31. Cléopâtre Bourdelle recalled that Maurice Herbette (1871–1929), the French ambassador to Belgium from 1922 to 1929, invited the Belgian sovereigns to name the Frenchmen they would most like to meet. Among the names was Bourdelle.

SIX > SELINA ARRIVES

1. Audio only of this letter.
2. Possibly Anson Conger Goodyear (1877–1964), an American businessman and art collector who served as President of New York City's Museum of Modern Art from 1929 to 1939, and who owned work by Bourdelle.
3. Chantilly is a town about 30 miles north of Paris with a forest and a park surrounding two châteaus, one with a museum.
4. Whit (or Pentecost) Monday is a public holiday in France.
5. Compagnie Générale Transatlantique, founded in 1861, was a French shipping company also referred to as the French Line.
6. Located in the Parisian suburb of Neuilly-sur-Seine, the American Hospital of Paris was created in 1906 to serve the American community.
7. Likely Lawrence Bertheaud Jr. (1917–1991).

8. The American Women's University Club, also known as Reid Hall, provided lodging for members of the American Association of University Women. Reid Hall had a history of hosting and promoting student artists prior to World War I. The building became a hospital during the war and then once again served as a residential center for young American women in Paris.

9. Most evenings music, dancing, or a lecture was provided in the Salon.

10. Dorothy Flagg Leet (1894–1994).

11. The Foreign Policy Association, founded in 1918, seeks to educate the United States public about foreign policy. The International Federation of University Women was founded in 1919 to promote friendship and understanding among women graduates; it became Graduate Women International in 2015.

12. Marguerite Milward (1873–1953) lived in India in the 1940s and produced some one hundred sculptures of men and women of the Indian subcontinent.

13. Ludwig van Beethoven (1770–1827) was a German composer.

14. Audio only of this letter.

15. St. Luke's Chapel, or The Little Tin Church, 5 Rue de la Grande Chaumière, was an American church constructed in 1892 and was connected to the garden of Reid Hall.

16. Audio only of this letter.

17. Auguste Rodin's *Monument to Balzac* (1891–97), in honor of French writer Honoré de Balzac (1799–1850), was unveiled in 1898, but not installed until 1939 at the intersection of Boulevard Raspail and Boulevard Montparnasse in Paris.

18. John Simon Guggenheim Memorial Foundation Fellowships were awarded in several fields of study including fine arts.

19. Herbert King Stone (1883–1945) had been head of the English and French Departments at Isidore Newman Manual Training High School in New Orleans and was an instructor at Tulane in 1922 and 1923. He went to Paris in 1923 and taught at the École des Hautes Etudes [School for Advanced Studies].

20. Leo Tolstoy (1828–1910) was a famous Russian writer and thinker. The daughter who spoke at L'Académie de la Grande Chaumière was likely Alexandra L. Tolstoy (1884–1979), executor of her father's estate.

21. Joseph John Campbell (1904–1987) and Angela Gregory were lifelong friends. See also Larsen, *A Fire in the Mind*.

22. Now known as Columbia University in New York City, an Ivy League school that was founded as King's College in 1754. Campbell graduated from Columbia University with a Bachelor of Arts degree in 1925 and a Master of Arts degree in 1927.

23. Sarah Lawrence College, located in Yonkers, New York, was founded in 1926 as a college to educate women in the arts and humanities. Campbell was on the faculty from 1934 to 1972.

24. The National Arts Club, founded 1898, is based in New York and fosters interest in and educates the United States public about the arts; *Joseph Campbell and The Power of Myth with Bill Moyers* was first broadcast in 1988; Billy Don "Bill" Moyers (b. 1934).

25. Église de Saint Eustache [Church of Saint Eustace] was begun in 1532 and is located on the Right Bank.

26. Possibly Marc-Antoine Charpentier's Messe de minuit pour Noël (ca. 1694).

27. *Crock of Gold* (1912). Stephens was an Irish novelist and poet.

28. Possibly a successor to the American Girls Art Club in Paris founded at Reid Hall in the 1890s.

29. Adelaide McLaughlin Moise.

30. Charles William Campbell (1867–?).

31. Journal entry, February 3, 1928.

32. Palais des Papes construction began in 1335 and was the Roman Catholic papal residence until 1377.

33. Les Baux-de-Provence is a medieval mountain village between Avignon and Marseille.

34. The Corniche d'Or is a scenic coastal road that runs beside the Mediterranean between St. Raphaël and Cannes, France.

35. *Appartement à Louer* [*McFadden's Flats*] was an American silent comedy released in 1927 in the United States; *Music Hall* may have been *Charlot au Music-Hall* [*A Night at the Show*], an American silent film starring Charlie Chaplin released in the United States in 1915.

36. Monte Carlo, where the casinos were located, is a district within the Principality of Monaco.

37. Catherine Brès Montolivo's name was later determined to be Jeanne Thérèse Brès Montolivo (1853–1929).

38. Joseph Brès (1820–1895) was a nephew of Jean Baptiste Brès (1788–1842).

39. Reid Hall.

40. The invoice for the sale of this goose to Tiffany & Co., 25 Rue de la Paix, Paris, is dated May 14, 1928.

41. Henry Strong Durand (1861–1929) was a medical doctor and philanthropist from Rochester, New York.

42. François Pompon (1855–1933) was a French sculptor of animals.

43. Josephine Elizabeth Campbell (1883–1965).

44. Above each location Selina had written the number of paintings Angela had done at each site: Avignon-1, Les Baux-1, Cannes-2, Cimiez-Nice-2, Carcassonne-2, Montauban-2, Villefranche-2.

45. French painter Edgar Germaine Hilaire Degas (1834–1917); Dutch painter Vincent Van Gogh (1853–1890); French Impressionist Claude Monet (1840–1926); French painter Édouard Manet (1832–1883).

46. Mother, Marie-Célestine Musson De Gas (1815–1847); maternal grandfather, Jean Baptiste E. Germain Musson (1778–1853); brother, Jean Baptiste René Degas (1845–1921); and maternal uncle, Michel Musson (1812–1885).

SEVEN ⟩ ART AND FRIENDSHIP

1. The Theosophical Society Hall in Paris, 4 Square Rapp, was built in 1912–1915.

2. Clare Wadleigh Hayes (1909–1997).

3. The Eerde castle and land in Ommen, Netherlands was given in 1924 to Krishnamurti and his Order of the Star in the East by Philip Dirk baron van Pallandt (1889–1979).

4. Curuppumullage Jinarajadasa (1875–1953) was a Theosophist writer and president of the Theosophical Society (1946–1953).

5. Fashion house in Paris founded by Jeanne Lanvin (1867–1946).

6. Russian pianist Vladimir von Pachmann (1848–1933).

7. *Tosca* (1900) by Giacomo Puccini; The Opéra Comique is a national theater founded in 1714 and located on Place Boieldieu; William Martin (1898–?) was an American tenor.

8. La Coupole opened in December 1927 on Boulevard Montparnasse.

9. Henry Rawle Wadleigh (1871–1937).

10. The gothic Cathédrale Notre-Dame de Chartres, parts of which date from 1194, is considered an architectural gem of Western civilization. The town of Chartres is about fifty miles southwest of Paris.

11. Raoul-Octove-Marie-Jean Harscouët (1874–1954) was Bishop of Chartres from 1926 to 1954.

12. Porte Guillaume, constructed in the fifteenth and sixteenth centuries, is a gateway built into the wall surrounding the city of Chartres.

13. Ballets Russes [Russian Ballet] (1909–29) was a traveling ballet company established in Paris in 1909.

14. *Le Lac des Cygnes* [*Swan Lake*] (1877) is a classical ballet with music by Peter Ilyich Tchaikovsky.

15. Maurice Denis (1870–1943) was a French painter and founder of the Nabi movement, a group of artists that rejected realism and adopted simplification.

16. Roman goddess of wild animals and the hunt.

17. Vaslav Nijinsky (1889–1950) was a world-renowned Russian-born ballet dancer.

18. Aveline and Dufet, *Bourdelle and the Dance: Isadora and Nijinsky*.

19. Ibid.

20. The Salon d'Automne [Autumn Salon] was held annually in the Grand Palais, which opened in 1900 and is located just off the Champs Élysées.

21. Journal entry, April 22, 1928.

22. Henry S. Durand was married to Harriet R. Durand (1873–1949).

23. Cité Internationale Universitaire de Paris [International Student Residence Halls of Paris] was an institution created in the years following World War I to promote peace and understanding among international students; Fondation des États-Unis [Foundation of the United States], completed in 1930, was one of the pioneer buildings at the Cité and was partially financed by American surgeon Homer Gage (1861–1938).

24. Probably the president of the Salon de Tuileries committee, Paul-Albert Besnard (1849–1934), a decorative painter and printmaker.

25. Bal, "Today is Varnishing Day For Salon des Tuileries," 9.

26. *Sapho* (or *Sappho*) (1887–1925) is of the female poet of ancient Greece, born around 615 B.C.; The mask, *Visage en pâte de verre de Jean Cros* [*Face in glass paste of Jean*

Cros] was a portrait of Irène Beatrice MacNeal Millett (1890–1963) sculpted by Bourdelle but carried out using the glass-paste technique in cooperation with Jean Cros (1884–1932), a French ceramicist and painter. Both sculptures may be found in the Musée Bourdelle.

27. Athanase Apartis (1899–1972) was exhibiting his *Carmen Visconti* at the 1928 Salon. He had a successful career as a sculptor and teacher in France and Greece.

28. A cast of Rodin's *Eve* (1881) can be found in the Musée Rodin in Paris.

29. Romainian-born sculptor Constantin Brancusi (1876–1957) first exhibited in Paris in 1906. His abstract and highly simplified *Bird in Space* (1923) is part of a series of sixteen marble and bronze sculptures.

30. Elizabeth Chase Geissbuhler (1901–2001) married Arnold Geissbuhler, who had also been a student of Bourdelle's at La Grande Chaumière. Chase became an authoritative writer on Auguste Rodin.

31. Spanish sculptor Mateo Hernández (1884–1949); French painter André Lhote (1885–1962); Dutch painter Piet Mondrian (1872–1944); Fainsilber from the studio; Germaine Richier, also in Bourdelle's studio; and French painter Maurice Utrillo (1883–1955).

32. Perhaps one of Piet Mondrian's paintings.

33. Bal, "The Week in Paris Art," 5.

34. Therese Fischer Graves Meloy (1905–1995) was a friend from New Orleans.

35. French Line vessel built in 1924.

36. Likely the Bois de Boulogne.

EPILOGUE

1. Elizabeth Morris Poucher (1895–1988) was an American artist who studied at L'Académie de la Grande Chaumière.

2. "On the Passing of Bourdelle," 12x.

3. Fontainebleau is about forty miles southeast of Paris. The Dufet property, located near Fontainebleau in the village of Égreville, is today the Musée-Jardin Bourdelle [Bourdelle Garden Museum].

BIBLIOGRAPHY

MANUSCRIPT COLLECTIONS

Angela Gregory Papers, Louisiana Research Collection, Tulane University, New Orleans, Louisiana.

Artists' Files, Williams Research Center, The Historic New Orleans Collection.

PUBLISHED WORKS

Agard, Walter. "Bourdelle, Lover of Stone." *International Studio* 77 (June 1923): 194–99.

Anonymous. "France and the Mississippi Flood." *New York Herald, Paris,* May 6, 1927.

Anonymous. "On the Passing of Bourdelle." *New York Times,* October 6, 1929.

Anonymous. "Angela Gregory." *Arts and Antiques,* 1 (November 1938): 2–6.

Angela Gregory Artist File, The Historic New Orleans Collection, New Orleans.

Aveline, Claude, and Michel Dufet. *Bourdelle and the Dance: Isadora and Nijinsky.* Paris: Arted, Éditions d'Art, 1969.

Bal, Georges. "Today is Varnishing Day for Salon des Tuileries." *New York Herald, Paris,* May 4, 1928.

Bal, Georges. "The Week in Paris Art." *New York Herald, Paris,* May 13, 1928.

Besant, Walter. *All Sorts and Conditions of Men: An Impossible Story.* Oxford; New York: Oxford University Press, 1997.

Bosco, Ronald, and Douglas Wilson, eds. *The Collected Works of Ralph Waldo Emerson: Volume VII: Society and Solitude.* Cambridge and London: Belknap Press of Harvard University Press, 2007.

"Bourdelle and the Gods," *Paris-Musées,* http://parismusees.paris.fr/en/exhibition/bourdelle-and-gods (Accessed August 2, 2017).

Bourdelle, Antoine. *Cours et Leçons à L'Académie de la Grande Chaumière, Tome 1, Cours, 1909–1910.* Paris: Paris-Musées, 2007.

Bourdelle, Antoine. *Cours et Leçons à L'Académie de la Grande Chaumière, Tome 2, Leçons.* Paris: Paris-Musées, 2008.

Bourdelle, Cléopâtre. "D'erreur en erreur tu t'éclaires, pourvu que tu aimes toujours." In *Chefs-D'oeuvre de L'art, Grands Peintres—Grands Sculpteurs, 139 Bourdelle,* by Enrico Crispolti. Paris: Hachette, 1969: unpaginated.

Casson, Stanley. *Some Modern Sculptors.* London: Humphrey Milford: Oxford University Press, 1929.

Cortissoz, Royal. "The Field of Art—Emile Antoine Bourdelle and the Renovation of French Sculpture." Scribner's Magazine (November 1925): 553–60.

Dobie, Ann B. "Angela Gregory," *Know Louisiana,* http://www.knowlouisiana.org/entry/angela-gregory (Accessed August 5, 2017).

Gihon, Jack. "Miss Gregory Begins Dream of Typifying the Southern Negro in Sculpture." *Morning Tribune,* November 12, 1928.

Gillet, Louis. "Bourdelle Number." *Art Gallery Magazine,* 1 (November 1925): unpaginated.

Gillet, Louis. "L'exposition Bourdelle." *Beaux-Arts, Chronique des Arts et de la Curiosité* (February 20, 1931): 1–2.

Glade, Luba. "The Uptown Lady Who Helped Decorate New Orleans, Angela Gregory." *States-Item,* March 1, 1975.

Hoffman, Louise C. *An Artist's Vision: Josephine Crawford.* New Orleans: The Historic New Orleans Collection, 2009.

Hoffman, Malvina. *Sculpture Inside and Out.* New York: Bonanza Books, 1939.

Kipling, Rudyard. "Recessional." In *One Hundred Poems Old and New, Rudyard Kipling,* selected and edited by Thomas Pinney. Cambridge: Cambridge University Press, 2013: 109.

Kramer, Hilton. *The Age of the Avant-Garde, 1956–1972.* New York: Farrar, Straus and Giroux, 1973.

Larsen, Stephen, and Robin Larsen. *A Fire in the Mind: The Life of Joseph Campbell.* New York: Anchor Books, 1991.

Mitchell, Claudine. "Entrepreneurs of the New Order: Bourdelle in the Park." *Oxford Art Journal,* 13 (1990): 101–112.

Murray, Peter. "Émile Antoine Bourdelle 1861–1929." In *Émile Antoine Bourdelle: Pioneer of the Future,* essays by Michael Le Marchant, Peter Murray, Douglas Hall, Peter Cannon-Brookes, 11–22. West Bretton: Yorkshire Sculpture Park, 1989.

Nichols, May Ellis. "Bourdelle." *American Magazine of Art,* 22 (March 1931): 185–92.

Roehl, Marjorie. "Angela Gregory, Sculptor, Dies at 86." *Times-Picayune,* February 13, 1990.

Rubinstein, Charlotte Streifer. *American Women Sculptors: A History of Women Working in Three Dimensions.* Boston: G. K. Hall, 1990.

Sternberg, Sadie Hope. "Sculptor Bourdelle Blames Socialists for Decay of Art." *New York Herald, Paris,* October 25, 1925.

Thiébault-Sisson, François. "Lettre de Paris." *La Revue* (March 2, 1931): 1.

Varenne, Gaston. *Bourdelle par lui-même.* Paris: Fasquelle Editeurs, 1937.

Votre Amie. "Entre Nous." *Times Picayune,* July 5, 1925.

Watson-Jones, Virginia. *Contemporary American Women Sculptors.* Westport: Greenwood, 1986.

INDEX

Page numbers given in italic type represent illustrations.